Outlines of
Australian Art

Outlines of
Australian Art

The Joseph Brown Collection

Daniel Thomas

Harry N. Abrams, Inc., Publishers, New York

Library of Congress Cataloging-in-Publication Data

Thomas, Daniel. fl. 1962.
 Outlines of Australian art: the Joseph Brown Collection/Daniel
 Thomas.
 p. cm.
 Bibliography: p.
 Includes index.
 ISBN 0-8109-1429-8
 1. Art, Australian – Catalogs. 2. Brown, Joseph – Art collections –
 Catalogs. 3. Art – Private collections – Australia – Catalogs.
 I. Title.
 N7400.T48 1989
 709′.94′074099451 – dc19 89-223

Text © Daniel Thomas 1973, 1980, 1989

First published in Australia by
THE MACMILLAN COMPANY OF AUSTRALIA PTY LTD
First edition 1973; expanded edition 1980; third edition 1989

Published in 1989 by Harry N. Abrams, Incorporated, New York
A Times Mirror Company

Printed and bound in Hong Kong

CONTENTS

DEDICATION

Over the years the members of my family have tolerated my involvement in art and indulgence in collecting. For this I am grateful.

I dedicate this third edition to my grandchildren Jennifer, Joel and Lisa.

ACKNOWLEDGEMENTS

I SHOULD LIKE to express my thanks to the following who have all contributed their share in producing this book.

To Daniel Thomas for the difficult task of selecting which items in the collection were to be the subject of the book and for writing the text.

To Mark Strizic and Adrian Featherston for their patience in meeting the demands made upon them and for the high standard of their photography in the first edition. To Ian McKenzie who took the photographs for the second edition. To Henry Jolles who photographed the works for the third edition.

To Alison Forbes for her help in the layout, and to Sandra Nobes, for her very professional approach to the task of design.

FOREWORD

BY JOSEPH BROWN

To MANY READERS this book will present a survey of Australian art. The principal aim in assembling this collection has been to illustrate, by representative examples, the course of development of Australian art over two hundred years of European settlement. It must not be forgotten, however, that this is a personal collection in the true sense. If certain periods or certain artists have been given special preference, that is entirely due to my exercising the personal taste which is the prerogative of every private collector. Other histories of Australian art exist of course, and the chief interest in this book might be that it is an account of one man's endeavour.

The collection consists of well over 400 works, nearly all of which are reproduced here. One should bear in mind that a private collection presupposes a passion and results from the pursuit of a personal goal. I did not have the facilities to employ staff to perform the time-consuming task of seeking out works at exhibitions and inspecting them as well as attending auctions. My livelihood, coming as it did from my work as an art dealer and consultant, and without a source of independent wealth, meant that art collecting could only blossom when it became a kind of obsession, an activity which in the end has shaped and dominated much of my life and thinking. However, although collecting can become an obsession, life is not all art. My love for my family transcends this dedication, and the art of loving and living is the most important art of all.

I DID NOT GROW UP in an environment that was in the least conducive to an interest in art. Brought to Australia at the age of fifteen, the seventh of eight children of lower middle-class Polish/Jewish immigrants, I was raised in a family which had precious few resources available to indulge in anything other than the mundane needs of everyday living. I had one year's formal education in Melbourne at the Princes Hill State School. It was a time when a child who wished to make a career as an artist could not do so without being labelled slightly odd by his relations and friends.

Despite this, in 1934, at the age of sixteen, I commenced a career in art when I won an art scholarship. This, however, had to be abandoned after only a few months of study since severe economic depression then gripped Australia. I had to take a job in order to contribute to the family budget. However, my interest in art was never relinquished and strong personal links with artists were maintained. Indeed, some of the most treasured works in the collection were gifts over the years from such friends as Daryl Lindsay, William Dobell, Russell Drysdale, Arthur Boyd, Clifton Pugh and Yosl Bergner, to mention only a few. In addition, since childhood I have been addicted to collecting art books, and for years I studied history of art, and the development of Australian art in particular.

Hopes that my early success in the business world (the fashion industry) would lead to a quick resumption of artistic activity were quashed by the outbreak of the Second World War. Service in the 13th Armoured Regiment (AIF) for four years was followed by marriage and domestic commitments. With the passing of the years, it became increasingly clear that my plans to return to full-time painting would not be realized, but the urge for some compensatory activity in the realm of art had to be appeased. Consequently, in the 1950s I began to give serious thought to making an Australian collection, with an emphasis on paintings which represented the development of Australian art, from colonial

days to the most recent times. At that time, as well as my own work and a small number of Australian paintings, I already had in my studio a few minor works by important late-nineteenth-century and contemporary European painters. These had been acquired at ludicrously low prices, largely because there were few people in Australia who were attracted to a small Renoir oil sketch, a crayon attributed to Toulouse-Lautrec, and similar works.

The art market then was not quite the same as it is now, and it is interesting to relate how one important European work was acquired. In 1954, after the auction sale of the collection in the estate of Sir Keith Murdoch, the late Joshua McClelland telephoned me. As his art consultant, and in keeping with Sir Keith's wishes, he was responsible for the dispersal of the collection. He told me that a very fine charcoal drawing of a reclining nude by Henry Moore had inadvertently been left out of the sale, and as he did not know of anyone else in Melbourne who would be interested in such an item, he wondered if I would like to purchase it for the reserve price of twenty-two guineas; the offer was taken up with enthusiasm.

Notwithstanding good luck with such acquisitions over the years, it became painfully obvious that my modest success in the business world would never keep pace with the slowly rising prices of significant European art, and a collection on this basis could never be assembled. It was therefore prudent to dispose of the overseas 'scraps' and with the proceeds I secured a few major Australian works which subsequently formed the nucleus of this collection.

I AM OFTEN ASKED if it is possible to assemble a number of good paintings with the funds at the disposal of the average person; the answer is a qualified yes. Lack of funds should never deter the aspiring collector and in fact it can often induce discernment, and, by forcing one to practise the utmost selectivity, help to sharpen aesthetic judgement. However, there are relatively few significant works by artists of the colonial and Impressionist period of Australian art coming on to the market these days; those that do bring exceedingly high prices and it cannot be denied that the acquisition of an important work by a distinguished artist is now completely beyond the reach of the average person.

It is disturbing to see the way in which wealth has begun to dominate the world of art and, in some instances, even the minds of its creators. Art has become a coveted status symbol, and is looked upon as a capital-gains commodity. Important considerations such as the spiritual value, the human enrichment that originally inspired its creators, have gradually been eroded. A small segment of the wealthy and leisured population is slowly but surely turning works of art into symbols of wealth and status. The increasing number of art auctions and the media coverage given to the prices paid for major works encourage the conclusion that art is becoming a spectator sport, with some auctions attracting audiences of many hundreds. The aesthetic and historical legitimacy of a work of art is lost during such an art boom. One can only hope that this fever which causes prices to further escalate for individual works of the colonial and Heidelberg School artists will subside and collectors will show greater willingness to learn, study and enjoy what art collecting is about.

Although it is often said that Australia is in the midst of a great period of art patronage, the truth is that it is still hampered by the massive indifference of the majority of the general public and the fact that there are still among us those who could best afford to participate, but remain inactive. However, it is noticeable that the number of collectors continues to increase, one might hope due to an awareness that the creativity of man is the vital counterpart to modern materialism.

It would be a shame to contemplate a situation in which, now that private and corporate collectors have largely replaced the regal, aristocratic and religious hierarchical collectors of the past, the joy of art collecting may be despoiled by the power of moneyed corporate tycoons.

As always, there is one avenue open to the less affluent collector. That is the acquisition of works by young artists before they gain widespread acceptance. Of course, this is always a gamble as the collector can no longer use his learning and the past experience of others, but has to rely exclusively

on his own judgement. There are many people, not wealthy, who have formed collections due more to their intelligence, knowledge and taste, than to the amount of money they had available. It is a lot harder to plot a course through the emerging modern painters and discover for yourself whose work is worthy of being in a collection. The logical way to go about selecting works of the younger groups of contemporary painters is to buy that which appeals to one's senses. A work of art is not only a visual experience, it is also an affair of the emotions, and therefore the collector must place his trust in his own responses.

A collector, while taking heed of things that have stood the test of time, should also be a precursor, and sometimes sheer stubbornness in sticking to one's choice ought to be exercised, even at the risk of being regarded as having extraordinary tastes. What may be called for here is to have the wonder of a child and the wisdom of an old and patient observer.

I have often been asked to name up-and-coming artists. I cannot, or rather dare not, recommend any one artist. One cannot quote names with any measure of confidence, let alone certainty. To those who ask, I can only congratulate them on their concern in this area for it is a commendable thing to support young artists. They need this support because without it many would, out of frustration, give up an art career.

The vast majority of paintings in this collection was secured years ago at a fraction of present-day market value. There have, of course, been exceptions. At Christies' first auction in Melbourne in March, 1970, a purchase was made which I regard as the most significant work to be offered at that sale; namely, the oil painting *Ferntree Gully* by Eugene von Guérard. It brought a record figure of $8500 for a work by this artist, but was by no means the highest price reached at that sale. Although at the time it meant great personal sacrifice, there was little doubt in my mind that in a decade or two this same painting could well be worth tenfold. In hindsight, this may seem like wishful thinking, but in the United States and Canada (countries which have colonial histories resembling our own), such increase in prices for similar works by 'frontier' artists had already taken place. A conservative estimate of the present-day value of this painting is $2 million.

Luck can often play an important part in art collecting. Some years ago, while visiting London, I wandered in to the Leicester Gallery. While I was looking at a painting by Streeton — a typical late 'pot-boiler' which did not greatly appeal to me — the director of that gallery mentioned he had two other Streetons in storage which he kept out of sight because he thought they were not saleable. I asked to see them. To my amazement he brought up two splendid and important paintings. One was *The Centre of the Empire* (plate 96); the other was, I think, probably the best Streeton of its period (later purchased from me by the Queensland Gallery) — *St Marks, Venice*. The director had already encountered the persistent reluctance of the average Australian collector to acquire works by Australian artists with a subject matter other than Australian. It is worthy of mention that there are still many Australian collectors who would decline the opportunity to own an overseas subject like this.

IN THE EARLY DAYS the problem of housing the increasing number of paintings in the collection became more and more acute, and was eventually solved early in 1967 by the purchase of a new home, the mid-nineteenth-century Caroline House. Originally built in 1856 for Captain Joseph Henry Kaye, RN, who was private secretary to Sir Charles Hotham, then the governor of Victoria, Caroline House was found after a long search and was the first property within my financial means which lent itself to the purpose of housing the collection, as well as meeting normal domestic requirements.

Although the original building was in a bad state of repair, its main attraction lay in the large and lofty rooms. Unlike modern houses, which tend to restrict wall space because of the large areas of glass in their design, Caroline House has uninterrupted hanging space, while at the same time, the French windows admit sufficient natural light to illuminate the rooms adequately during the day.

Now the collection has once more outgrown its home and I cannot accommodate many of the contemporary works on the walls of Caroline House.

SINCE PUBLICATION OF the first selection of works from the collection in 1973, its number has continued to grow. It should be noted that seven major works from the original collection are now with the Australian National Gallery in Canberra and the National Gallery of Victoria, though they are reproduced in this new book so that a continuum could be maintained in the span of two hundred years.

In recent years, the principal expansion of the collection has been in three areas. First, some important items — though not major works — have been acquired of the early colonial period, that is, the period dating from the voyages of discovery to the pre-gold-rush years of the mid-nineteenth century. Notable amongst these are minor but interesting items by John Eyre, Richard Browne and Benjamin Duterrau, as well as a fine but small Conrad Martens watercolour. The huge escalation in prices for works by artists of the gold-rush era, followed by those of the Heidelberg School painters, has meant I have been unable to afford to secure significant works of that period. Nonetheless, I have managed to acquire a splendid portrait study by William Strutt (plate 45), and an exciting oddity by Arthur Streeton, an oil *In the artist's studio* (plate 89), painted on a tambourine.

In second place, the collection has been greatly enriched by the inclusion of works by artists of the 1930s and 1940s, including paintings and sculpture by Clarice Beckett, Robert Campbell, Eveline Syme, Bessie Davidson, Ola Cohn and Danila Vassilieff, to name but a few.

Next, I have sought to bring the collection up to date by acquiring works by the younger generation of present-day artists such as Geoffrey Bartlett, Davida Allen, Vicki Varvaressos, Nicholas Nedelcopoulos, Ian Westacott and others.

The fulfilling of such aims, and the occasional acquisition of a work by the avant-garde, offers new excitement, and is the life-blood of collecting. Another challenge occurs when artists who have an established reputation in one medium elect to explore the creative possibilities of another. John Perceval, Arthur Boyd and, to a lesser degree, Fred Williams have produced significant ceramics and drawings as well as paintings. Boyd and Williams have also produced an enormous and very significant output of etchings. The collection has gradually been enriched by the inclusion of items in these media.

Some works which possibly should be included in the collection continue to elude me, and perhaps these omissions will be rectified in time. For instance, it is hoped that an early Antipodean work by Robert Dickerson may be acquired. There are of course others which deserve to be included. When works become available that have a place within the two-hundred-year time span, and if resources are in hand, they will be added to the collection.

I make no attempt to offer a theoretical diagnosis on the virtues of contemporary art and it would be less than honest of me to suggest that I am enraptured with every item of the Contemporary School which I have selected. However, bearing in mind that the collection is recognized by some as one of national importance, I have felt obliged to make concessions to ensure a fair representation of contemporary forms of expression. Yet the transparent excellence of some of these works suggests that it is the standard, rather than the art, that warrants revision.

Once the validity of this mode of thought has been recognised, the final results appear almost simple; any intelligent undergraduate can understand them without much trouble. But the years of searching in the dark for a truth that one feels, but cannot express; the intense desire and the alternations of confidence and misgiving, until one breaks through to clarity and understanding, are only known to him who has himself experienced them.

Albert Einstein 1933

The fact that a certain form of expression has not yet won widespread recognition by the general public does not diminish its validity in any way, nor need it disturb its creators. Nowadays, thankfully, one can discern a refreshing degree of receptivity by the general public of much recent art. In my view, the private collector has the right to select works that reflect his own tastes, just as his library of books should

above all represent his intellect. There are, for example, no works relating to the genre of 'performance' and conceptual art in this collection. I do not believe these have a place in a private collection that is housed in a private home.

It is not my intention to go into the arguments for and against modern art. Most people will sympathize with those who spend their creative energies in trying to expand their artistic horizons, and we should bear in mind that it is difficult to judge the historical significance of the artists of our own generation. The Impressionist painters, almost universally admired today, were in their time, accused of being totally unable to perceive beauty.

Art is symbolic, and the artist in his interpretation employs a language which changes from generation to generation. The older generation seldom understands what the younger generation is saying. Let us try to understand the artist as a witness of his time who, no less than any other member of society, is sensitive to change. The accusation most commonly levelled against modern artists is that they deprive us of the visual experience of the physical world as we know it. But once we have accepted the premise that an abstract work of art can be an entity in itself and need not be a reflection of an object that already exists, or a happening that we have experienced, we can learn to appreciate modern art in its proper context.

The inevitability of posterity consigning what is worthless to oblivion, will ensure that only works by artists who have made a direct contribution to the progress of art will endure. Throughout history, relatively little work has been good enough to transcend time and be all things to all men.

IT MAY WELL BE ASKED if an individual has the right to keep to himself works of art that could be regarded as a part of our national heritage. Needless to say, a private collector has no obligation to permit the general public to view his acquisitions, assembled over a period of many years through the exercise of much discipline, hours of scholarship, and the denial of pleasures enjoyed by those who would consider his pursuit to be an obsession. Be that as it may, the owner of a collection which reaches the point of being of national significance usually regards himself as only the custodian of such works; he normally recognizes the contribution he can make to public enlightenment and will afford the public the opportunity to view his collection. Indeed, since my move to Caroline House thousands of people have visited and viewed the collection though it has not been 'open' to the general public.

National galleries are invariably stocked far beyond their functional capacity, and generally can only display a fraction of their large holdings at any one time. They are not in a position to buy every worthwhile work which appears on the market, consequently some debt is due to those who are devoted to this form of endeavour; but for their efforts, many works of art would have been lost to posterity. In any event, many works acquired and cared for by private individuals are eventually incorporated into museums by means of bequests and gifts.

For thousands of years people have collected art; it is an obscure, but with some, a persistent impulse. The phenomenon of art collecting is too instinctive and too universal to be dismissed either as mere fashion or as a status symbol. More likely, it is an irrepressible expression of the individual who sees in art a means to deep aesthetic gratification.

The collector usually has two driving motives: first, the desire to possess something that attracts his attention, and second, the wish to complete a series once the collection has been commenced. There are, of course, other motives, such as the acquisition of paintings to decorate a house; or for an outright investment purpose.

Many aspiring collectors tend to own an assortment of paintings resulting from the impulsive and haphazard purchase of largely inferior works by well-established artists, and by following fashions created by dealers to serve their commercial interests. Such collections are generally inspired by

superficial motives and dissolved and reformed with every fluctuation of market values and changing

tastes. Aesthetics and standards of quality play little part and the result is often a hotch-potch of paintings, rather than a relevant, cohesive and valid endeavour. The best advice that can still be given to the collector is for him to ask himself: Has the work a life of its own? Is it valid as a work of art? And above all: Does he like it?

To gather a truly important collection requires an innate sense of artistic quality, balanced to varying degrees with a genuine belief in the need to uphold cultural values, and a devotion to scholarship.

THE DIVERSITY OF STYLE of the collection illustrated in this book is inevitable when one considers the time span it covers.

With an amusing conflict of opinion, devotees of contemporary art have criticized me as an arch-conservative, whereas those who favour the traditional style of painting, the work by artists of the Heidelberg School and the colonial era, consider the collection to be biased in favour of the contemporaries. The truth is that I have never been inclined towards any particular style, be it impressionist or hard-edge.

This particular collection covers as far and as wide a range of Australia's art as my intellectual and financial resources permit. Not one to dismiss the product of present-day artists as of no consequence, and believing some of it at least to be valid, I am not beset by the apprehension of those who seek the security of things that have stood the test of time.

To collect is to be selective, the very act of collecting requires the exercise of selectivity. I have elected that my collection be judged not only on the exceptionally fine items but also on those that at this stage have not yet been tested by time. Allowances may be made for poorly chosen work on the ground that such works may have had relevance to the collection at the time of their acquisition.

Any collection which aspires to encompass Australia's artistic process would not be complete without the inclusion of sculpture, but there was, and still is, lack of public interest in this form of expression due, in the main, to difficulties caused by the weight of materials generally used, and sometimes because of their fragility, as in the case of ceramics. However, collectors are now less timid about such problems, and there is evidence that more people have come to realize that the ownership of good sculpture is more within the scope of the average collector than the ownership of good paintings. As in the United States and Europe, modern Australian sculpture has given birth to a new concept of form and space, and heavy emphasis is placed on the expressive value of materials. Indeed, many of our sculptors have broken away completely from the accepted media of the past, and some have utilized such material as scrap metal.

Naturally enough, landscape painting is well represented in this collection, as it was the main subject matter of work of the colonial period, and the main preoccupation of artists of nineteenth-century Europe. In Australia, of course, the creative genius of the early artists was absorbed by the novelty of an unfamiliar landscape and foreign flora and fauna.

There is a preponderance of portraiture, too, in this collection, though portraiture is usually neglected by Australian collectors. The excuse which is commonly given is that the portrait may wrongly be assumed to be that of a member of the collector's family! Portraiture had rather formal beginnings in Australia and in the main it recorded the appearance and customs of its patrons; apart from the notable exception of the work of Augustus Earle, Benjamin Duterrau and Thomas Wainewright in Tasmania, it did not often record the mainstream, which was largely composed of convicts and pioneer settlers. However, in this respect we owe a great debt to S.T. Gill who so vividly recorded many aspects of colonial life, including the pathos of the working class, and the bawdy life on the goldfields. He could hardly be considered a portraitist, but his painting of 'Baby', his favourite barmaid (plate 35), has a warmth and sensitivity seldom found in the commissioned portraits of that period.

The reluctance of some collectors to own portraiture is only equalled by those who refuse to consider drawings. Few collections have within them a reasonable representation of drawings. Generally the explanation given is that drawings have been overlooked because of lack of space (the average collector would rather have an oil, and to a lesser degree a watercolour, in preference to a drawing), but it is more probably due to the fact that the purchase of a drawing often requires more courage than any other form of collecting.

The importance of this collection, as of any other, is the sum of the works it represents. But that in turn can only be a small part of the total work of the artists, and of the periods in which they lived, all of which make up the tradition of Australian art. Despite some unavoidable omissions, my ambition to acquire a collection which covers the full spectrum of Australian art over the past two hundred years of its history has I feel now been achieved.

Joseph Brown
Melbourne 1989

INTRODUCTION AND TEXT BY DANIEL THOMAS

INTRODUCTION
AND TEXT BY DANIEL THOMAS

AN ART DEALER is, or should be, an art-museum curator's best friend. Neither profession need be rewarding financially; in both professions the reward is a sense of creative achievement which comes when a collection begins to have a greater meaning than the works of art ever had in isolation.

Usually the curator has only one museum collection to improve and adjust; he or she does not often have the pleasure of beginning a new collection. The dealer on the other hand is helping to form many collections, and may indeed offer his or her choicest discoveries to public collections, for the curator will always make sure the dealer knows the museum's needs and, since the public collection is most likely to be nearest the ideal, a significant addition to it will have a more striking effect than elsewhere. However, there are numerous private collections in which a dealer will participate creatively, often from a collection's birth.

There must be great pleasure in deciding with whom each find will be most happily placed and perhaps the dealer is best considered as a godparent to many collections, supervising their progress to spiritual maturity. After all, some collections do stop growing, a house becomes overcrowded, a goal becomes reasonably fulfilled, and the godparent is no longer needed. On the other hand some collectors, like some people, never stop developing; they might produce branch collections like the one which Dr Norman Behan placed in two Brisbane colleges, or more commonly they might develop in quality without developing in size. In 1973, when I wrote the Introduction for the first edition of this book, I expected that would happen with Joseph Brown's collection. His goal of a full chronological history of Australian art was then reasonably fulfilled and his house could scarcely hold more. And although nothing of high quality had then left the collection, some artists originally represented by no more than typical specimens of their style had had their representation greatly improved as opportunity arose.

In 1988 Joseph Brown updated his collection to include characteristic works of the 1970s and 1980s; if parts of his house have become temporarily uninhabitable with stored works of art, the needs of the book have outweighed domestic comfort. In the bicentenary year of European settlement in Australia, the value of surveys of Australian art was especially appreciated and it is surprising to realize that *Outlines of Australian Art* has so long remained the only full survey in a single book. Its only rival is the exhibition book *Creating Australia: Two hundred years of art 1788-1988*, which similarly includes media other than painting.

Indeed, a handful of major works has left the Joseph Brown Collection since 1973, as gifts or fully facilitated sales to art museums. (The first such departure was Eugene von Guérard's masterpiece *Ferntree Gully in the Dandenong Ranges*, given in 1975 to the Australian National Gallery.) These works were retained as illustrations in the 1980 edition of this book and their new homes are identified in this third edition.

Is it unusual to find that a dealer keeps a private collection rigidly separate from his trading collection? Not at all. Some do, some don't. In any case, like Kym Bonython in Adelaide, Joseph Brown was a collector long before he was a dealer.

Is it unusual to find a private collector systematically building up a history of Australian art? Yes it is. Dr Behan did it for his colleges in Brisbane though not for his personal collection. Otherwise, private collectors seem to specialize: for example in one period, like the so called 'Heidelberg School'

or art nouveau or the avant-garde; or in one or two favourite artists; or in one or two favourite subjects (ships, or flower-pieces, or local topography); or, often without being aware of it, in favourite formal qualities (rounded modelling, or flat angularity, or tonalism or colour); or in a particular medium (watercolour, or sculpture or etching).

Joseph Brown's goal of a complete history of Australian art was more ambitious and more difficult than any of these and, since a curator is necessarily involved in the same goal, I was able then especially to appreciate his skill and admire his energy. (I hasten to add that collections formed on other principles are no less admirable.)

Where has Joseph Brown fallen short of his goal, and where are the strengths of his collection? Obviously lacking are major works by the Australian Nationalists of the late-nineteenth century, by Tom Roberts and Arthur Streeton. Such works are all in the museums already, for they have been highly regarded for several generations. In addition, living in Melbourne, Joseph Brown in 1973 had not always found good examples of the work of Sydney artists, though the purchases of recent art have given the collection excellent regional balance.

In 1973 one could also say that the contemporary period was inadequately represented, though since Joseph Brown's collection is, after all, contained in a private house, he could be excused the large, museum-scale paintings which were the major works of abstract expressionism (Peter Upward) and of colour painting (David Aspden, Michael Johnson). If he had not yet finally made up his mind about the art-historical position of then-young artists like Aleksander Danko, Nigel Lendon, Ti Parks, Peter Powditch, Michael Brown, Dale Hickey, Robert Hunter or many others, that too was readily excusable, for only a specialist in the avant-garde could feel confident. Works by some of them subsequently entered the collection and are illustrated in later editions of this book, as is work by many artists who emerged after that 1973 list was made.

There is a special, personal flavour to the collection which comes from the presence of work by Yosl Bergner, Vic O'Connor, Albert Tucker, Arthur Boyd and other Melbourne artists who were young and struggling in 1939. Bergner's work was acquired at the time, Tucker's and Boyd's much later, yet they all group themselves as works of Joseph Brown's own period and generation, for he too was a struggling young art student in the thirties. Brown himself once had aspirations towards being a professional sculptor. The comparatively large number of sculptures in the collection, and the fact that sculpture is given its proper place in Australian art history, reflects this early ambition.

If work by Melbourne artists of 1939 and work by sculptors are present partly by virtue of Joseph Brown's early personal history there is another unique area of strength in the collection. Australian painting from the period prior to the 1880s has scarcely been admired in this century. The admirers of the nationalist painters of the 1880s, of Streeton, Roberts and McCubbin, denigrated their predecessors so effectively that only in the 1960s were John Glover, Eugene von Guérard and W. C. Piguenit reinstated as major artists. Certainly their work is different from that of Streeton and Roberts, but it is just as good. Since work of that period had been out of favour, some of its masterpieces were still available for an intelligent collector who knew his art history; the masterpieces were not already in the museums as were those by Streeton and Roberts.

Thus, a great strength of the Joseph Brown Collection lies in colonial and Victorian painting. Not only are Glover, Martens, von Guérard and Chevalier represented by their very best work, but a range of lesser mid-nineteenth-century figures is also to be seen here as nowhere else in Australia.

Further, Joseph Brown has conducted rescue operations for Australian art that had found its way to foreign countries. The outstanding examples of paintings by John Russell and Roy de Maistre in his collection are a reminder that it was he who brought back to Australia from those expatriates' estates the many works which are now in this country.

I HAVE NOT ALTERED the judgements made in the original Introduction of 1973 and have altered its text only to accommodate subsequent developments. The same applies to the book's principal art-historical text, even though its chapters were originally written to accompany eleven separate groups of illustrations, whereas in this edition the illustrations are in a single continuous sequence. The eleventh chapter, 'Contemporary Art', is now greatly expanded.

Picture captions and catalogue entries now incorporate the results of later research into titles, dates, attributions. Artists' working names have been changed in some cases, for example *Eugene* von Guérard is now preferred to Eugen or Eugène. Some of these improvements were launched in the exhibition catalogue *The Joseph Brown Collection* published by and in aid of Austcare Victoria, Melbourne, for an exhibition of 177 works held at the National Gallery of Victoria, Melbourne, 31 October–7 December 1980, but they are not present in the 1980 edition of the book.

The first edition of 1973 (which in fact was issued in 1974) contained 144 plates plus eight figures within the text. The expanded edition of 1980 contained 61 additional plates. This third edition has further expanded the picture history of Australian art to some 400 illustrations. As a personal appendix there is also a group of portraits of Joseph Brown by his artist friends plus a selection from the paintings and sculptures made by Joseph Brown, dealer, consultant and private artist.

Daniel Thomas
1989

1 ROMANTIC VOYAGERS

ENGLISH PAINTING REACHED its greatest heights in the age of romanticism. Richard Wilson's landscapes begin the movement around 1760, the Pre-Raphaelites close it a hundred years later, and J. M. W. Turner is the central figure. Turner is not only England's greatest painter of any period, he is perhaps the world's greatest painter of the romantic period.

Since Australia was colonized by Britain at the time of this upsurge in English painting, our earliest colonial art is an extension of English romanticism.

Romanticism in painting was largely a matter of landscape. Instead of welding society together with conventional moralities from Christian religion or from Roman history, art was now allowed to become more individual and private. Society had become stable enough to allow the luxury of a taste for disorder, for untamed nature, mountains, wilderness, storms, or oceans. In the romantic period the mediaeval world, the exotic orient, or an imaginary, primitive Golden Age of uncorrupted natural innocence were all preferred to the long-dominant culture of classical Rome.

So when the scientific voyages of Captain James Cook initiated a practice of including professional artists in ships' companies there was no difficulty in finding young painters eager to voyage to the end of the world. They were embarking on romantic journeys.

Immediately before Cook's first Australian landfall in 1770, Tahiti had seemed to him a paradise inhabited by aristocratic noble savages. Australia itself seemed less picturesque though George Stubbs, the great romantic painter of animals, did produce pictures of a kangaroo and a dingo from skins and sketches carried home to England. It was not Australia but the South Seas, China and India that had tempted artists to travel in search of exoticism and romance.

The most accomplished of Captain Cook's artists was William Hodges, who sailed on the second voyage to the Pacific in 1772–5. Australia was not visited and one of his English landscapes is illustrated here. As an expedition artist, his methods were similar to those of other official artists on similar scientific voyages, for example William Westall who sailed with Captain Matthew Flinders during his charting of the Australian coast in 1801–3.

Westall was nineteen and straight out of the Royal Academy Schools in London when he was taken on by Flinders. He was not the only artist on board. As usual, there were specialist natural-history artists as well, to make accurate studies of plants and animals. Sydney Parkinson's natural-history sketches of 1770, made on Cook's first voyage, were worked up in London by draughtsmen like Frederick Nodder to make them ready for reproduction as engravings; the 1789 *Banksia* is an example.

The 'fine art' painters like Hodges and Westall, professionally trained in landscape and the human figure, were inevitably affected by their scientific companions. On board with Hodges, there was an outstanding astronomer and meteorologist; with Westall two outstanding botanists. Thus Hodges became more interested in clouds, storms and specific effects of light and weather than any other painter before Turner and Constable and Westall's Australian landscapes are carefully filled with botanically recognizable banksia trees and waratahs in flower.

Westall in 1802 also made sketches recording Australian Aboriginal artists' paintings on rock shelters, and other works of art, seen in Arnhem Land and elsewhere in the Northern Territory. Rock-paintings had been made there for at least 20 000 years and in the nineteenth century their imagery

began to be transferred to portable paintings on bark, for Europeans to collect. (Rock-engravings from the same cultural tradition but situated in South Australia were being made 32 000 years ago.) Anthropologists were the principal collectors of bark-paintings until the 1940s, then tourists and art museums began to appreciate them as well.

The bark-painting which provides the first illustration for this book thus stands for the continuous tradition of Australian Aboriginal art, continuous from the most ancient works of art known anywhere in the world to innovative works in the late-twentieth century. A resurgence of Aboriginal painting in the 1970s and 1980s provides further illustrations for the end of this outline of Australian art.

In the 1830s, towards the end of the period of scientific voyages, Conrad Martens reached Sydney after sailing around South America with Charles Darwin on the *Beagle*. Darwin's interest in geology and fossils, which eventually led him to propound the theory of evolution, surely made Martens a more accurate observer of Sydney's rocky sandstone outcrops, and of its vegetation, than he would have been otherwise, and the shipboard experience also made him, like Hodges, a skilled connoisseur of weather effects.

The artists on those voyages were not present merely as factual recorders, though if photography had been invented they might not have been hired. They were also present as illustrators, that is, they were expected to combine material from several different shipboard drawings into information-packed compositions, made on their return home to England. These compositions would be handed to an engraver to copy as book illustrations in the official published account of the voyage, and they would also be worked up by the artist himself into large oil paintings to be shown in the annual exhibitions of the Royal Academy, then deposited in the halls and corridors of the Admiralty Office in London.

Therefore, although Westall was the first European artist of any quality to visit Australia, all his Australian oil paintings remain in England. A large collection of his shipboard sketches is in the National Library of Australia, Canberra; the Mitchell Library, Sydney, owns a watercolour composition of Sydney Harbour. The latter is dated 1804, two years after his visit to Sydney, when Westall was in fact in China.

The watercolour in the Joseph Brown Collection is a similar composition, executed in London in 1808, five years after Flinders had visited the Indonesian island of Timor during the circumnavigation of Australia.

Westall did not admire Australia (or Timor); nor had he expected to. He wanted to use Australia as a stepping stone to Asia or Tahiti; 'Though I did not expect there was much to be got in New Holland [as Australia continued to be named until 1817] I should have been fully recompensed for being so long on that barrin coast, by the richness of the South Sea Islands which on leaving England I had reason to suppose we would have wintered at instead of Port Jackson [Sydney]. I was not aware the voyage was confined to New Holland only; had I known this I most certainly would not have engaged in a hazardous voyage where I could have little opportunity of employing my pencil with any advantage to myself or my employers.' He was in China when he wrote this letter to Sir Joseph Banks, asking permission to stop off in Ceylon, 'a country where I could scarcely fail of success, the rich picturesque appearance, every part affording infinite variety, must produce many subjects to a painter extremely valuable. As no painter has yet been there what I should acquire would be perfectly new. Subjects from New Holland can neither afford pleasure from exhibiting the face of a beautiful country, nor curiosity from their singularity, New Holland in its general appearance differing little from the northern parts of England.'

If Westall's watercolour of Timor is hardly romantic in itself, it at least evidences the romantic role of intrepid voyager in which young English artists then cast themselves.

They were a fairly tightknit group. Hodges, the first such voyager to the Far East and the Pacific, later spent the six years from 1778 in India, becoming the first professional British landscape painter to work there. He was a friend of William Westall's elder brother, Richard Westall. At the Royal Academy Schools a fellow student of William Westall was William Daniell, who had already spent ten

years painting in India; Daniell was appointed artist to Flinders's expedition but on becoming engaged to Westall's sister he withdrew, and Westall was given the post. Johann Zoffany, not Hodges, had been the original choice for Cook's second voyage, and later Zoffany too spent six years in India.

So appointments to the scientific voyages were not essential. The artists also made their own freelance voyages.

Augustus Earle, not represented in the Joseph Brown Collection, was the next artistically significant traveller to Australia after Westall. He breezed through in the 1820s, having arrived by accident on his way to India. He had previously spent four years in Brazil, two in the Mediterranean and two in the United States. He spent three years in Australia and New Zealand.

Immediately after returning to England from Australia and India, Earle was appointed to Captain FitzRoy's scientific survey of South America on board the *Beagle*, where Charles Darwin was the naturalist. Falling ill at Rio de Janeiro, he was replaced by yet another young English artist cruising towards India in search of romantic subjects: Conrad Martens.

Martens never achieved his Asian goal. After the *Beagle* had spent a year investigating Patagonia and Tierra del Fuego, he left it in Chile and sailed for Australia by way of Tahiti and New Zealand. When he arrived in 1835, he surely intended soon to move on to India and then home to England. Instead he remained in Sydney for the rest of his life and became one of Australia's first permanently resident artists to make a modest living from his painting.

It is true that a natural-history artist, J. W. Lewin, had arrived as a settler as early as 1800, but his drawings of plants, birds and insects, and a few landscapes, failed to earn him a good living. He had to try farming, and shopkeeping, and other trades.

It is true also that John Glover, a much more important artist than Martens, had arrived in 1831, but Glover came at the end of an English career, to a remote farm in Tasmania. He continued to paint, but he was comfortably off and did not need to sell his work.

Martens settled into a more usual situation for an artist, a prosperous city, the capital of a flourishing colony. Sydney by the 1830s was an enchanting seaport, busy as a mediaeval trading port, the winding arms of the harbour dotted with romantic Gothic villas; Government House and Fort Macquarie even gave an illusion of castles. When Martens married and had his own house above the harbour in North Sydney, he too chose to build in the Gothic style.

He must have been attracted to Sydney as much by its own romantic charms and by his awareness of a local market for his work as by his original intention of finding exotic Australian subjects to take back to the English art market.

What the small local market demanded was evidence of progress: views of the city and seaport, or portraits of the settlers' country-houses. Some views were kept in Sydney, many were sent home to relatives in England. The more popular views were requested many times and were willingly provided, with variations in the foreground framing of the view, even thirty years after the original sketch had been made.

Not only Australian views, but also views of New Zealand, Tahiti, Rio and Tierra del Fuego were requested by Sydney customers — for example the Patagonian wasteland in the Joseph Brown Collection, which also exists in a larger version in the National Gallery of Victoria. Having been sketched originally in the company of Charles Darwin we can be sure that it is more than a romantic symbol of the end of the world, the remotest wilderness; it extends this idea further with the knowledge that the carcass can become, eventually, a fossil carrying information into the remote future.

Martens's oil painting in this collection is an Australian subject, probably from the south-western districts towards Goulburn where the artist travelled in 1839, and it shows a more personal romanticism than most of his work. If Martens as a young man subscribed to a conventional taste for harbours, sunsets, waterfalls and wilderness, and if the majority of his customers continued to want these subjects (which after all were the great J. M. W. Turner's subjects), yet this Australian inland landscape shows
that he had begun to identify with his new country and to fall in love with its real pastoral life as well

as with the ideal, poetic pastorals found in the paintings of Turner and before him, of Claude Lorrain.

Confronted with this unfamiliar, real pastoral, the old pictorial formulas did not quite fit. Instead of graceful Italian curves and charming balance of chiaroscuro, the Australian loneliness and silence and heat required more uniform spacing of calm verticals, and a uniform hot tonality. When the subject required an Australian style, it received it.

In spite of the opinion often repeated in the twentieth century that the early-colonial painters could not observe accurately, that they always got their gum trees (eucalyptus trees) wrong, this painting shows more than accurate observation, it also shows a convincing image of Australian life. Of course the early-colonial market more often wanted art than observation, that is they wanted a landscape composition that resembled Claude Lorrain or Wilson or Turner, and they usually got it. And of course such landscape compositions had never closely resembled real landscapes or real trees in England or Italy or anywhere, they only follow a set of compositional rules favoured by English artists. Not until well into the nineteenth century did a new generation of European artists begin to value naturalistic observation. Before them there was more careful observation in the work of Hodges and Westall and Martens than was normally found in landscape art.

John Skinner Prout spent three years in Sydney and four in Hobart (whence he briefly visited Melbourne) before returning to England in 1848. His lively watercolour sketch of giant tree-ferns was reworked as a lithograph published in Hobart and as a large watercolour exhibited in London in 1852. The Tasmanian versions are populated by artists sketching outdoors in the coolness of this mountain resort above summertime Hobart; the London version is populated by Aborigines who would not have been there in Prout's time and the exotic living-fossil tree-ferns are exaggerated in size. Gum trees were far less interesting to the European audience, for whom tree-ferns signified not only romantic travel to the other side of the world but also time-travel to the prehistoric past of dinosaur-like botany, the megaflora of the Carboniferous Age.

John Glover, the most important of all early-colonial painters, was already firmly fixed in the traditional landscape formulas when he arrived in Tasmania in 1831, aged sixty-four. Even in England he had been considered a conservative artist, continuing into the 1820s the Italianate conventions of Richard Wilson's work of the 1760s. He never became as free or as wild as Turner; he preferred peace, calm and stability. Like Wilson and Turner he loved both Italy itself and the seventeenth-century Italian landscape paintings of Claude Lorrain. He visited Italy on sketching tours, he owned two paintings which he believed to be by Claude; he made drawings to keep as a record of his own major paintings in emulation of Claude's set of similar drawings, the *Liber Veritatis*.

For his occasional untamed landscapes Glover had an alternative prototype, Salvator Rosa, the source for the picture of the mountain stream, only where Salvator would introduce lurking bandits, the figure in Glover's picture is a purposeful countryman, perhaps a shepherd in search of strayed sheep.

But for his more usual pastoral valleys and golden seaports Glover departed little from Claude's example of tranquillity, balance and subdued harmony. The view towards London from above Greenwich, one of Glover's finest works, at least departs from Claude, as does most of Glover's work, by depicting a real place; it is not an imaginary or a composite view. It involves the spectator more closely than Claude's work ever does and is therefore very much of its own nineteenth-century romantic period. The two relatively large-scale foreground figures quietly gaze out at the same view as the spectator, they share it not only with each other but also with the spectator gazing at the painting. Thus the picture is not a totally self-contained entity, it claims the spectator's active participation by a highly effective device, much used at this time by the great German romantic, Caspar David Friedrich.

Glover, for all his financial and popular success in London had not achieved full critical acceptance there, never being elected to membership of the Royal Academy. He was a farmer's son; in his early years he was a drawing master at Lichfield in the English midlands. In the 1820s Australia began to be known not only as a land of exotic curiosities and a receptacle for convicts but also as a country where

free settlers might easily achieve success. Friends of Glover, the Allports from Lichfield, had emigrated to Australia.

Perhaps the Greenwich painting is partly a dream of departure from London to a pastoral Arcadia across the oceans. Certainly Glover achieved this dream. For although in Tasmania he painted repetitions of English and Italian views for the local market which wanted romantic nostalgia, and fairly wild Tasmanian landscapes with Aborigines for the European market which welcomed romantic exoticism, there is a third category which is probably his best: romantic pastorals, an Arcady come true. In them, his childhood as a farmer's son, his admiration of Claude's shepherds in an agricultural paradise, his dissatisfaction with London, his final achievement of his own paradise at the end of the world, all mesh in a small handful of deeply felt paintings, none, unfortunately, in the Joseph Brown Collection. A man and his dog might look with utmost contentment at a homestead, an orchard in blossom, a valley full of cattle. Or a harvest might be gathered in warm twilight, or a flower garden might display the most splendid red geraniums and yellow broom. The former painter of artificial pastorals now lived, and knew he would die happily, in a real Arcadia, near Deddington in northern Tasmania.

CONVENTIONAL MORALITIES expressed within traditional classical or Renaissance artistic forms continued to co-exist with the new excitement of romantic science and exotic travel. The most important of all social questions for the British colonists was their displacement of the Aboriginal people. Tasmania's settlers had lived in fear of attack by Aborigines until George Augustus Robinson between 1830 and 1834 rounded up the few remaining, and persuaded them to be resettled on Flinders Island.

Benjamin Duterrau, a sixty-five-year-old English artist, emigrated to Hobart in 1832 and ambitiously attempted a number of large, awkward paintings of the Tasmanian Aborigines. In 1835 he issued an etching in order to attract subscribers to pay for a proposed 'National Picture', a picture 'in commemoration of the Aborigines [of Tasmania] and of the benefits received through their conciliation to the colony . . . by the exertions of Mr G. A. Robinson, who is the principal figure in this picture, conversing in a friendly manner with the wild natives, which induced them to quit barbarous for civilized life'.

The artist failed to attract subscriptions and eventually, in 1840, embarked on three unsaleable paintings of the Conciliation, one of them ten feet high by fourteen feet wide and now lost, another six feet wide, now being the most famous painting in the Tasmanian Museum & Art Gallery, Hobart. The etching is in reverse of the original composition sketch and of the paintings. The composition derives, in a general way, from Raphael's figure groups, harmoniously interrelated by gesture and gaze; one Aborigine's pose derives from a classical statue, the *Borghese Gladiator*.

The moral lesson, as perceived in 1835, was 'to shew the advantage of mild and gentle treatment, and its final superiority over force and bloodshed'. But by 1840 half the Tasmanians resettled on Flinders Island had died and the survivors were ethnographic curiosities, believed to be the last of their 'nearly extinguished' race. The moral lesson in the 1980s is very different from that intended by the artist, and it is not reassuring but troubling.

2 CONVICTS, AMATEURS, TRADESMEN

THE VERY FIRST professional European artists to work in Australia did not come by choice like Glover, Martens, Prout, Earle, Westall or Lewin. They were convicts transported from England, usually for the crime of forgery, since an artist's skill could easily be put to the design of false banknotes.

None was a very good artist and most came from provincial centres, not London. The first was Thomas Watling who arrived in 1792, only four years after the initial settlement was established at Sydney in 1788. Others were John Eyre who arrived in 1801 and Joseph Lycett in 1814. When their sentences were complete they returned to England, sometimes by way of India.

Their work is valued chiefly for the information it provides about the appearance and progress of the colony and is better when straightforwardly topographical, as with Eyre, than when it attempts the classically artistic formulas for romantic landscape, as with Watling.

Many of the colony's naval and military officers could draw competently as amateurs. For example Governor Philip King's drawings were copied in London as engravings to illustrate a book on Port Jackson and Norfolk Island.

Convicts and amateurs between them provided a great body of visual records of Australia's earliest colonial beginnings but they provided it chiefly for an English audience, through London publishers of prints and picture-books. John Eyre's *Port Jackson Harbour*, engraved for a set of 24 *Views in New South Wales* published in Sydney by Absalom West during 1813–14, is one of the first colonial productions. The engraver, the convict Walter Preston, while in Newcastle also produced 12 engraved views for Captain James Wallis's *An Historical Account of the Colony of New South Wales*; they were available in Sydney in 1819 but were redated for the book's publication in London in 1821.

The grandest early-colonial view book was Joseph Lycett's 50 *Views in Australia, or New South Wales and Van Diemen's Land delineated*, produced in London after his pardon and his departure from Sydney in 1822. Lycett apparently used other artists' drawings of Van Diemen's Land, which he does not seem to have visited.

Richard Browne, who arrived in Sydney as a convict in 1811, contributed to Absalom West's engraved *Views* but when freed in 1817 mainly produced lively if caricaturish drawings of the town Aborigines.

Convicts who arrived later were more inclined to remain in Australia after they were freed, for, like the free settler Martens in the 1830s, they recognized that a sufficient local market at last existed for their art.

George Peacock, transported in 1839, freed in 1849, found work as a meteorological officer at South Head, above the entrance to Sydney Harbour. His job must have left him with time to spare, for he took up painting. Since Martens was the leading professional artist resident in Sydney his style imitates that of Martens and he is one of many amateurs and minor professionals who produced small oil paintings, not much larger than a postcard, as souvenirs of Sydney. Sometimes they were copied from Martens's lithographs.

W. B. Gould, transported to Tasmania in 1827, freed in 1835, had worked in London as a

draughtsman for a large publisher, which presumably meant copying other artists' work. While still a convict he produced a great many watercolour studies of Tasmanian native flowers and fish at the demand of officials interested in natural history. Once he was free he seems not to have cared for nature. He became the only colonial painter to specialize in still life, of dead game, or fish, or fruit and flowers. The subjects are almost always English. Most English flowers and fruit actually grew in Tasmania but even though he inscribed some flowerpieces as 'Painted from nature' it is likely that he painted more from wax fruit and artificial flowers, or from engravings. Almost identical still-life paintings made in England at the same time cause problems of attribution when they reach the present-day art market in Australia.

What he was selling was not so much nostalgia as a highly conventionalized form of domestic decoration, specifically dining-room pictures, usually for the dining rooms of inns. In this time, J. C. Loudon's influential manual of advice on correct home-furnishing required landscapes in the drawing room, portraits in the hall, and still-lifes in the dining room, so Gould was selling symbols of middle-class correctness, doubtless to the lowest levels of the aspiring middle class.

Gould also painted a few portraits from life which failed to please his clients, and some river and waterfall landscapes, so conventional and stiff that one would hesitate to call them Tasmanian without their impeccable documentation. Thus his picture of sailing ships off a rocky coast, certainly painted in Hobart in 1840, might in fact be developed from a sketch of the Tasmanian coast, though the decorative style would normally make one assume that it was copied from an engraving and that the coast could be anywhere in the world. Gould is an endearingly primitive artist, clumsy but broad and direct. His signature is usually a clear, tradesmanlike *W. B. Gould, painter*, and one feels he would be equally at home painting inn signs, coach doors and theatre backdrops.

Pictures of ships have always existed in their own separate undercurrent of art. The market for them is obsessional, it does not demand good painting, but it does demand total accuracy in the ship's rigging and conformation. It is an insatiable demand, as easy to fill as the demand for pornography, for to non-addicts all ship paintings look the same. The ships might be different, but the composition is usually repeated many times by the one artist. (A similar underworld of horse painting also exists.)

For forty years, Frederick Garling's innumerable watercolours recorded ships he saw in Sydney Harbour during his work in the Customs Department. The harbour itself is almost always introduced as an identifiable setting.

In 1876, three years after Garling's death in Sydney, Haughton Forrest, a one-time army captain and civil servant, arrived in Hobart and soon devoted himself entirely to painting. His marines are never given an easily recognizable coast, though in fact many of those painted in Tasmania are labelled by the artist as English subjects. All that mattered was the likeness of the ship; he would then add a background of his choice. Forrest also painted tight, metallic landscapes which were successfully trans-ferred to Tasmania's postage stamps.

A third marine painter represented in the Joseph Brown Collection is Thomas Robertson, hitherto unknown to Australian art history. His canvases are the largest and most ambitious within this specialized field, and those that have come to light carry dates in the 1850s and 1860s. He seems to have been associated with New Zealand as well as Melbourne.

Portraiture is another field which had its own specialized, tradesmanlike artists until they were displaced in the 1850s by the new invention of photography. Major painters produced occasional portraits when they chose, for example the versatile itinerant Augustus Earle in the 1820s painted large portraits in oils of public figures. However, the portrait specialists were less often oil painters than draughtsmen or miniaturists. Small, portable, low-priced portraits were preferred to oil paintings.

J. A. Houston's portrait of his brother would have been drawn in Edinburgh before Dr Naysmith Houston emigrated to Melbourne, but it is entirely typical of the small pencil-and-wash portraits executed in Sydney in the 1810s and 1820s by Richard Read senior, or in Hobart in the 1840s by Thomas Wainewright and Thomas Bock. All three had been convicts.

The even smaller portrait miniatures of George and Rosalie Waterhouse, in stippled watercolour, were probably painted in Hobart, for the children were born there.

Portrait specialists who worked in oils, from the 1840s to the 1860s, include Joseph Backler who roamed New South Wales country towns, Richard Noble who worked in Sydney (his most attractive known portrait is in the Joseph Brown Collection), and O. R. Campbell in Melbourne and Sydney, though none of those is as good as Bock when he painted in oils, or as J. M. Crossland who worked in Adelaide in the 1850s. Portraits, often sensitive and touchingly immediate, are the most numerous works of early-colonial art.

3 GOLD BOOM CITY

GOLD WAS DISCOVERED in Australia in 1851, most of it in the colony of Victoria. Melbourne, which had been the small centre of an outlying pastoral district, suddenly boomed. By the end of the decade it was a much larger city than Sydney and it remained so until early in the twentieth century.

Naturally the art scene moved to the biggest, wealthiest, most hustling city. Sydney and Hobart became quiet backwaters.

S. T. Gill is the artist most commonly associated with the Victorian goldfields for he produced many lively drawings and lithographs illustrating their activities. However he had been in Adelaide previously, having arrived there in 1839 as a young man with some London experience in a 'portrait gallery', which must have been a place for quick, while-you-wait character sketches. Nobody in Australian art has captured the cheerful animation of city crowds, of miners, or bush workers so well as he. He is a very democratic pictorial journalist, who might have taken up photography in a later age and exploited its immediacy and speed.

The sketch of a woman called 'Baby' is a Melbourne subject, later than his gold-rush period. The other watercolour, a South Australian landscape subject, reminds us that Gill in 1846 was one of the last artists to be taken on a journey of exploration — not a South Sea voyage but instead an inland journey towards the deserts. He retained a strong feeling for pastoral life and his studies of stockmen and Aborigines are as important as his gold-diggers and city shopkeepers.

William Strutt arrived in Melbourne just before the gold-rush; his eyesight had suffered from book-illustration work and, aged twenty-four, he planned to take up farming. The long sea-voyage evidently cured him for he continued to work as a lithographer and to paint, though many of his Australian canvases were completed after his return to England twelve years later. He was the most accomplished artist to have settled in Australia for, although he was English, he had studied in Paris under Horace Vernet and Paul Delaroche who gave him an unrivalled mastery of figure drawing, both human and animal, and of organizing an elaborate composition.

The dog waiting by a flower stall is characteristic of Strutt's lovingly painted animals and his masterpiece, an eleven-foot canvas now in the State Library of Victoria, is a great surge of terrified animals fleeing before a wall of fire and smoke. It rises nobly to the occasion in its treatment of a major event in Australian history, the bushfires which swept Victoria on 'Black Thursday', 1850.

Another Melbourne artist, Thomas Clark, conveyed a lyrical feeling for pastoral life in this period. He filled pale blond grasslands with flocks of tranquil sheep, with kangaroos and cattle, all on peaceful terms with Aboriginal families. He also continued to provide the standard romantic themes of waterfalls, crags and fern valleys that had become routine with Conrad Martens and earlier artists.

J. H. Carse, who moved to and fro between Melbourne and Sydney, is a lesser painter who continued these same standard romantic themes even longer, until the 1880s. The unusually good example of his work in the Joseph Brown Collection is interesting for its demonstration of the change from the restrained colour harmonies of the pre-Victorian painters like Martens, to the wide range of softly pretty colours that was favoured by the mid-Victorians. George Rowe, represented in the collection with a topographical lithograph of civic progress, and Henry Burn are two more minor artists whose paintings introduced a chocolate-box, rainbow prettiness of colour in the 1850s and 1860s; it was probably influenced by the colours that were available in the earliest chromolithographs, then recently invented.

14

Prettiness is never much admired by educated taste. If it became common in mid-Victorian English art it is because a large commercial middle class, educated differently from the landowning and professional classes, now existed for the first time, and wanted art. If it became common at the same time in Melbourne it is because Melbourne was a big enough city to support its own large commercial class, as distinct from the landowners, clergymen and lawyers who had been the principal art patrons before the gold-rush.

Prettiness is not only a matter of rainbow colours. It is more a matter of small scale, busy rhythms and ornamental detail. Pretty pictures are small in size, as well as scale, like those by William Dexter and Henry Gritten. Dexter, who arrived from England in 1852, aged thirty-four, had been a painter on china; in Australia he painted English rustic scenes, birdsnests and still-lifes, but seldom anything recognizably Australian. Gritten, son of a London picture-dealer, arrived at the same time; he painted the parks and gardens of Melbourne, or the country as if it were a city park, or views of Hobart, which had become a summer resort for the citizens of Melbourne.

In this highly urbanized situation, the rest of Australia receded a little from the city's consciousness. Melbourne began to look after itself, it was soon equipped with all the proper institutions. An art museum, the National Gallery of Victoria, opened in 1864 with a few English paintings similar to those of Dexter and Gritten. The National Gallery School opened for art students in 1870 — Thomas Clark was the well-loved drawing master — and in the same year an art society, the Victorian Academy of Arts, held its first annual exhibition. (Sydney responded, and by 1876 had equipped itself with similar institutions.)

Chester Earles was regularly praised in the Academy's exhibitions for painting figure subjects when everyone else painted nothing but landscape, and he became the Academy's president in 1873. He was as uninterested in the Australian world around him as William Dexter, for he usually exhibited exotic Oriental maidens or picturesque Breton peasants. The painting of 1872 in the Joseph Brown Collection is also unreal. The landscape glimpsed through the windows could conceivably be Australian, though probably it is not, but the confrontation of the man with two women could not possibly be taking place in 1872. The dress, the hairstyles and the furniture all belong to the 1840s. Is the picture worked up from an idea conceived in England during the artist's student years, or is it perhaps an illustration for a popular novel of the earlier date? In any case, it has additional charm for being thus doubly Victorian.

Three years later, Emma Minnie a'Beckett, then twenty years old, painted a charming watercolour of an authentic Melbourne late summer interior which appears to reflect Chester Earles's style. (She became Mrs Arthur Boyd senior.)

No other Australian city supported such an inward, unconcernedly un-Australian art as that of Burn, Gritten, Dexter and Earles.

Robert Dowling as a young man produced straightforward colonial portraits in Launceston, Tasmania, and in Victoria before going to London in 1856. There he painted extremely sentimental small pictures like *An afternoon siesta*, aimed straight at middle-class city-dwellers' hearts, but although he continued to live mainly in London his customers were often from Melbourne. For example, Miss Annie Ware, painted by Dowling in London in 1882, was the daughter of the house at Yalla-y-Poora, a station homestead in the Western District of Victoria.

Thomas Woolner, a sculptor member of the Pre-Raphaelite Brotherhood in London, had emigrated to the gold-diggings of Victoria in 1852 but soon retreated to Melbourne and to his art. During his two years in Australia he made twenty-four graceful portrait medallions. After returning home to England he kept up his Australian connections for over thirty years and obtained the commission for a colossal statue of Captain Cook erected in Sydney in 1879.

Towering over the painters of gold-rush Melbourne were Eugene von Guérard (who painted a landscape of Yalla-y-Poora) and Louis Buvelot. These two share the next chapter with a lesser Melbourne painter of the same period, Nicholas Chevalier, and W. C. Piguenit, the Sydney painter who closes and climaxes the Australian extension of European romantic painting.

4 HIGH VICTORIANS

EUGENE VON GUÉRARD, Nicholas Chevalier, Louis Buvelot and W. C. Piguenit are Australia's leading painters of the high Victorian period. The first three worked in the colony of Victoria; von Guérard arrived in Melbourne in 1852, Chevalier in 1855, Buvelot in 1865. Piguenit, despite his French name, was Australian-born; after resigning from the Tasmanian Survey Department in 1872, aged thirty-six, he moved in 1880 to Sydney as a full-time painter. He was the first Australian-born professional painter.

All were wanderers in search of romantic landscape and thus continued and closed the tradition to which Westall and Martens belonged. Two of them continued the early-nineteenth-century tradition of the luxurious picture book, though now the albums were published in Melbourne not London: *N. Chevalier's Album of Chromo Lithographs* was issued in 1865, *Eugène von Guérard's Australian Landscapes* in 1867. Two prints for these albums were developed from major paintings in the Joseph Brown Collection, Chevalier's *Mount Arapiles and the Mitre Rock* and von Guérard's *Ferntree Gully in the Dandenong Ranges*.

The text accompanying von Guérard's lithograph of the Ferntree Gully mentions that '...the scene lies in the vicinity of the Southern Dandenong Saw Mill, about five and twenty miles eastward from Melbourne; ... a comfortable hotel in the immediate neighbourhood, the Gully is a favourite resort for summer tourists'. This sounds as if the book were aimed at the same big-city commercial middle class that liked Henry Gritten's paintings and the texts accompanying many of the lithographs also mention tourism. However they would have been intrepid tourists indeed to reach the summit of Mount Kosciusko, or the mountains in the Australian Alps which von Guérard especially favoured. He was a tourist of an extreme kind, like the earlier Augustus Earle. Only whereas Earle embraced Australia in a tour of the exotic East, von Guérard probably saw Australia as part of the same warm south that for centuries had beckoned Germans to Italy.

Von Guérard was the son of a Dusseldorf artist who became a painter of portrait miniatures at the Austrian court. Eugene was born in Vienna but in 1826, aged fourteen, he left for Italy with his father, who was shortly established at the Bourbon court of Naples. Father and son travelled extensively in Naples and Sicily; Eugene had already studied in Rome and there met the expatriate Germans Peter Cornelius, Joseph Anton Koch, Julius Schnorr von Carolsfeld and other members of a remarkable group of high-minded religious reformers of art whose painting aimed for the purity and simplicity of feeling which they found in Italian art of the early Renaissance. Their aims were similar to those of the later English Pre-Raphaelites, whom they were unknowingly to influence. A sober truthfulness to nature was prized, and an intense respect for the subject portrayed; they condemned the use of conventional formulas in composition or in brushwork as being mannered and careless. The result was a highly finished and elaborately detailed style of painting.

After his father's death, von Guérard returned from Italy to Germany in 1838 and enrolled, by then a mature student in his late twenties, in the Academy of Art at Dusseldorf. Under Wilhelm von Schadow, a former member of the German group in Rome, the Academy had become one of the leading schools in Europe. Von Guérard is thus much closer to the sources of German romanticism than were Australia's artist immigrants from England to the sources of British romantic painting.

Why, after twelve years in Italy and fourteen in the Rhineland, did von Guérard come to Australia? Obviously, like many Germans, he had a romantic predilection of travel, and for warm climates.

But in 1852 he heard about the goldfields of Victoria. Though painting might have been something to fall back upon, he came chiefly as a gold-digger. It was well over a year before he left the Ballarat diggings to set himself up in Melbourne as a landscape painter.

Von Guérard's exceptional qualities as an artist were quickly recognized. His work was bought by the wealthy squatters. In 1870 he became the first Curator of the National Gallery of Victoria and Head of its art school (Thomas Clark was the drawing master under him). Yet he left no significant followers and after his return to Dusseldorf in 1882 he was soon forgotten, perhaps because the artists and writers of the 1880s were to become aggressively nationalistic. They sought characteristically Australian subject matter from everyday life, they sought a mythology of pastoral workers and blazing sunshine, and they were looking to France and the new art movements, Impressionism and Naturalism, for a free, informal style. German (or English) romanticism was at once too personal and too universal: you could commune with nature in a mountain wilderness anywhere in the world, and anyway crags and waterfalls were considered less typical of Australia than were grassy plains. Moreover the tight, detailed style of painting simply looked old-fashioned by the 1880s; it was thought little better than botanical or topographical art.

Today, in a less nationalistic age, we can more easily appreciate von Guérard's achievement. His waterfalls, jungles, wilderness and crags, found on sketching tours in Victoria, Tasmania, Adelaide, New Zealand and Sydney, are much more highly charged with content than those of Augustus Earle, Conrad Martens or Thomas Clark. Theirs are picturesque, his are cosmic. That is, von Guérard's patient detail is a humble acknowledgement that God's smallest creations are as important as the largest; they are not glossed over for the sake of a general effect. At the same time the spectator's eye is usually carried beyond both the small and large landscape elements to an infinite dramatic space. His skies make one think of heaven, his mountains often look like altars. Not only was romantic landscape in general a kind of nature-worship, the Germans in Rome had been specifically religious: they were called the Nazarenes, and they formed a quasi-monastic community.

Besides Christian symbolism one can find an awareness of violence in von Guérard's work. Sometimes a geological formation seems to show the earth exploding. Mountain peaks violate the sky, waterfalls destroy rock. The vegetation writhes orgasmically in the Ferntree Gully painting and today we might consider such a sexual treatment innocently pre-Freudian. In other paintings trees are strangled by vines, dead skeleton trees become crutches for the dying. Death and regeneration are a continuous cycle.

It is not without significance that at a costume ball in Melbourne in 1863 von Guérard chose to be Salvator Rosa. Rosa stood for the violence of Naples, and among the earlier masters of landscape painting he was the alternative to Claude Lorrain's Roman tranquillity.

Von Guérard, like Glover and Martens, painted tamed landscapes as well as wild ones, squatters' homesteads as well as mountains. His homesteads however were little known to the general public, for they were directly commissioned by their owners and seldom exhibited, illustrated or bought for the museums.

In 1864 the first Australian work to enter the National Gallery of Victoria was a six-foot canvas by Nicholas Chevalier of the Buffalo Ranges. Von Guérard's *Spring in the valley of the Mitta Mitta with the Bogong Ranges* followed almost immediately, and his *Mount Kosciusko* soon after that.

Similarly, in 1875 in Sydney the first works to enter the Art Gallery of New South Wales were a cloud-swept Tasmanian mountain by W. C. Piguenit and a New South Wales waterfall by Conrad Martens.

Yet the landowning squatters appreciated dramatic landscapes as much as the portraits of their pastoral homesteads. Chevalier's *Mount Arapiles and the Mitre Rock* was painted for Alexander Wilson, a 'shepherd king' in the Wimmera district and owner of this mountain. *Ferntree Gully* was one of eight major paintings by von Guérard which dominated the English country-house of Frederick Dalgety, founder of a large Australian pastoral company. And Joseph Brown's smaller version of the National

Gallery of Victoria's *The valley of the Mitta Mitta* was originally owned by the same John Ware who had commissioned the view of his Western District homestead, Yalla-y-Poora.

Von Guérard's homestead paintings are microcosms of the world. He loves to show both mountain and plain, water and sky. He respects the outbuildings as well as the house and indulges in microscopic pleasures of agricultural equipment, a winepress, or a waterbutt. Flowers and vegetables, poultry and flocks are often included in the grand embrace of all that humankind requires and humans usually give tension to the pastoral. An Aboriginal group might observe in passive silence while Europeans hurry their horses down a drive. The Europeans' restless energy is noted, ambiguously; it is both creative and destructive.

Nicholas Chevalier had none of von Guérard's intellectual depth, and not much taste as a painter. He was chiefly an illustrator. Born in Russia of Swiss parents, he went from Lausanne to study in Paris, Munich and London, then at twenty-seven came to Australia to become the first cartoonist for *Melbourne Punch*. He drew many newspaper illustrations for wood engravings and his chromolithographs, technically excellent, were among the first in Australia.

Though they were the stock-in-trade of Alexandre Calame, the leading Swiss painter in Chevalier's time, a friendship with von Guérard might have strengthened the choice of subjects for Chevalier's paintings: crags and waterfalls, usually larger than von Guérard's, always gaudier in colour and more papery in structure. The two artists shared several sketching tours through the mountains.

When von Guérard went to the costume ball as Salvator Rosa, Chevalier went as Rubens. Rubens was a courtier-artist and diplomat, and so was Chevalier, for, after a painting trip from Melbourne to New Zealand, he left Australia in 1868 by joining the Duke of Edinburgh's world cruise. He settled in London where a number of royal commissions came his way.

W. C. Piguenit, born in Tasmania and largely self-taught, acknowledged the influence of B. W. Leader, the English painter of swamps. Perhaps the paintings by Chevalier and others in the National Gallery of Victoria influenced him too, for mountains, rivers and clouds are almost his only themes. Yet they were a real part of his earliest life, as Hobart is poised between a river and a mountain and clouds constantly mingle indeterminately with the land. From the age of thirteen he spent more than twenty years as a government surveyor, gaining further experience of mountain and cloud. He moved to Sydney as a full-time painter, encouraged by Eccleston Du Faur, a surveyor, a promotor of the Blue Mountains as a tourist resort, and a founder of the Art Gallery of New South Wales. Piguenit in Sydney continued to paint the Lane Cove River at Hunters Hill (where he lived) and the Blue Mountains as if they were as misty as his native Tasmania.

His art is surprisingly isolated and very conservative even in the 1880s when it was most admired — but Sydney then had little else but illustrators and Piguenit's sensuous paint surfaces, sometimes thickly scarred and caked, sometimes delicately matt, must have given special pleasure to those who loved painting for its own sake. His colour was restrained, his tonality often dark, his mood conventionally romantic; all qualities to displease the nationalist generation which was to follow him and suppress his work as it suppressed that of von Guérard.

However we can now admire Piguenit for the steady conviction in his painterly obsessions, the lyrical relish for darkness and flood at a time when sunshine and drought were being claimed as the proper subjects of Australian art.

John Ford Paterson is to some extent a Melbourne counterpart of Piguenit, though less accomplished. Scottish-born and trained, he settled in Melbourne in 1884 where he painted late-romantic landscapes, dark rivers, iridescent fern glades, wild seacoasts like Buvelot's in the Joseph Brown Collection and twilight landscapes with flocks of sheep — like Buvelot's *Summer evening near Templestowe* which had been in the National Gallery of Victoria almost as long as Louis Buvelot had been in Australia.

Louis Buvelot was another Swiss, from the same region as Chevalier. (Charles Joseph La Trobe, the first Governor of Victoria, had a Swiss wife, he recruited a number of immigrant Swiss vignerons

from Neuchâtel, so perhaps that is why Swiss artists also chose Melbourne.) He arrived in 1865, aged fifty, and like nearly all his colleagues he had already roamed much of the world — a year in Paris, seventeen in Brazil, an experimental visit to Calcutta. Yet he does not seem to have been a romantic at heart. He occasionally painted mountains but he made them seem smaller than they really were, occasionally an Australian fern gully or a Brazilian jungle, occasionally a Western District homestead or a waterfall.

This collection's beach scene with breakers and strange, surging rock formations is one of the most extreme among Buvelot's conventionally romantic images, though even it is domesticated by the group of strolling figures and it is as much a study of natural textures and effects of light as a romantic image.

Buvelot became more an intimist in landscape than a romantic. His sketching tours mostly took him to the suburban farms of Heidelberg, Templestowe or Dromana. His paintings dwelt affectionately on bits of earth and bark and foliage, weathered fences and humble buildings. Such commonplace subjects surprised Melbourne and so did his broad handling of richly-textured paint. In fact this was modern art, Australia's first sight of French painting of the Barbizon school, and Melbourne's art students were profoundly disappointed in 1870 when the better-qualified but more old-fashioned von Guérard became first Head of the National Gallery School. Not only were Buvelot's technique and style more modern, but his choice of subject matter was also more relevant and accessible to the city's students.

The public, as well as the students, soon learnt to admire his work. By the 1870s, native-born Australians for the first time outnumbered the immigrant population and for the first time the pleasures of self-recognition and self-discovery became an important part of Australian culture. Buvelot's Barbizon style enabled him to accept the look of domesticated Australian landscape in a natural, affectionate way. He never placed Aborigines in a landscape as von Guérard did to indicate the European takeover of their land for sheep and cattle. Buvelot simply accepted the dignity of a stockman's labour, the presence of the sheep, the pastures and the gum trees.

The public was surprised to find that the commonplace was beautiful: 'Mr Buvelot has shown us what a fund of unsuspected beauty is to be found in the gnarled and contorted form of an old gum tree; what charming accidents of colour may be supplied by the blue gum tints of a young sapling and by the dull gold leaves of a withered branch; how susceptible the dry bed of a sandy creek is of pictorial treatment'.

Buvelot had many imitators and disciples. He died in Melbourne in 1888, much loved, and honoured as the father of Australian landscape painting. However the next generation, though it respected his work, considered it insufficiently Australian. For one thing it showed the influence of Dutch seventeenth-century landscape painting and also retained something of Claude Lorrain's compositional and tonal balance and harmony. For another, it had been painted in the studio, not in the open-air, and open-air painting was to become an article of faith in a period of exaggerated nationalism.

5 NATIONAL FIGURES AND LANDSCAPES

THE YEAR OF BUVELOT'S DEATH, 1888, was also the hundreth anniversary of Australia's settlement. The centennial celebrations helped reinforce the demand for a uniquely Australian art. So did the movement towards political federation, achieved in 1901 when the six separate British colonies became the Commonwealth of Australia.

The most famous of all Australian paintings remain the consciously nationalistic subjects produced in the brief period between the centenary and federation. They are large figure compositions, deliberately painted for public situations and are now in art museums, which were their intended destination. None, therefore, is in Joseph Brown's private collection. They were, in any case, few in number. Tom Roberts painted five: two were sheep-shearing subjects, near-sacramental in mood; one was a drover's battle with thirst-crazed sheep; one a cattle muster; and one a subject from the recent past, a mail coach bailed up by bushrangers, yet painted with the spacious dignity of a classical frieze.

Real Australian labourers, Australian life, Australian history, were deliberately ennobled by being given museum-scale representation; Australian landscape was also ennobled by its use in these paintings but it was now very different from the landscape of von Guérard or Buvelot. Blazing heat and sunshine were now thought more symbolic of Australia than Buvelot's gentle twilights and although the nationalist generation continued to paint many intimate twilights, and increasingly to poeticize them, the big national subjects were always high noon. Arthur Streeton, never much of a figure painter, made the sunlight itself carry the main load of symbolism in his great railway-tunnelling picture or in his panoramas on the Hawkesbury River near Sydney, the most history-drenched pastures in Australia. Even Frederick McCubbin and Charles Conder, much more personal and private as artists than Roberts or Streeton, essayed occasional heat and dust-storm subjects around 1890.

Effects of light had been Buvelot's chief concern, but the French Impressionists were to tackle more extreme effects than the Barbizon school with which Buvelot was affiliated and it was during art studies in London in the early 1880s that Tom Roberts learnt something of Impressionism.

Though Whistler's English mists and nocturnes were the Australian students' main idea of Impressionism, Roberts toured Spain in October 1883 and there painted Joseph Brown's study of sunlight at Granada. It is not Impressionist in colour analysis, nor in brushwork; it is too descriptive. It belongs within the tradition of academic Orientalism. But it at least chooses an informal, uncomposed view and it does fix an effect of strong sunlight such as no Australian artist had hitherto attempted.

When Roberts returned to Melbourne in 1885, landscape painting in the open air was already practised but it was he more than anyone else who set up the artists' camps at suburban beaches or in the suburban bush. Darebin was one early painting ground, Beaumaris another. Box Hill from 1886 was the most important. Heidelberg, discovered by the young artists in 1888, was little visited by Roberts and seldom by McCubbin, yet because Streeton and Conder later remembered their two summers at Heidelberg with special nostalgia, and because more was written about them than the other members of the group, the open-air realists of the 1880s and 1890s since the 1940s have been named, but with insufficient justification, the Heidelberg School. If Box Hill was the earlier and more important Melbourne painting ground, there were also for Sydney the ocean beaches and the Hawkesbury River, where Conder had worked before coming to Melbourne, and where Roberts and Streeton were to work

through the 1890s after they left Melbourne. Indeed the hard, sparkling paintings of Australian sunshine were mostly done in Sydney, whereas Melbourne produced more gentle, poetic twilights.

The unsatisfactorily named 'Heidelberg School' really means a group of Melbourne painters, and a few in Sydney, who followed Buvelot's example in choosing subjects from the suburban countryside (Buvelot had been sketching at Heidelberg in the 1860s) and in dwelling on effects of light; who, encouraged by Roberts, went beyond Buvelot's example by painting in the open air, chiefly at Box Hill, then at Heidelberg and later in Sydney, by painting harsh sunshine as well as gentle twilights, and who sometimes painted more sketchily and composed more casually than Buvelot.

Their controversial but successful 1889 exhibition of small, sketchy, nine-by-five-inch 'Impressions' was attacked as '. . . splashes of colour . . . slap-dash brushwork . . . a paint pot accidentally upset'. It is the story of Whistler in London all over again, except that he sued the critic who complained in 1877 of 'Cockney impudence . . . flinging a pot of paint in the public's face'. Streeton's sketch painted on the unlikely support of a tambourine gives an idea of the exuberant studio life of this community of young artists. It was a community which included women artists, notably Jane Sutherland.

Roberts sometimes painted twilight landscapes in his Melbourne years, and occasionally added figures whose emotional relationship with each other heightens the mood of tenderness, transitory poetry and loss. The sketchy oil painting once called *The Parting* was attributed to Roberts by his executor when his studio contents were being sorted. An attribution to Streeton is now preferred; he more often painted 'poetic' landscapes and a sketch drawing by Streeton for the composition has now come to light.

Typical of Roberts is sober, academic, sunlit realism, wonderfully exact in its observation. Joseph Brown's late painting, from the 1920s, of a blond Australian hill is as admirable an example as the Spanish doorway of 1883.

Conder and Streeton were more flighty and erratic, more inclined to imitate Whistler, more 'aesthetic'. They were younger anyway; twenty and twenty-one at the time of the 'Nine-by-five Impressions' exhibition, when Roberts was thirty-three and McCubbin thirty-four.

It was young Conder and Streeton who were reading the Symbolist and romantic poets, who saw the open-air weekends and the pretty girls at Heidelberg as real-life 'pastorals', indeed as *fêtes champêtres*.

Streeton was Whistlerian and aesthetic in his choice of eccentrically narrow 'Japanese' formats, like the two Sydney panels, one a harbour subject, one an ocean beach with nude bathers. These bathers are intended as nymphs, a deliberate attempt to equip a new nation with a mythology of spirits that belong uniquely to the Australian landscape. Streeton's *A bush idyll* shows fairies airborne among the gum trees and at the same time Sydney Long began to populate the bush with European demi-gods. Long's etching *The Spirit of the Plains* was worked up in London from a Sydney painting of 1897; A. H. Fullwood's *Girl with galah* has a similar intention to Long's image of companionship with brolgas. The same impulse had made Roberts produce a more literal set of figures for an Australian mythology from the stockmen, prospectors and shearers in his big museum pictures.

The mythology of fantasy was probably encouraged in a general way by current European trends and, more particularly, by the European success of Bertram Mackennal.

Mackennal, a Melbourne-born sculptor well known to Streeton and Roberts when he revisited Australia from 1888 to 1891, had subsequently been much noticed in Paris for his life-size nude statue of Circe, the mythological temptress. (The Joseph Brown Collection includes one of Mackennal's extremely fine statuettes of this figure.) He was Australia's most successful artist on the international scene and by 1894 his *Circe* was considered 'Young Australia's masterpiece'. Another Melbourne artist doing well in Paris was Rupert Bunny, whose *Sea idyll*, a painting of mythological seashore nudes had entered the National Gallery of Victoria in 1892, long before any of the local realists were represented in their hometown's art museum. Charles Douglas Richardson's green-painted plaster statuette *A Seaside Vision* is another example of international Symbolism by a Melbourne artist.

21

It is highly probable that the nymphs and fairies of Streeton and others were painted in emulation of Bunny and Mackennal. Moreover, Streeton's standing figure of 1895 is surely a temptress and may even be specifically intended as a Circe. (A few years later Roberts exhibited a large, unsuccessful Circe.) Streeton's painting now titled *The Spirit of the Drought* is overtly Symbolist.

Symbolist subjects of this kind have been overlooked at the expense of Streeton's landscape paintings. Their presence here is one of the most useful corrections to the balance of Australian art history provided by the Joseph Brown Collection.

THE POLITICAL NATIONALISM of the 1880s and 1890s accounts for the emergence of heat and sunshine as an Australian symbolism, for Australian bush workers as realist mythology-figures, and for European demigods in Australian landscapes as fantasy mythology-figures. The Australian reception of some aspects of modern French art, Impressionism and Naturalism in the 1880s, Symbolism in the 1890s, also helps account for the look of the paintings.

However another more technical matter also affected art of this period — the art schools began instruction in the figure. Previously artists had arrived in Australia fully trained and many were already specialized in landscape.

The first generation of Australian-trained art students expected as a matter of course to receive instruction in the figure and at first, in von Guérard's time at the National Gallery School in Melbourne, they felt the instruction was inadequate. In 1879–80 Tom Roberts and Frederick McCubbin were the student ringleaders in a dispute about a life class.

George Folingsby emigrated from Munich in 1879 because of a suggestion that there was room for a portrait painter in Melbourne, as indeed there was. In 1882, he succeeded von Guérard as Head of the National Gallery School where he remained until his death in January 1891. Folingsby's work has not been illustrated in any previous account of Australian art, but it was influential and it has real merit.

Melbourne's best-known portraitist, John Longstaff, was a pupil, though he is represented here not by a portrait but by a typically Box Hill-Heidelberg twilight landscape and a French landscape sketch.

The nude study done by Phillips Fox as a student, in 1884, belongs to Folingsby's period and although the drawing-master was still O. R. Campbell (who was succeeded by McCubbin two years later) it was Folingsby's leadership that had so encouraged work in the life class since the student rebellion five years earlier.

Folingsby's own painting of a lady in fancy costume, picking autumn blackberries, has all the art school virtues of elaborately modelled drapery, sensuous fabric textures, and control of the human figure. It is one of several such subjects by Folingsby which must have been the prototypes for many similar Melbourne canvases of costumed figures in landscapes. McCubbin's *The letter*, 1885, and Roberts's *Reconciliation*, 1887, are examples. In them the artists were looking for subjects to exercise their skill as figure-painters. A little later they embarked upon the nationalistic subjects of bush workers, or the fantasy mythologies.

Yet McCubbin never really gave up the sheer painterly pleasures of finding an attractive model, dressing her up in an elaborate costume, placing her in a pretty landscape, and making a picture whose appeal is aimed more at the senses than at the intellect or patriotism.

His *Autumn Memories* of 1899 continues Folingsby's tradition, though unlike Folingsby's painting it was probably done in the open air. McCubbin greatly admired the French artist Jules Bastien-Lepage whose Naturalist example he followed here: the effect of light is not bright and transitory but uniform and grey so that work on the large painting could be continued for many days; the model's pose is heavy and relaxed for the same practical reason. Indeed McCubbin is one of the most natural, instinctive

22

painters in Australian art. As everyone said, he was 'the dearest old fellow'. When in 1907 he made his only visit to Europe he saw all his favourite masters: 'Turner — divine, like pearls — dreams of colour, no theatrical effects, but mist and cloud, sea and land, drenched as they actually are, in light. Such tender brilliancy. You feel how he gloried in these tender visions of light and air. Veronese, Titian, Rembrandt, Gainsborough . . . the work of the old painters is intimate and loving'. The early portrait of McCubbin's relative, Miss Moriarty, is 'intimate and loving' in regard to her as an individual; the late study of a nude is intimate and loving in regard to female flesh in general; and even later the near-abstract landscape sketch is intimate and loving in regard to an artist's life-long materials and activities, the directly sensuous application of paint to canvas and the miracle by which the results of this action can stand for both earth and air, matter and space. Many Australian artists have become mean-spirited as they grow older and their art has diminished in conviction. McCubbin is a rare exception.

E. Phillips Fox, a student under both Folingsby and McCubbin in Melbourne, and who then immediately went to Paris for further study, is also a tender intimist. He is at his best with his own family, with domestic situations like flower-arranging, or picnics. The enchanting mother and child are his sister and her daughter, painted in Melbourne on a visit from Paris and the warm feminine cosiness of so much of his painting is perhaps due to this Jewish sense of family. His wife, Ethel Carrick, became a charming painter of Impressionist landscapes with figures. His later nude, more impersonal, was painted in France from a model who subsequently married the painter Penleigh Boyd.

Fox was in Melbourne throughout the 1890s, conducting a private art school, the first to teach fully Impressionist landscape methods. Tudor St George Tucker, his co-teacher, had also returned from France, having painted this collection's *Springtime* at Étaples in 1890. Even so the bulk of Fox's work was portraiture, as it had to be for anyone who wanted to live by his art.

Roberts likewise, although usually remembered for his landscapes and his national subjects, made his living chiefly from portraits. The canvases in the Joseph Brown Collection are typical of the style which made him Australia's leading painter of public figures in the 1890s. The portrait relief of his wife and the etching of Louis Buvelot are not in Roberts's usual media. The latter was a memorial to a major predecessor. So even in this field of portraiture Roberts was often consciously painting for nationalistic reasons: he requested sittings from the political father of federation, Sir Henry Parkes; the Australian Aborigines, then thought to be dying out, were recorded for posterity in many dignified portrait studies.

THERE WERE OTHER portrait and figure-painters who arrived about the same time as Folingsby. Arthur Loureiro, a Portuguese, and Girolamo Nerli, an Italian, arrived in 1885. Loureiro remained in Melbourne where he was remembered mainly for his landscapes which were said to be the first to introduce 'Impressionist', violet-coloured shadows. Nerli was a rolling-stone bohemian, who moved on to Sydney, New Zealand, Samoa, Brisbane, Perth and back to Melbourne before returning to Europe. His technique was thought very dashing and sketchy (that is 'Impressionist') in an 1887 figure subject *A Bacchanalian Orgie* and his many portraits also have a dashing, illustrator's vulgarity.

Julian Ashton, half-Italian but English-born and Paris-trained, arrived in Melbourne in 1878 as an illustrator for the *Illustrated Australian News*. Five years later he settled in Sydney where he soon became an influential teacher. Art-teaching then more than now had to equip students for work as illustrators; photographic illustration did not yet exist, so black-and-white work for newspapers provided a good income for many artists. Ashton's influence meant that Sydney taste would for a long time value drawing and graphic dexterity over such purely painterly values as colour and structure. George W. Lambert, Sydney Long and Thea Proctor, typical Ashton pupils in the 1890s, flirted easily with the linearism of art nouveau though later, after long periods in England, they each became more formal.

A Melbourne graphic artist like Norman Lindsay quickly moved to Sydney, where most of the illustrated magazines were published. He began to exhibit romantic watercolours, marginally art

nouveau in style, and to gain a reputation as a rebel in the cause of sexual liberation and nudity.

Two other decorative, near art-nouveau watercolourists, J. J. Hilder in Sydney, and Blamire Young in Melbourne, also emerged in the first decade of the twentieth century. They were admired by graphic-oriented taste and indeed Blamire Young had started out not in newspaper illustration but in a newer branch of the graphic arts, namely poster design and advertising layout. This was a better background for seriously aesthetic art than the formless vignettes of newspaper work. It is probably true that from the 1880s a generation or two of Australian painters were adversely affected by the demands of illustration even when, like Roberts, they did not care for such work. Few of them except McCubbin became colourists unless they had had much experience in Paris, like Fox. Moreover the big subjects from national life and Australian history that Roberts and McCubbin introduced to painting around 1890 had already been the stock-in-trade of newspaper illustration for some time.

Even artists like David Davies and Walter Withers whose best work in their brief Australian careers has a fine painterly tactility and subtle colour show the influence of illustration in their figure subjects. In this collection, the farmer's daughter by Withers and the head by Davies are perhaps too consciously informative about rustic life and character. These two lived and painted near Heidelberg longer than any other artists and their scenes of suburban farming have a democratic feeling for the dignity of both men and women at work in the elements. If a similar feeling was common in the recent art of Bastien-Lepage in France and George Clausen in England, and if it derived originally from J. F. Millet and Gustave Courbet, it was nonetheless genuinely experienced by the Australian nationalist school and was one of their most admirable qualities. Roberts's large museum pictures of men at work are of course central to this democratic tendency.

BERNARD HALL SUCCEEDED Folingsby as Head of the National Gallery School in Melbourne in 1892 and remained until his death in 1935. Like Folingsby, he had trained in Munich; with von Guérard's Dusseldorf background the first three heads of Australia's most important art school were all German-trained. In spite of his long reign over what was then Australia's most important school, Hall's work, like Folingsby's, has been conspicuously absent from previous accounts of Australian art. One reason for the neglect is probably personal: he was thought to be cold though more likely he was painfully shy. Certainly he seems to have been short of friends anxious to promote his painting. However his own scrupulous honesty probably insisted that in his dual position as both Head of the art school and Director of the National Gallery of Victoria he should actively prevent any attention being given to his art, so as to avoid suggestions of unfair advantage. Another reason for neglect is his complete lack of interest in nationalistic art. He seems never to have painted an Australian landscape or a subject from Australian history. He did not care for illustration. He thought popularity was irrelevant to a work of art. In fact he was the complete aristocratic art-for-art's sake aesthete; his *The Quest* is a tribute to the refined pleasures of Omar Khayyam. 'A good artist paints for his peers, a bad one for his patrons'. A good picture 'increases our faculty of *seeing* beautifully, which is the end aim of the whole matter'. 'Art illustrates nothing but its own particular point of view. Art has nothing to do with the ethics of the Sunday-school — Bad workmanship is the only immorality known to it'. Thus his world lies largely within his studio, where nude models, traditional studio props, bric-à-brac, shawls, mirrors, stools and windows are no more — he might claim — than abstract forms, colour notes, and tonal values.

Like all his generation (he was thirty-two when he arrived in Melbourne), Hall greatly admired the impersonality of Velasquez and approved Whistler's portrait of his mother being de-personalized by the title *Arrangement in grey and black*. His admiration for Alma-Tadema's and Albert Moore's beautiful abstract compositions of attractive mindless girls is evident in his own work. Many of Hall's paintings are intelligent, painterly speculations on the eternal painterly problems of illusion and reality. A model might confront both a mirror and a canvas on which she is already represented. She might

24

stare at a mask. Or colour and chiaroscuro are made to play tricks with volume and weight. Yet sometimes the models' flesh seems obsessively caressed by the painter. And sometimes the model is posed deliberately to shock: *Colour medley* is the name of a picture which indeed contains a brilliant medley of vivid cushions on a sofa, but from its centre a model confronts the spectator, silk-stockinged legs apart, gown wide open, and wearing on her head a respectable hat. He is not only a superb technician, he also had a genuine relish for the erotic. It is embodied in paintings structurally far superior to Norman Lindsay's, and far more intense and concrete than Lindsay's fantasies. (Norman Lindsay's etching illustrated in this book is uncharacteristic, for it has a strong sense of actuality, not fantasy.) Hall's eroticism is open, and quite without the ambiguous guilt later found in Arthur Boyd's.

It is astonishing that the persistent demand for a recognizably Australian art should have prevented such excellent and interesting paintings as Bernard Hall's from being recognized simply because they are private and personal. Here again, the Joseph Brown Collection's great value is its presentation of an artist who does not fit the conventionally accepted scheme of Australian art history.

6 EXPATRIATES

JOHN RUSSELL, Bertram Mackennal and Rupert Bunny began their careers in the 1880s, at much the same time as Roberts, Streeton and McCubbin. Unlike the latter they chose to work chiefly in Europe. Instead of contributing through their art to the nationalistic needs of Australian society they were more concerned to find a small place for themselves in the mainstream of world art. Though in general they were not nationalistic, Bunny in the 1910s hoped to paint a great allegorical series of murals interpreting Australian life and over the years Mackennal provided a number of public places in Australia with statues expressing not only the pomp of the British Empire but also, in his cenotaph figures in Martin Place, Sydney, something intended more purely for Australian needs. Streeton, during his less extensive expatriation painted Trafalgar Square, *The Centre of the Empire*.

John Russell, however, scarcely competed in the public world of art at all. Although in the early years of the twentieth century Mackennal and Bunny were acknowledged by the Australian public as the country's most famous artists Russell remained almost unknown except to his fellow painters until long after his death. He had a private income. There was no need to sell his work and therefore no pressing need to exhibit it or otherwise make it known. Yet Russell was the only Australian to have had direct contact with several of the great masters of nineteenth-century art, and to have been admired by them.

Russell had left Sydney to study in London and he suggested the 1883 walking tour of Spain which produced Tom Roberts's first sunlit landscapes. Then Russell moved from London to Paris, where he entered the Atelier Cormon at about the same time as van Gogh. In the late summer of that year, 1886, Monet encountered Russell at Belle-Ile, an island off the coast of Brittany favoured by landscape painters: 'He was hanging around me while I worked and ended up by asking was I not Claude Monet (the Prince of Impressionists). It gave him immense pleasure, he is nice, and that evening we had a walk together, and tonight I am to dine with him'. Russell's companion at Belle-Ile, a beautiful Italian girl soon to become his wife, had modelled for Rodin who became a good friend of Russell. Émile Bernard, an admirer of Seurat's divisionism, was Russell's colleague at Cormon's. Van Gogh sat for a portrait by Russell and exchanged a number of drawings with him. Gauguin met Russell in 1887; the Impressionists Sisley and Guillaumin became friends. Ten years later the young Matisse encountered Russell at Belle-Ile and was given two of the van Gogh drawings.

Thus, from his arrival in France, Russell was closely in touch with many great artists. Winters were spent in Paris or the south, summers in his house at Belle-Ile, and it was there that many fully Impressionist seascapes were painted. Nor did he completely lose touch with Australia; he continued to write to Roberts, though a letter shown to Streeton produced an impatient response: 'He seems to love the open air very much, and, therefore, must be a fine chap . . . But he does seem to me to bother too much about the ways and means — really there is not time enough to do that. I should think t'would take a man off his inspiration or idea'. Yet if 'ways and means' meant divisionist colour-theory, autonomous non-descriptive brushwork, or decorative, repetitive composition — in short Monet's example from the 1880s — this is exactly what gives Russell's work strength and vigour. By comparison the Australian open-air landscapes by Roberts and Streeton look drab, timidly illustrative and flimsy.

The undated canvas of almond blossom on a gold ground may be relatively early, for Russell wintered in Sicily, a land of almond groves, in 1887–8. Its Japanese decorativeness, too, is more common in French Impressionist painting of the 1880s than later and had been of interest to advanced artists

for twenty years. (Russell is known to have collected Japanese woodcuts as early as the mid-1870s on a trip to Asia from Sydney.)

Later, the two Belle-Ile seascapes are completely Impressionist in their glamorous colour, animated surfaces, and relentless visual rhythm. They might even contain some of van Gogh's Post-Impressionist ideas about colours expressing emotions, for there is an 1887 letter from Russell to Roberts which is not entirely about complementary colours: 'But when we get to colour. The gorse and heather — yellow and purple. Orange boat sails, blue sea. Red rocks — green sea. All a matter of *feeling*'.

Russell shows a more than usual involvement with the sea: we know that he was a powerful swimmer, that as a youth he cruised to Tahiti and China, that he built his own yacht at Belle-Ile, and that when he retired to Sydney in the 1920s he spent much more time with his boats than in his waterfront studio at Watson's Bay. His best pictures are usually sea pieces, and in the end he seems more profoundly interested in the sea than in painting.

Certainly the impulse to paint dwindled after his wife's death in 1908. He confined himself more to watercolours done while moving restlessly around the Italian Riviera, Switzerland and the Pyrenees. He remarried in Paris, left Europe after the war, tried New Zealand, but finally returned to Sydney for the last eight years of his life.

Bertram Mackennal was the complete professional. The son of a sculptor, he left Melbourne before he was twenty, to study in London and Paris (where Russell helped him with studios and with money). He became the first Australian artist to have a work purchased for the Tate Gallery, London, to be elected a member of the Royal Academy, to be knighted, and to become wealthy from his art. Obviously he was entirely at home in London's academic art establishment. Yet he was by no means pedestrian and his standards were never compromised or commercial.

The sensitive terracotta head was probably modelled in Melbourne when he revisited it from 1888 to 1891. Bronze-casting facilities must have been inadequate, for a number of similar terracottas exist from this period.

Mackennal's extraordinarily refined bronze statues and reliefs began immediately after his subsequent return to France. The actress Sarah Bernhardt, on tour in Australia, had strongly advised him to go to Paris; he then modelled a relief portrait of her, and in 1893 the life-size figure of Circe was his first great success. Sarah Bernhardt herself is a major iconographical theme in art nouveau, a sort of high priestess of the style, and her interest in the young sculptor might have directed him towards mythological subjects like Circe and to his glamorous female portraits.

London soon became his base, where Alfred Gilbert's sculpture influenced Mackennal. Both sculptors are part of the late-nineteenth-century Renaissance Revival, a revival not only of Renaissance and Mannerist subjects, either classical or Christian, but also of intense admiration for the human body and for superbly luxurious craftsmanship in metal or stone. It was a revival of Benvenuto Cellini and Pisanello as much as Michelangelo, and Mackennal's portrait reliefs often show elegant women posing as Florentine madonnas.

Mackennal's art was not unappreciated in Australia. Many commissions were shipped out from England. He revisited his birth-place in 1901 and 1926, the last time with an exhibition of small statuettes which were enormously admired.

Rupert Bunny arrived in Paris 1886 aged twenty-one, about the same time as the rather older John Russell. His art became neither as modern as Russell's nor as refined as Mackennal's but more than any other Australian's it has a natural grandeur of spirit. Only McCubbin, in his more provincial situation, has something of the same open affection for simple physical sensations.

Bunny not only admires the look of beautiful, healthy bodies, he also occasionally emphasizes their sexuality with a startlingly erotic image concealed in background shrubbery. Indeed he is interested in much more than the visual sense. He makes one aware of the scent of flowers and grass, the murmur of conversation and the sound of rustling silk, the smoothness, warmth and weight of a lapful of kittens, the taste of a basketful of perfect tomatoes. He is especially good with direct sensations of warm

27

sunlight, cool water or breeze against flesh.

We know that he loved food and wine, and clothes, that music and theatre were important to him as well as the art of conversation, that his wife was an opulent French beauty, and that on his retirement to Melbourne after her death he enjoyed the company of beautiful young people like David Boyd and Alannah Coleman. Obviously his art's appeal to the total range of sensuous experience was an expression of his own natural inclinations.

All the same, in his time, the idea of combining all art forms into one totality was widespread. It was present in Wagner's operas, and later in Diaghilev's Russian ballet. The English Arts and Crafts Movement continental art nouveau, even the later Bauhaus and French Art Deco, encouraged painters to move out into related fields and Bunny in fact designed several tapestries and ballet décors, and dreamed of great murals in architectural settings.

Stylistically, however, and in choice of subject, Bunny was rather conventionally of his time. His canvases of sea goddesses are typical Old Salon exhibits of the early 1890s. (He did not show at the breakaway New Salon till much later.) Airiness and freedom of handling had been taken over from Impressionism, and an interest in saturated colour, but the elaborately posed figures remain the central concern of such academic compositions.

These pictures are saved from absurdity by Bunny's conviction about their basic content, namely the invigorating qualities of fresh air, light and water. But he might well have been equally convinced about the value of the ostensible mythological subjects. The *Odyssey* and *Iliad* as childhood storybooks had given him 'a lifelong love of the Greek myths', and in his old age 'rather disconcertingly he would speak of the old Olympian gods and goddesses, the Greek heroes and their women as casually and familiarly as of next-door neighbours, with a reminiscent smile for the charmers and that look of slight distaste for the vengeful and meddling ladies'. His mythologies were not entirely a response to Paris art fashions, they were also a natural outcome of his liberal education.

In the first years of the twentieth century Bunny abandoned mythological subjects and, following his marriage in 1902, the figure compositions began to be taken from everyday domestic life. Occasionally they were as grand as a painting by Veronese but mostly they were small and intimate like the picture Joseph Brown has titled *Nattering*. Their informal subjects are the same as those favoured by the Impressionists but the colour, though pretty, remains academically tonal, more a balance of light and dark than the unified tissue of high-keyed colour which is true Impressionism.

At the turn of the century there are a few landscapes with a good feeling for men at work in the open air. There are some grand portrait tributes to such fellow-artists as singers, dancers and actresses.

Then real life disappears again. After the First World War mythological subjects, uninhabited south of France landscapes, and flower-pieces are almost the whole of Bunny's art, but more startling is the change in style; he had become a modern artist if modern means flattened forms, shallow space, an acknowledgement of the framing edge, and pure non-descriptive colours whose relationships generate their own radiance instead of representing light. An understanding of Matisse's Fauvism, of Gauguin and Bonnard, must have contributed to this change but it is likely that a more immediate cause was the sensational pre-war excitement of the Russian ballet, and its décors.

For the remainder of Bunny's life the vibrant colour and controlled rhythm of his painted canvases were perfect vehicles for what had always been his content; namely a celebration of that state of well-being in which all the physical senses are in a heightened state of receptivity, when, as Baudelaire said, 'Without actually taking refuge in opium . . . the sky breaks through in an improbably transparent blue to infinite depths, when sounds take on the ring of music, colours begin to speak and scents tell of the world of ideas.'

7 TWENTIETH-CENTURY CONSERVATISM

POLITICAL FEDERATION of the Australian colonies was achieved in 1901 and suddenly the artists who had been sharing in Australia's nation-building seemed to lose their impetus. Most of them left for Europe to study the old masters. Some remained there permanently. Others, like Streeton, Lambert and Roberts, returned after the First World War to dominate the Australian art establishment in the 1920s. Those who did not leave Australia seemed to dwindle in energy.

The younger generation at the beginning of the new century did not start out as conservatives, even if that is what they eventually became. They mostly began as art-for-art's-sake aesthetes, flirting with art nouveau. But since art-for-art's-sake implies an admiration for the whole tradition of great art they soon moved from art nouveau to masters whose example might be personally relevant — Gainsborough or Bronzino for George W. Lambert who was to become a painter of society portraits, Constable or Turner for the landscape painters, Rubens or Watteau for Norman Lindsay's figure compositions, Velasquez for Hugh Ramsay and Max Meldrum.

The landscapes by Lambert and Sydney Long in the Joseph Brown Collection were painted shortly before those artists left for Europe. They are virtuoso displays of wilful linearism, drawing for the sake of making graceful arabesques, not for the sake of sober observation. Fine adjustments of interval are a preoccupation of J. J. Hilder, Blamire Young and of Elioth Gruner in his early paintings; fine distinctions of colour and of muted tones are also major preoccupations in their work and the work of Hans Heysen and Penleigh Boyd. With so much emphasis on refinement and delicacy it is not surprising that in this period a high proportion of the artists are watercolourists.

Although Heysen became the acknowledged master of the Australian gum-tree, and Penleigh Boyd, in his brief career, of Australian wattle-blossom, the impulse was not markedly nationalistic. Rather, the subjects were chosen for their softness and grace. Penleigh Boyd's favourite term of approval was *spirituel* and the fact that the subjects were frequently softened by mist — a common enough phenomenon in Heysen's Adelaide hills and in Penleigh Boyd's Yarra valley but by no means symbolically Australian — further confirms the anti-nationalist intentions of the time. There was no longer any need for artists to assert, to point out the special qualities of Australian life. Instead there was a feeling that a new nation should let its artists get on with the artist's special task of creating beauty.

They were also reflecting a general European tendency towards extreme refinement and towards an art of minute distinctions; in painting Whistler remained an influence, in music there was Debussy, and in literature Henry James and Marcel Proust.

Lloyd Rees's career began around the time of the First World War, under the influence of Hilder's and Gruner's patient, infinitely careful refinement. He deepened the impulse by long study of Turner's landscape art and of Italian Renaissance landscape painting like that of Giovanni Bellini or Mantegna. An awareness of colonial Australia's architectural history emerged in Sydney in his time, and of city planning and urbanism as humane studies.

The result for Rees was an art which instead of isolating uniquely Australian qualities, as in the nationalist centenary period, attempted the exact opposite. He wished to dignify our experience of

Australia in a different way, namely by making Australian landscape look like the landscapes we know in Italian Renaissance paintings, and humanizing it by adding evidence of human occupation. He offers us a sense of having a past but instead of merely the local past of pioneers, bushrangers and convicts he told us that we can claim all past civilization for our own. Australia is part of the universe and participates in its slow rhythms and harmonies — be they rhythms of human settlement, geological or botanical cycles, or art-historical influence.

William Dobell's art was formed in Sydney in the 1920s where Julian Ashton's school still placed most value on drawing and illustration and where George W. Lambert was the most conspicuous example of a successful artist. Besides Lambert, who was a fashionable portrait painter, the other most famous and wealthy artists in Sydney were newspaper cartoonists. Dobell, a building-tradesman's son with a gift for drawing, kept these ideals: he was content to display his great skill as a draughtsman in the representation of sculptural volumes but did not explore colour or composition; he was content to make money from commissioned portraits; and, most fruitfully, in his independent paintings he kept an earthy yarn-spinning, worker's relish for human character, eccentricity and role-playing.

A notorious lawsuit in the 1940s contested the award of a portrait prize to what some considered a caricature by Dobell. There was no case: it was decided that even if the painting were a caricature, a caricature was still a portrait. However the lawsuit made Dobell for a time the most famous of all Australian artists.

The general public at first displayed a primitive horror of the artist's witch-doctorish power of obtaining likenesses or distorting them, then in a few years switched to excessive adulation. The public also regarded Dobell's art as modern.

He himself claimed to be a traditional, academic painter, and so he was. When he returned in 1939 from ten years' study in England his acceptance by the conservative art establishment was immediate. To some extent he took Lambert's former place.

Dobell had greatly admired the work of Goya and Rembrandt but he must also have looked at Italian Renaissance portraiture to have painted the *Study for 'The Cypriot'* and the *Self-portrait* in the Joseph Brown Collection. Similarly, eighteenth-century English painting is well understood; Gainsborough's influence appears in some female portraits, Reynolds's device of giving humans a slight animal likeness is used, Hogarth's low-life subjects have something in common with those chosen by Dobell.

Dobell's intentions might not have been so lofty as Lloyd Rees's, but the result was similar. He intended to celebrate the variety and variability of human character, but by so often evoking painting by the great European masters he also provided ancestry, history and security for a gallery of Australian faces which previously lacked these attributes.

The strongest of all the early-twentieth-century conservatives was Max Meldrum. His studies under Bernard Hall at the National Gallery School in Melbourne would have helped form his admiration for the great impersonal, reticent tonalists Velasquez, Corot and Whistler. Perhaps his complete lack of interest in nationalistic subject matter also derived from Hall. Though Meldrum did paint a few Australian landscapes it was the process of observation which was their true subject, not the gum-trees. Perhaps he knew Bernard Hall's statement that '. . . *seeing* beautifully . . . is the end aim of the whole matter', for he devoted his entire career to the cause of truthful perception. From 1913 when he returned after fourteen years in France, until his death in 1955, he was a missionary; he set up schools, gained many disciples and issued two gospels, *The Invariable Truths of Depictive Art* in 1917, *The Science of Appearances* in 1950.

'The eye' said Meldrum, 'is solely concerned with tonal, proportional and chromatic values and the observation, definition and translation of these three things constitute the highest and purest form of the depictive art.'

His omission of drawing from this list of a picture's constituents would have seemed scandalously

provocative to a generation of line-worshippers whose training was geared to the graphic arts. For

Meldrum 'drawing' was a matter of shape not outline. The layout of areas, their intervals — in short the 'proportional values' of his credo — amounted to drawing and in this sense his drawing is masterly. Few Australian artists have shown such powerful control over a repeated series of verticals, or radials, or other forms of underlying geometry.

Although he approved 'chromatic values' he did not usually enjoy colour. For him pleasure in colour was a sign of decadence typical of romantic art, which he hated because it expressed the artist's emotions. 'Chromatic values' did not mean colour for its own sake, but colour relationships, their relative weight and value. So fierce a disapproval of self-revelatory, self-indulgent or self-expressive art indicates an over-developed sense of original sin and a consequent determination to submit to some kind of universal order. Thus for Meldrum art becomes religion, and his light and dark paintings become moralities of good and evil.

Two artists of the same generation as Meldrum had short careers.

Hugh Ramsay left on the same ship as Lambert, spent two years in Paris where he studied Velasquez in the museums but then, his health failing, returned to Melbourne in 1902 and died four years later aged twenty-nine. His brilliantly assured grand-manner portrait groups were unique in Edwardian Australia. This collection contains an art-school nude from his time under Bernard Hall and two studies from after his return: a Whistlerian composition of the fiancée he did not marry and an introspective self-portrait, growing a beard to fill his time on the inland farm where it was hoped, unsuccessfully, to halt the consumption of which he would soon die.

Web Gilbert's career as a sculptor began slowly for he was largely self-taught and was long unable to give up his work as a pastrycook. By the eve of the First World War he was successful enough to visit London where he became an Australian war artist. War memorials continued after his return to Melbourne in 1920 and at his death in 1925 he was working on an Anzac Memorial for Port Said. The more intimate portrait studies in marble and bronze belong to the same tradition of Edwardian refinement and grace that is led by Mackennal.

8 MODERNISM

DURING THE FIRST WORLD WAR a number of young artists consciously took up a modernist position. Like those who deliberately emulated the old masters the modernists were not often markedly nationalistic; like the conservatives they felt that a new nation was not mature until it joined the mainstream of the world's great art.

In Sydney, where modernism was strongest, it was in the art classes of Anthony Dattilo-Rubbo that Roland Wakelin, Grace Cossington Smith and Roy de Maistre emerged as the three leading pioneers. Cézanne, van Gogh and Gauguin were the artists constantly discussed — Wakelin at this time even named his cottage 'Cézanne' — and most of all it was colour-theory that interested them.

When Wakelin in 1928 looked back on their beginnings he remembered, 'Colour was the thing it seemed — vibrating colour . . . We commenced to heighten our colour, working in stippling touches . . . Miss Cossington Smith produced a series of cartoons on topical subjects in vivid colour, using an extremely simplified symbolism.' He also compared a modern still-life by Cézanne with an academically illusionist one, saying that in the latter 'we have destroyed the rhythmic flow of line — that *concentric* feeling in the design, the feeling of "radiation from centres" which is a basic truth of Life itself . . . the colour has lost all that *vitality* which separate juxtaposed touches give. We have sacrificed Life in the design for outward appearance.'

Colour plus simplified design (in the sense of coherent structure) apparently equalled Life. The impulse therefore was not drily theoretical; like the European beginnings of abstraction with Kandinsky and Mondrian, it was partly spiritual.

It is significant that Grace Cossington Smith, the quietest personality of this group but the best painter, shows an innocent, religious respect for the subject painted, for the integrity of the individual brush-stroke and for the integrity of the picture plane, that she often painted church interiors and that the avenue of trees in her suburban street could become, in Joseph Brown's painting, the equivalent of an aisled church. Again, Roy de Maistre after he left Australia became a convert to Roman Catholicism and produced some of England's most important works of contemporary religious art, among them a series of Stations of the Cross for Westminster Cathedral.

It was in 1915 that Wakelin exhibited with the Royal Art Society of New South Wales a large landscape which employed only the three primary colours and white, and that Grace Cossington Smith exhibited a figure in an interior whose frontal, flat-plane decorativeness emulated Cézanne. These two paintings were a public beginning of modernism in Australia.

Within a year or two de Maistre, who was studying music as well as painting, picked up some advanced ideas on the relationship between colour and music and with Wakelin put on a small exhibition in August 1919, to illustrate their theory. It caused an uproar, though the more tolerant agreed that the style might perhaps make good posters. One of de Maistre's pictures from the colour-music exhibition is in the Joseph Brown Collection. A scene above Berry's Bay in Sydney, it must have been painted in Wakelin's company, for an identical composition exists by him; Wakelin's title is known, *Syncromy in Orange Major,* and de Maistre's picture would have had a similar title. The two works might even have been painted in the open air for they are both on small boards of outdoor sketching size.

The word Synchromy had been invented by some young Paris-American artists whose work was discussed and illustrated in a new book known to Wakelin and de Maistre. Synchromy was meant to

sound a musical word, like symphony, but it further implied a great concern with colour and its interaction.

At the same time as these small colour-music landscapes, Wakelin and de Maistre also painted a few completely abstract colour-scales. They were not exhibited in public, and were thought of as experiments in interior decoration and in the effect of colour on mental health, for de Maistre had also been talking to the head of a psychiatric hospital. However these unusually advanced experiments were soon abandoned for another set of student experiments. This time it was tone scales, suggested by Meldrum's teaching, and the low-keyed painting by Wakelin in the Joseph Brown Collection is an example of their tonal phase.

No more abstract painting appeared anywhere in Australia until the 1930s. Wakelin, as well as Cossington Smith, became a colour painter of landscape, still-life and interiors. De Maistre, who left Australia in 1930, soon became a leading English cubist. When he started out in London he knew the then-young Francis Bacon who contributed to the mood of disturbing unease which became characteristic of de Maistre's angular compositions.

Modernists like Cossington Smith, Wakelin and de Maistre were thus more than formalists. Their work embodies personal visions, lyrical, romantic, perverse or metaphysical.

Other modernists could be nationalistic. Margaret Preston's work, more purely decorative, less complex in structure than that of the three pioneer Post-Impressionists, was the most popular modernism in Australia from the 1920s to the 1940s. She made a point of depicting Australian native flowers, or bush landscapes; around 1940 she turned to a style based upon that of Australian Aboriginal art. Although the earlier work is richly beautiful in colour she came to believe that a subtle drabness, keyed to earth colours, was characteristic of both the Australian environment and Aboriginal art. She also believed that Australia's naturally occurring forms were bold and geometric, the cylindrical banksia flower for example, and that large simplifications were therefore true to Australian experience. An artist will find a reason to paint the way he or she wants and the fact that Australia also has plenty of delicately wispy vegetation is no reason to deny the merit of Margaret Preston's art. Although flannel flowers, painted for the picture in the Joseph Brown Collection, are less monumental than they appear in this very large canvas, the picture is nonetheless a successful essay in modernist geometry.

Thea Proctor, like many other artists, returned around 1920 after twenty years in Europe. She became an influential taste-maker in Sydney and together with George W. Lambert helped create a sympathetic audience for the young modernists. Her own work paid homage to the highest standards, the drawings of Ingres, the colour of Matisse.

Australia's leading modernist sculptor, Rayner Hoff, arrived in 1923. A young Englishman appointed to Sydney's principal teaching position, he might have been influenced by Norman Lindsay's then prevalent fauns and nymphs but a revival of Renaissance categories was common enough in England, as we have seen with Bertram Mackennal.

In Melbourne there was less support for modernism than in the Sydney of Lambert and Thea Proctor who encouraged it from an established position, of Margaret Preston who made it popular and patriotic, and of Roy de Maistre who briefly made smart society take an interest in it.

Some Melbourne artists abandoned Australia at an early stage in their careers.

Miles Evergood had been forgotten when he revisited Australia in the 1930s with an exhibition of vivid expressionist landscapes. As a young man he had left Melbourne for the United States about 1900, which is when Joseph Brown's head of an old man must have been painted. Evergood's name then was Myer Blashki.

Horace Brodzky was another young Melbourne artist who left before the First World War to live in New York and London where in the early years he was a friend of Gaudier-Brzeska, Ezra Pound and the Vorticists. His later English work, less colourist but much more formal, was scarcely known in Australia until Joseph Brown began to import it.

The two modernist artists who stayed to work in Melbourne were Arnold Shore and William Frater.

Frater's portrait of his wife, strongly organized but dark in colour, bears the date 1915, the same year as the beginning of modernism in Sydney. Later he followed Cézanne and Shore followed van Gogh to become painters chiefly of landscape.

By the 1930s modernism was in demand. Arnold Shore and George Bell in 1932 opened a school to teach modern painting. In Sydney in the same year Grace Crowley and Rah Fizelle opened their more advanced school. The most famous pupil of Melbourne's George Bell school (Arnold Shore soon left the partnership) was Russell Drysdale. Peter Purves Smith was a friend and fellow student. So were David Strachan and Sali Herman.

Purves Smith's work is scarce, for his career was interrupted by war service before his early death in 1949. The Joseph Brown Collection contains one of his major paintings, typical of the George Bell school and similar to early work by Drysdale, but in fact a Paris park subject from a study trip to Europe on the eve of war. It has a fresh humour which is personal to Purves Smith but chiefly it is concerned with post-Cézanne monumentality, firmness and structure. The period believed that Impressionism lacked structure, so instead it emphasized the solidity of objects, the firm planting of weight on the ground, the clarity of each element, the stability of secure horizontals and verticals, the simplicity of geometric forms — a circle composition in this painting by Purves Smith, often a triangle in Drysdale's work.

This classic structure is Drysdale's special strength. It links him with Tom Roberts who was, in his big museum pictures, the most formal of the nineteenth-century nationalists. It implies study of the old masters who also provided the example for Drysdale's opulent Venetian colour and for the technique of elaborate underpaintings and glazes which seemed so startling to a generation of artists brought up on direct, unworked techniques, either Impressionist or expressionist. What startled the general public was not Drysdale's technique but his subject matter. Some influence from surrealism was inevitable in any young artist beginning his career in the late 1930s; added to subjects of drought, erosion and outback struggle, at a time when Impressionist idylls of gum-trees and sheep were still a standard manufacture in Australian landscape painting, the impact of Drysdale's vision was considerable. From his first one-man show in 1942 he was commonly accepted as one of the country's leading modern artists.

Of course a modern formalist preferred a stable, horizontal, flat landscape inhabited by a few simple forms, but Drysdale had grown up on the land in the New South Wales Riverina — very near where Roberts painted his first big subjects of bush life — and he had a deep personal involvement with the workers of the inland and the outback. For an exhibition catalogue he wrote of the outback: 'Magnificent in dimension, old as time, curious, strange and compelling, it rests in ancient grandeur, indifferent to the challenge of man . . . Into its thin ownership came first the outposts, then the settlements of a new incongruous partnership. The wild man and the overlander . . . Cadillacs and camels, flying doctors and brolgas, corroborees and cinemas . . . There was room for them all. The white tin town of Broome whose pearls find their market in Paris . . . Death dances at Melville and picnic races at Alice, and over it all the tremendous vault of the sky, pressing down the land . . . Ominous skies of red dust, and the brilliant glitter of a million stars at night . . . A world where incongruity becomes the accepted commonplace.'

Drysdale's 1940s shift from the 1880s convention of depicting bush life in the productive inland to depicting life in the 'outback' — the land further out, in semi-desert country — was a shift which rapidly captured the Australian imagination and established a new convention: henceforth the symbolic image of Australia in art and in popular culture was no longer blond, sheep-supporting grassland but would become instead the mysterious Red Centre, the geographical heart of the continent. By the 1980s, easy access for tourists to Ayers Rock (and its return, as Uluru, to Aboriginal tribal ownership) together with the striking new developments in Aboriginal painting among the Central Australian desert communities, and wider appreciation of Aboriginal culture generally, had made the Red Centre a spiritual and mythic heartland for the nation.

Besides Drysdale there were several other artists in Sydney during the 1940s who emphasized classical structure and old-master technique and whose mood was poetic or surrealist. David Strachan was one, Justin O'Brien another. Jean Bellette's paintings were neo-classical in subject matter as well as structure; the figure composition in the Joseph Brown Collection represents dignified gods or heroes as in the paintings by Poussin which were her prototypes.

Eric Wilson on the other hand was a more sober modernist, less concerned with the old masters, more interested in Australian landscape, and interested most of all in building up rounded, tactile volumes. This was Dobell's main interest and although Joseph Brown's painting by Eric Wilson represents a landscape in southern New South Wales near to the landscape which gave birth to Drysdale's art, Wilson's art belongs more in spirit with that of Dobell.

9 EXPRESSIONISTS
AND ANTIPODEANS

THE INAUGURAL EXHIBITION of the Contemporary Art Society of Australia in June 1939, in Melbourne, signalled a revolution in Australian art. It was a noisy, quarrelsome period. George Bell was one of the society's chief founders and the recent success of his school's kind of Post-Impressionist formalism—distortion and 'cross-eyed drawing' to its conservative antagonists—had provoked R. G. Menzies into establishing a conservative Academy of Australian Art. The short-lived academy had in turn provoked the modernist artists into forming the rival Contemporary Art Society, but the society soon went beyond genteel Post-Impressionism. George Bell and his pupils consequently withdrew from the Contemporary Art Society and several moved to Sydney where modernism had been launched as far back as 1915. Sali Herman, Russell Drysdale and David Strachan were some of these refugees from Melbourne's quarrels.

It was not a case of a Contemporary Art Society being taken over by a more advanced group of modernists. There was scarcely any non-objective painting in Australia in 1939; what little there was continued in Sydney, not Melbourne, and when abstraction versus figuration finally became an issue it was because twenty years later the rebellious Melbourne generation of 1939 felt threatened.

The issues in 1939 were professionalism, rationality and politics. The Post-Impressionist modernists were the guardians of professionalism. For example Drysdale's classical composition, his old-masterly painting techniques were developed in this school. Virtually self-taught painters like Sidney Nolan and Arthur Boyd looked amateur or unprofessional by comparison, especially when they painted spontaneously and rapidly to suit their expressionist approach. In addition these painters took a serious interest in naive art and child art for they too are fresh, spontaneous and uncomplicated by convention.

When laymen, that is men who were not professional artists, were allowed to participate in the Contemporary Art Society's decisions it upset the older modernists. It was just as bad to have John Reed, a patron of the younger artists, supporting a seemingly clumsy daub by Sidney Nolan as it was to have Mr Menzies promoting Hans Heysen's academic realism.

Irrationality was another enemy of hard-earned, laborious professionalism. Spontaneous, unplanned painting that worked itself out only in the process of execution seemed a denial of professionalism. When the imagery itself was irrational, as in surrealism, or seemingly non-existent, as in abstraction, the subversion was compounded, and both surrealism and abstraction were exciting the interest of younger artists. Late in 1939 in Australia's most important exhibition of modern European art it was a surrealist painting by Dali which caused most scandal. In 1940 the young Sidney Nolan held an exhibition of small Klee-like abstractions, but his imagination, like that of the European surrealists, was as strongly fired by literature as by purely visual experiences. In poetry the irrational has always had more licence than in painting; Nolan himself has written and published poetry, in 1939 his first exhibited work was a portrait of Rimbaud. It might not have been clear that a tendency towards the irrational was also a tendency towards the literary but this would have been further anathema to the older modernists who had once struggled to liberate themselves from Victorian story-telling.

Political content however was clearly recognizable in the work of another group of painters. Classical Post-Impressionism is naturally aristocratic; its dislike of democratic politics might have been consciously justified by claiming that the paintings were too literary, too concerned with telling a story.

The group of political realists included Noel Counihan, who painted memories of the economic depression. Vic O'Connor's anti-war paintings imagined the situation of refugees in Europe. So did Yosl Bergner's, who was himself a pre-war Jewish refugee from Europe to Melbourne. Even when Bergner painted what to us seems no more than a Cézannesque exercise in organized planes, the subject in 1938 would obviously have been Melbourne slum housing and hence a political subject. Similarly Danila Vassilieff's *Fitzroy street scene* would also have seemed, in 1938, a politically provocative choice of a slum subject.

Vassilieff, a recent arrival who had wandered the world, was admired by Nolan as the first fully spontaneous painter he had met. In 1939 Arthur Boyd shared a one-man show with Bergner. These two Europeans, Bergner and Vassilieff, were highly influential in directing the young painters towards an art that grew immediately out of the life they lived in Melbourne.

In the early 1940s Sidney Nolan, Arthur Boyd, John Perceval and Albert Tucker together produced the most remarkable body of urban subjects in Australian art. Australia is one of the world's most highly urbanized nations, yet its mythology is almost entirely rural. The Melbourne expressionist painters were interested in the myths subscribed to by Australian society and by the late 1940s they were also becoming interested in landscape both for its own sake and as a vessel for Australian mythology. But during the war years their big-city subjects, more often fantastic than realistic, became the first serious expressions of what life is like for the majority of Australians.

It was their avoidance of the artificial, the trivial and the conventional which makes this generation so important. Their revolution was to take subject matter seriously.

Albert Tucker's art is the toughest. His series *Images of Modern Evil*, later re-named *Night Images*, was rather specifically about wartime corruption, prostitution and sexuality in the streets, trams, cinemas and houses of Melbourne. Later his more mythic subjects were concerned with the predatory rape of Australian landscape by European explorers and pioneers.

Nolan was never so dour, but much of his work too shows a melting involvement of figures with landscape and early city subjects include parks filled with embracing couples. In Italy he once noticed '. . . a relationship between the people walking outside a church and the people inside painted on old frescoes. They all looked the same. It began an exciting notion that ultimately one would get in Australia this same kind of involved and fruitful relationship, that our art would look like us and we would look like the art.' His chief insight is that Australians don't yet know who or what they are, or what Australia might be like. All his art expresses uncertainty. It is full of surprised leaps of understanding, cuts of connection. Not only Ned Kelly but all Nolan's figures are trying out masks and faces. All his landscapes are geologically tentative and uncertain: the *Unnamed Ridge, Central Australia* could be ridges of sand momentarily halted. Nor is this state of permanent doubt and flux confined to Nolan's Australian subjects. Antarctic ice-floes shift and heave, African animals are caught in only one moment of their evolution; even Nolan's actual paintings operate on a visual razor's edge. Sometimes they can seem tentative, formless patches of paint; at other times the patches of paint can miraculously achieve identity as a poetic image.

Arthur Boyd's city subjects from wartime Melbourne show fear for the possibility of survival in such an urban wasteland, rather than Tucker's indignant disgust or Nolan's tentatively lyrical embrace. They also establish Boyd's major obsession, the beast in us all, the ease with which we can retrogress to the bestial or the primitive, or be dismissed as a mere insect.

A key picture by Boyd is *An Angel spying on Adam and Eve* and it indicates that his polymorphous fellow-feeling for the beasts is balanced by knowledge of religious disapproval. God was practically a member of the extended family in the devout household where Boyd grew up on the farm and orchard outskirts of Melbourne. Parents, grand-parents, uncles, brothers and sisters were all painters, potters or writers. (His father, Merric Boyd, was a potter whose bowls and vases brought clay to life in post-art-nouveau writhing plant forms. Similarly Arthur's paint surfaces are always tactile and organic.)

But if God had been an everyday presence in the Boyd household so were the great masters of painting. Thus it became an easy, natural thing to portray his own family group in Rembrandt's manner, or to give crowded Brueghelian subjects settings which were localized, though not insistently, in Melbourne—a last judgment, a Melbourne burning. Tintoretto became the example for some frescoes of Biblical subjects in Australian bush landscapes, painted in 1948 on the walls of an uncle's house near Berwick.

Berwick is beyond the suburban fringe and a series of pure landscape paintings now appeared, his first in ten years; henceforth observation of Australian landscape for its own sake was as important as the human drama it might contain. Unlike Nolan, whose landscapes always look lonely and isolated, as if seen for the first time, Boyd gives his landscapes a sense of belonging to an existing family of paintings; Brueghel's cornfield is evoked, or the blond grassy slopes of Streeton's outer-suburban Melbourne landscapes of the 1880s.

Portraits of his friends occur at all periods. Like his father, Arthur Boyd makes pottery. Even after he made a home in England in 1960 the themes of man, family, beast and landscape changed little, they were only enriched by contact with the art of the museums. Arthur Boyd's is the grandest imagination in Australian art.

John Perceval shared many of Boyd's preoccupations in the 1940s: big-city hysteria, the Brueghelian and Biblical crowd scenes, then, by 1948, farm subjects which belong to van Gogh's family of landscape paintings. Perceval also made pottery but eventually he became chiefly a landscape painter. Unusual for his time, he was entirely an open-air painter. He needs the immediate presence of his subject: 'At all time my work is primarily a response to the subject, to light and trees, air, people etc . . . due to a desire to equate the vitality, the pulse of life in nature and the world around us.'

In 1959 these openly expressionist Melbourne painters of 1939 finally acquired a group name, the Antipodeans. Nolan had long been based in London, Tucker was in Europe though he would soon return. Boyd, Perceval and five recently established artists held a group exhibition as The Antipodeans and published an accompanying manifesto, written for them by the art-historian Bernard Smith.

Though they said their obligation was neither to place nor nation, they also believed they had a duty to draw upon their experiences of society and nature in Australia. But beyond all else they felt they had to 'defend the image'. 'The existence of painting as an independent art is in danger. Today *tachistes*, action painters, geometric abstractionists, abstract espressionists . . . threaten to benumb the intellect and wit of art with their bland and pretentious mysteries . . . we see young artists dazzled by the luxurious pageantry and colour of non-figuration. It has become necessary for us to point out . . . that the great Tachiste Emperor has no clothes—nor has he a body. He is only a blot—a most colourful, elegant and shapely blot . . . We are witnessing yet another attempt by the puritan and iconoclast to reduce the living speech of art to the silence of decoration.'

The group's inability to recognize expressive imagery in non-figurative painting was understandable across their generation gap. Their reassertion of the importance of serious content was admirable, though of course serious content was present in much of the art they thought merely decorative. They were mistakenly understood to be narrowly nationalistic but though their content was personal and therefore inevitably Australian, their raids on the European old masters were no less voracious than those of the abstract expressionists on the contemporary international scene. The Antipodean Manifesto's antagonism to abstract art, though understandable, was its only serious absurdity.

The remaining participants in the Antipodean exhibition were Charles Blackman, Clifton Pugh, John Brack, David Boyd (a brother of Arthur) and Robert Dickerson, the only Sydney member. Jon Molvig, an expressionist working in Brisbane, and Fred Williams, then painting large-scaled figure subjects, might have but did not join the group.

Clifton Pugh's art lies within an Australian tradition of carefully observing tender grasses and bush foliage, a tradition that extends back to Frederick McCubbin and Thomas Clark. Within this tenderness he sets the occasional brutality of raw nature, and again McCubbin provided an example of bush

tragedy, lost children and pioneer burials. Early observers of bush landscape like McCubbin and Roberts also produced a large body of tenderly observed portraits, and Pugh follows this pattern as well.

Blackman's art is more private, being chiefly concerned with poetic images of figures communicating through touch, scent or temperature. It is an intimist art where the scent of flowers, the texture of a tablecloth, the warmth of a patch of sun have heightened significance, and where body-memory of previous positions in space is frequently imaged.

John Brack is the least typical of the Antipodeans—for he is above all impersonal and distanced from his subject matter. Though he has observed city and suburban life in Melbourne it is not the appearance of people and place that interest him as much as their rituals and artificialities. It is the artificiality of art itself that interests him most, including its strange conventions of the studio nude or the still-life. Brack's mannerist art is unique in Australia for its extreme intelligence and dry sophistication.

10 SYDNEY ABSTRACTION

THE ANTIPODEAN MANIFESTO of 1959 showed that the figurative expressionists felt threatened by a new fashion for abstraction. Although the Manifesto did not say so it was in fact generally understood that the abstractionists had taken over in Sydney and that Melbourne was defending figurative art. A rather artificial antagonism between Sydney and Melbourne was generated and there were many who saw Melbourne's figurative art as the only true repository of genuinely Australian values, whereas Sydney's abstract art was a sell-out to international values. Although the Antipodean Manifesto itself made no such claim, the word 'Antipodean' did seem to imply an exclusively nationalist position.

It is true that there had recently been a sudden upsurge of interest in abstract expressionism but it was not confined to Sydney. When in 1956 a survey exhibition of contemporary Australian painting was collected for a tour of Honolulu, Vancouver and San Francisco it included abstract paintings from Melbourne by Donald Laycock, John Howley, Leonard French, Roger Kemp, Lawrence Daws and, astonishingly, Arthur Boyd, as well as from the Sydney artists who were most strongly identified with the movement, John Passmore, William Rose and John Olsen. Later in 1956, Passmore, Rose and Olsen, with Eric Smith and the more abstract sculptor Robert Klippel, held a manifesto exhibition in Sydney and confidently named it *Direction I*.

If 1956 is therefore a convenient marking point in Australian art history, it was no real conversion to abstract expressionism. Not till around 1960 did full gestural, large-scale, non-figurative painting emerge, most strikingly in the work of Peter Upward and Stanislaus Rapotec.

The so-called abstract expressionists of 1956 were influenced more by French tachisme than by large-scale American painting, for an official French exhibition had toured Australia a few years earlier with paintings by de Stael, Manessier, Hartung, Vieira da Silva, Soulages and similar artists.

Nor in 1956 were the Australians fully non-figurative: theirs was a new kind of landscape painting, though more often city landscape than country landscape. In the 1956 survey exhibition of contemporary Australian painting the Melbourne abstractionists gave their pictures titles like *Forces of a City*, *The Army*, *City Force*, *Contemporary Space*, *Iridescent City*. Only Arthur Boyd's had the non-committal title *Painting* (it looked like a light-filled sky). In Sydney, William Rose was non-figurative, but Olsen and Passmore were obviously romantic painters of urban landscape. Of his *Views of the Western World* Olsen said 'the thing which I always endeavour to express is an animistic quality—a certain mystical throbbing throughout nature'; what his paintings actually looked like was a pattern of light and movement upon a big-city seaport, namely Sydney Harbour. The Sydney artists were very interested in Dylan Thomas's *Under Milk Wood*, an evocation of the totality of life in a Welsh seaside town and that is what they were attempting for Sydney: 'It's all there—the seaport, ships coming in and out, the dawn, the sun, the great cranes, men working, traffic, movement—everything—*I want to get it all down.*'

John Passmore was the central figure, and senior by twenty years to Olsen. Born in 1904, Passmore returned to Sydney in 1950 from seventeen years in England and immediately his Cézanne-influenced painting excited the admiration of young artists on account of its sheer painterly skill so that he became a much-sought teacher.

Passmore knew that artists' aims cannot be stated clearly. They were attempting he said, 'to break

down the confines of what has gone before . . . to disembowel it, turn it upside down. The aim is to break away a barrier and get at something—the something that every artist and, for that matter, every person knows . . . They are trying to get away from the known and what restricts them . . .' Or: 'I don't know—everything is in the melting pot. Tantôt libre, tantôt recherché'. 'Whatever I do a stronger sense pulls towards something else—an unintelligibility sets in—then things are right'. And again 'I am always shifting and restless. There is a great force—an ambient sense mass.'

This sounds like a surrealist talking about automatism and surrealism's belief in chance and uncertainty appealed greatly to Passmore. When he was in London he found that 'the air was electric . . . Strident, voracious—destroy everything . . . Yesterday was as dead as mutton. Today won't last long—it was very swift and exacting. All was movement, the ground moved—it made necessity. You had to feel the ground move. Salvador Dali came to London to lecture in a deep-sea diving suit . . . It was Gaga, but in the whole Gaga daring was the eternal profundity.'

Cézanne too had a feeling for the shifting movement of landscape even beneath his desperately controlled planes, so his style was an appropriate starting-point for Passmore's. It was a style that could carry not only Passmore's general feeling about indeterminacy and chance but also his specific subject matter which is almost always the sea. In the early 1950s it was usually Sydney Harbour from Millers Point, a little later it was the ocean beach at Newcastle, where he taught for a while, then there were more Sydney Harbour subjects, and beach subjects from the ocean suburbs near Manly.

After 1960 Passmore scarcely exhibited, so his public career lasted only ten years. However, his art had already become an extremely beautiful embodiment of his personal obsessions. 'You had to feel the ground move'; but the sea moves more constantly than the land; the beach too is a zone where fish or humans can be shifted out of their proper element. And there the wind gains heightened significance, supporting the flights of birds, tossing the surface of the ocean or altering the contours of the shore.

Passmore's feeling for the sea need not be explained simply by his having been born in Sydney, a city where the tides and the ocean are ever-present; nor should this explain John Russell's similar preoccupations in an earlier period. It is more likely that Passmore was compelled, like any artist, to make certain forms and then found, consciously or unconsciously, a subject matter which would fit those forms. The result was an art which proposed a fresh response to a multitude of visual and physical experiences that were immediately at hand. It was much less abstract than it seemed at first, and it was intimately regional rather than 'international'.

Passmore was the most influential painter in Sydney in the 1950s but two others had equal prestige, Ian Fairweather and Godfrey Miller. They were older than Passmore, but their work first began to be exhibited in Sydney at about the same time as Passmore's; both were aged nearly sixty.

Ian Fairweather never lived in Sydney but it was at Sydney's Macquarie Galleries that his work was regularly exhibited from 1948. Scottish-born, he studied painting at the Slade School in London immediately after the First World War, then emigrated to Canada. Chinese culture was his ideal and he soon began to roam the East, making a brief appearance in Melbourne in 1934. There the George Bell circle knew and respected him, and to Russell Drysdale, then a student, he seemed the first real artist they had ever seen. After further years in the Philippines and India he settled in Australia in 1943. From then he lived mostly in Queensland, from 1953 on Bribie Island near Brisbane.

Like that of other George Bell School refugees from Melbourne's expressionism, Fairweather's work was appreciated in Sydney for its consummate professionalism. His painting in 1934 had the firmness and structure which was the ideal of the George Bell School but by the 1940s he had abandoned illusionistic modelling for a unique linear style. Brilliant drawing is again a quality which Sydney has especially prized but Fairweather's line was not put to the service of illustration or of expression as in the West, it was used instead for what are virtually Chinese ideograms. His lines explore and evolve, they become a kind of pictorial writing, half calligraphic poem, half representation, and ultimately they become concise and powerful images of some human state of being—like making music, rowing a boat,

sleeping, eating, feeling old, getting drunk.

Fairweather's were almost always figure paintings, seldom landscapes. They might be everyday figures from village life at Bribie or memories of a marketplace in Bali; they might be subjects from literature or Christian or Buddhist religion. But he felt that his work had only one subject: 'By one subject I mean *people*—that is to say not in a particular sense, but generally speaking.' More pretentiously one could say his art is about the human condition. For him painting was a way of meditation: 'I'm not concerned with other people when I paint . . . although I am pleased when I do communicate. To me, painting is a personal thing. It gives me the same kind of satisfaction that religion, I imagine, gives to some people . . . painting to me is quite a mystery, I really don't know how I do it. Things gradually develop. I like to have them hanging on my wall working, and in time they grow by themselves. I take a very long time over them and I do a lot of alterations. Painting to me is something of a tightrope act; it is between representation and the other thing—whatever that is.' Maybe, 'the other thing' is pure form, abstract beauty, harmony. Like so many of his generation, Fairweather followed Cézanne in a struggle to order the chaos of nature, but at the same time his paintings reveal all the stages of their organic growth. They have extraordinarily sensuous surfaces, immense variety in handling and touch, and in subtle harmonies of colour.

Colour indeed was a final aspect of the fully painterly professionalism which gave Passmore and Fairweather such stature in the 1950s; for the leading artists of the 1940s—Dobell, Drysdale, Nolan and Boyd—colour had been a less essential structural element than tone.

Godfrey Miller, the third artist to dominate the Sydney art scene in the 1950s, was similarly a hero of the art schools long before the general public paid him much attention. New Zealand-born, he graduated in architecture but after a long visit to the Philippines, China and Japan in 1919 he moved to Australia and painted in Melbourne for ten years. At the Slade School, London, from 1929 he studied sculpture for two years, returned to Melbourne, then in 1933 went to London again, continued drawing at the Slade and became deeply involved with Chinese art, Indian philosophy, cubism, abstraction and Kandinsky's *Concerning the Spiritual in Art*. In 1939 he returned to Australia and settled in Sydney where from 1948 he taught drawing at the National Art School. Not until 1952 did Miller publicly exhibit a painting. It was called *Unity in Blue* and it caused a sensation among the artists of Sydney. The virtues of academic, classical painting were present on the highest level: control, balance, the unity of small parts within a larger whole, sculptural volume, architectural space created by warm and cool colour. His subject matter might come from real landscapes near Sydney (and, in the landscape in Joseph Brown's collection, from emulation of Cézanne's quarry paintings) but his content is always philosophical.

'I work by geometry and the stars'. 'The making of a unity is a difficult, subtle and unstudied matter . . . Did we fail to realize a little of creative sense was, or would be, of powerful and magical benefit? Why did we progress largely by drift on the one hand and war on the other?' Miller's land-scapes, figures and still-lifes were thus, in their way, anti-war statements. He wished us to see that everything in the universe coexists and interconnects; if we understood this, war might cease.

Miller quoted Goethe: 'He who would the whole understand/ First takes it to pieces/ And when the parts he holds in his hand/ He finds he has lost the Spiritual Band'. And Francis Thompson: 'Thou canst not stir a flower/ Without the troubling of a star'. And Dante: 'All things are arranged in a certain order and this constitutes the form by which the Universe resembles God'—to which Miller added the comment: 'That is a splendid approach to painting a still-life.' And finally he quotes a Buddha Mantrum: 'I stood in the Presence of the Splendour of the Forms/ But my Intuitions were not yet pure . . .'. He believed he had made drawings whose structural principles were the same as the structure later proposed by physicists for the atom.

Miller, Fairweather and Passmore were the most admired artists in Sydney in the 1950s. Earlier however, there were three other Sydney painters whose work was often entirely non-objective and entirely unconcerned with any specifically regional or national qualities. They were Grace Crowley,

Frank Hinder and Ralph Balson. A fourth member of this circle was Rah Fizelle, who did not become so resolutely non-figurative and remained interested in Australian bush landscape.

Grace Crowley who had studied in Paris under André Lhote and Albert Gleizes, and Rah Fizelle who was also just back from Europe, together established classes for modern painting in Sydney in 1932. Melbourne's school for modern painting was opened by Arnold Shore and George Bell the same year but the Sydney group was more advanced, for cubism not classical Post-Impressionism was their chief interest. Frank Hinder painted with them from 1934 when he returned from seven years' study in the United States and Ralph Balson also joined the classes then.

In 1939, the year that Melbourne saw the first exhibition of the Contemporary Art Society, these advanced Sydney artists held *Exhibition I*, a group manifesto in which three sculptors also participated. If war had not intervened and if the Contemporary Art Society had not come into existence they would have continued with annual exhibitions.

Their generally cubist work of 1939 caused some journalistic uproar because of its distortion of natural forms, though their manifesto's talk of scientific theory, colour phenomena and 'third or more dimensions' was disliked more than their art. But when their work soon became non-objective—Balson's one-man show of 1941 was the first in Australia to be confined to non-objective painting—then nobody seemed to take offence or even to notice it. Although they all exhibited regularly through the 1940s and 1950s neither the public nor their fellow artists paid much attention. Even the 1956 explosion of abstract expressionism failed to bring them much notice, for their geometric abstraction then seemed old-fashioned and cold. Yet their painting is among the most serious and, in Balson's case, arguably the best ever done in Australia. Though they were not deeply involved with theosophy like Godfrey Miller, or Buddhism like Ian Fairweather, there was of course a general awareness that pure abstraction imaged the underlying order of creation. Mondrian and Kandinsky, the European founders of abstract painting claimed their art represented the fundamental nature of the cosmos.

Frank Hinder shared more of this belief than the other Australians. In America he had studied at the Roerich Museum, New York, a hotbed of Indian philosophy, and at Taos, an art-and-nature colony in New Mexico. Later in Sydney he would participate in the Blake Prize Exhibition for religious art.

Balson on the other hand thought of his paintings as images of scientific not religious truth. Apart from Mondrian his favourite reading was books on Einstein, astronomy and evolution.

At the time of *Exhibition I* however, there was more talk of pictorial form than of religion or science. In the exhibition foreword, by Eleonore Lange, their kind of art was referred to as 'the neo-classicism of this century'. One of their bibles was Jay Hambidge's book *Dynamic Symmetry : The Greek Vase*, which set out principles of geometric proportion implying growth and dynamism, as opposed to static geometry. It was a revelation to discover that the ancient Greeks or Raphael or Ingres had used geometry in their art.

They saw the central problem of modern painting as 'Composition based on *colour laws* instead of linear or atmospheric perspective . . . Stating the relation of colour areas to the pictorial plane . . . Henri Matisse was the first to offer a new system of order, that is of composition, in replacing the vanishing point by the pictorial plane. Each colour in a neo-classical picture is determined in its area, tone, value, hue, by its power to interpret third and often fourth and more dimensions, in their direction to the pictorial plane . . . the endeavour to arrange colour relations and spatial values into an ordered whole is the subject of a modern picture'. Such intelligence about painting was previously unknown in Australia.

With this kind of theoretical background to fit his natural gift for colour Balson's art steadily developed. So did his thought. In 1949: 'The spread of books, prints and the victory over space made possible by the radio will mean in time that the old individual egos will be submerged in a kind of universal ego . . . the source of true design is to be found in cosmic laws.' In 1955: 'Painting must dig deeper and deeper into the mystery and rhythm of the spectrum and that means existence of life itself.'

In 1956: 'As one grows older one contemplates more and more, and maybe the ultimate goal of the arts is the ineffable . . . I want my forms and colours to have the density and at the same time the fluidity of James Joyce's words.' He was then sixty-five, at last able to retire from his work as a house-painter and become a full-time instead of a weekend artist; it was the year of abstract expressionism in Australia and his style changed too, from geometric to painterly abstraction. In 1960 he visited France and England for the first time: 'I have long held the belief that the arts of man are his expression of his concept of the universe, and now that I am in Europe the pattern becomes logical and convincing . . . The Impressionists . . . a groping towards and understanding of the source of life—light and its division into a spectrum . . . The next tremendous step is the concept of Einstein, the concept of relativity, the destruction of the absolute, the static . . . the vision of it I get as a painter fascinates me. A universe without beginning, without end. A continuous creating, destroying and expanding movement, its one constant the speed of light . . . Gravitation, matter, space, time . . . A unified field, a field of inter-actions, an electromagnetic field . . . energy, the atoms that reach us from the sun, is the source, the rhythm of existence, and the very narrow band, the spectrum, is all we have to try and reach the rhythm and relativity of the universe with the substance of paint'. Balson erected a splendid structure of ideas upon his inborn gift for colour.

There is one personal link between Balson and the abstract expressionists. The sculptor Robert Klippel who joined Passmore and Olsen in the *Direction I* exhibition of 1956 had shared an exhibition with Balson four years earlier. His sculptures are almost always constructed, not modelled or carved and when he returned from studies in Paris and London he found that the constructivist paintings of Balson and Crowley were the only local work that shared his preoccupations. However his London sculptures had become for a while surrealist and this aspect of his art drew him to the romantic abstract expression-ists as well. He does not deny that references to seaport shipping and cranes might have got into his sculpture but mainly he is concerned with an ambiguity between mechanical forms and organic forms. In his hands, machinery turns into an organism or he finds that organisms are articulated as precisely as machines. Klippel's sculpture has the same rigorous respect for formal structure as Balson's painting, and the same sense of the work of art being only part of a universal continuum. The sculptures are not self-contained, they discharge energy into their surrounding space. They are the most elegant and exploratory sculptures in the whole of Australian art.

11 CONTEMPORARY ART

As MENTIONED IN THE INTRODUCTION the Joseph Brown Collection makes no claim to represent recent Australian art comprehensively.

It includes some Melbourne abstractionists of the 1956 generation, Leonard French, Donald Laycock and Asher Bilu.

French was never an abstract expressionist but his mechanistic, geometric style was not entirely isolated: Roger Kemp, an older religious abstractionist, was an important influence on him and several of French's contemporaries shared his interest in machine forms, both as menace and as a sign of democratic, factory workers' honest labour. Lofty symbolism, either Christian, Oriental or concerned with classical myth, has continued to be the aim of a surprisingly large number of Australian artists. Clifford Last is a sculptor whose work shows the same motivation.

Donald Laycock and Asher Bilu both began as abstract expressionists but by the mid-1960s their styles had become more individual. Laycock, still interested in space and light and myth, developed an original imagery of fruit as erotica and fertility and at the same time as science-fiction space vessels. These works have extreme beauty and extreme absurdity, and it is their hilarious quality which makes them act so effectively on the spectator. Bilu's discs are also concerned with release into a state of timelessness, though they are more passive in their invitation than Laycock's.

Pop Art never gained many adherents in Australia. Mike Brown and Richard Larter were probably the best. However, in the early 1960s it did provide a climate in which young artists might once again experiment with figurative art. George Baldessin's sculpture owes most to his Italian training, and to his own ideas about man trapped in society like a performer on a stage, but when it first appeared it was welcomed as a kind of Pop Art.

Brett Whiteley's brilliant talent gave him a reputation in London while still in his early twenties. The earlier collage-style abstractions derive from his admiration of Australian landscape, of Lloyd Rees's humped landscape paintings, and of female forms. His impetuous embrace of a great variety of media extends to sculpture, ceramics and prints as well as painting, but even his sculptures keep to the same characteristic looped and swinging forms.

The other Australian besides Whiteley to gain some international fame in the 1960s was the sculptor Clement Meadmore who left in 1963 for New York. His fabricated steel box-tubes give an illusion of having being bent; thus they embody a powerful sense of muscular physical energy. The art of Barnett Newman was a strong influence and Meadmore's sculpture was welcomed for its warmth amongst the coolness of the Minimal Art movement.

Sydney Ball's hard-edge painting of 1966 and Ostoja-Kotkowski's Op Art collage of 1965 are in the collection as early tokens of the marked revolution in Australian art in the late 1960s. Suddenly the emotional heat of the abstract expressionists, or the lofty imagery of the abstract symbolists was displaced by a generation which felt, like Balson's generation of 1939, that art should first concern itself with its own internal problems. In painting this chiefly meant an investigation of colour and shape, in emulation of Matisse. Again this was very similar to Balson's programme of thirty years earlier.

There were many luxurious colour painters in the late 1960s. They did not often explain their art as a symbol of scientific or religious order. More often, in Sydney at least, they professed a relaxed

acceptance of the way their own environment can easily get into what might seem purely formalist art—the light, the heat, or the coolness of surfing. Art that is as sensuous to the eye as colour painting readily images other sensuous experiences.

Two painters, more conservative than those already mentioned began to be widely admired in the 1960s: Sam Fullbrook and Fred Williams.

Since the late 1940s Fullbrook had been painting portraits of left-wing politicians, and subjects of outback labour and Aboriginal neglect. Curiously, his style is extremely lyrical for he believes that children or unsophisticated people like lyrical prettiness best, and that therefore it is one of the most democratic styles. His subjects are often innocent people, children and country workers, and his occasional aeroplane subjects also see these small, primitive aircraft, flying with their wheels down, as simple and vulnerable.

Fullbrook's and Williams's work shows constant awareness of their predecessors; Fullbrook's the sensuous masters like Gainsborough and Titian, Williams's the highly structured masters like Mondrian and Matisse, though Daumier's surprising presence and sensuous paint-handling made him Williams's favourite.

Williams greedily challenged many masters in many different ways. A certain pigment was used because it was used by Michelangelo. A superb etcher, he cropped his copperplates and printed confusing variant editions because Rembrandt did. A canvas was given the exact dimensions of Tom Roberts's *Bailed up* because Williams wished to challenge his Australian predecessor and do a new version of a hill slope and repeated vertical gum-trees. He said 'When I paint a picture I remember all the pictures I've ever seen—in the Uffizi, the Louvre or in London.'

Although in Australian landscape-painting Roberts and Drysdale have been as formal as Williams, and Rees and Boyd as involved with the old masters, Williams more than any Australian landscape artist has combined formal and technical strength with both art-historical learning and the most accurate observation. His pictures look right pictorially, but they also look amazingly right as observation—of subtle Australian colours in bush vegetation and pastoral plains, of the way trees scatter and coalesce, and of the way hills fall and skies press down. His ambition, observation and skill made his work, until his death in 1982, the most significant recent addition to the continuing story of Australian art.

IF FRED WILLIAMS'S LANDSCAPE PAINTINGS seemed in 1973 the best and the most Australian of the new works of art with which to conclude the first edition of this book, they were not the most characteristic art of that moment. Paintings and other traditional art objects which can be commodified and marketed were receiving less critical attention than the artistic process leading up to the production of objects. The creative process could perhaps be experienced by the widest range of society, wider than 'elitist' professional artists who made objects for the few, or by 'elitist' wealthy or educated consumers who bought or appreciated those objects. Ephemeral sculpture and installation, performance art, video art, poster art, photography and craft arts received more attention than, say, oil painting or bronze sculpture. Two years earlier, Sydney's Contemporary Art Society had devised an exhibition *The Situation Now: Object or Post-object Art?*; in 1973 the most significant art events seemed to have been a large outdoor *Sculpturscape* exhibition at Mildura of ecology-conscious ephemeral work and the import by John Kaldor of the 'living sculptures' Gilbert & George whose performance art was seen in Sydney and Melbourne. In 1969 Kaldor's earlier import of Christo to produce a short-lived *Wrapped Coast* in Sydney had given a conspicuous start to the new sensibility.

Dematerialization of art and questioning of the place of art in society were international movements. More significant within Australia was the fact that 1973 saw the end of thirty-five years of conservative federal government and, after the withdrawal of Australian military assistance to the United States in Vietnam, the beginning of the end of thirty-five years of Americanization of Australian culture. Decorative formalism in American-style painting, either abstract-expressionist, hard-edge or

lyrical abstraction, would give way to post-modernism. The only American art influence to survive the anti-Americanism of the time was Pop Art, both because of its 'democratic' recognition of popular culture in, say, comics, advertising and packaging images and because of its post-modern openness about appropriating existing imagery.

Robert Rooney's *Born to die*, an ironic look at wartime heroism, Ivan Durrant's *Clark Gable nightflight*, Richard Larter's *Untitled* mass-media stars, and Gareth Sansom's *Temptation* show the exuberance and wit which Pop-related painting has maintained from the 1960s to the 1980s. Lorraine Jenyns's *A tiger's tale* is an example of the comparable 'funky' ceramic sculptures which emerged in the 1970s.

By the early 1980s, again as part of an international neo-expressionist movement, 'painting was back'—but in fact it had never gone away. Arthur Boyd and other expressionist artists formed in the 1940s continued at the height of their powers; so did abstract expressionists like Dick Watkins. And a one-time abstract painter Peter Booth, whose dark rectangles had opened up to reveal personal nightmares, from 1977 began to be perceived as the most genuinely expressionist of those working within the new vision. Davida Allen's neo-expressionist paintings of pregnancy and parenting owe much to her Brisbane predecessor Jon Molvig and to early-twentieth-century German expressionism.

John Brack's intense delight in artificiality, in paintcraft, in appropriation of past masterpieces (for example by Seurat, Manet or Degas), and of popular images, and his delight in modern everyday life, meant that this 1950s Melbourne artist would become for the 1980s its master proto-post-modernist.

Peter Tyndall's post-modern paintings, all titled *A person looks at a work of art . . .*, are descended from Brack's sophisticated 'Melbourne cool'. Stephen Benwell's pottery quotes the world's history of ceramic art and Imants Tillers's paintings re-use existing powerful images known to him only from mechanical printed reproductions. Less cool than its knowingness makes it seem, the best post-modernism is passionately impressed by the power of art.

A different kind of cool sophistication was Minimal Art, a late-1960s international movement to which the Melbourne painter Robert Hunter is affiliated. An art of infinitely subtle relationships of colour and tone, floating on the surfaces of simplest neutral grid-forms, Hunter's paintings also are less cool than they seem. He has often put his life at risk; he is accident-prone. 'Hunter liked wrecking. He preferred tearing apart to construction. The deep struggle for structure is an ideal world for him.' His art is an ecstatic dream of order and calm for those who live chaotically and violently.

The theatrical drama, and sometimes the violence, of early-1970s performance art by Ken Unsworth and Mike Parr can be seen reappearing in their return-to-the-object works. Unsworth's sculptures are usually metaphors for extreme physical sensations, of extension, compression, inflation—or death and resurrection. Parr's huge drawings with self-portraits are a fight against easeful withdrawal, a constant reassertion of the difficult need to retain a presence in the world.

In the 1980s the work of these two, and of Booth and Tillers became the most frequently requested from Australia for international exhibitions of contemporary art. It matched the international sensibility of the time.

Regionalism was presented as an opposing value to internationalism in the anti-American early 1970s. It did not only mean 'Australian' values versus 'American'. It meant Brisbane, Adelaide, Perth, Hobart, Canberra and Darwin versus the 'international' cities of Melbourne and Sydney; it also meant country versus city. Thus senior artists marginalized by working in Perth (Howard Taylor), Adelaide (Ivor Francis), Canberra (Rosalie Gascoigne), Brisbane (Robert MacPherson) or in Tasmania (Bea Maddock) were brought to notice. So were younger artists in north Queensland (Tom Risley) or Adelaide (Hossein Valamanesh).

Marginalization by non-metropolitan residence was however less vocal a complaint than those made on behalf of women artists and of 'multi-cultural' or 'non-Anglo-Celtic' artists. Australian women artists, at least since 1920s modernist painting and printmaking, have in fact been numerous and excellent, but Australian culture as a whole, including its art made by male or female artists, had been

absent from the education systems and hence from the consciousness of 1970s social activists.

'Non-Anglo' artists have been numerous in Australia since the 1930s–40s wave of Jewish refugees and central and eastern European displaced persons. Sali Herman, Desiderius Orban, Teisutis Zikaras were earlier arrivals; Paul Partos and Imants Tillers, formed artistically in Australia, have some Czechoslovakian or Latvian qualities; but it is a more recent arrival from Iran, Hossein Valamanesh, whose *Target practice* speaks most clearly of his abandoned cultural origins, and a younger artist like Nicholas Nedelcopoulos whose *The Great Australian Dream* speaks of his alienation from Melbourne's social structures.

The most marginalized Australians are the Australian Aboriginal people. This picture-survey of Australian art begins with a traditional bark-painting from Arnhem Land, a work which differs little from what was made before European colonization of Australia began in 1788. Bark-paintings in the 1980s have become much larger and more spectacular.

Mid-twentieth-century tourist-market watercolours of Central Australian desert landscapes by Albert Namatjira's followers, Ewald Namatjira and Otto Pareroultja, illustrate the first well-known innovative school in Aboriginal painting, although nineteenth-century innovations by individual Aboriginal artists are numerous.

Trevor Nickolls is one of a new wave of big-city Aboriginal artists whose work sometimes expresses the loss of their traditional culture but earlier, in 1971, at Papunya in the desert west of Alice Springs, a very different new kind of Aboriginal painting began.

Traditional culture was alive in the Western Desert. Drawings in the sand were still being made, to get what was needed from the Ancestral Beings and to pass on essential knowledge to future generations. The same imagery is equally powerful for Aboriginal ritual purposes if painted in acrylic on boards or canvases, as was done from 1971 at Papunya, and later elsewhere. Nevertheless the main purposes in producing the paintings for sale were to develop an art-based economy and, more important, to show to other cultures something of what the Aboriginal people valued. Aboriginal painting, sculpture, basketry, jewellery, pottery and textiles have undergone creative revival and in the 1980s Aboriginal art, both traditional and urban, has left the ethnographic margins of Australian artistic consciousness and has become central to the thinking of Australians in all spheres of life. That shift was the most important cultural fact at the time of Australia's Bicentenary.

THE COLLECTION

Dates in parentheses are those that have been established by research
rather than given in inscriptions.

Australian Aboriginal artist, Arnhem Land
Fish (1940s) Ochres on bark

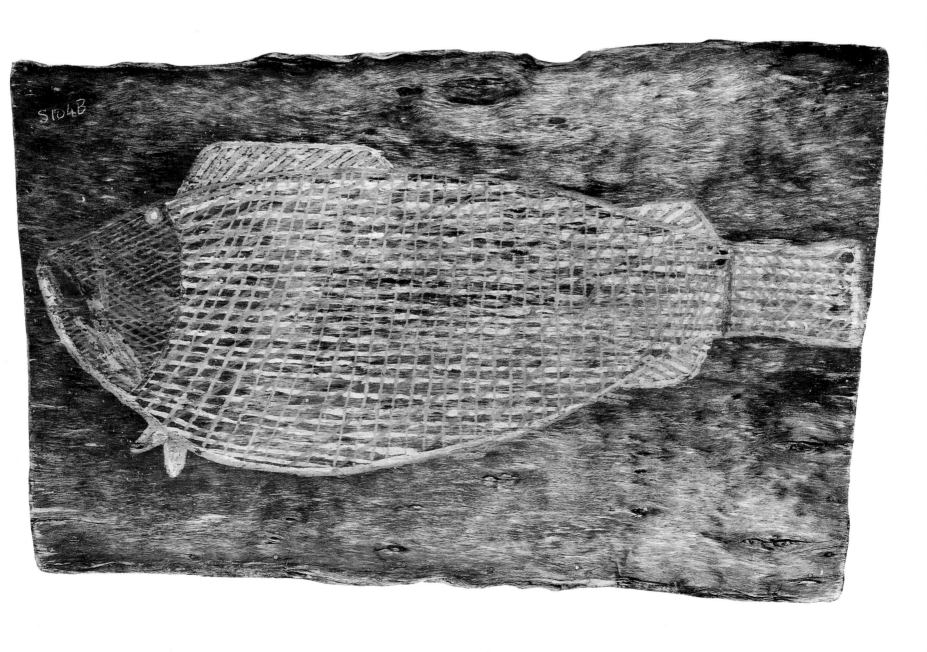

After **F.P. Nodder**
The Banksia
The Banksia gibbosa 1789 Engraving, hand-coloured

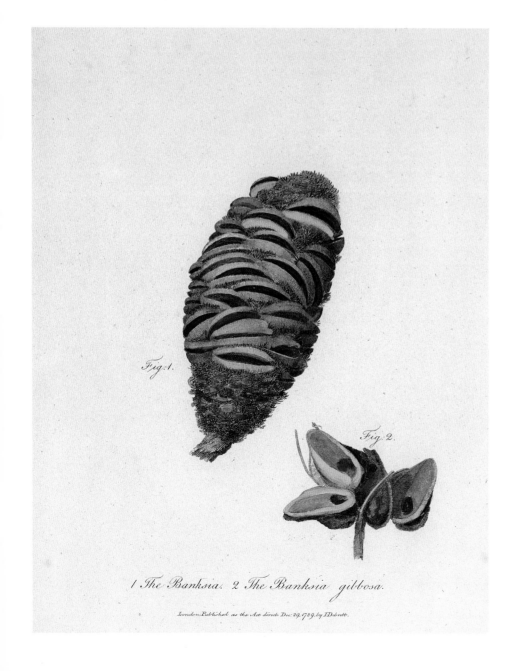

1 The Banksia. 2 The Banksia gibbosa.

London Published as the Act directs Dec. 29, 1789, by I.Debrett.

William Hodges
Wooded river landscape with a waterfall (*c.* 1776) Oil

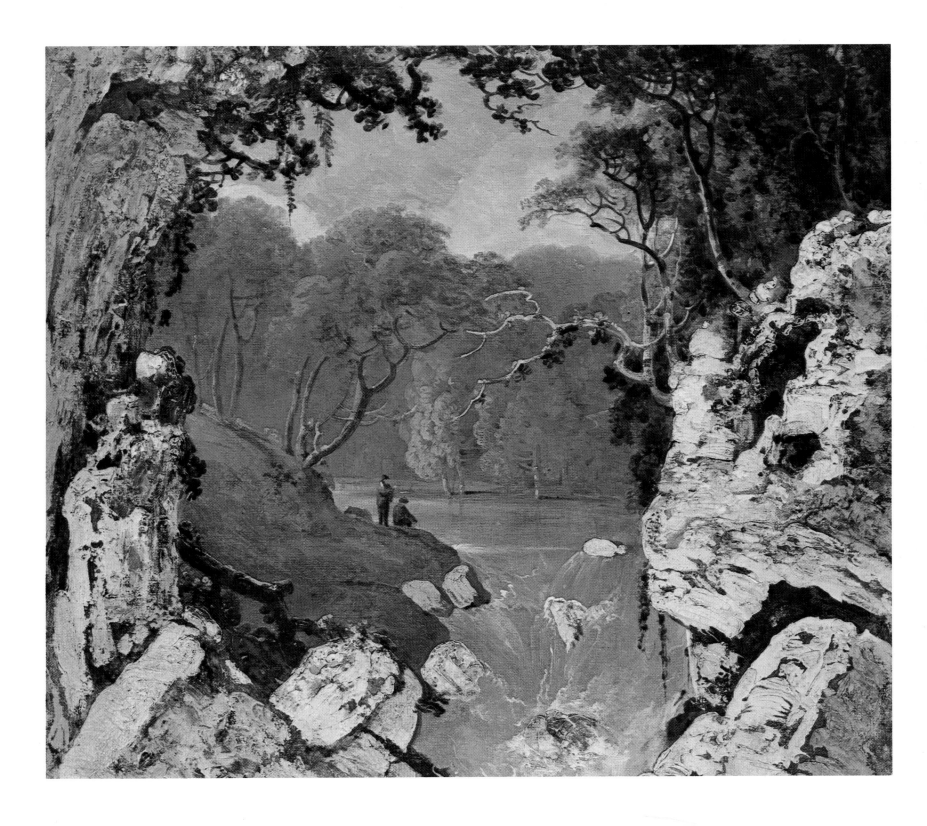

After Robert Cleveley
View in Port Jackson 1789 Engraving, hand-coloured

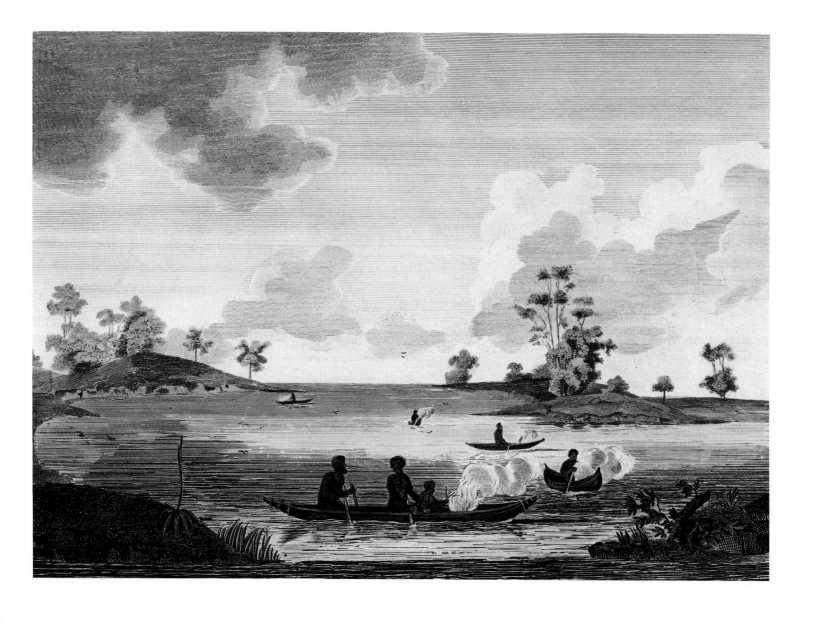

After John Eyre
Port Jackson Harbour, in New South Wales, with a distant view of the Blue Mountains 1812 Engraving, hand-coloured

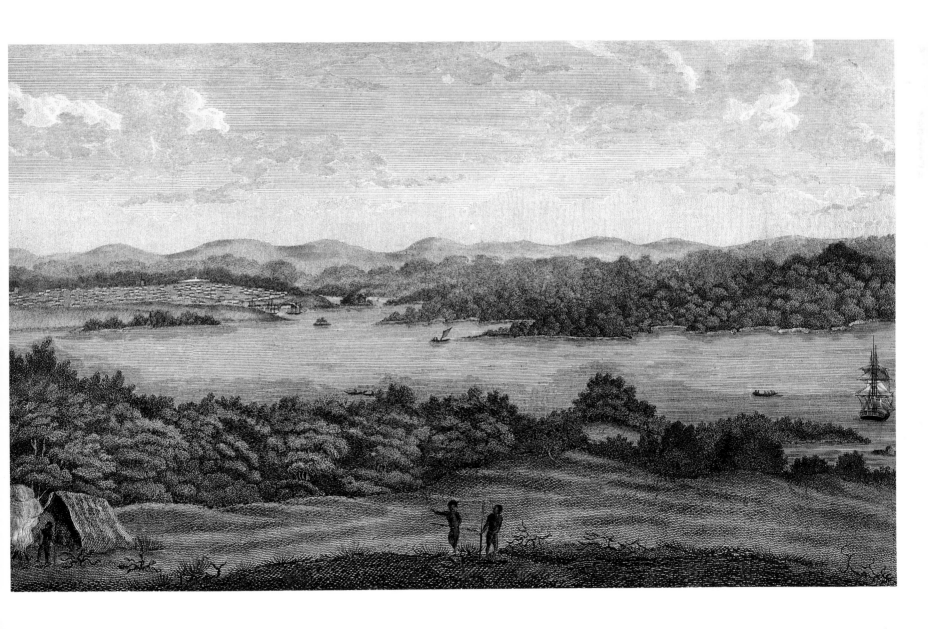

William Westall
The wreck of The Porpoise (1803) Pencil

William Westall
The island of Timor 1808 Watercolour

Walter Preston
View of Hunter's River, Newcastle, New South Wales (1819) Engraving

Walter Preston
View of Hunter's River, Newcastle, New South Wales (1819) Engraving

Joseph Lycett
Distant View of Hobart Town, Van Diemen's Land, from Blufhead 1825 Aquatint, hand-coloured

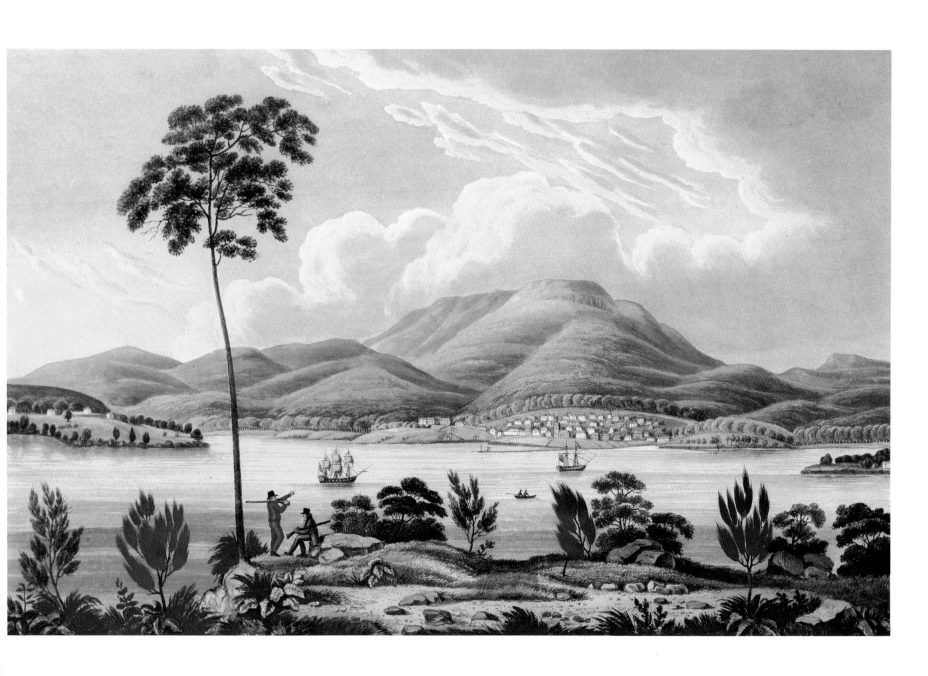

J. W. Lewin
The tree creeper (*c.* 1813) Engraving, hand-coloured

Richard Browne
Killigrant (1820) Watercolour

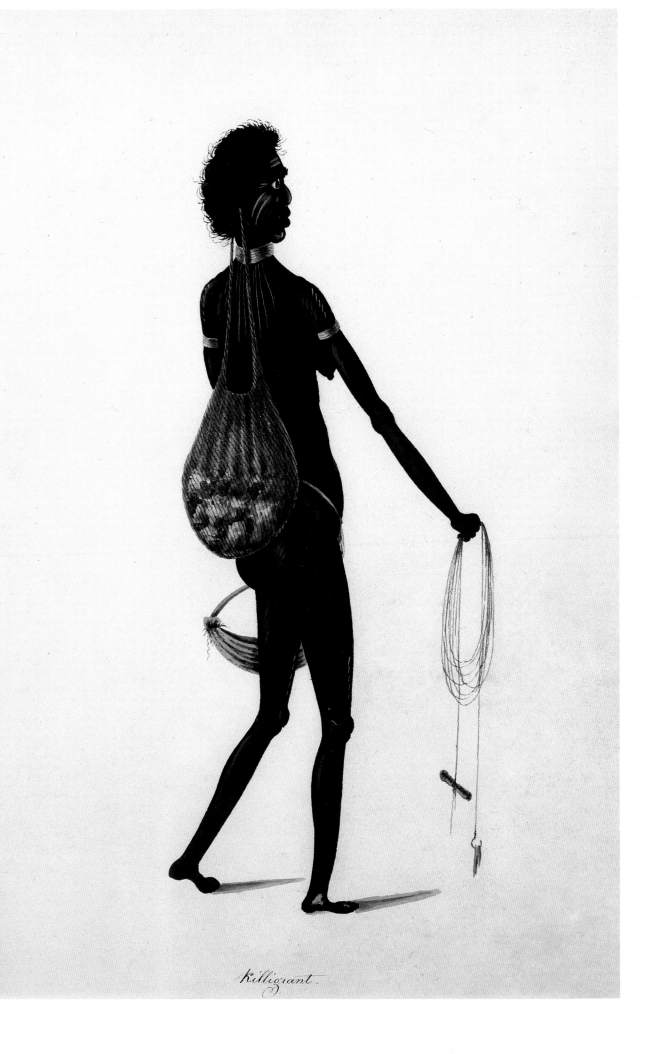

Killigrant.

12

John Glover
View of London from Greenwich (*c.* 1815) Oil

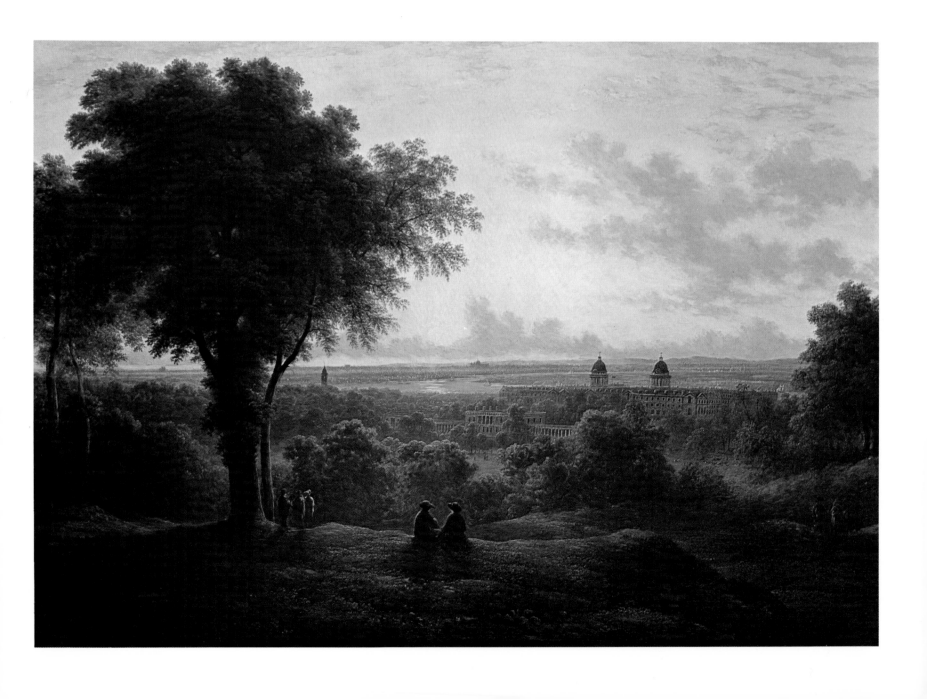

John Glover
View of London from Greenwich (*c.* 1815) Oil

John Glover
A mountain torrent (*c.* 1837) Oil

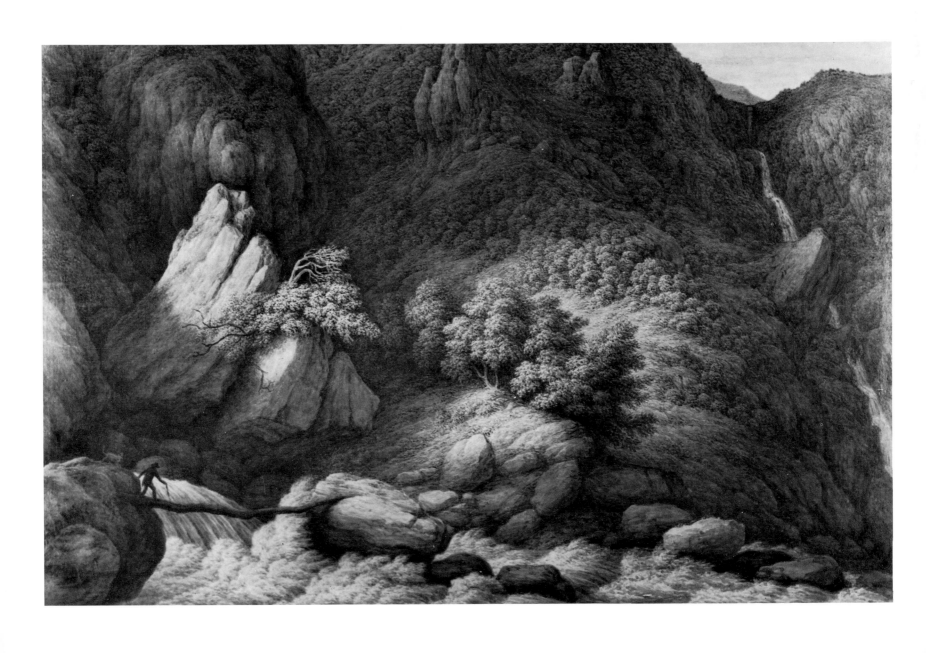

Benjamin Duterrau
The Conciliation 1835 Etching

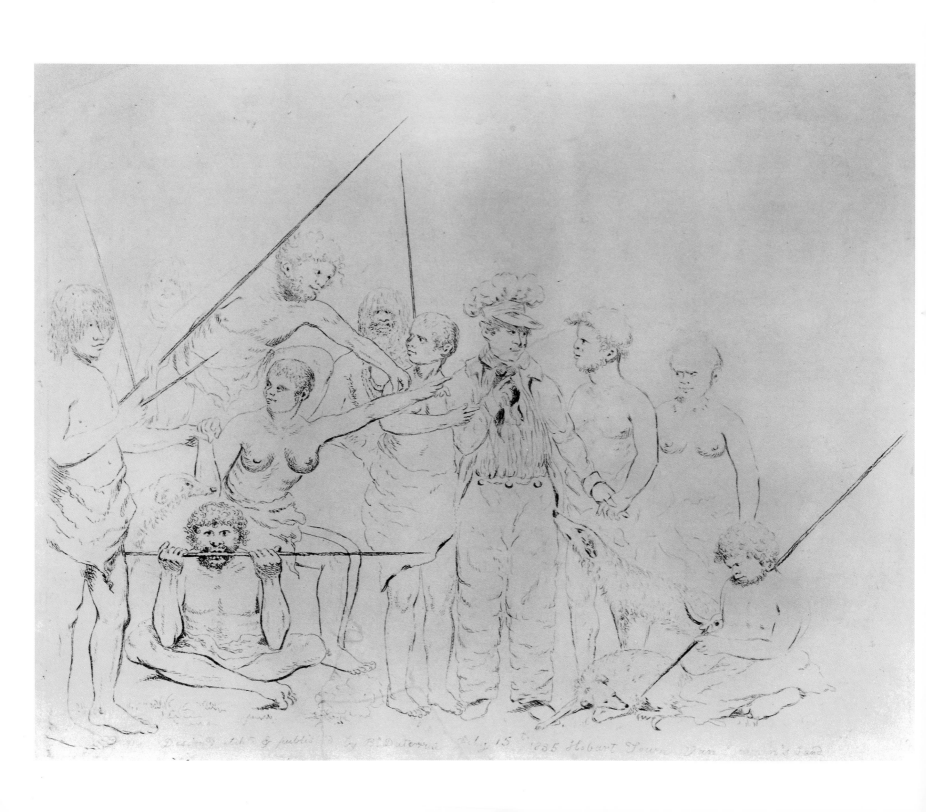

John Skinner Prout
Fern Tree Gully, Mount Wellington 1844 Watercolour

16

Conrad Martens
Coastal Scene near Exmouth
(1829) Watercolour

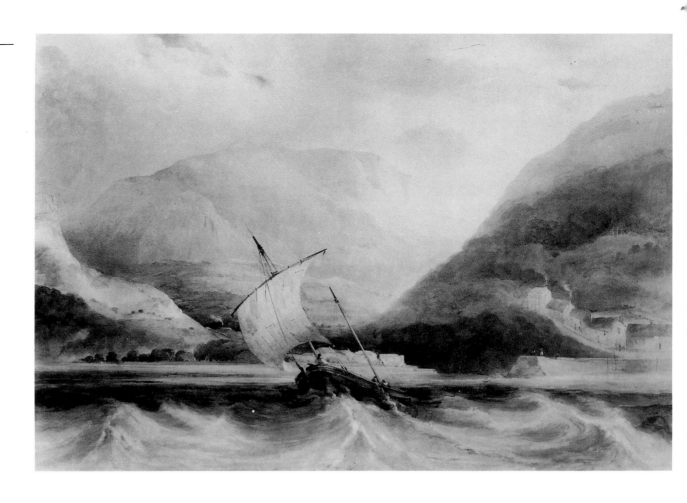

17

Conrad Martens
Rio Santa Cruz
(after 1833) Watercolour

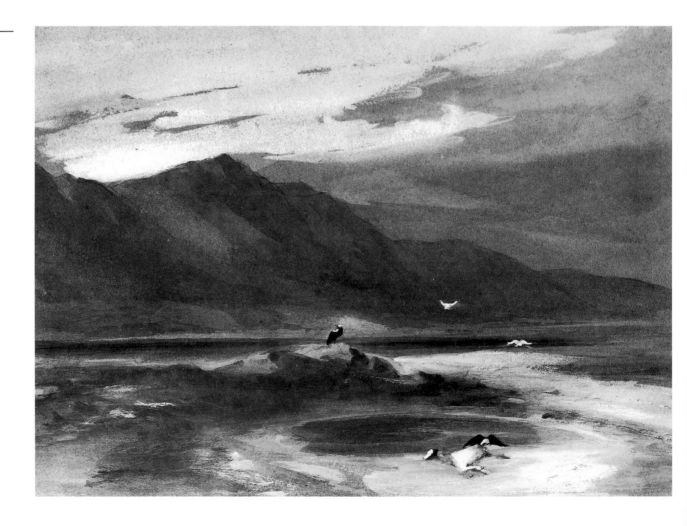

Conrad Martens
Australian landscape with cattle and a stockman at a creek 1839 Oil

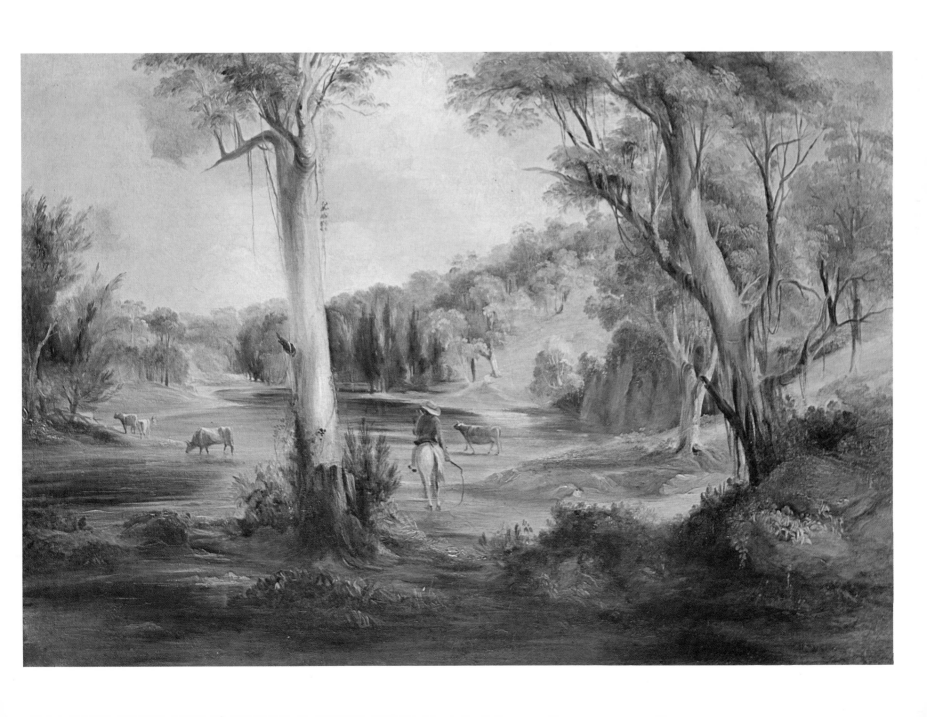

Conrad Martens
Aboriginal camp site (*c.* 1840) Watercolour

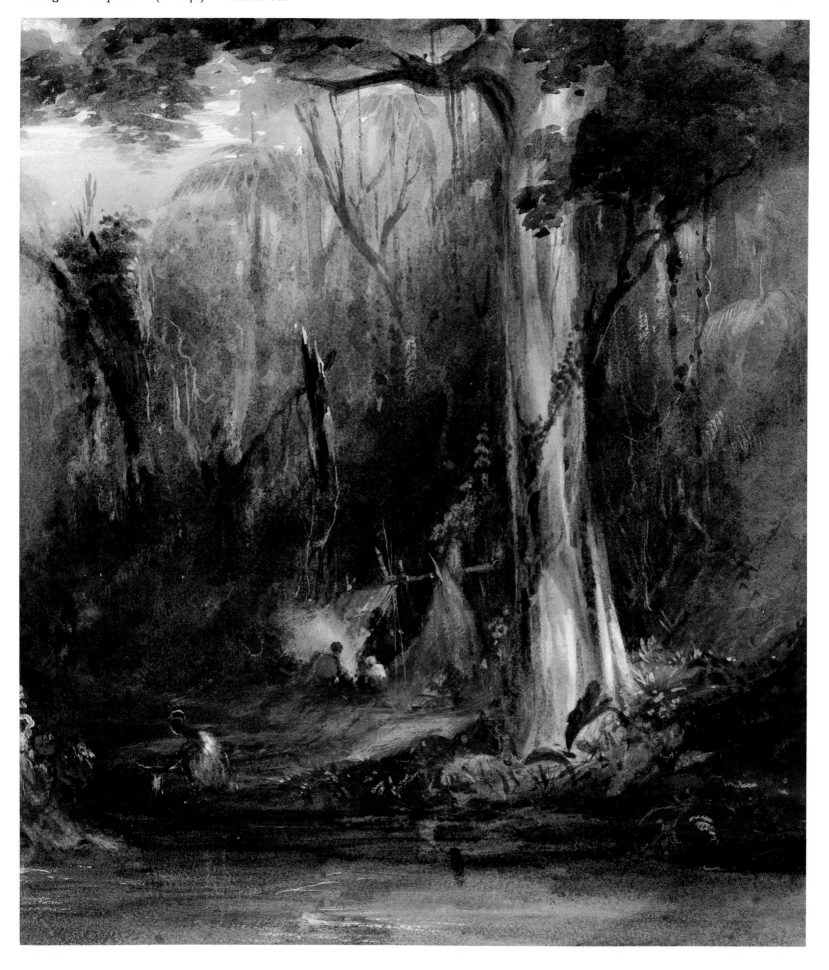

Conrad Martens
Aboriginal camp site (*c.* 1840) Watercolour

Conrad Martens
View of Sydney from St Leonards 1842 Lithograph, hand-coloured

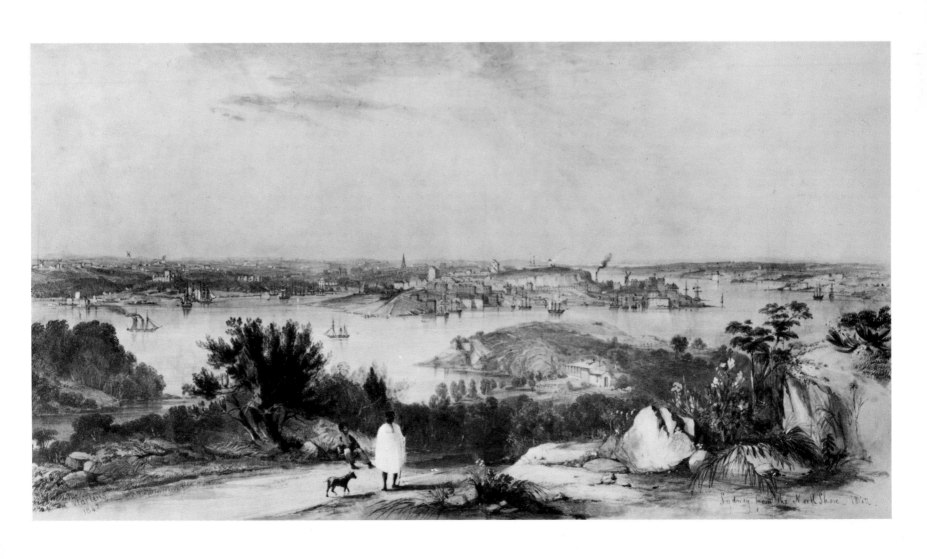

George E. Peacock
View of the Heads of Port Jackson, New South Wales, from above Vaucluse Bay (1840s) Oil

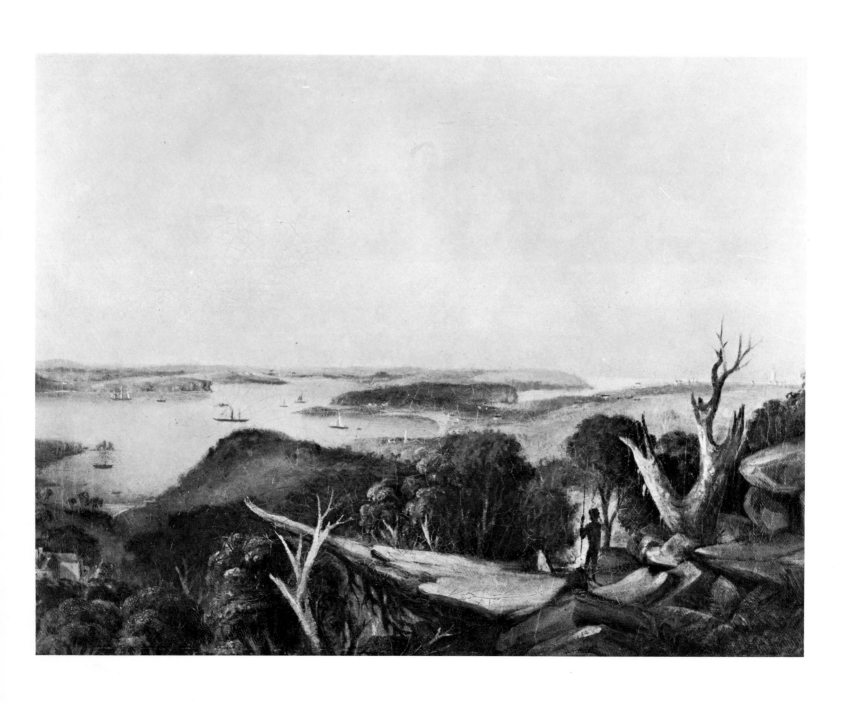

George French Angas
The City and Harbour of Sydney 1852 Lithograph, hand-coloured

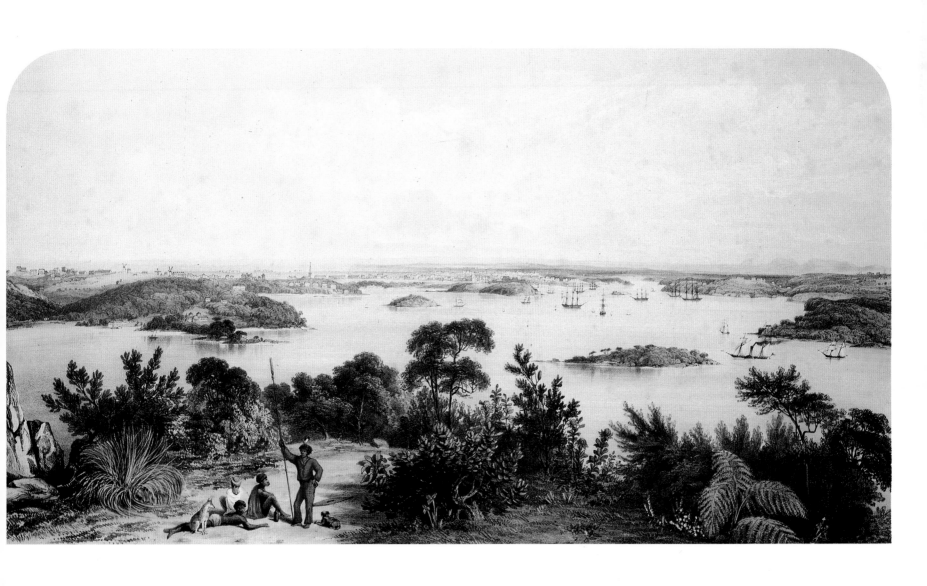

George French Angas
The City and Harbour of Sydney 1852 Lithograph, hand-coloured

W. B. Gould
Sailing ships off a rocky coast 1840 Oil

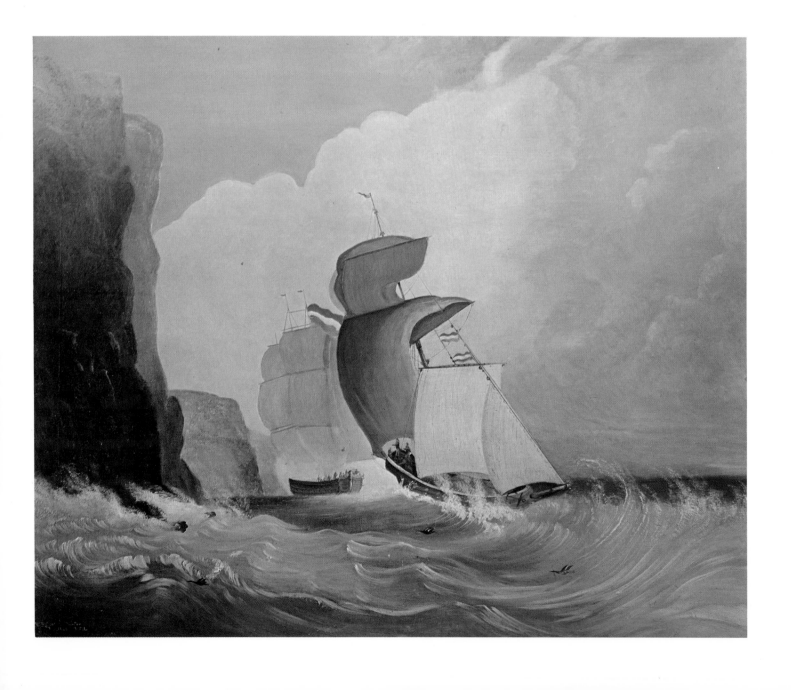

W. B. Gould
Sailing ships off a rocky coast 1840 Oil

W. B. Gould
Flowers and fruit 1842 Oil

William Dexter
Wheatfield with bird's nest (1850s) Oil

Unknown artist
Landscape with kangaroos in foreground (c. 1850) Oil on board

Unknown Tasmanian artist
George and Rosalie Waterhouse, children of Susan Waterhouse (1840s) Watercolours

Unknown Tasmanian artist
Emily Jones (*c.* 1860) Pastel

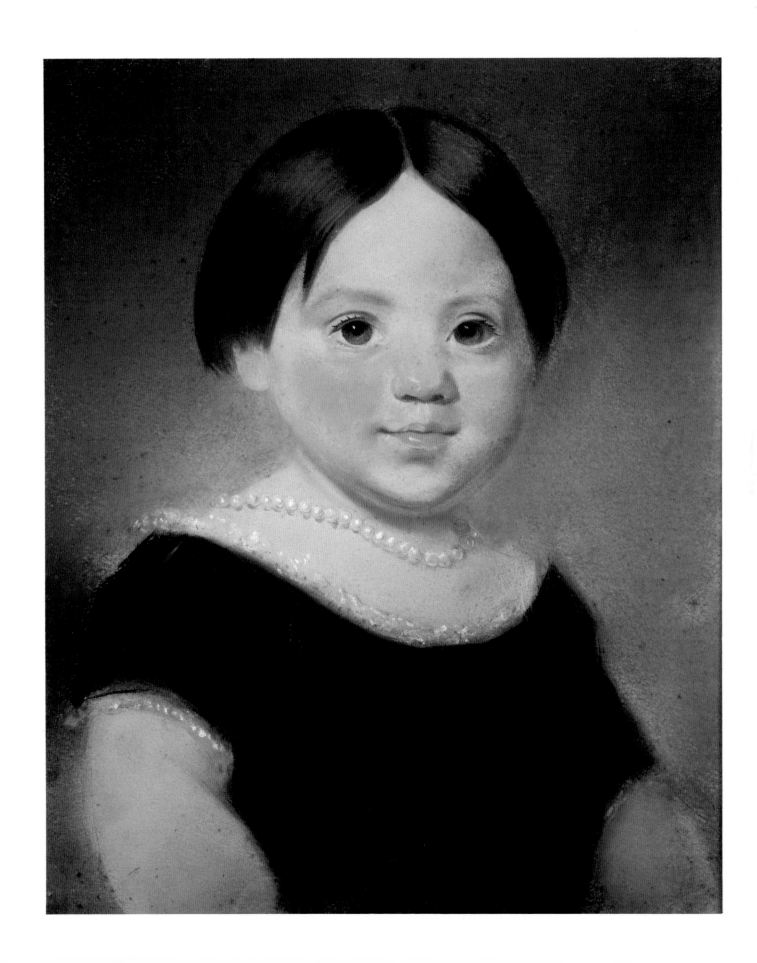

George Rowe
Panorama of Melbourne from Flagstaff Hill (1859) Lithograph

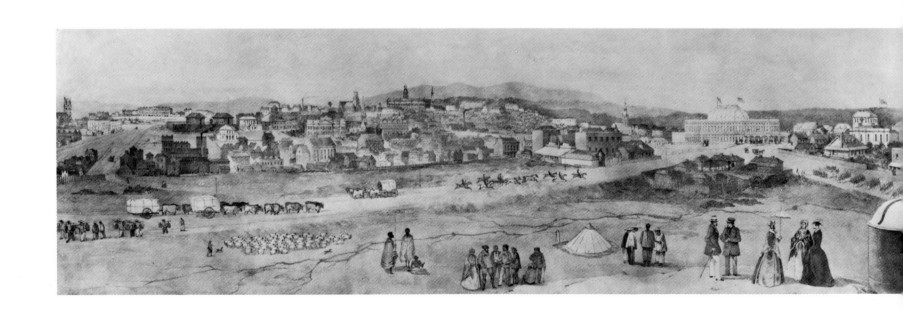

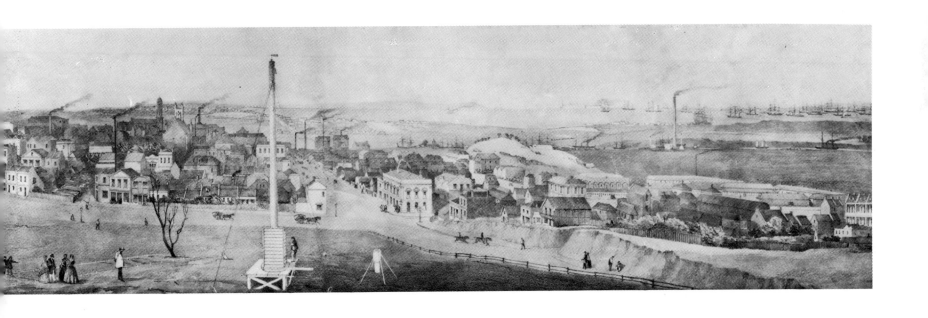

J. A. Houston
Portrait of Dr E. Nasmyth Houston (1840s) Watercolour

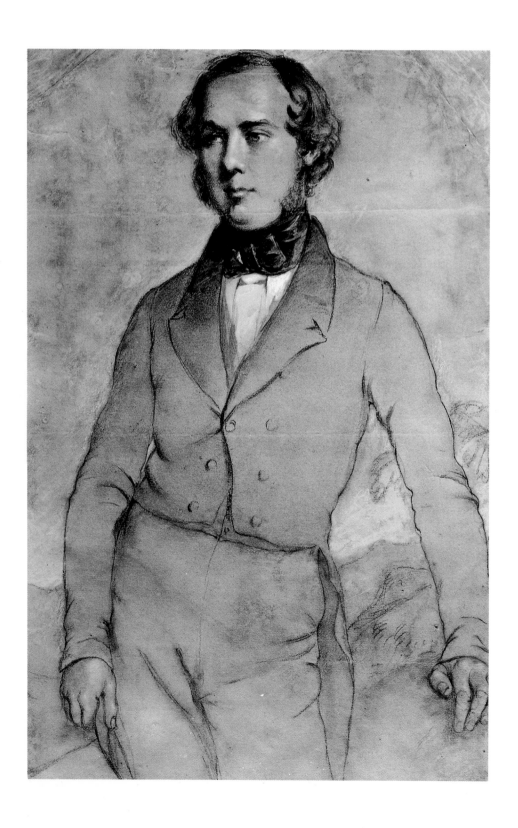

Henry Gritten
Melbourne from the Botanical Gardens 1865 Oil

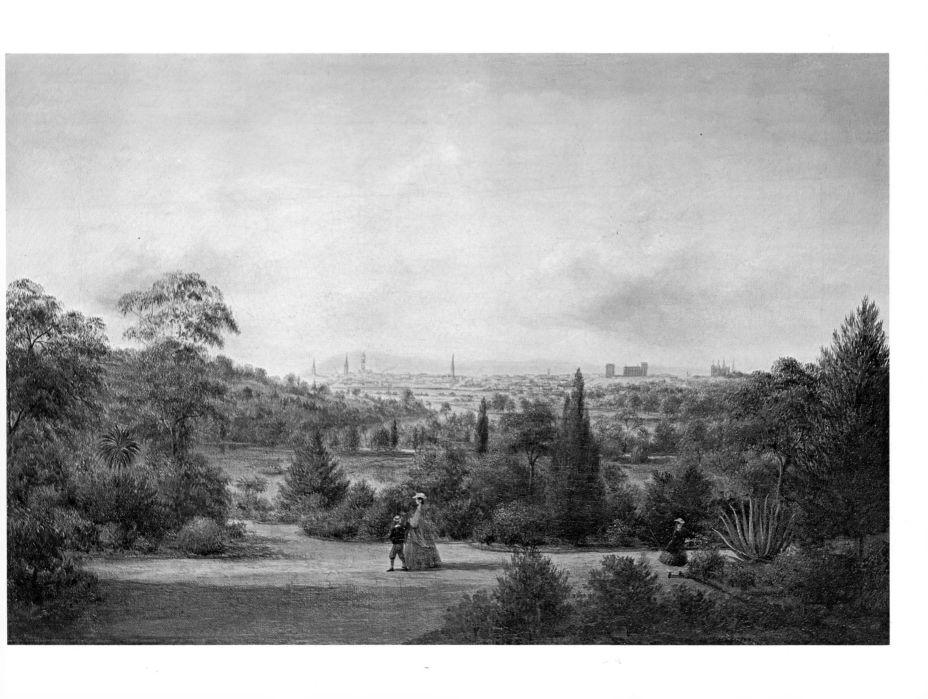

S. T. Gill
The Flinders Range (*c.* 1865/1870) Watercolour

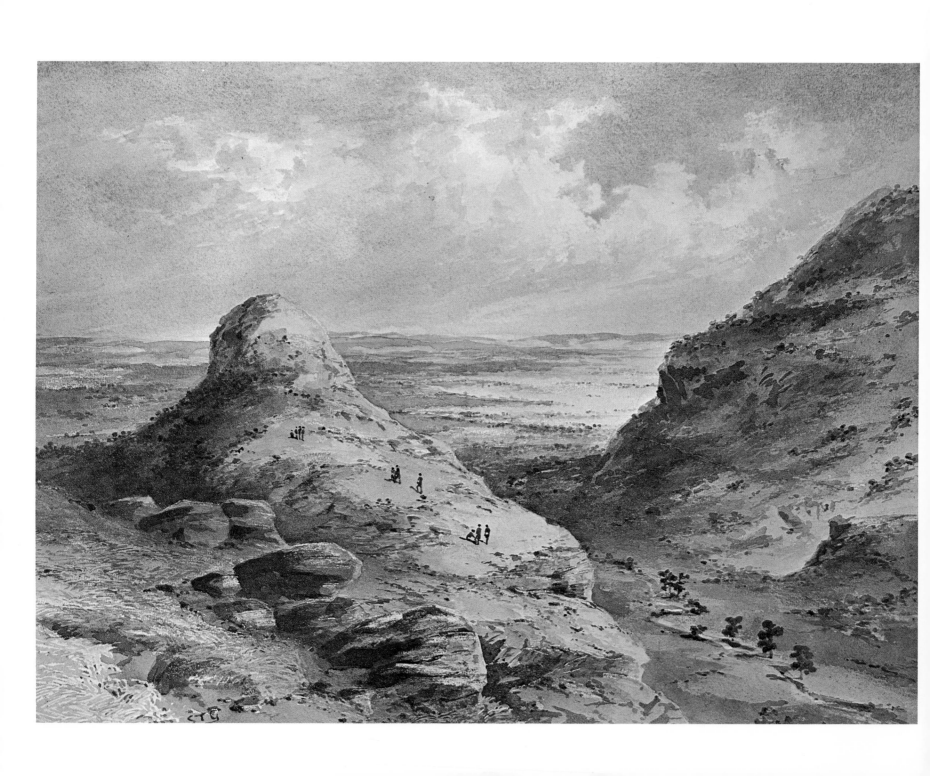

S. T. Gill
Tin dish washing (c. 1865) Watercolour

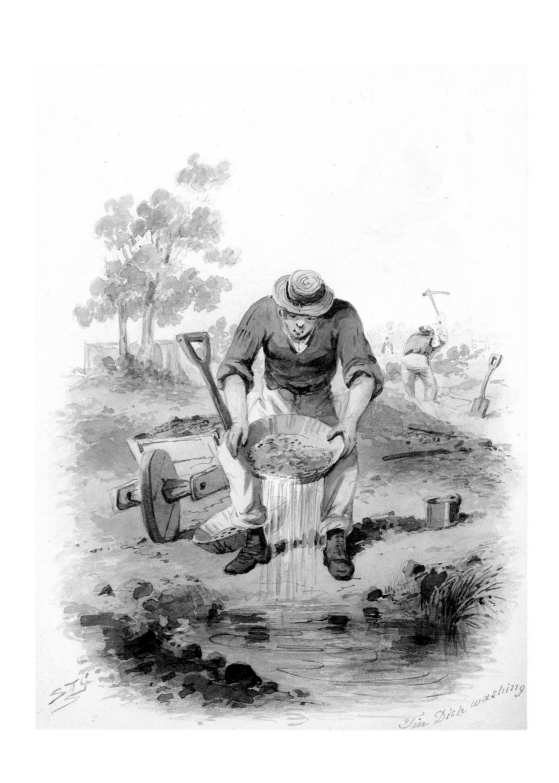

S. T. Gill
A Bendigo mill 1852 (c. 1865) Watercolour

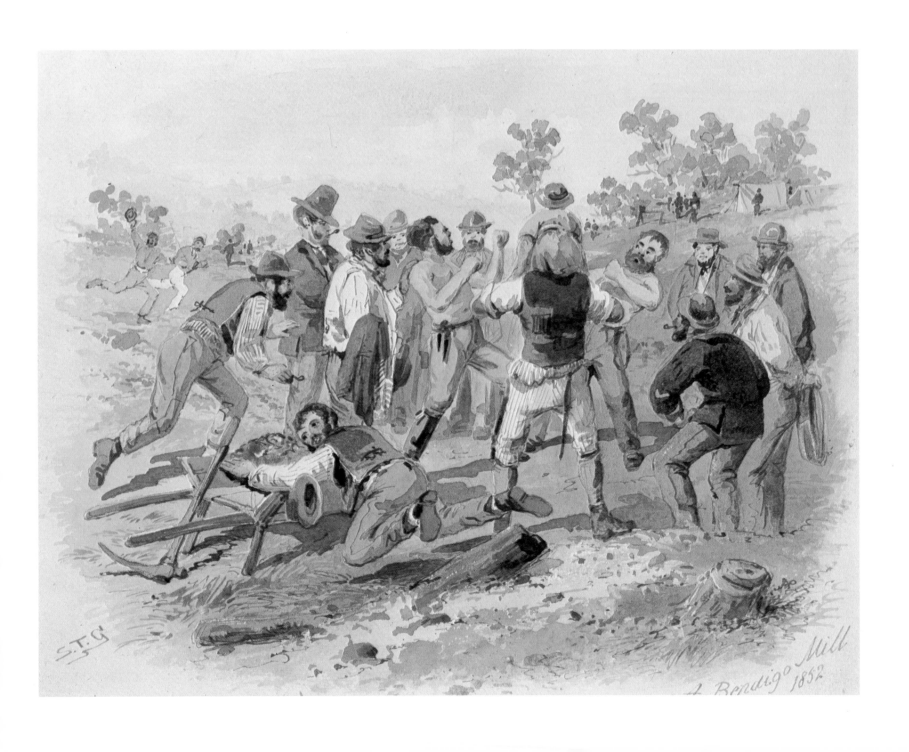

S. T. Gill
Baby 1867 Watercolour

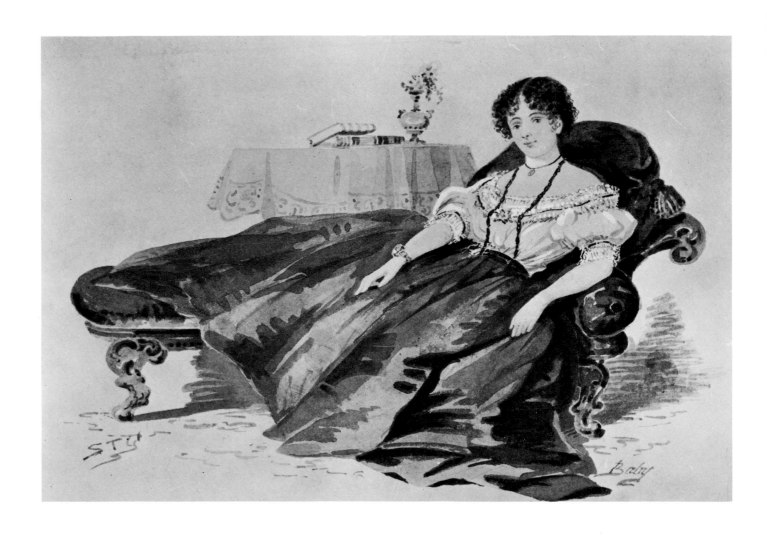

Owen Stanley
Leaving Sydney Harbour for Bass Strait 1848 Watercolour

Frederick Garling
Schooner in full sail, leaving Sydney Harbour (1860s) Watercolour

Thomas Woolner
Sir Charles Nicholson 1854 Bronze

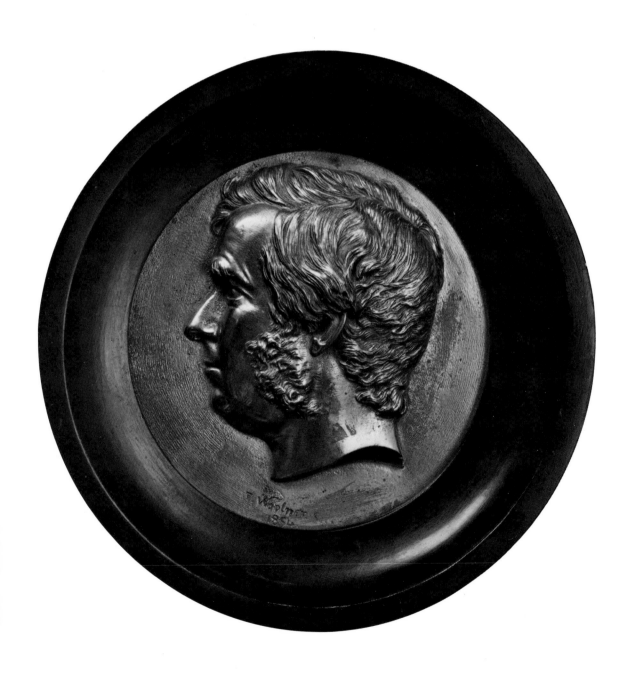

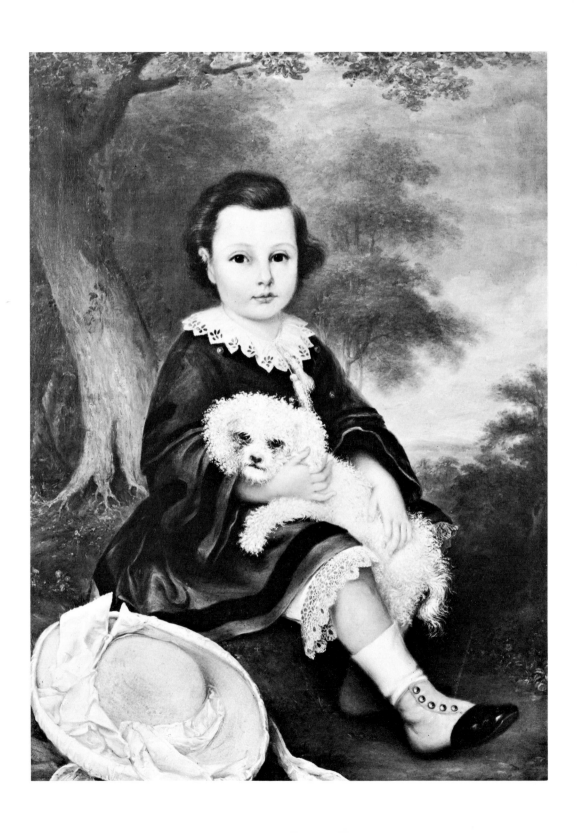

39

Richard Noble
Master Benedetto John Bernasconi 1860 Oil

Thomas Robertson
View of Hobson's Bay (c. 1857) Oil

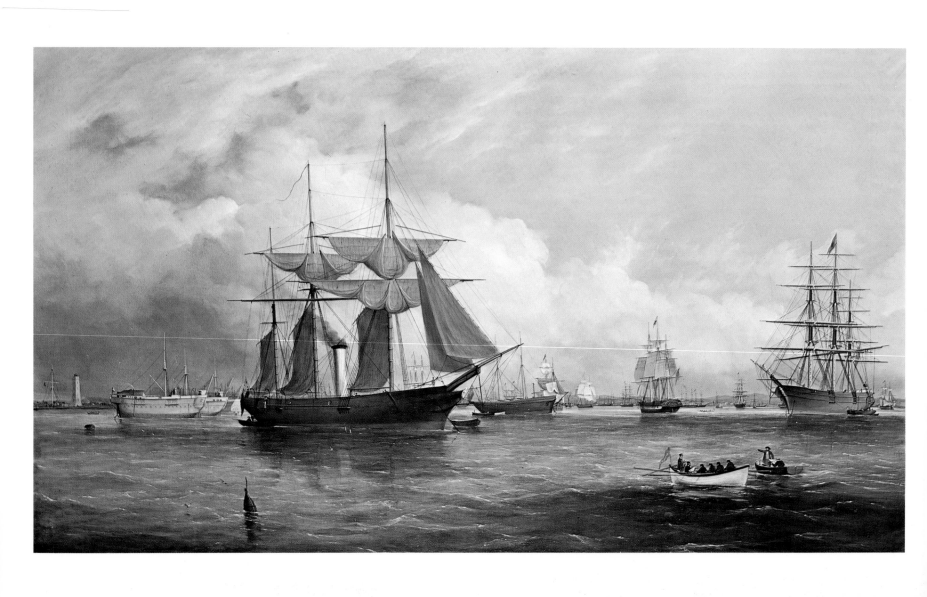

41

Henry Burn
Studley Park Bridge over the Yarra (*c.* 1860) Oil

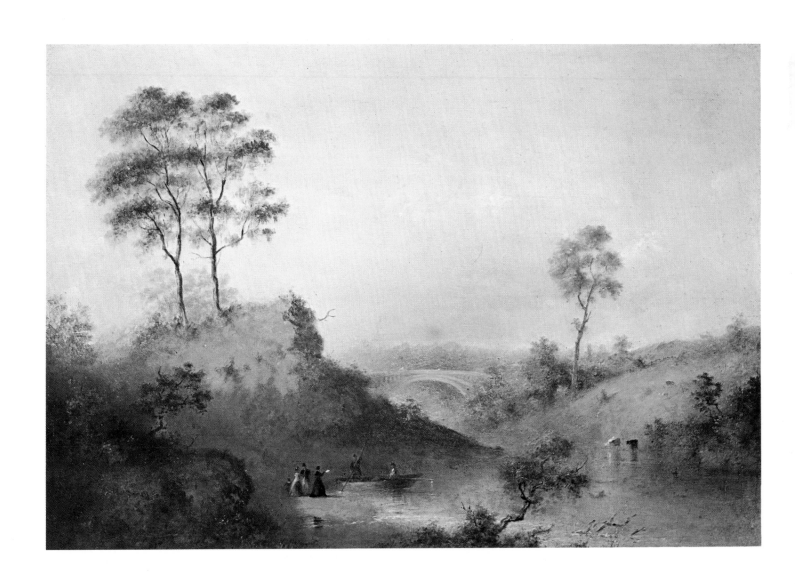

Henry Burn
Harvest scene 1876 Oil

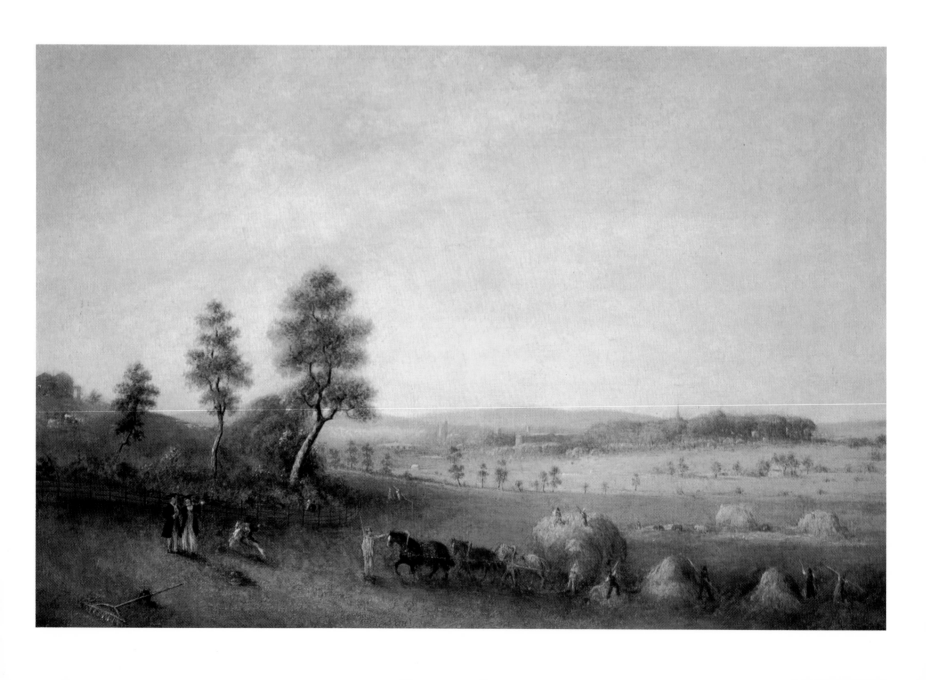

Haughton Forrest
Shipwreck off a steep coast 1877 Oil

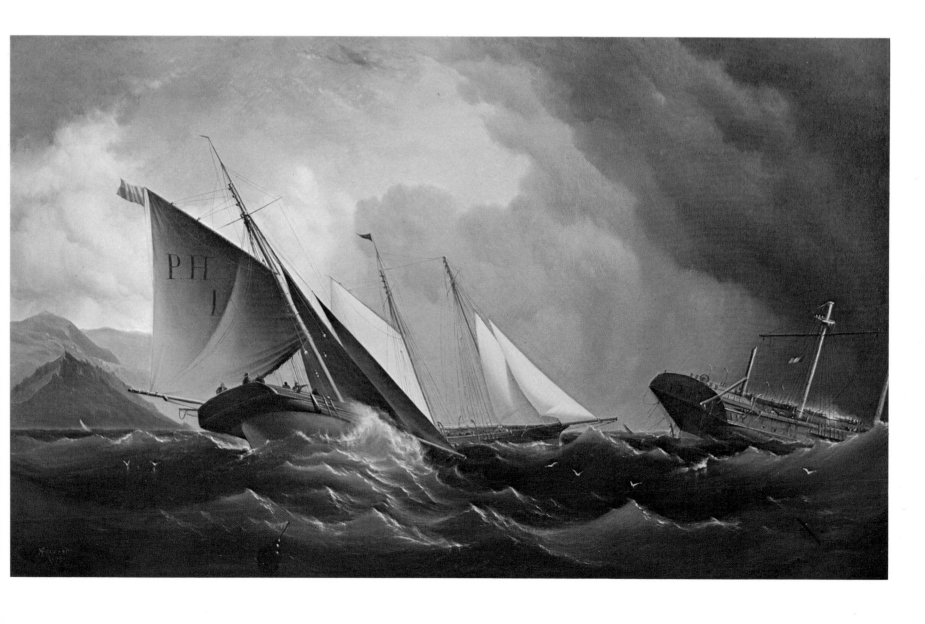

Unknown artist
Gold finders (c. 1860) Oil

William Strutt
Study for man 1883 Oil

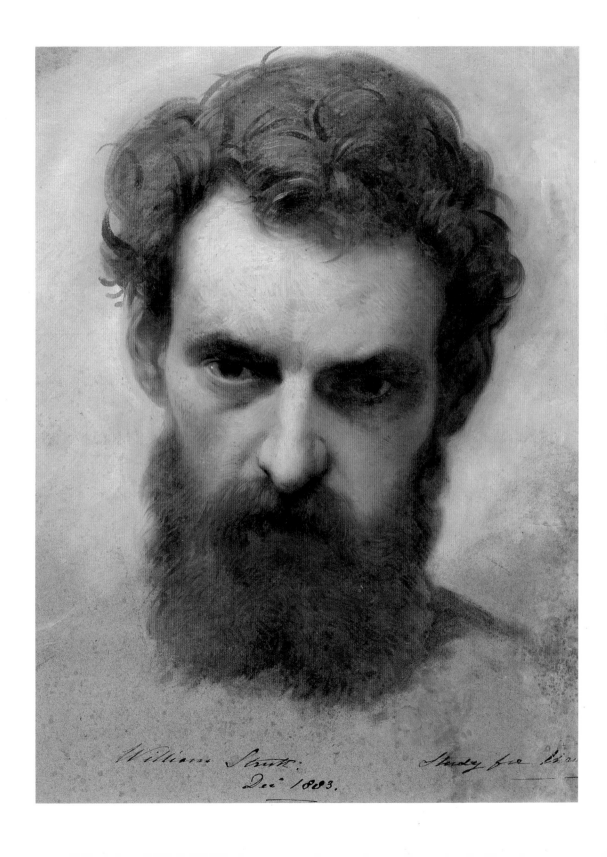

William Strutt
Lady Blunt's Arab mare, Sherifa 1884 Pencil and crayon

William Strutt. F.S.

Feb 5th/84.

Study from a celebrated Arab mare.

William Strutt
Dogs with flowers and game (1850s) Oil

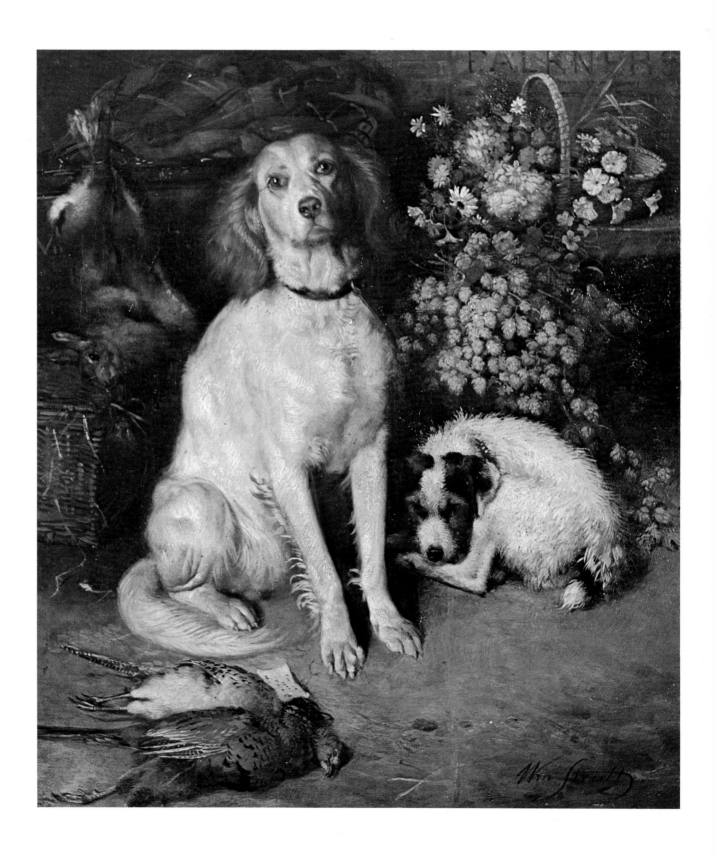

Thomas Clark
The Wannon Falls (1865?) Oil

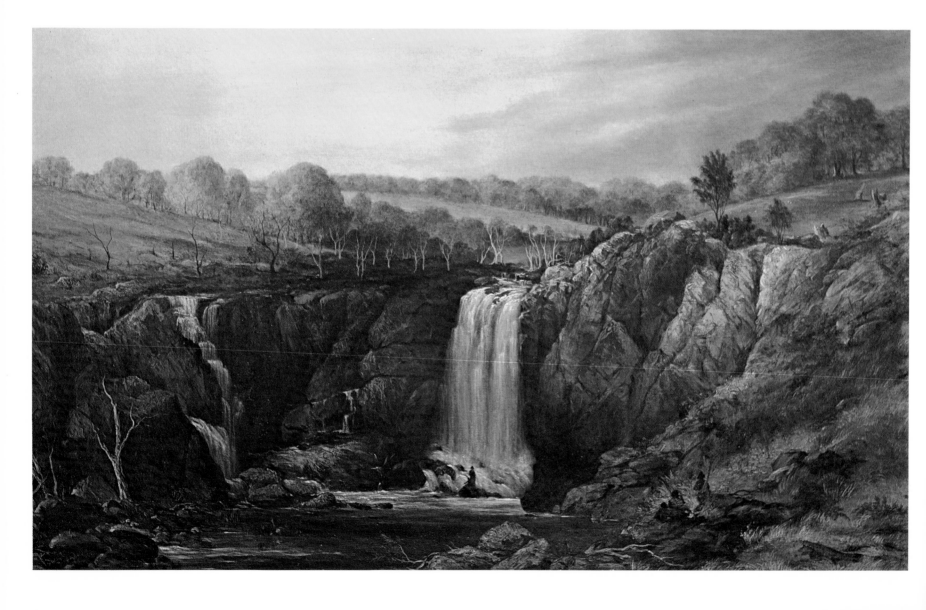

Robert Dowling
An afternoon siesta 1859 Oil

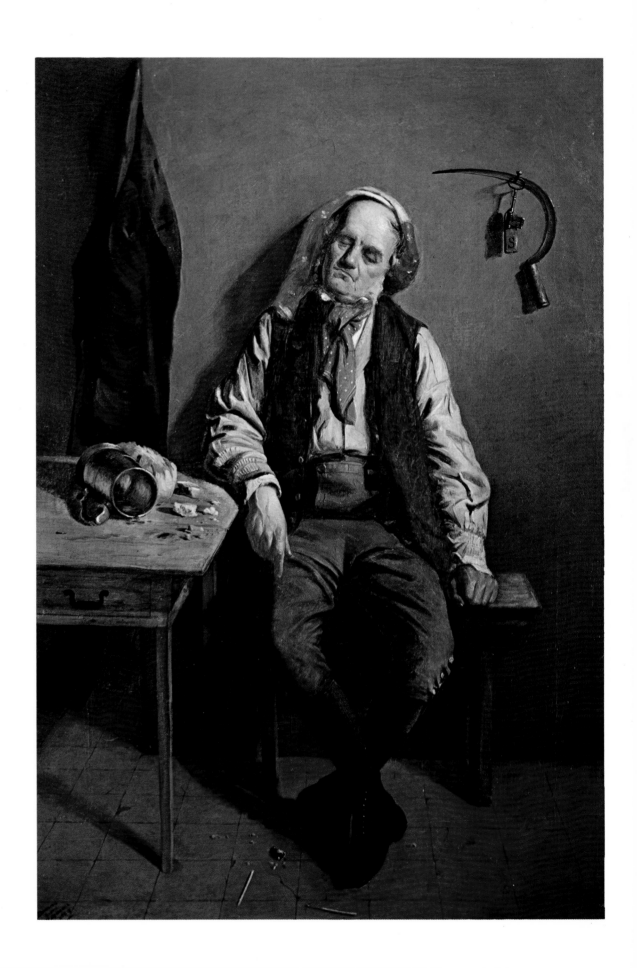

Robert Dowling
John Ware (c. 1860) Oil

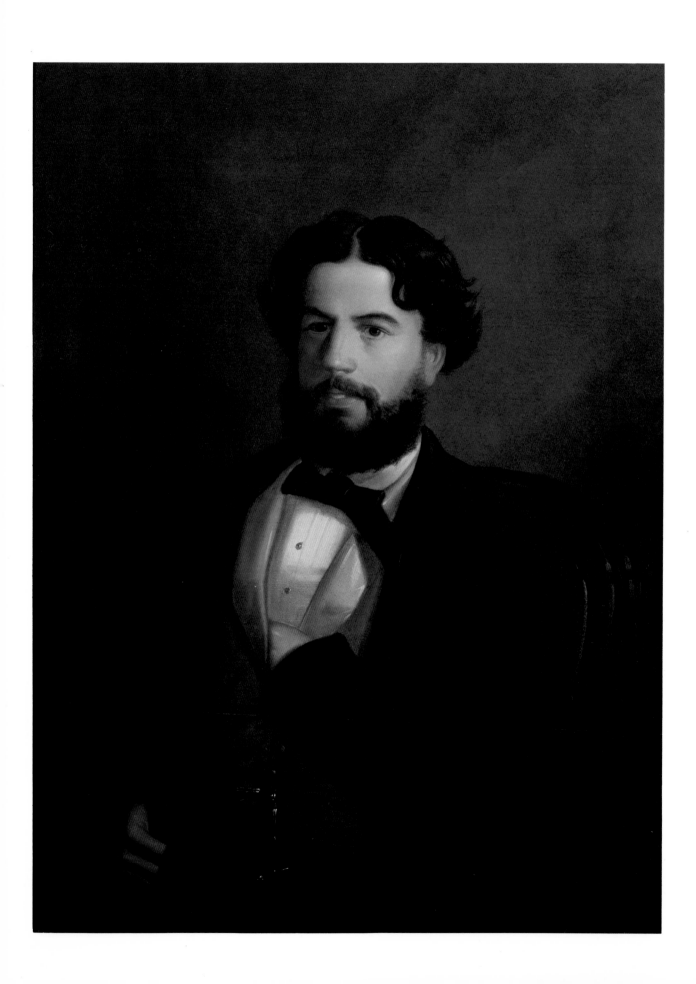

Robert Dowling
Miss Annie Ware 1882 Oil

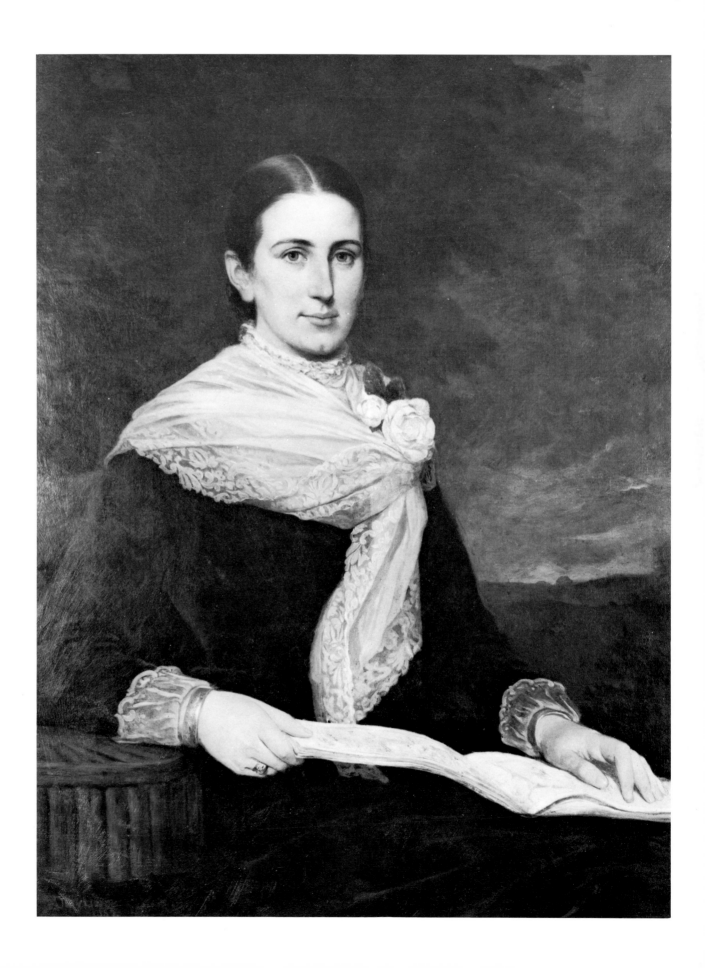

Eugene von Guérard
Yalla-y-Poora 1864 Oil

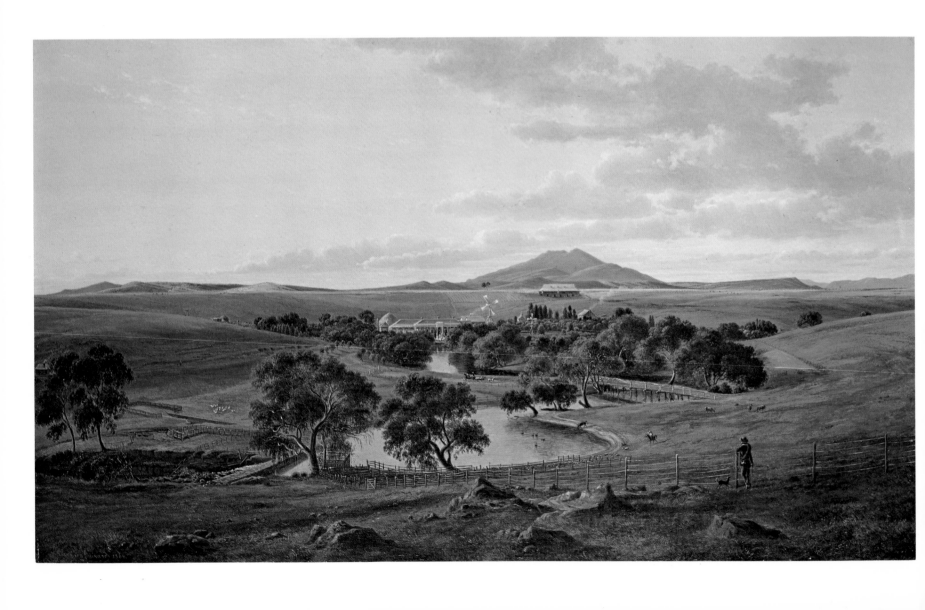

Eugene von Guérard
Spring in the valley of the Mitta Mitta, with the Bogong Ranges in the distance 1863 Oil

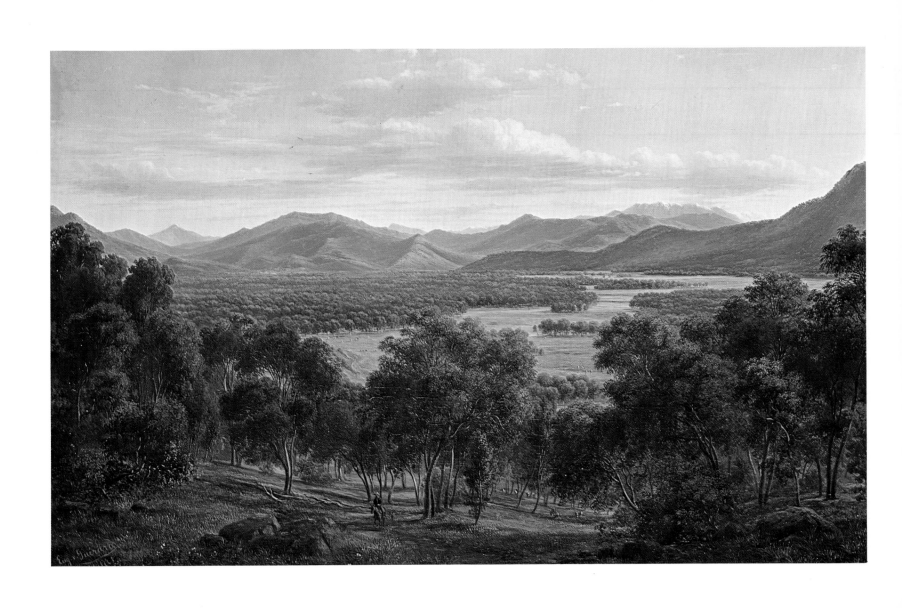

Spring in the valley of the Mitta Mitta, with the Bogong Ranges in the distance 1863 Oil

Eugene von Guérard
Ferntree Gully in the Dandenong Ranges 1857 Oil
Gifted to the Australian National Gallery

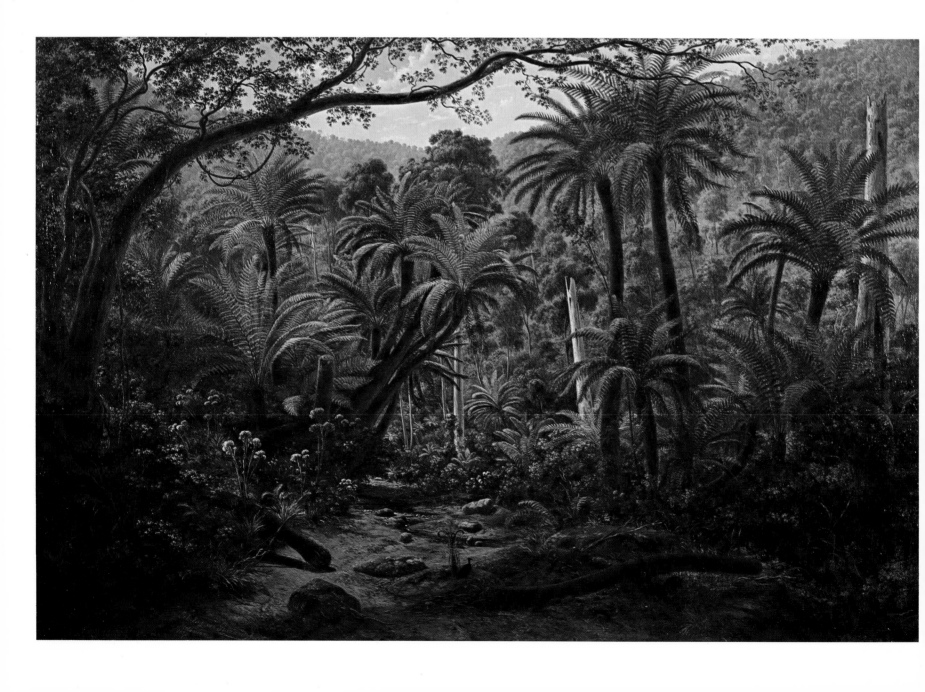

55

Nicholas Chevalier
Mount Arapiles and the Mitre Rock 1863 Oil
Gifted to the Australian National Gallery

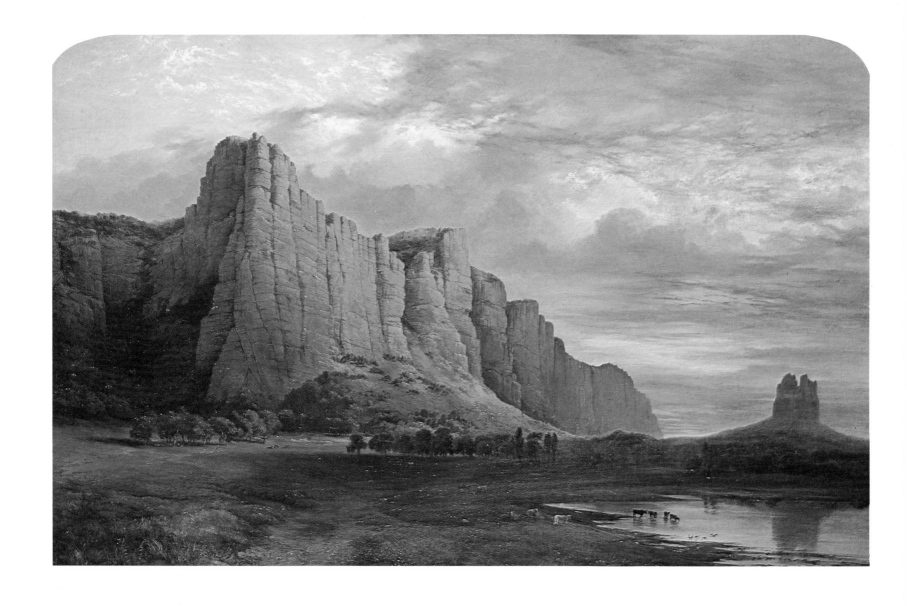

Louis Buvelot
Farm sheds below the You Yangs 1874 Pencil, white gouache

Louis Buvelot
Farm sheds below the You Yangs 1874 Pencil, white gouache

Louis Buvelot
Bush track, Dromana 1875 Oil

Louis Buvelot
Childers Cove 1875 Oil

Louis Buvelot
Pastoral 1881 Oil

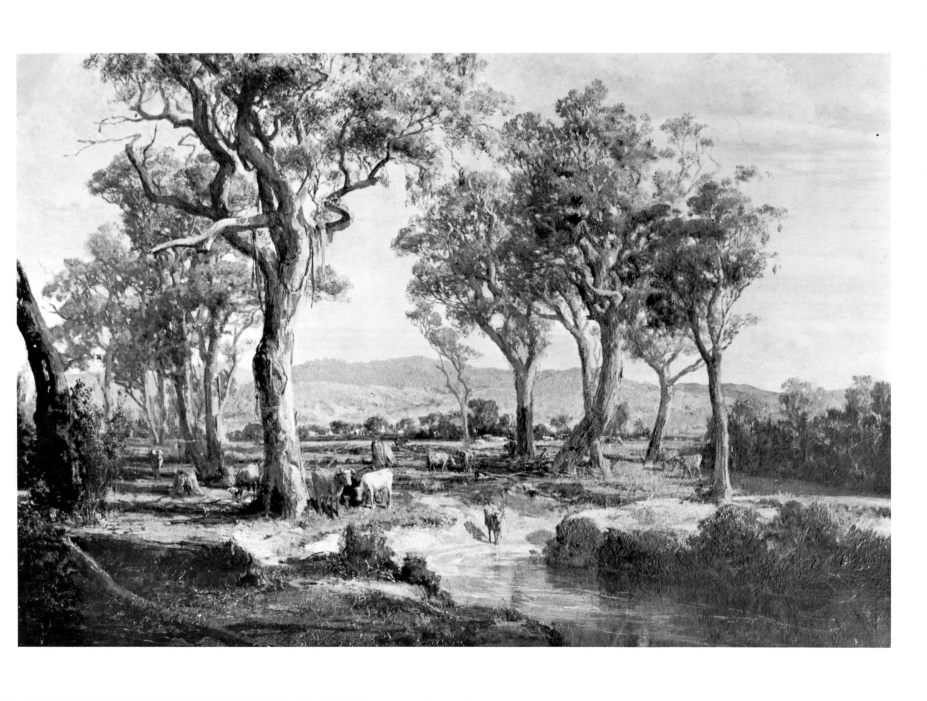

Chester Earles
Interior with figures 1872 Oil

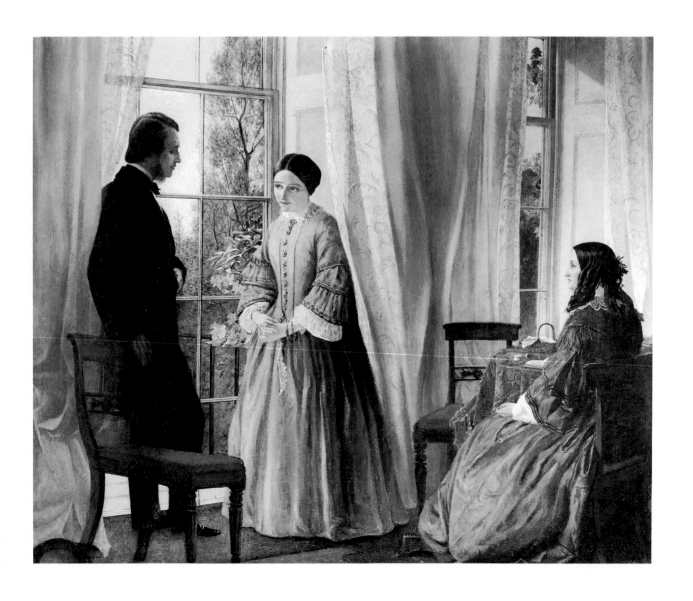

Chester Earles
Interior with figures 1872 Oil

Emma Minnie Boyd
Interior with figures, The Grange 1875 Watercolour

J. H. Carse
The Weatherboard Falls, Blue Mountains 1876 Oil

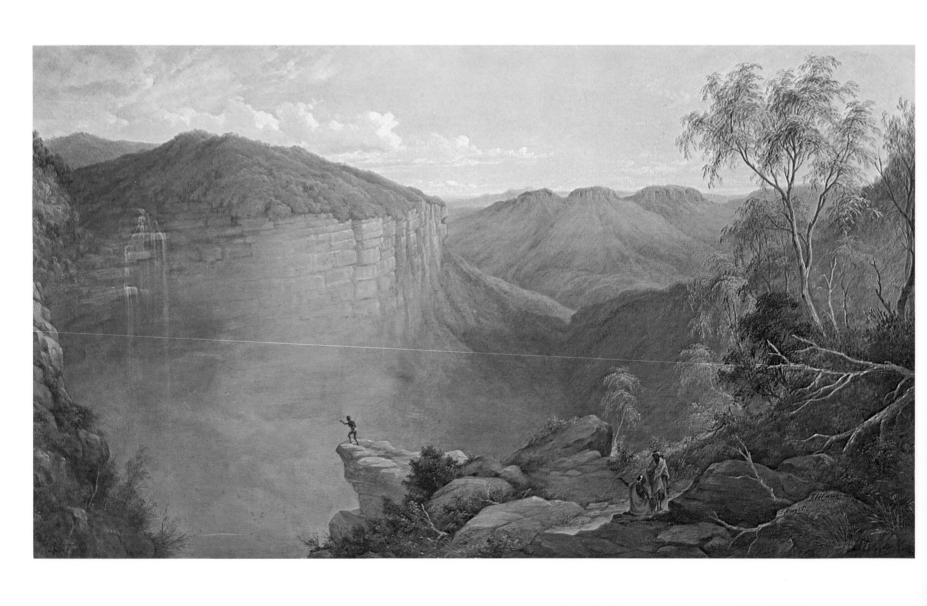

W. C. Piguenit
A winter's evening, Lane Cove (1888) Oil

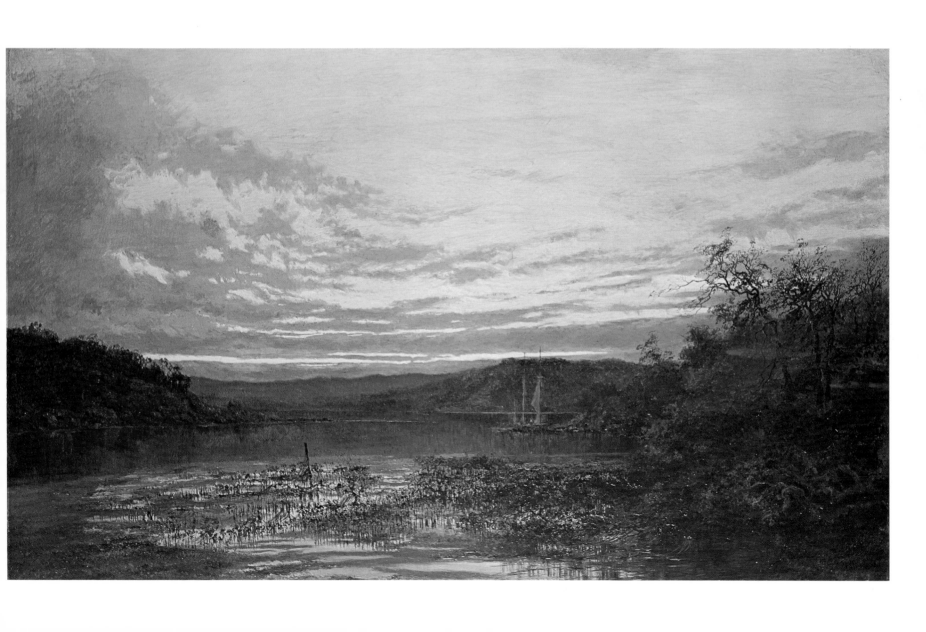

G. F. Folingsby
Autumn (*c.* 1882) Oil

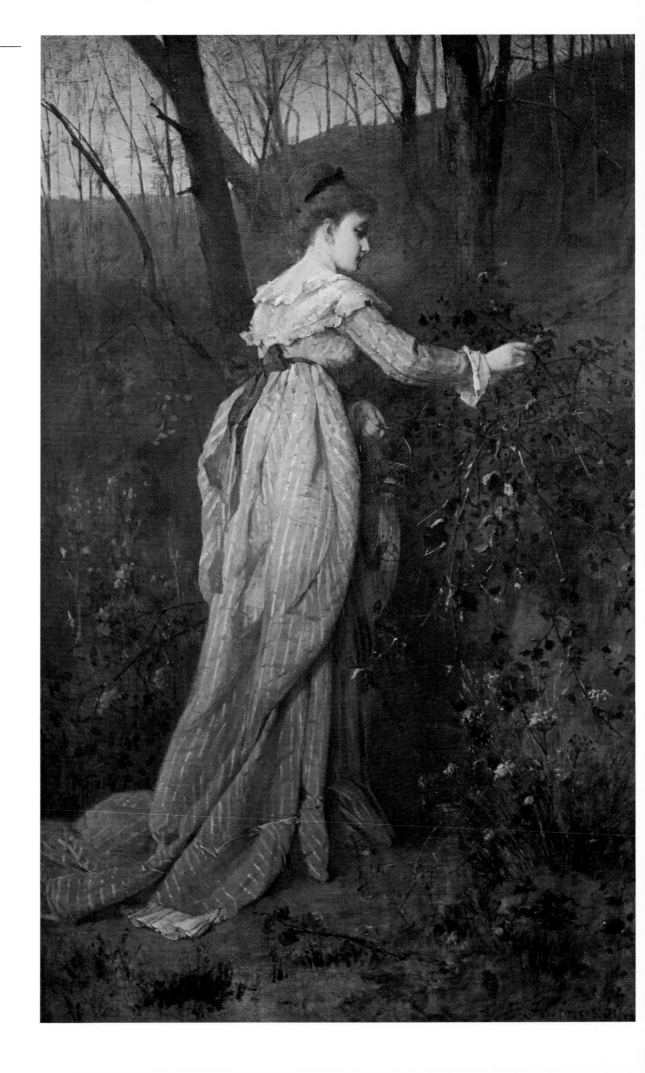

John Ford Paterson
Sunset, Werribee River 1886 Oil

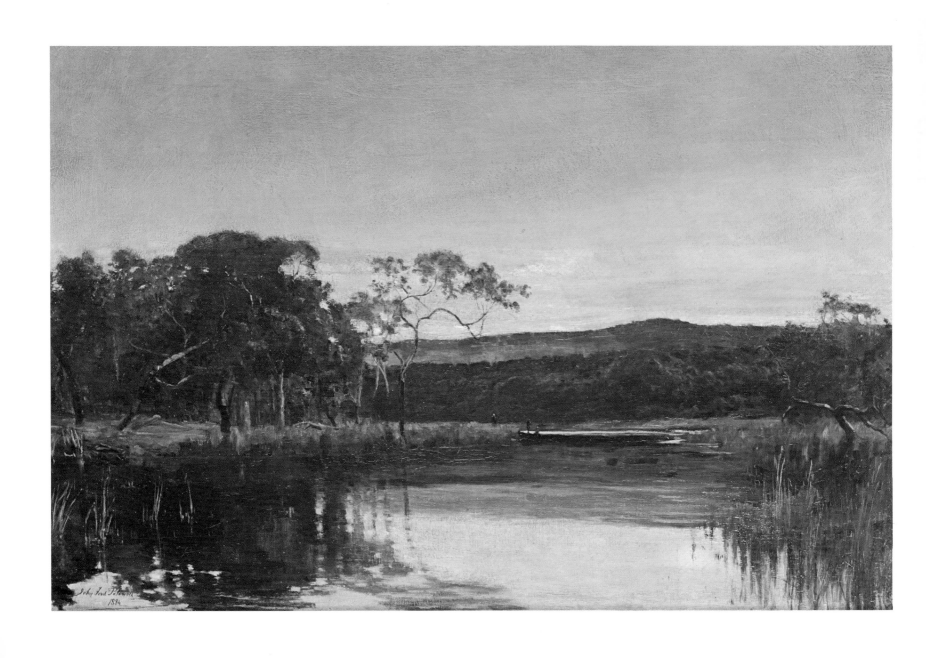

Girolamo Nerli
Botanical Gardens, Sydney 1886 Oil

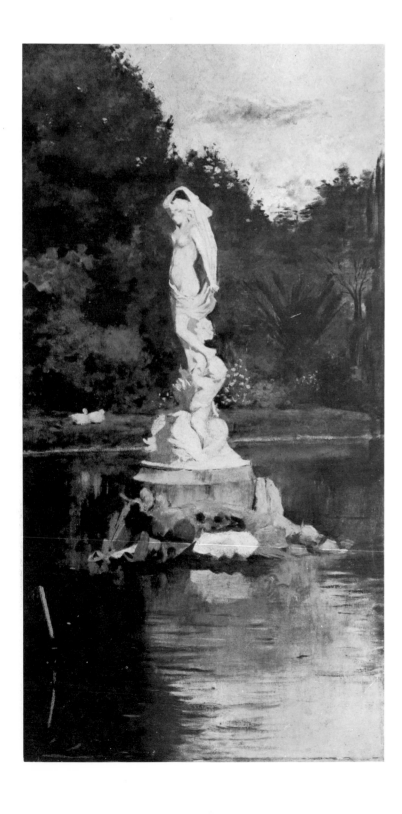

Girolamo Nerli
Botanical Gardens, Sydney 1886 Oil

Girolamo Nerli
Coast scene with pier (1890s) Oil

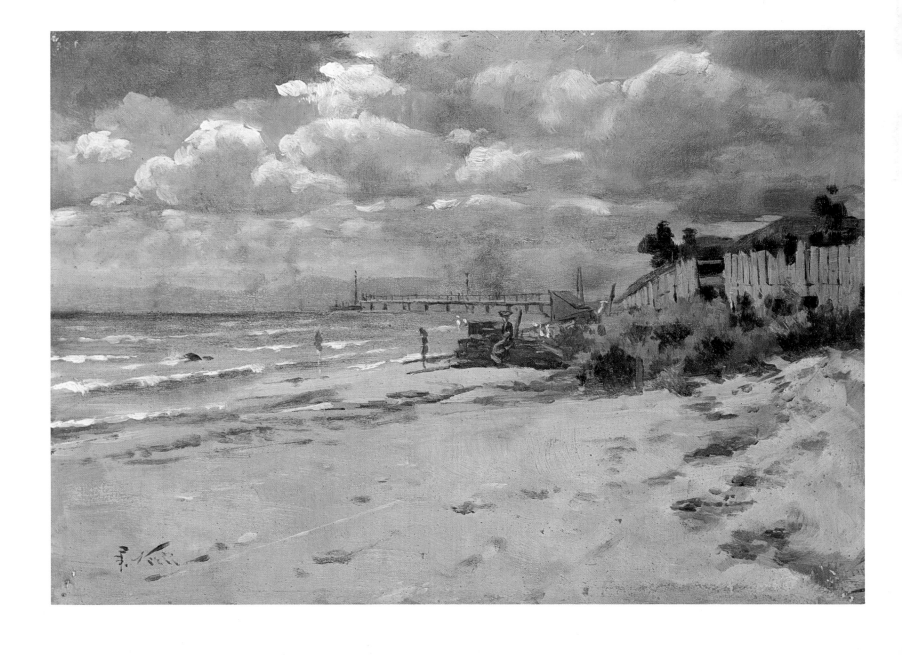

Julian Ashton
Study of a woman's head (1890s) Oil

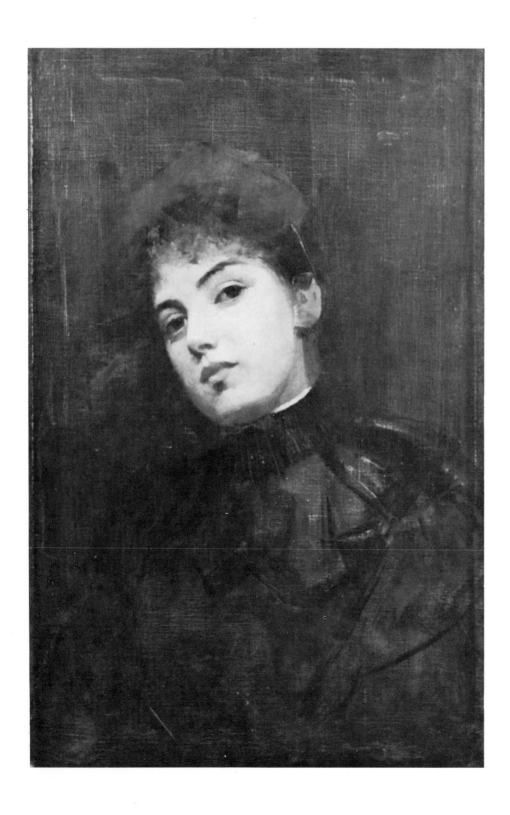

Julian Ashton
A tranquil afternoon (*c.* 1890) Oil

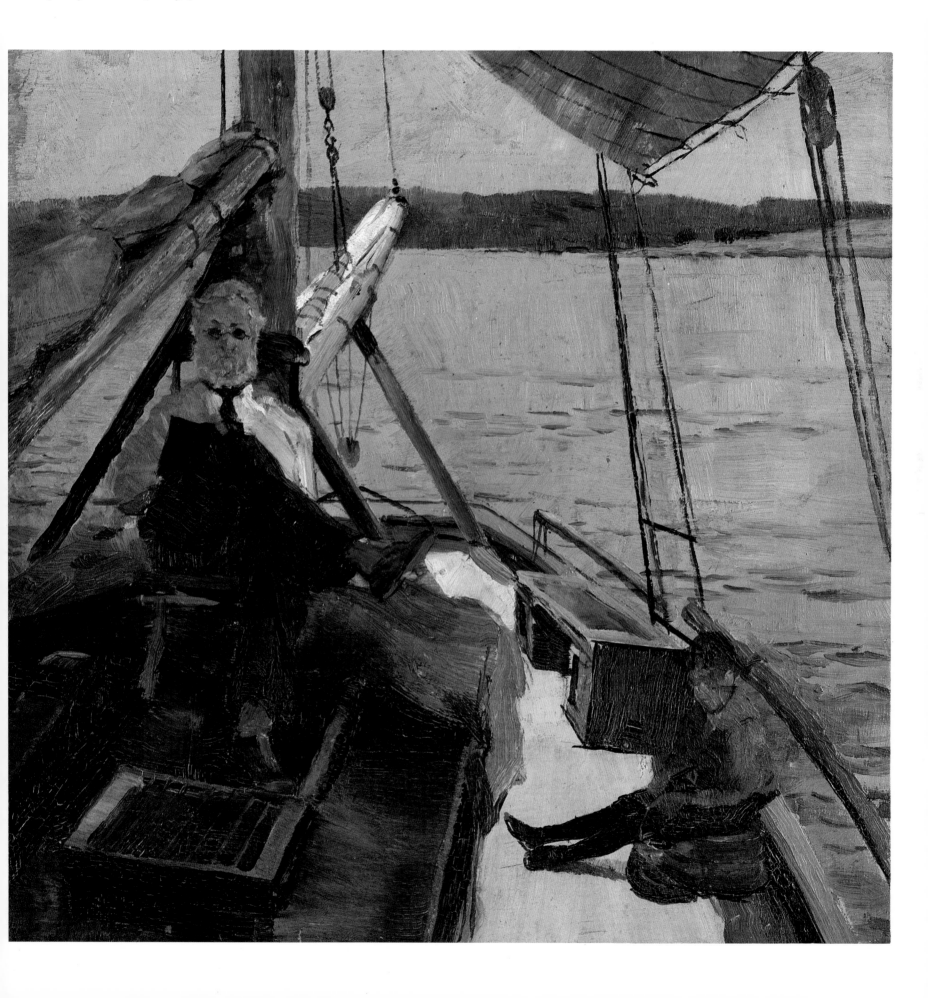

Arthur Loureiro
An autumn morning (1893) Oil

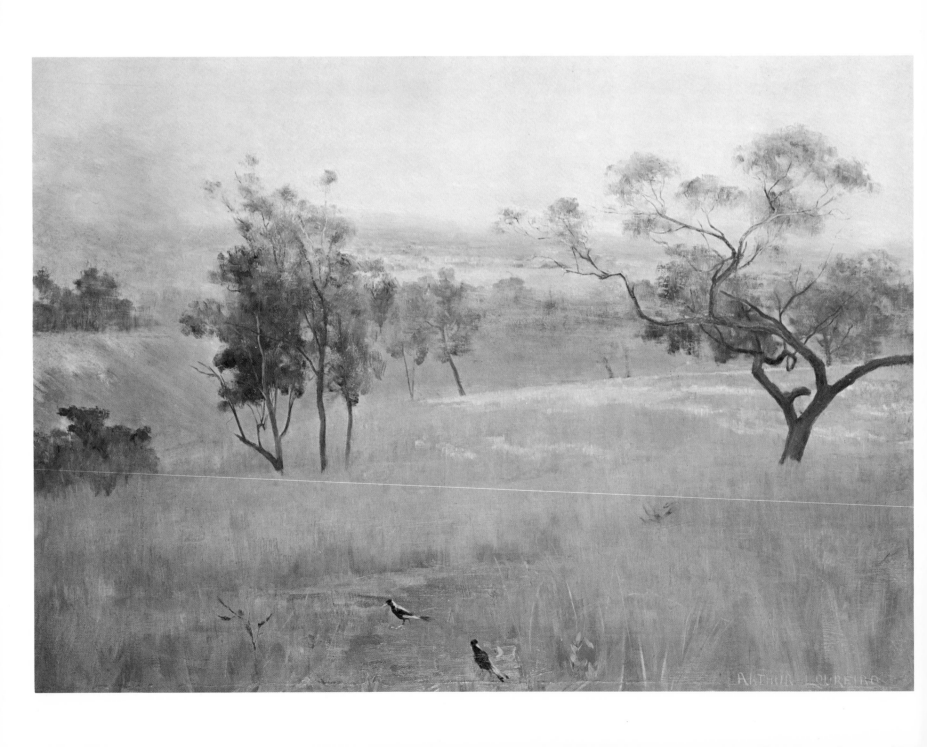

Walter Withers
Farmer's girl 1892 Oil

Tom Roberts
Louis Buvelot (1886) Etching

Tom Roberts
Moorish doorway, Granada 1883 Oil

Tom Roberts
Marie Wechsler (1895) Pastel

Tom Roberts
Marie Wechsler (1895) Pastel

Tom Roberts
Captain Broomfield 1898 Oil

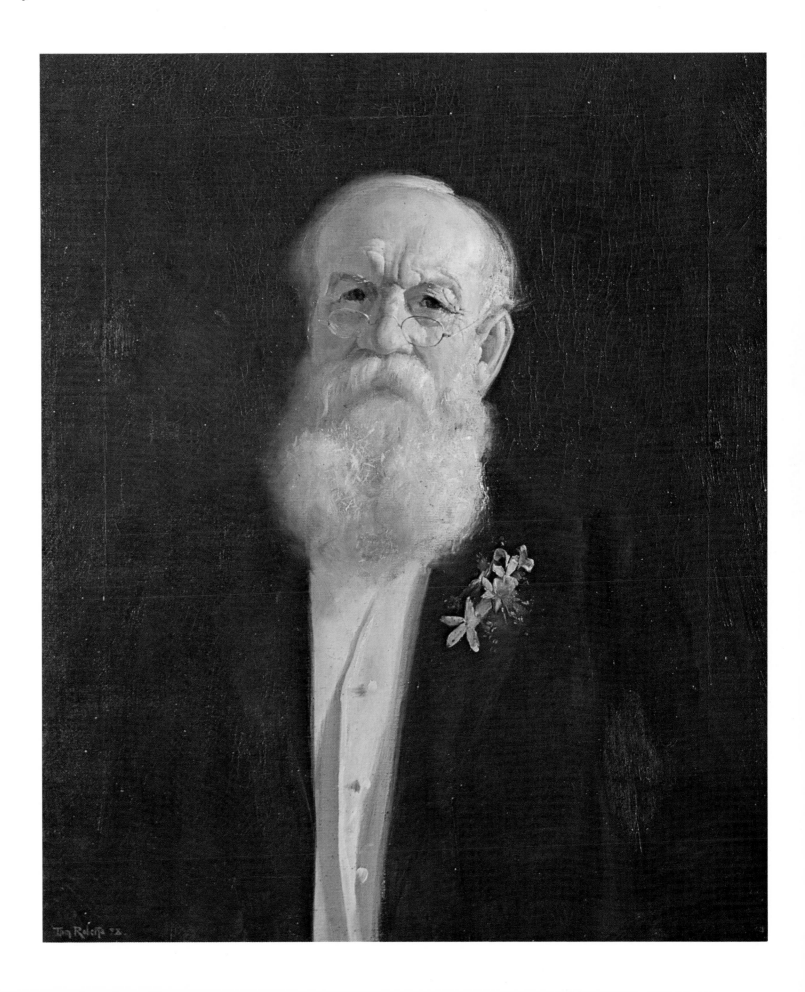

Tom Roberts
The artist's wife (1905/1980s) Bronze

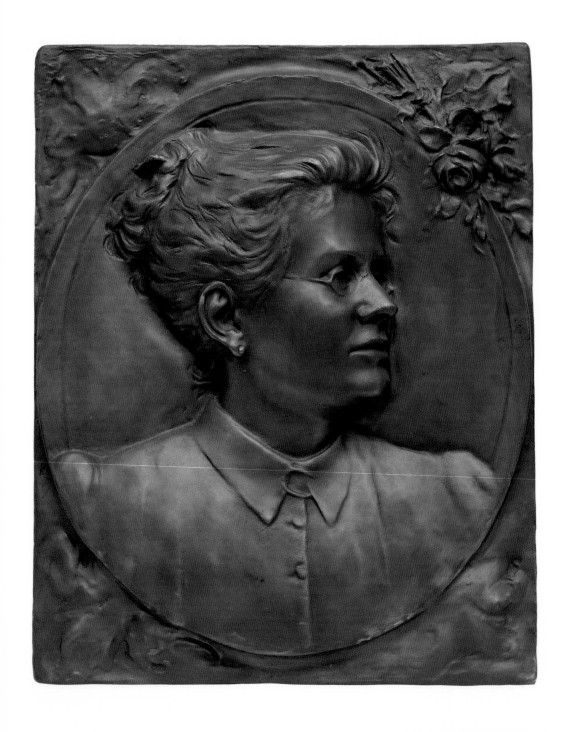

Tom Roberts
Australian landscape (*c.* 1925) Oil

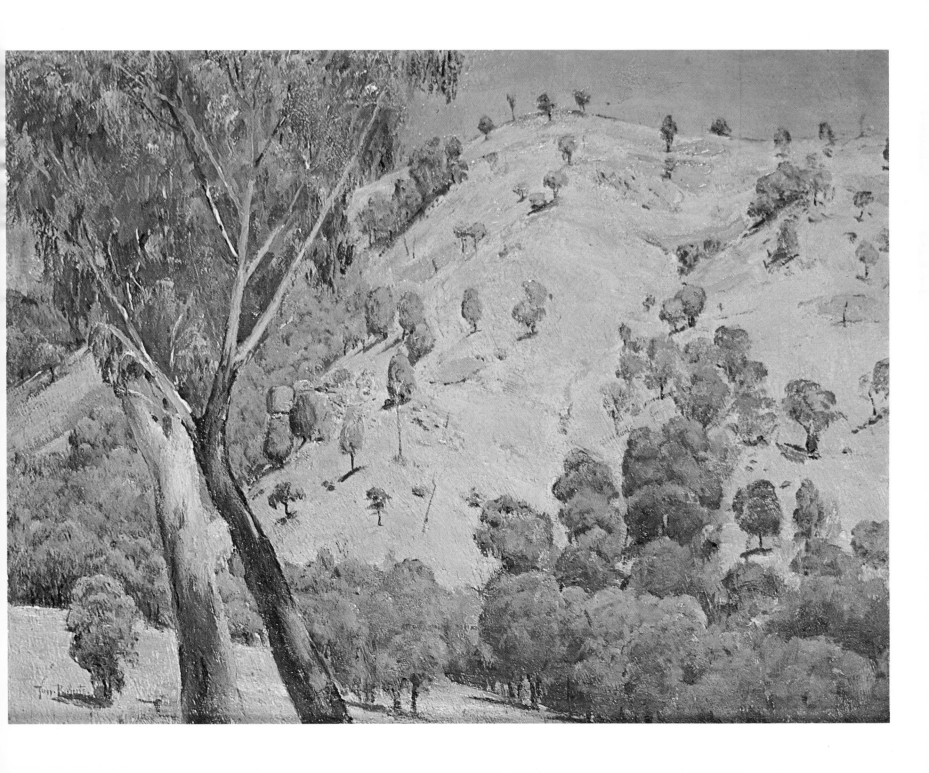

Frederick McCubbin
Mary Jane Moriarty (1889?) Oil

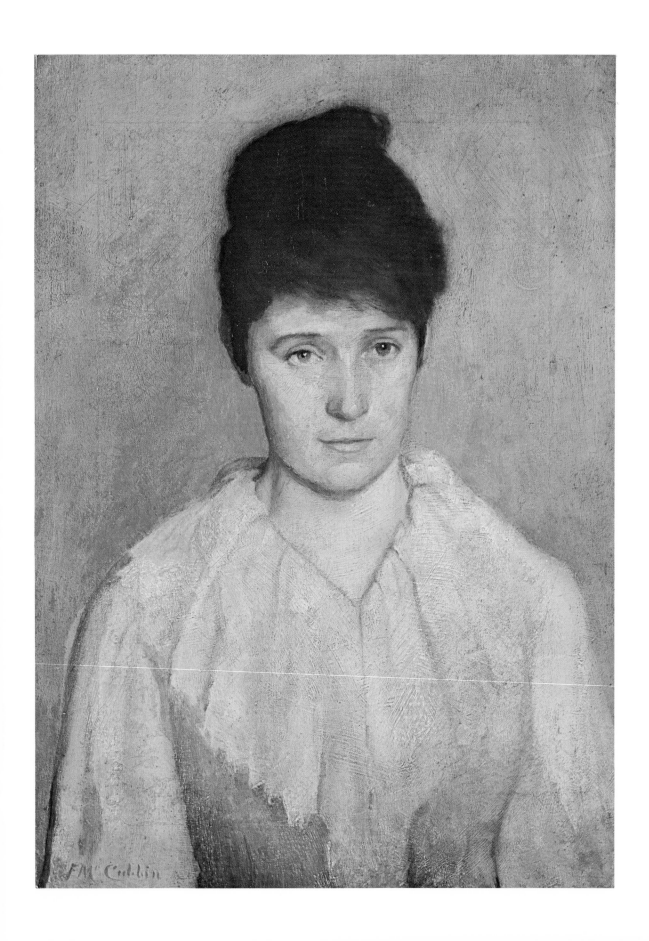

Frederick McCubbin
Autumn Memories 1899 Oil

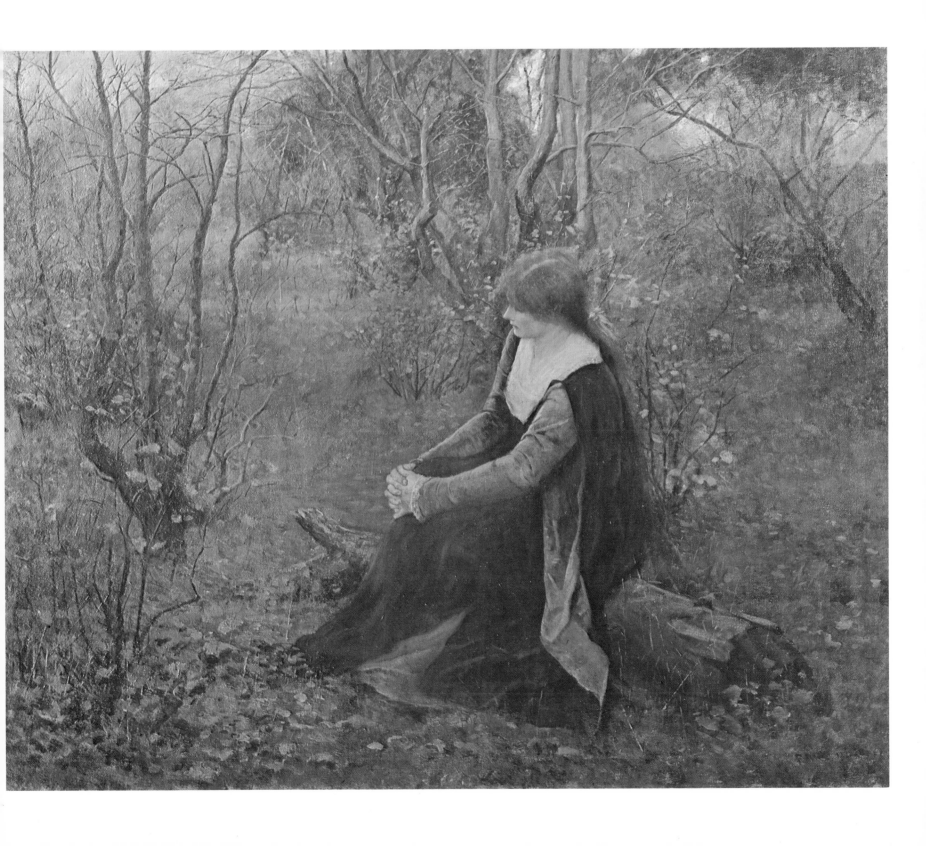

Frederick McCubbin
Nude study (*c.* 1910) Oil

Frederick McCubbin
The coming of spring (*c*. 1908) Oil

Frederick McCubbin
Landscape sketch, Macedon (1915) Oil

Jane Sutherland
The creek (*c*. 1895) Pastel

Clara Southern
Landscape with cottage (*c*. 1900) Oil

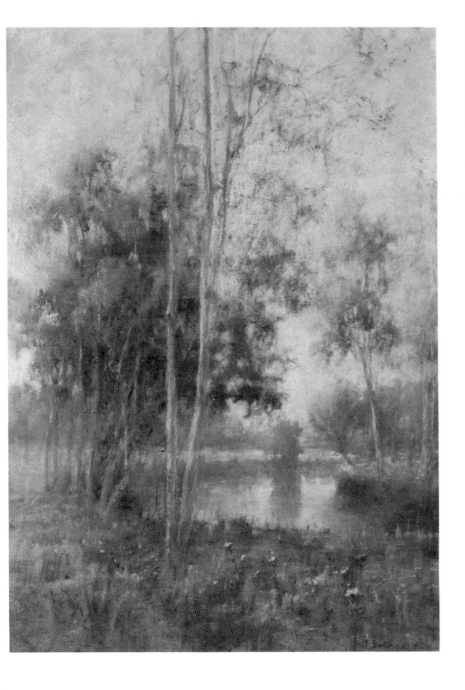

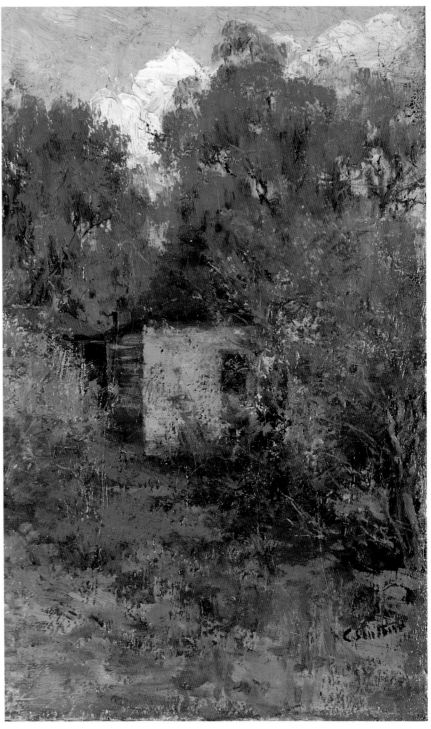

Louis Abrahams
Lion's head 1880 Oil

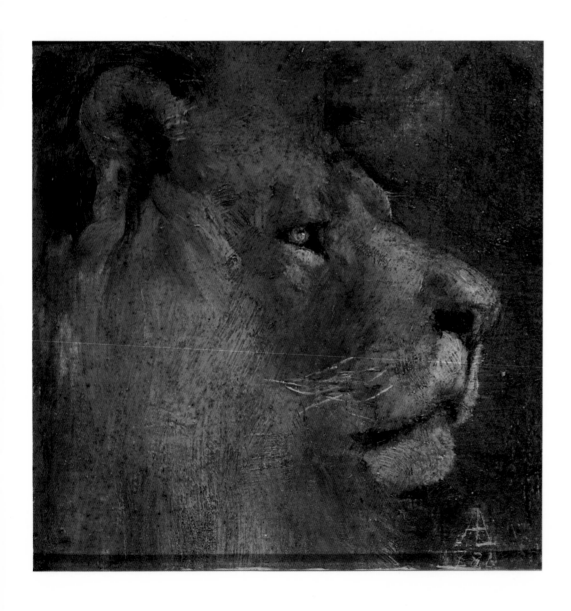

Charles Conder
Miss Raynor (*c.* 1890) Oil

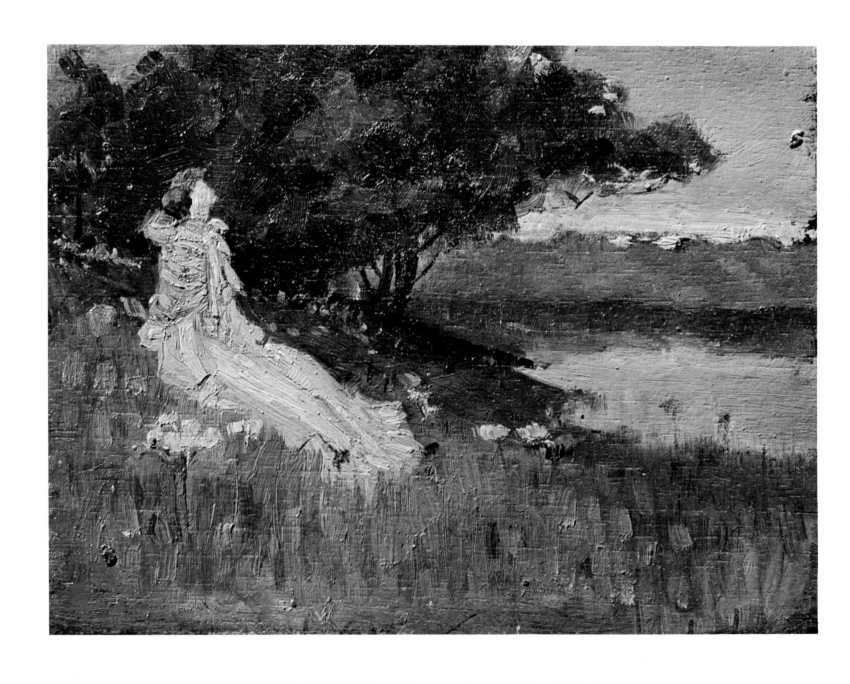

Charles Conder
The meeting (c. 1895) Watercolour on silk

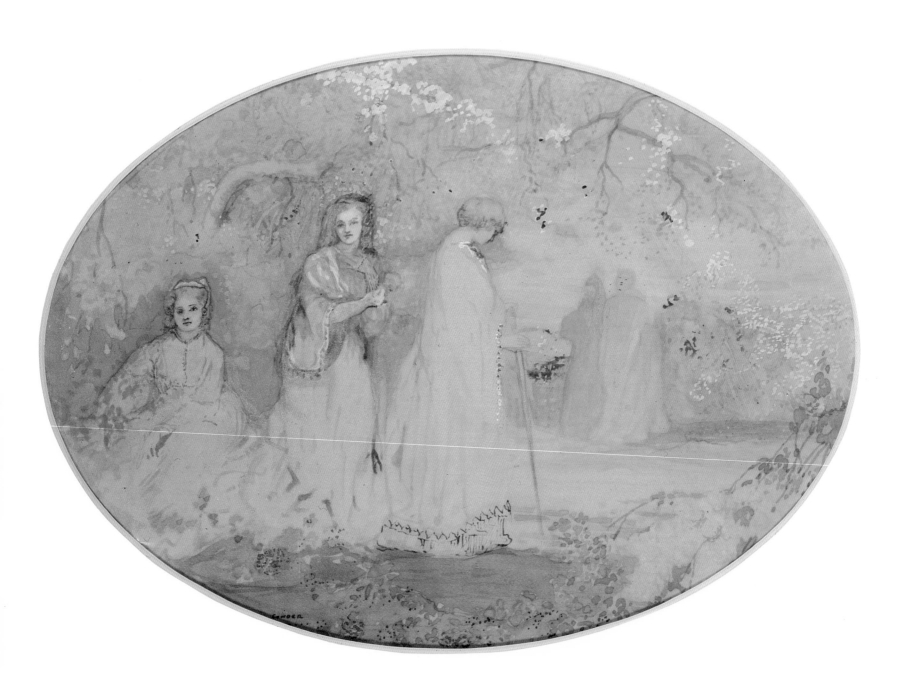

Charles Conder
Figure composition (*c.* 1905) Oil

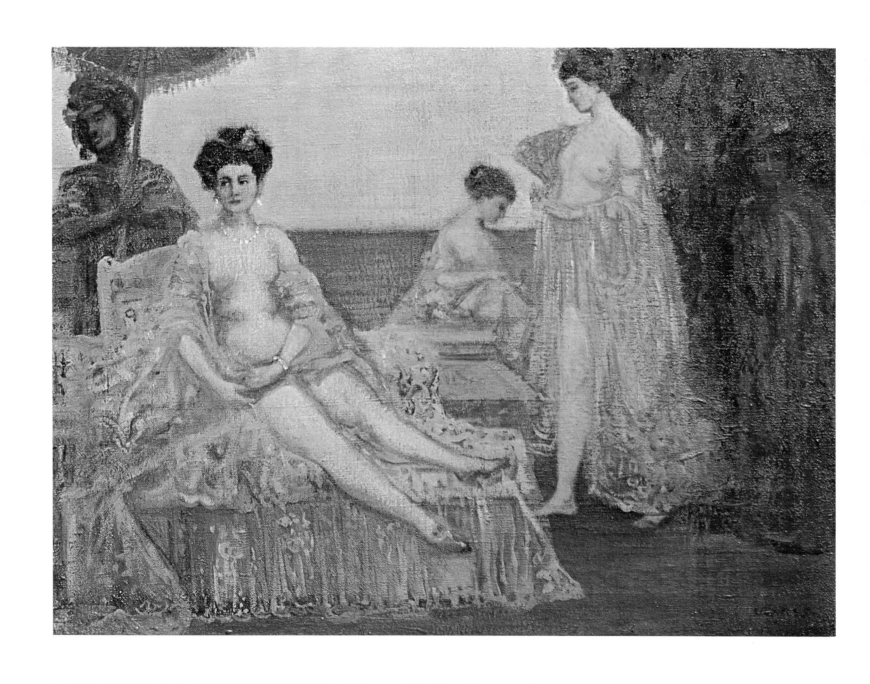

Arthur Streeton
In the artist's studio 1891 Oil on a tambourine skin

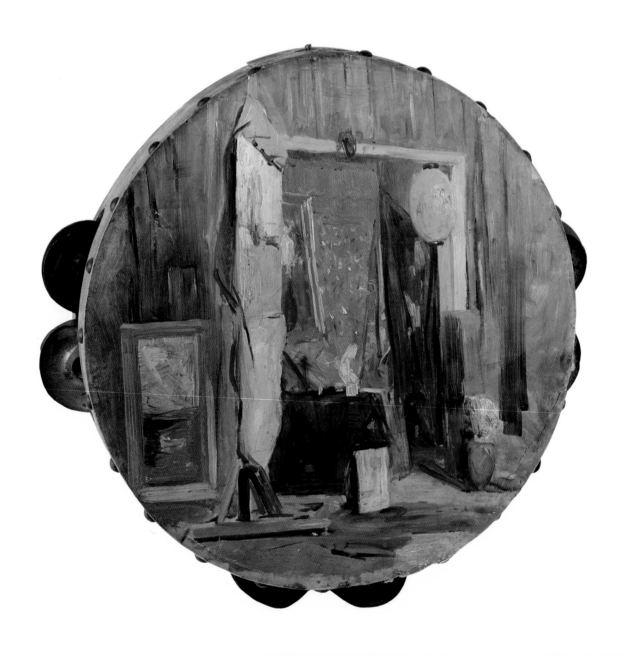

90

Arthur Streeton
Figures on a hillside, twilight (*c.* 1889) Oil

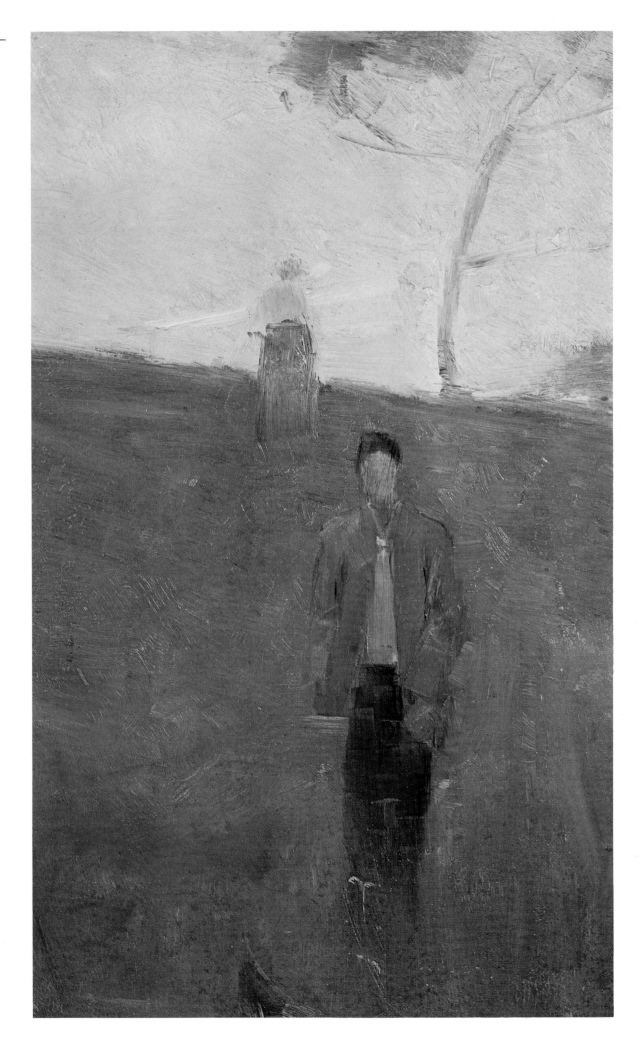

Arthur Streeton
The Spirit of the Drought (c. 1895) Oil
Gifted to the Australian National Gallery

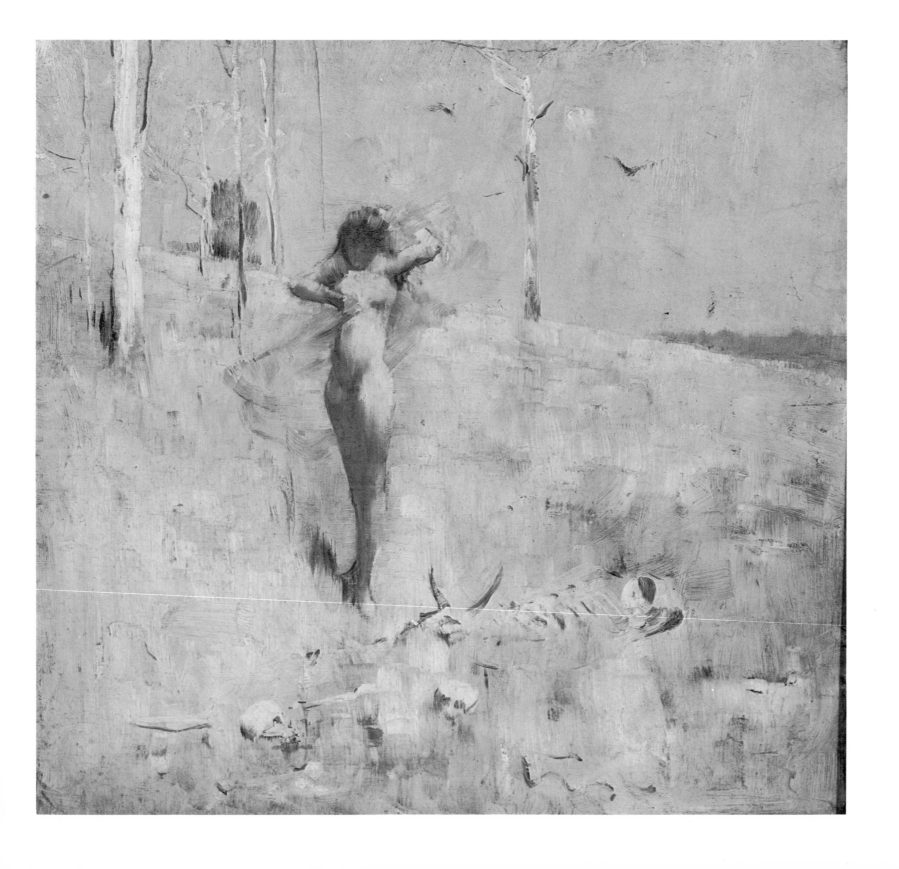

Arthur Streeton
The Spirit of the Drought (c. 1895) Oil
Gifted to the Australian National Gallery

Arthur Streeton
Bathers (*c.* 1896) Oil

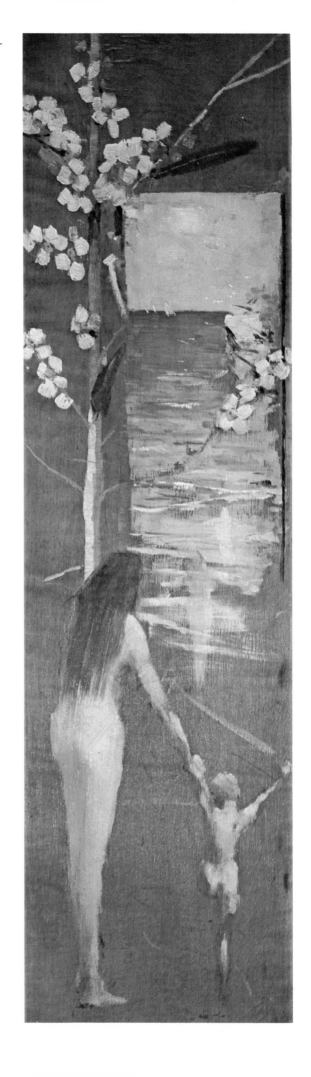

Arthur Streeton
Standing female figure 1895 Oil

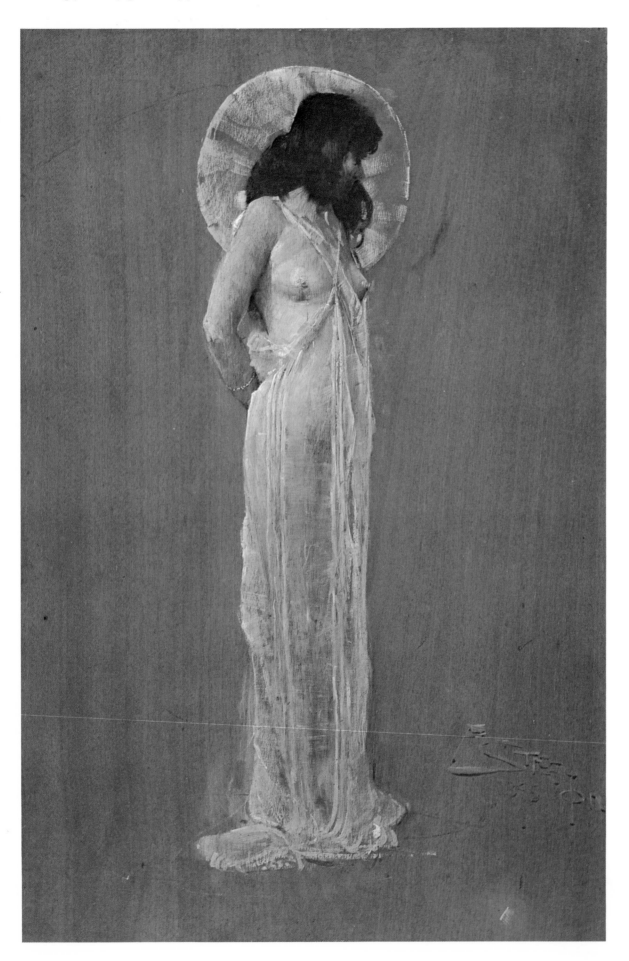

Arthur Streeton
Sydney Harbour　1895　Oil

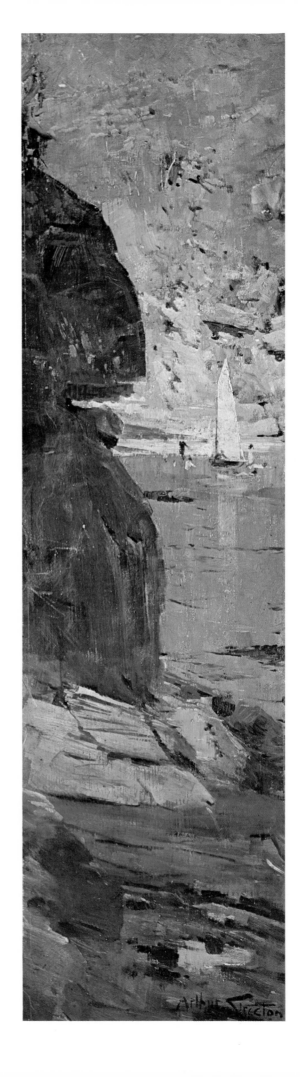

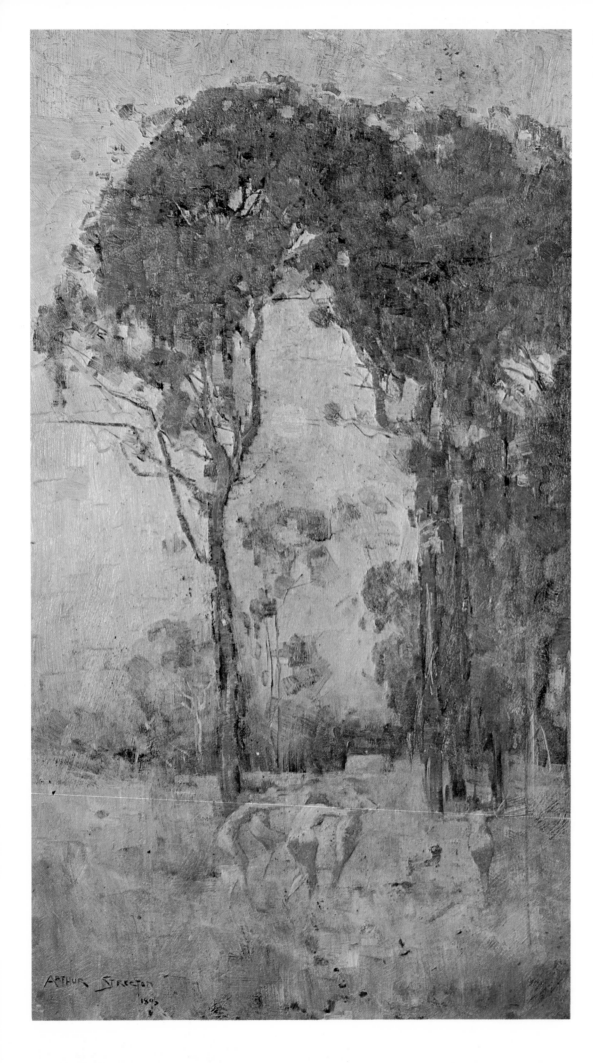

Arthur Streeton
A bush idyll (1896) Oil

Arthur Streeton
The Centre of the Empire (c. 1903) Oil
Gifted to the National Gallery of Victoria

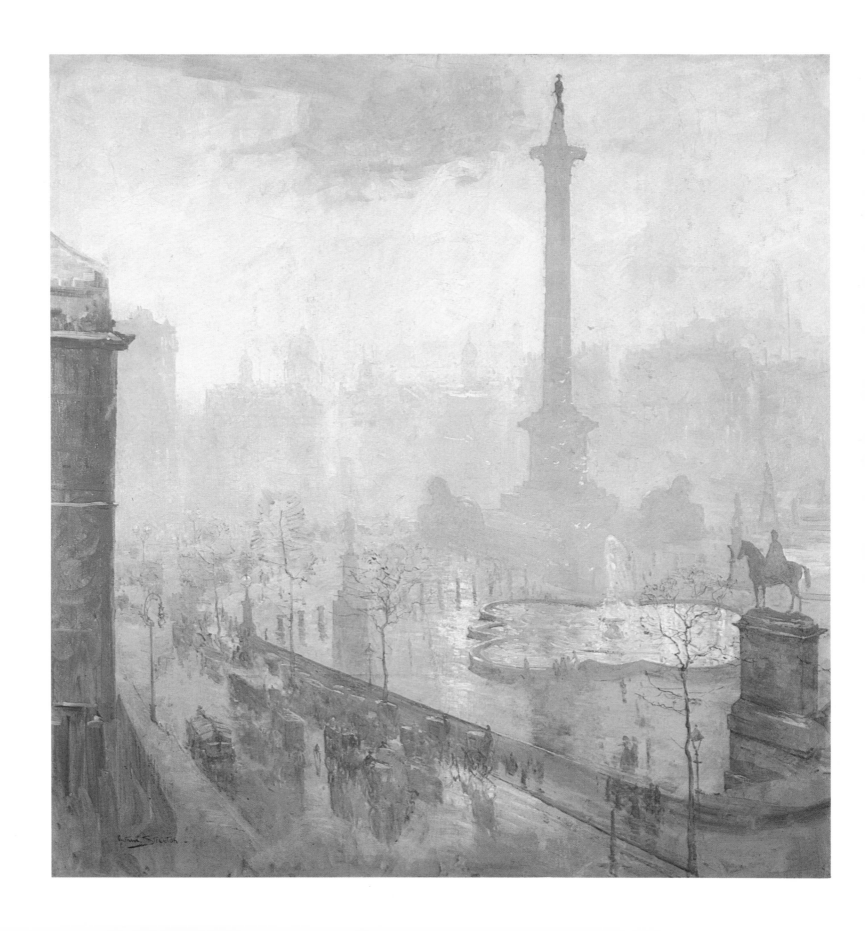

John Longstaff
Farmhouse (*c.* 1889) Oil

John Longstaff
Twilight landscape (1896?) Oil

Bertram Mackennal
Portrait head of a woman (*c.* 1888) Terracotta

Bertram Mackennal
Circe (1902/1904, from 1892 statue) Bronze

Bertram Mackennal
Goddess (1890s) Bronze

Bertram Mackennal

Tudor St George Tucker
Springtime 1890 Oil

E. Phillips Fox
Nude study 1884 Charcoal

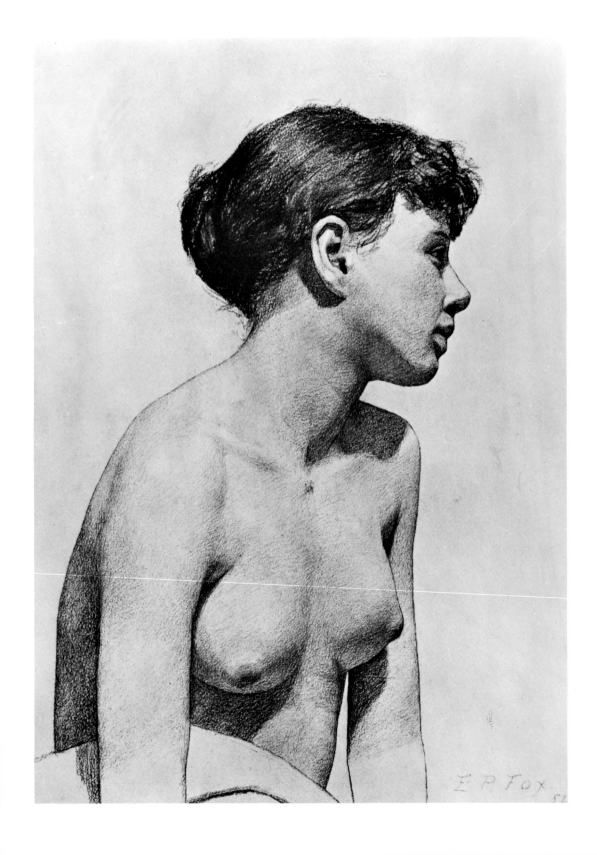

E. Phillips Fox
Studio, Charterisville (*c.* 1895) Oil

E. Phillips Fox
The bathers 1912 Oil

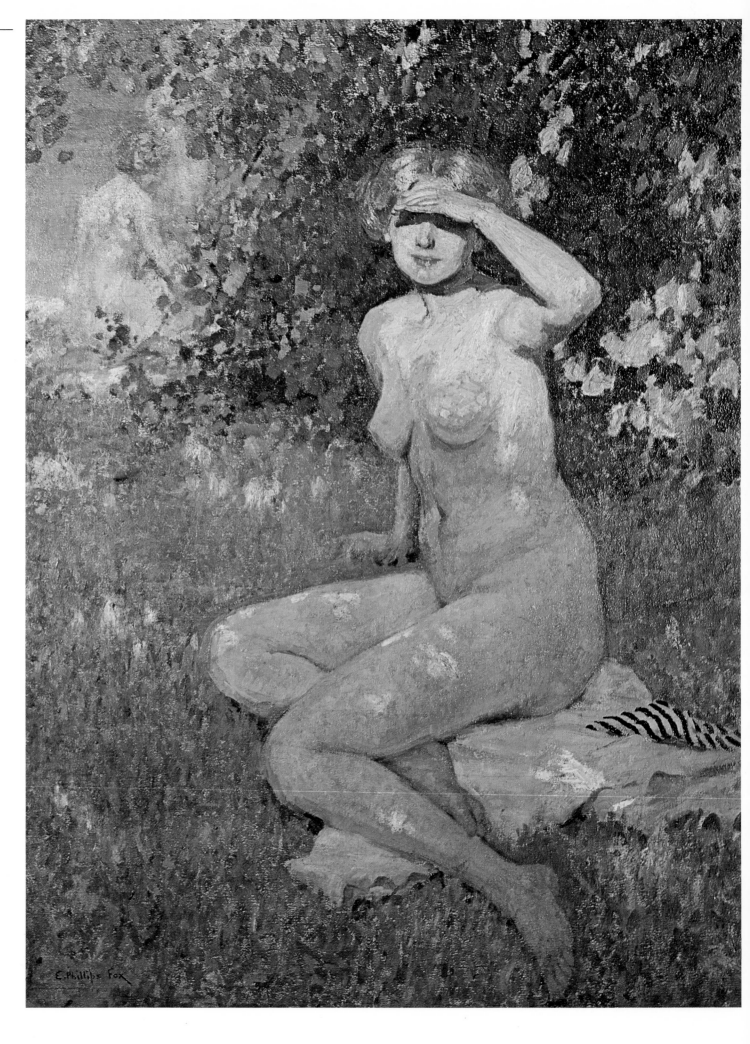

E. Phillips Fox
Mother and child 1908 Oil

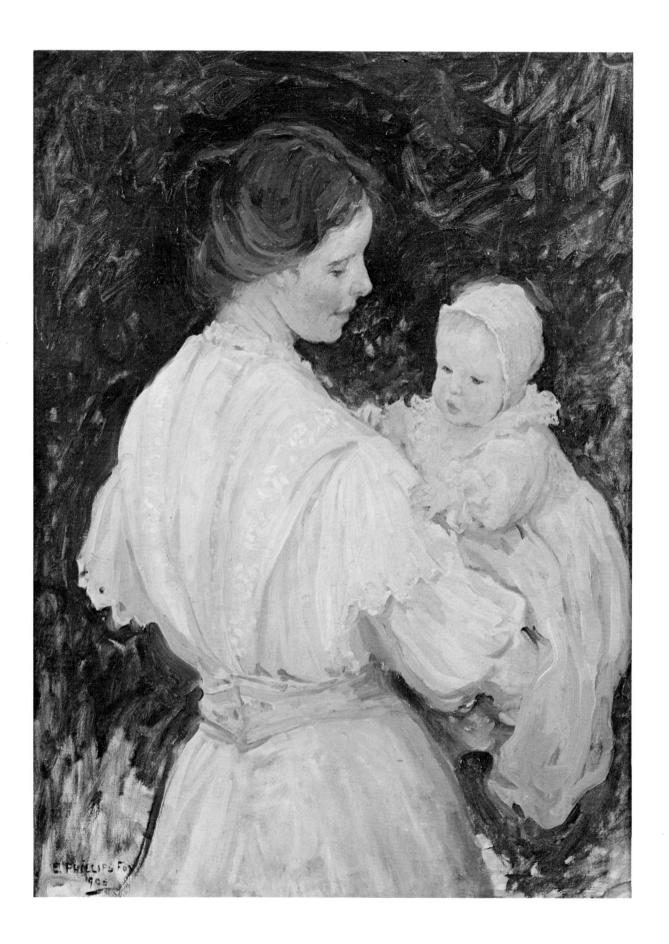

Ethel Carrick
Figures on jetty (*c*. 1910) Oil

Ethel Carrick
Figures on jetty (*c*. 1910) Oil

Rupert Bunny
Mermaids dancing 1896 Oil

109

Rupert Bunny
Haymaking, Finistère (1900) Oil

Rupert Bunny
Nattering (*c.* 1908) Oil

Aby Altson
Nymphs in grotto 1896 Oil

A. H. Fullwood
Girl with galah (1890s) Gouache

Mortimer Menpes
Peasant woman (*c.* 1890) Oil

Charles Douglas Richardson
A Seaside Vision (*c.* 1900) Plaster

David Davies
Street scene, Dieppe (*c.* 1910) Watercolour

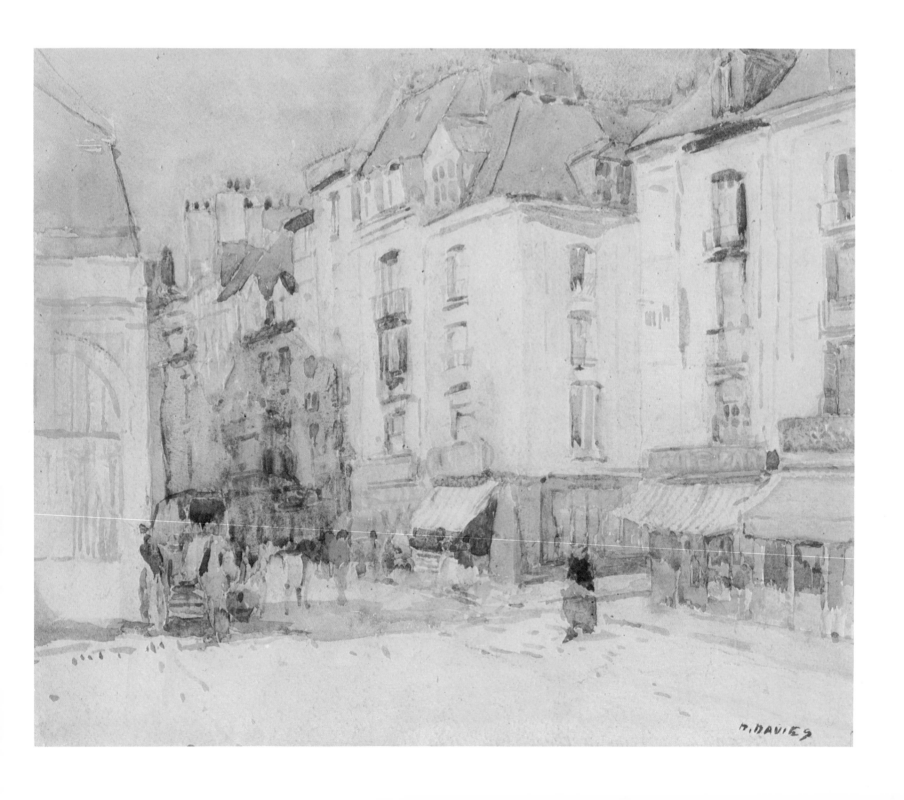

David Davies
Head of a man (c. 1895) Oil

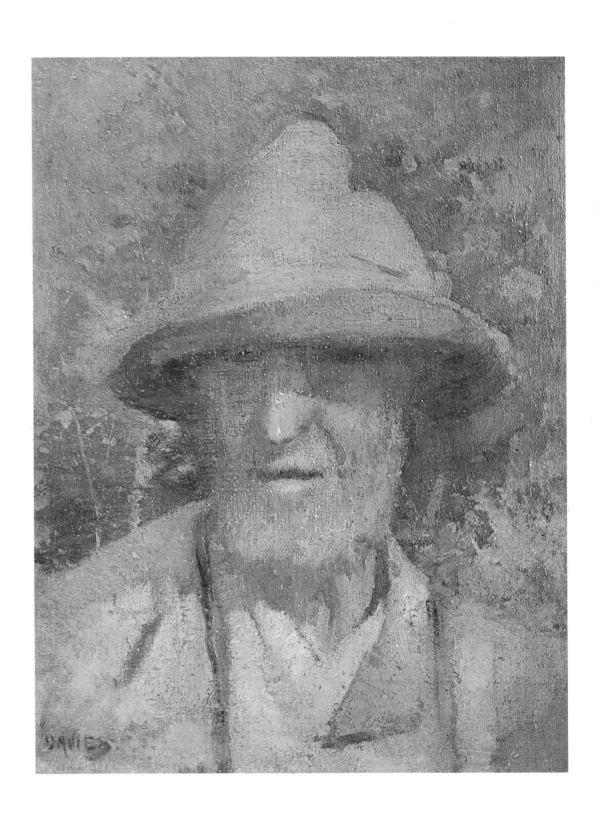

John Russell
Doña Peppa Mattiocco 1886 Conte crayon

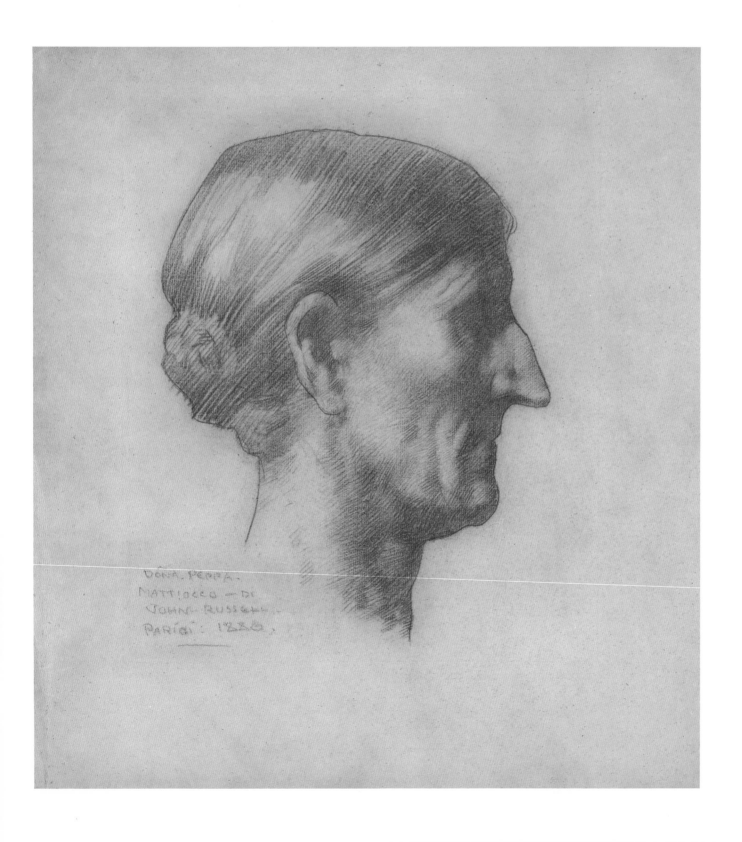

John Russell
Elge, Italy 1889 Oil
Gifted to the National Gallery of Victoria

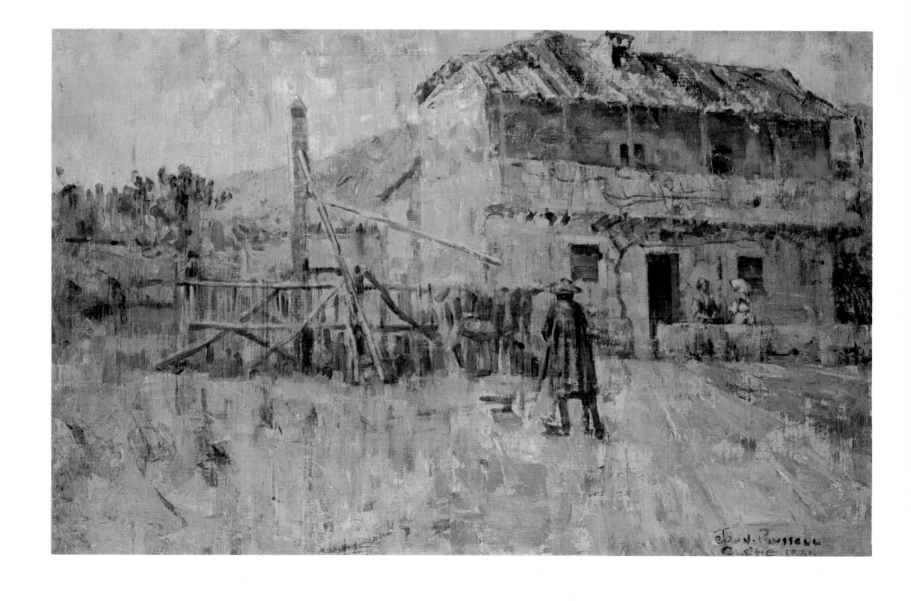

John Russell
Almond tree in blossom (1887?) Oil

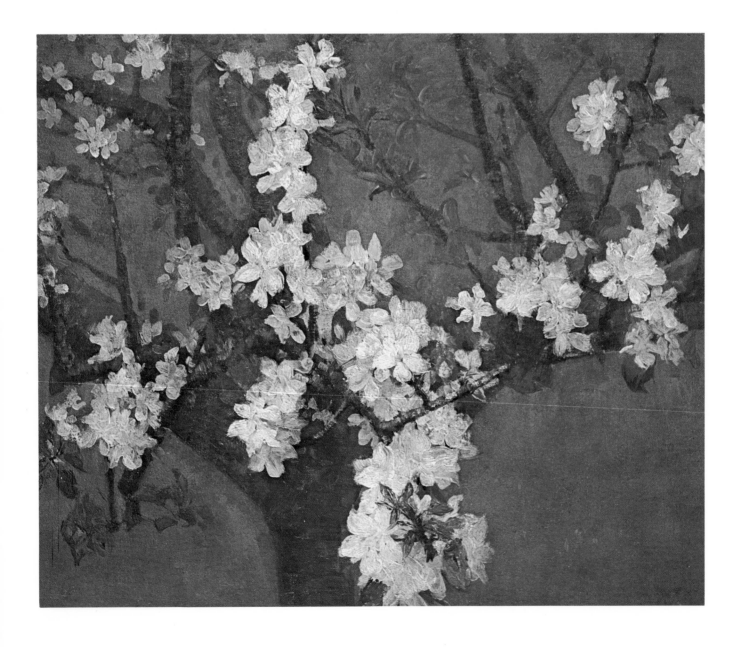

John Russell
Almond tree in blossom (1887?) Oil

John Russell
Fishing boats, Goulphar 1900 Oil

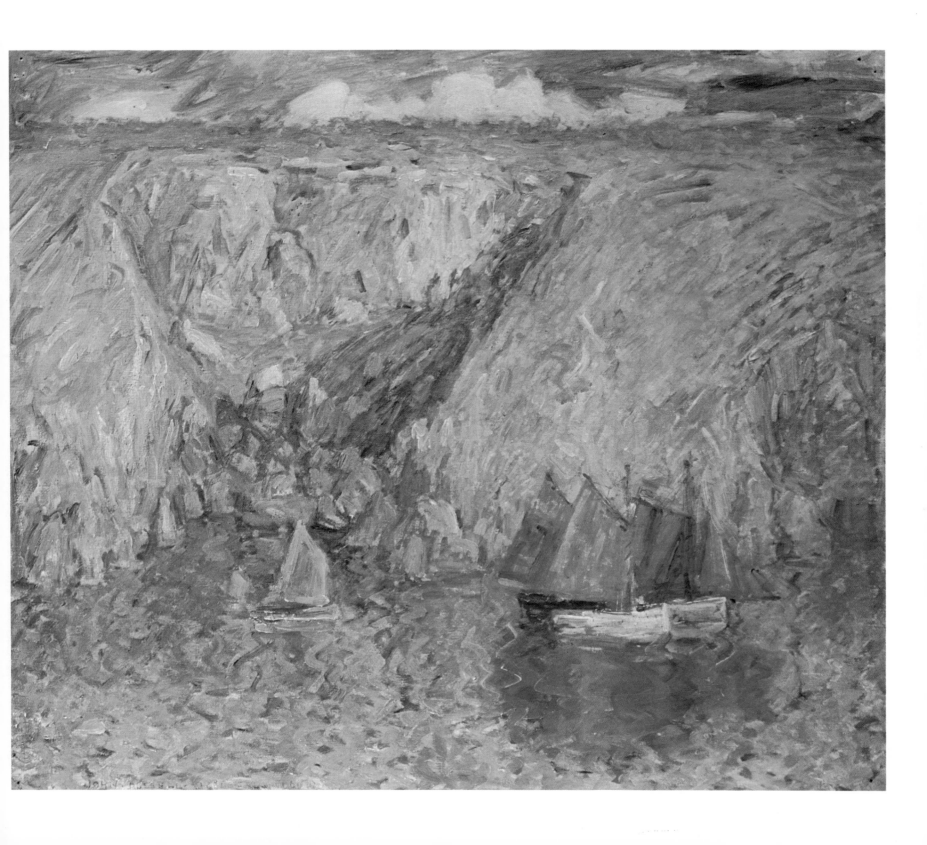

John Russell
Rhododendrons and head of a woman (*c.* 1900) Oil

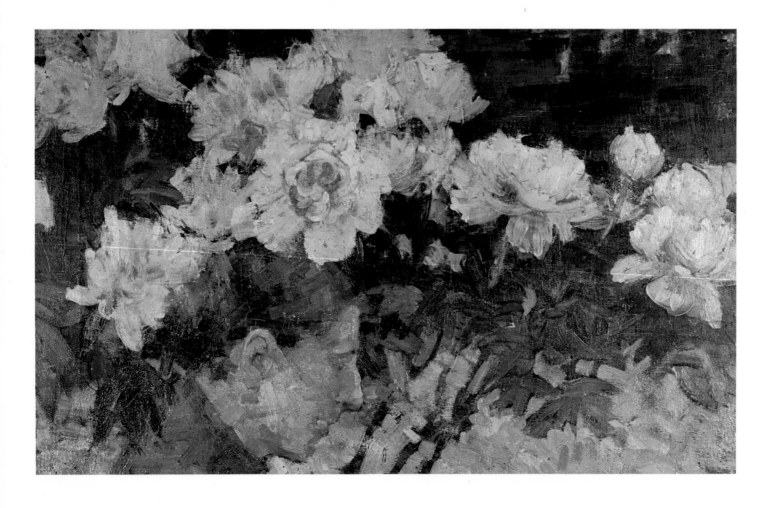

John Russell
Rhododendrons and head of a woman (*c.* 1900) Oil

John Russell
Rough sea 1900 Oil

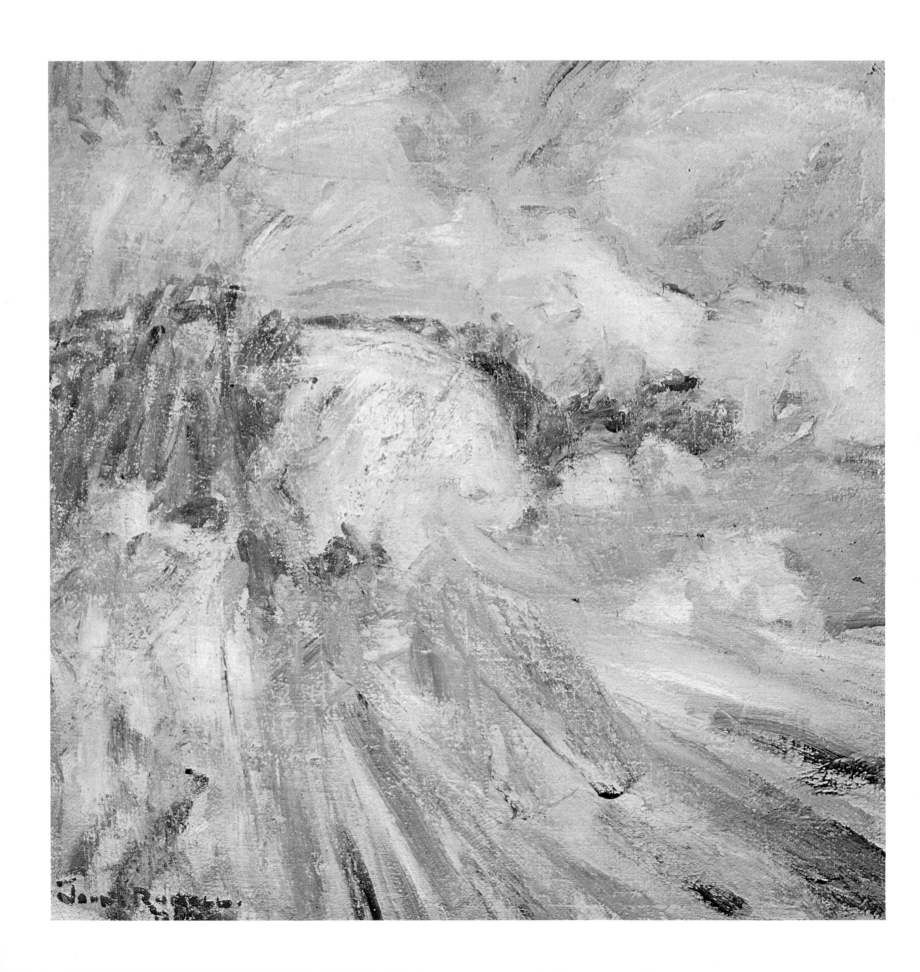

123

John Russell
Portofino (*c.* 1915) Watercolour

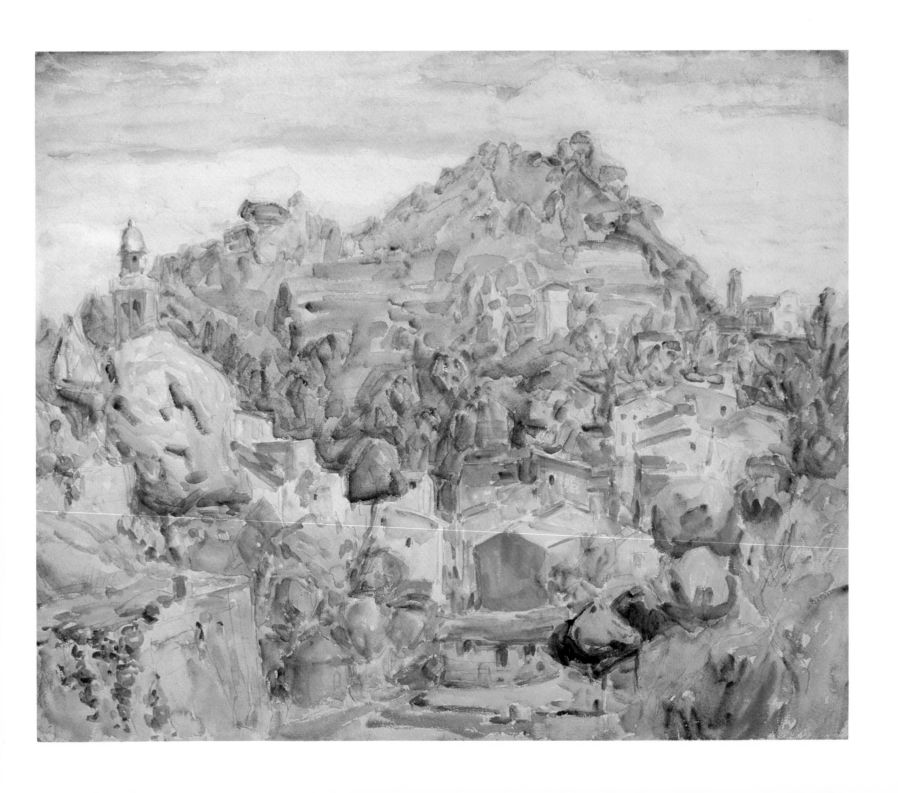

John Russell
Muscovy bungalow from below (1920s) Watercolour

Sydney Long
The Spirit of the Plains (1918) Aquatint

Sydney Long
The Spirit of the Plains (1918) Aquatint

126

Sydney Long
Farm landscape 1905 Oil

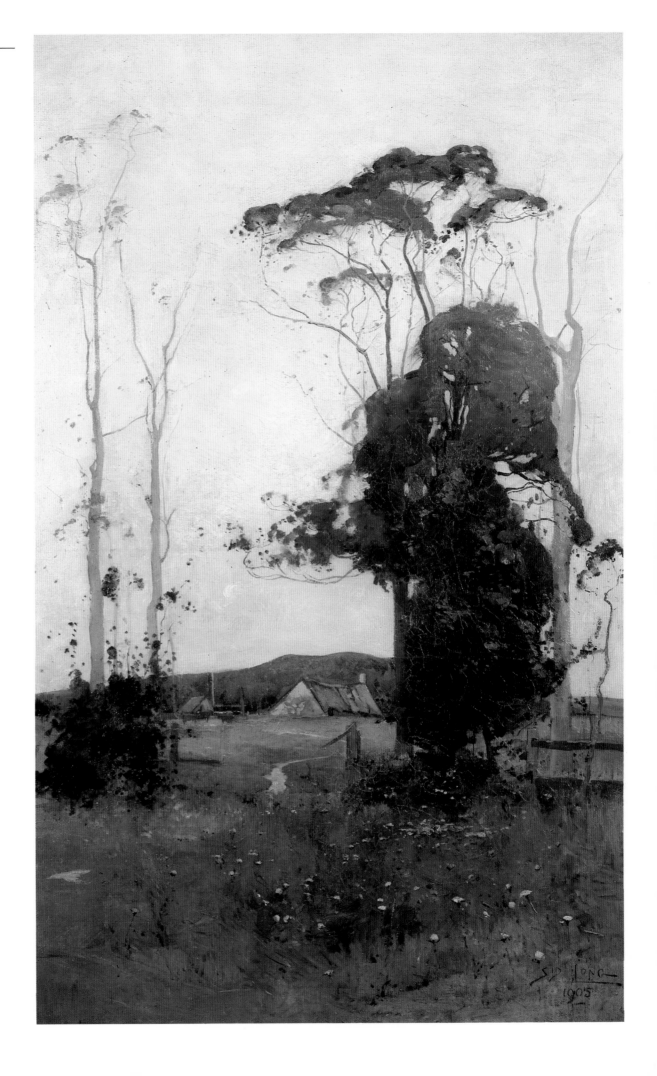

Bernard Hall
The artist's wife (1890s) Oil

Bernard Hall
The artist's wife (1890s) Oil

Bernard Hall
The Quest (c. 1905) Oil

Bernard Hall
Staircase to Public Library (1930s) Oil

Bernard Hall
Nude reading at studio fire (1920s) Oil

George W. Lambert
Self-portrait (*c.* 1900) Oil

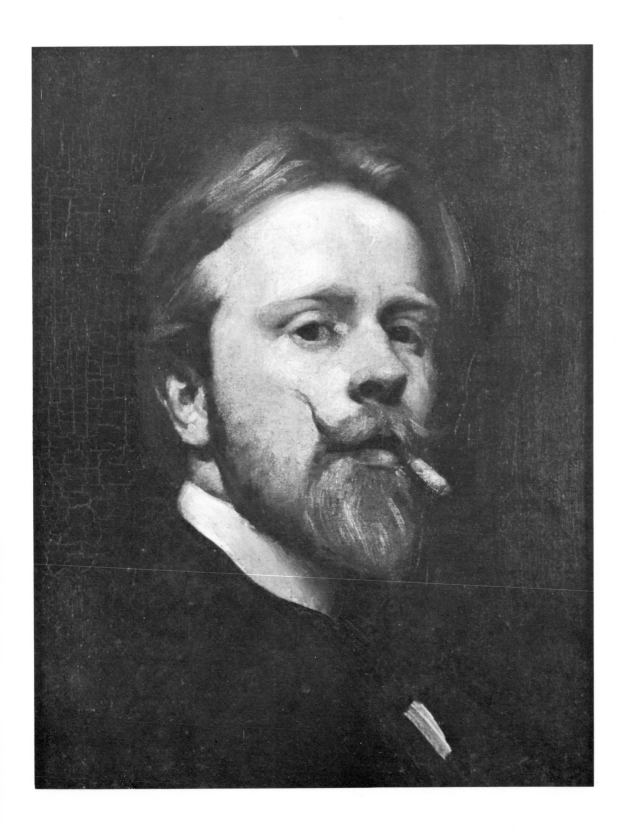

George W. Lambert
Self-portrait (*c.* 1900) Oil

George W. Lambert
Landscape 1900 Oil

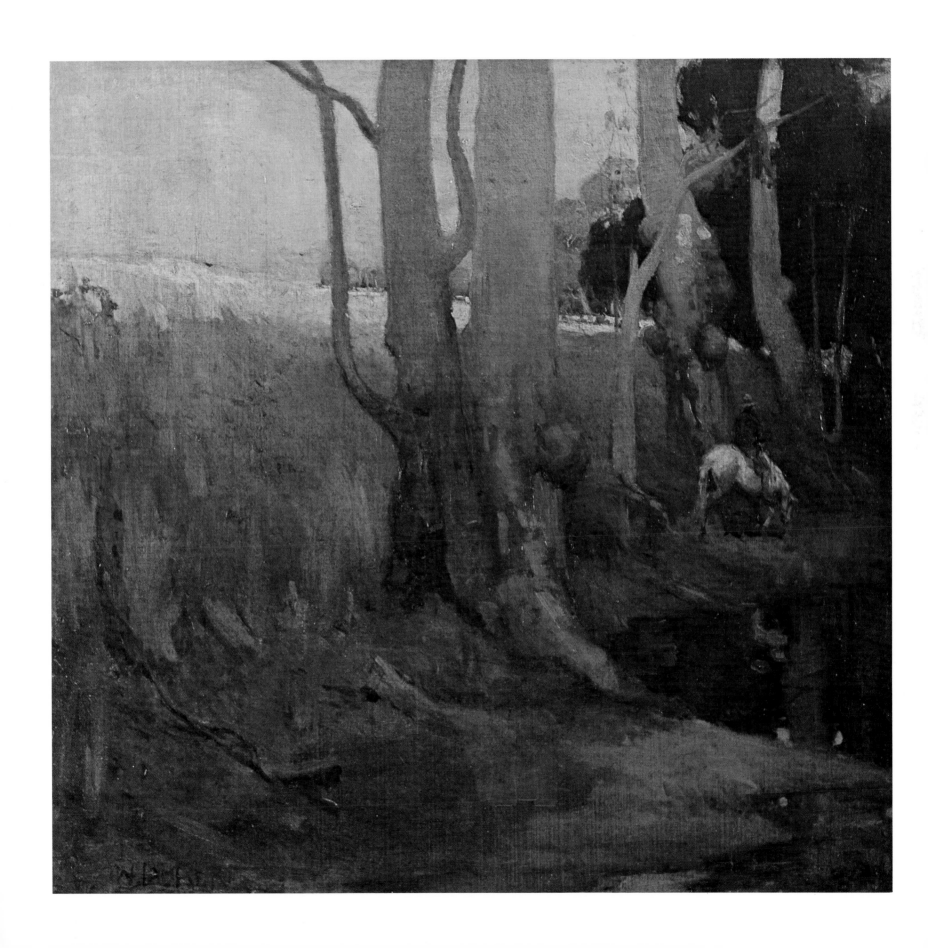

133

Miles Evergood (Myer Blashki)
Head of an old man (c. 1897) Oil

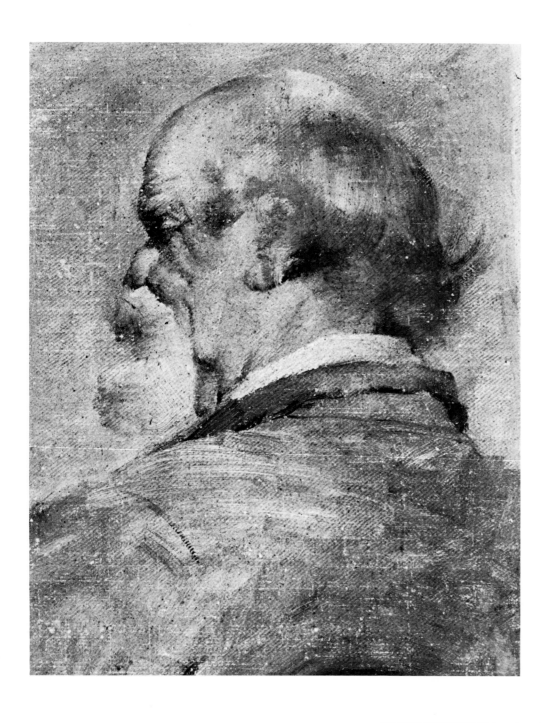

Miles Evergood (Myer Blashki)
Head of an old man (c. 1897) Oil

Hugh Ramsay
Seated nude 1896 Oil

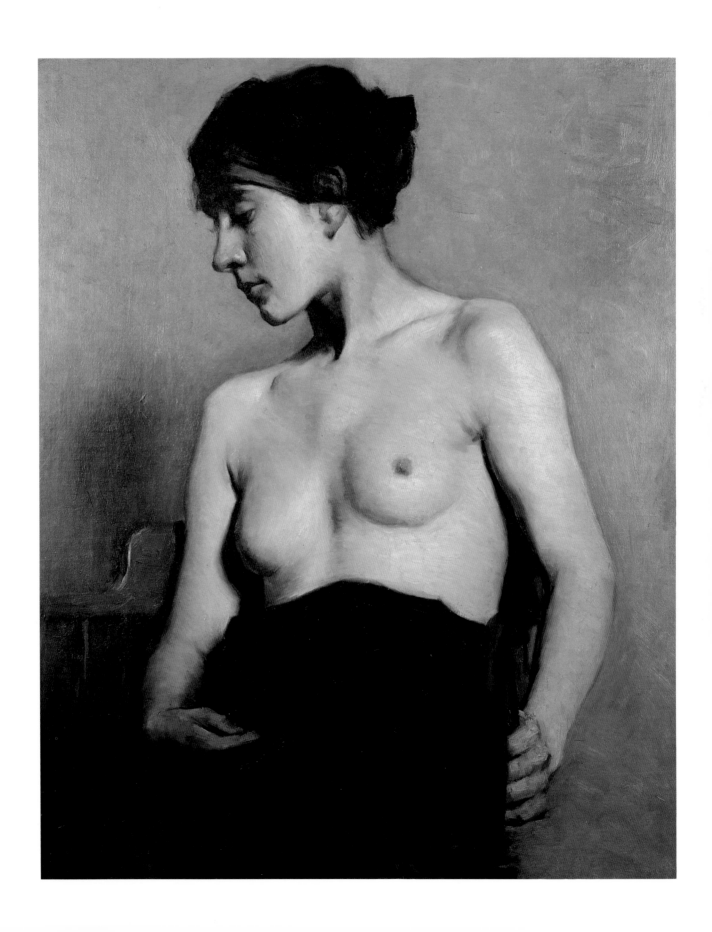

Hugh Ramsay
Seated figure (1903/1904) Oil

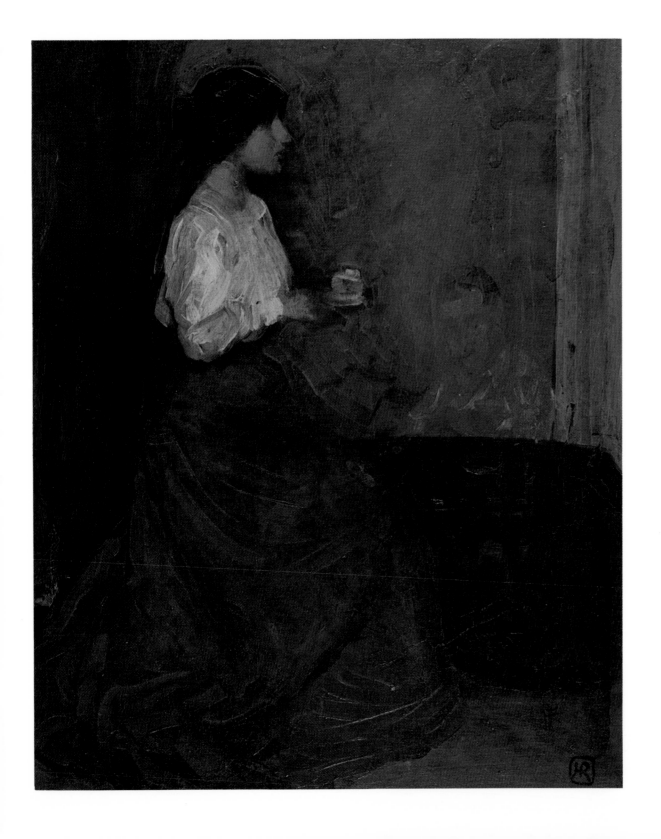

Hugh Ramsay
Self-portrait (1904) Oil

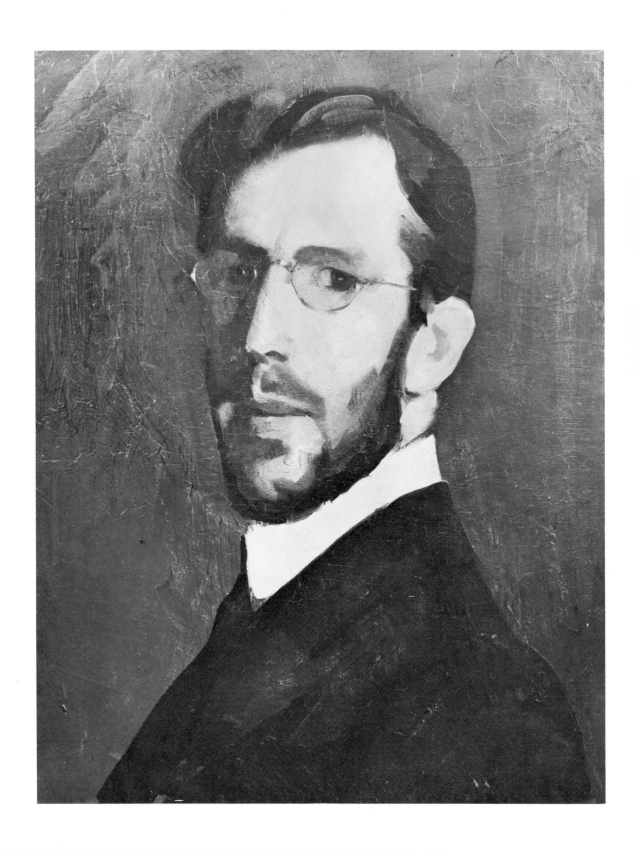

Max Meldrum
Flowerpiece 1943 Oil

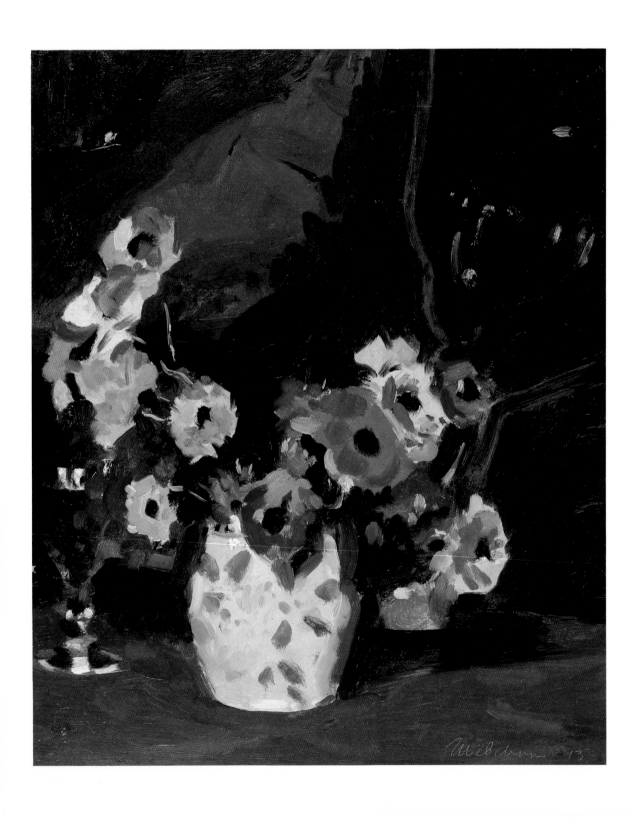

Max Meldrum
Studio interior (1930s) Oil

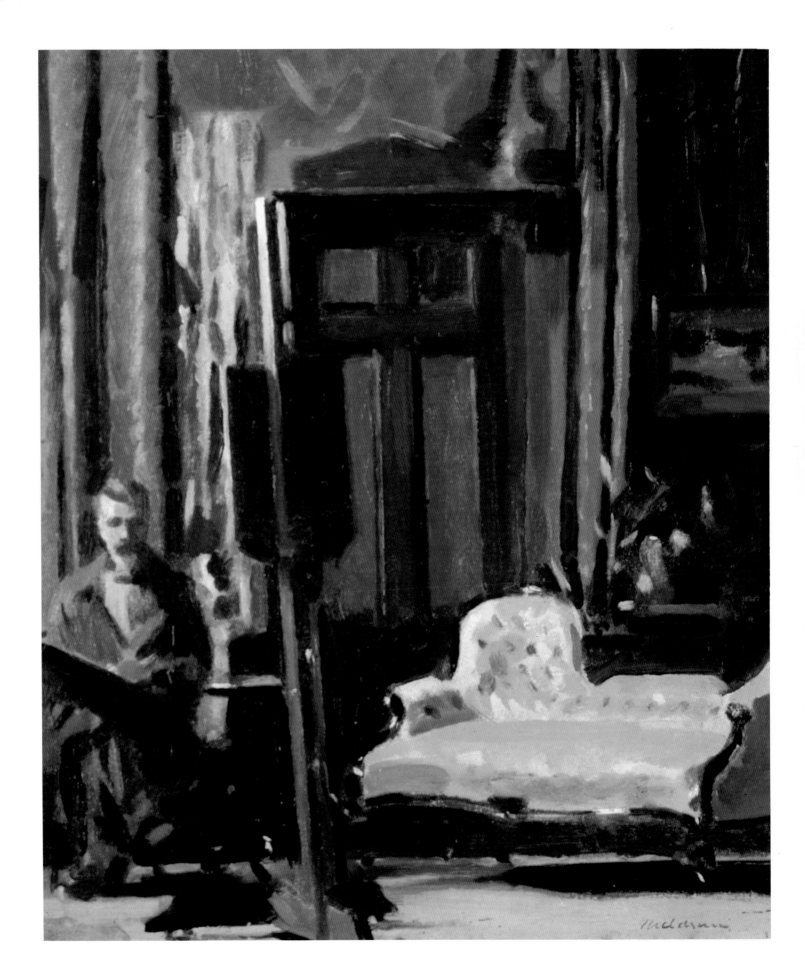

J. J. Hilder
Bridge (*c.* 1910) Watercolour

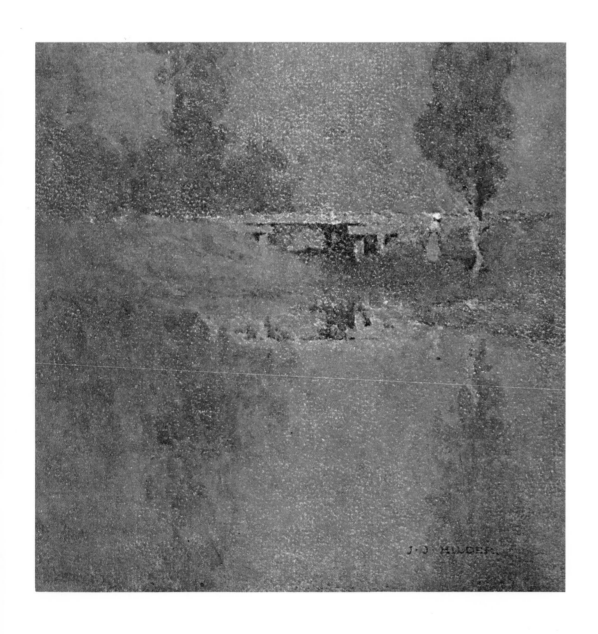

J. J. Hilder
Bridge (*c.* 1910) Watercolour

Elioth Gruner
Misty landscape (*c.* 1920) Oil

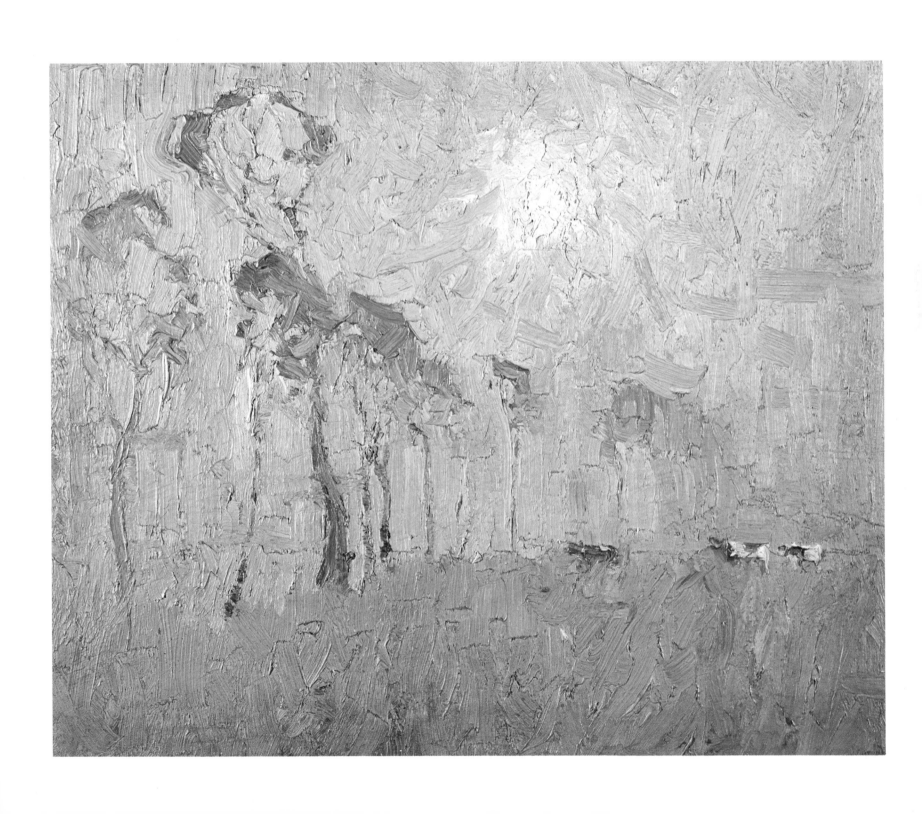

Hans Heysen
Gum trees 1918 Watercolour

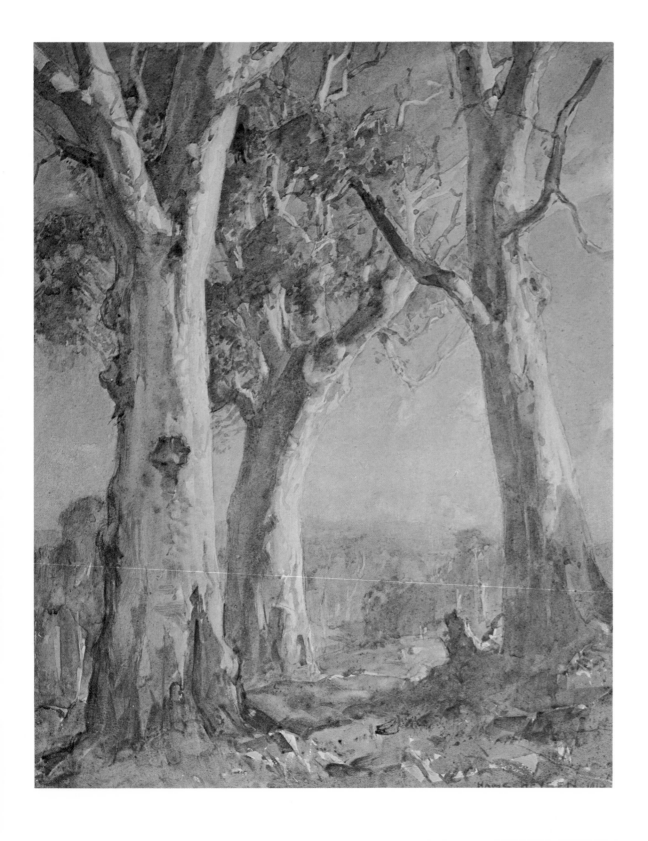

Penleigh Boyd
Wattle on the Yarra (*c.* 1920) Oil

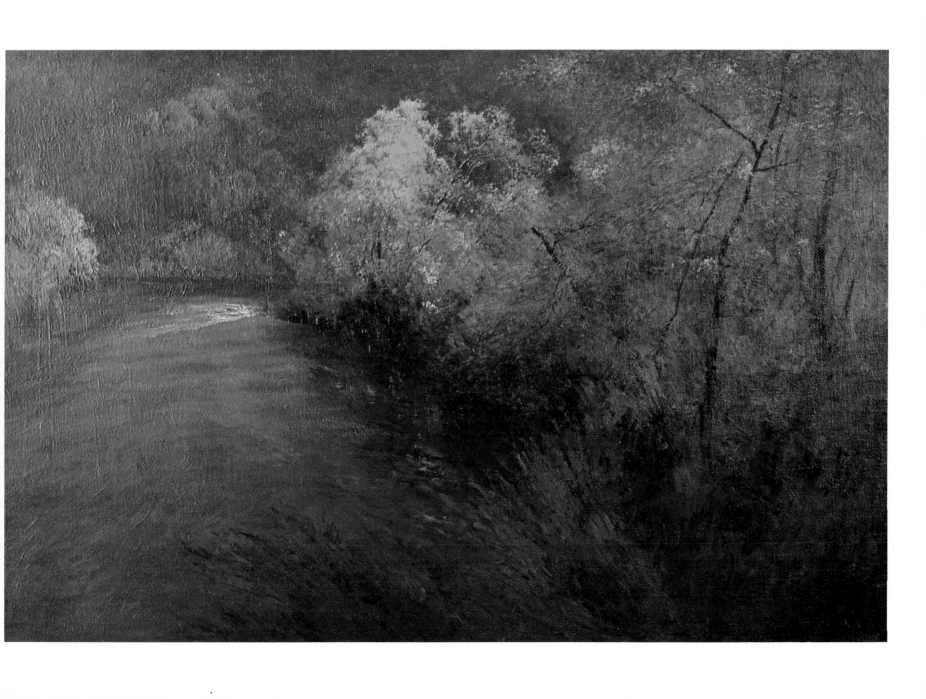

Rayner Hoff
Faun and nymph (1924) Bronze

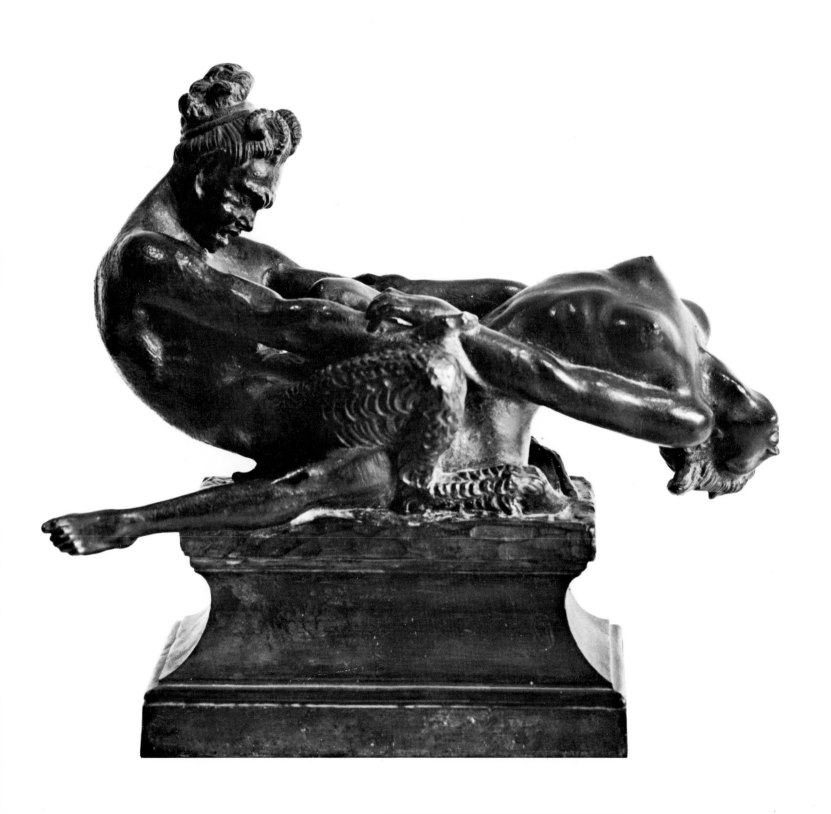

Blamire Young
Moonlight revels (c. 1924) Watercolour

Web Gilbert
Dorothy (1913) Bronze

Norman Lindsay
Bedroom scene (*c.* 1909) Etching

Norman Lindsay
The Garden of Happiness (1920s) Pen and ink

Cumbrae Stewart
Weeping girl 1924 Pastel

Cumbrae Stewart
Weeping girl 1924 Pastel

Clarice Beckett
Sherbrooke Forest (c. 1925) Oil

M. Napier Waller
The dance 1926 Watercolour

Harold Herbert
Morning sunlight 1931 Watercolour

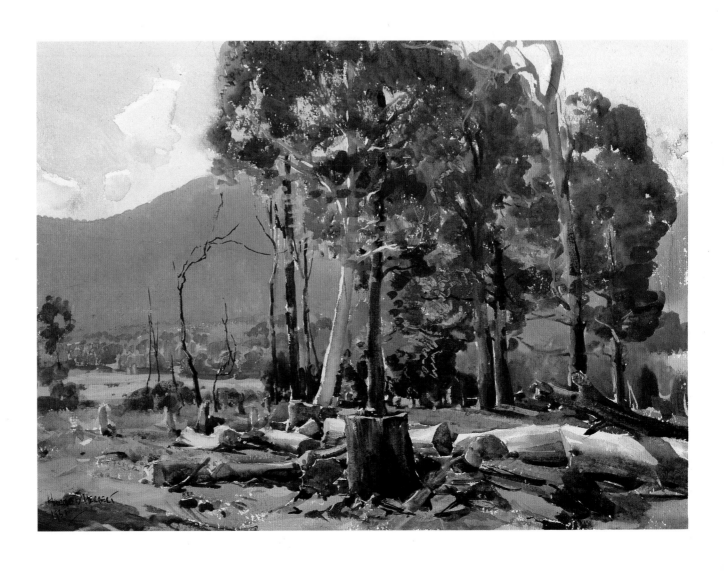

Robert Campbell
A corner of Berry's Bay, Sydney Harbour 1939 Oil

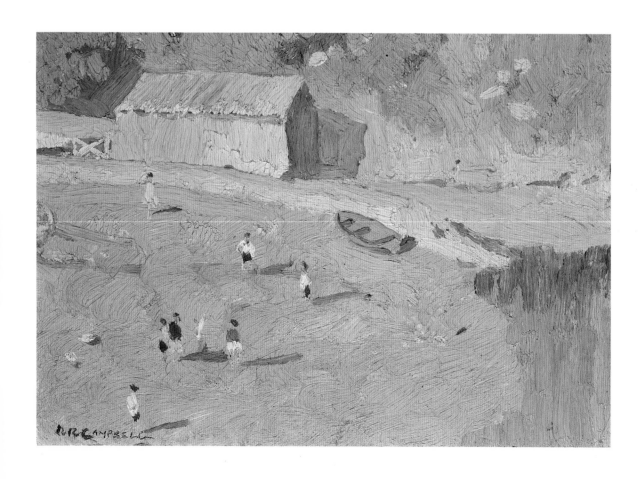

Florence Rodway
Little girl holding orange 1934 Pastel

Mary Cockburn Mercer
Lesbians (*c.* 1940) Watercolour

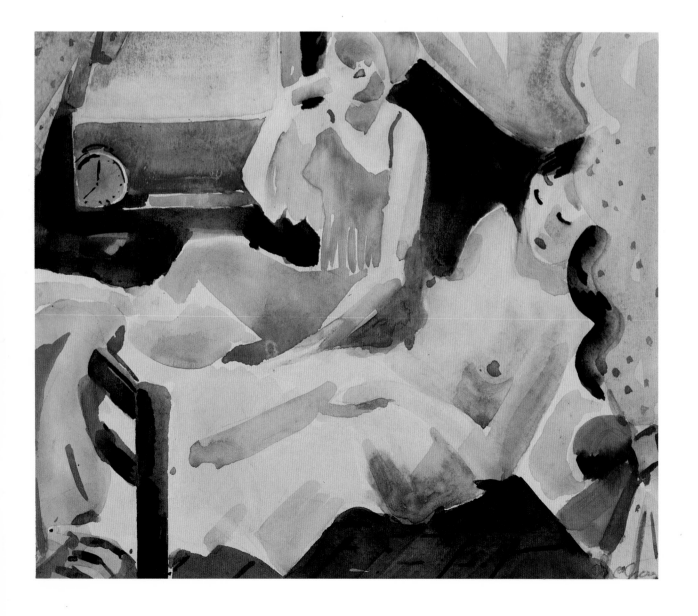

Kathleen O'Connor
White flowers and jug (*c.* 1920) Oil

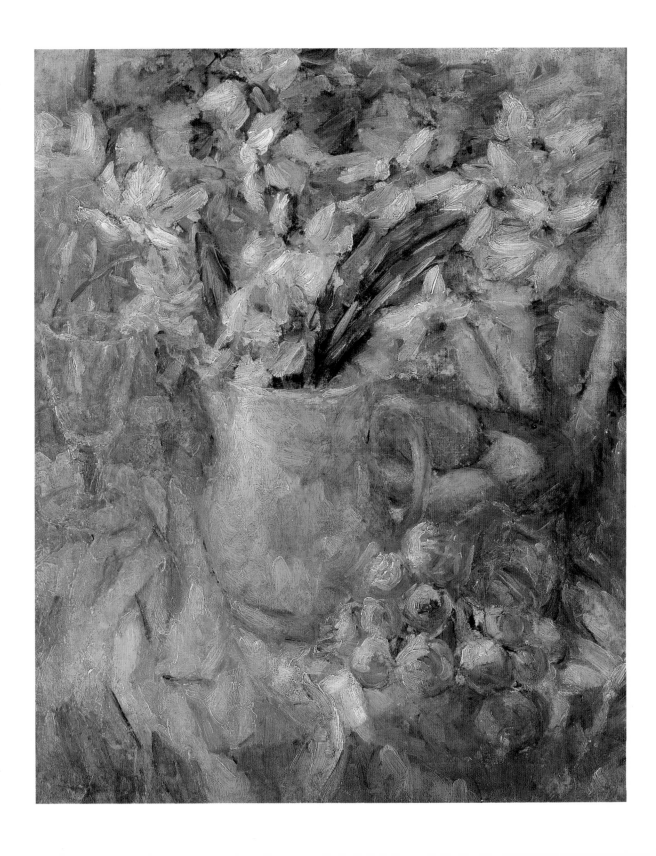

Ola Cohn
Confucius (1920s) Wood

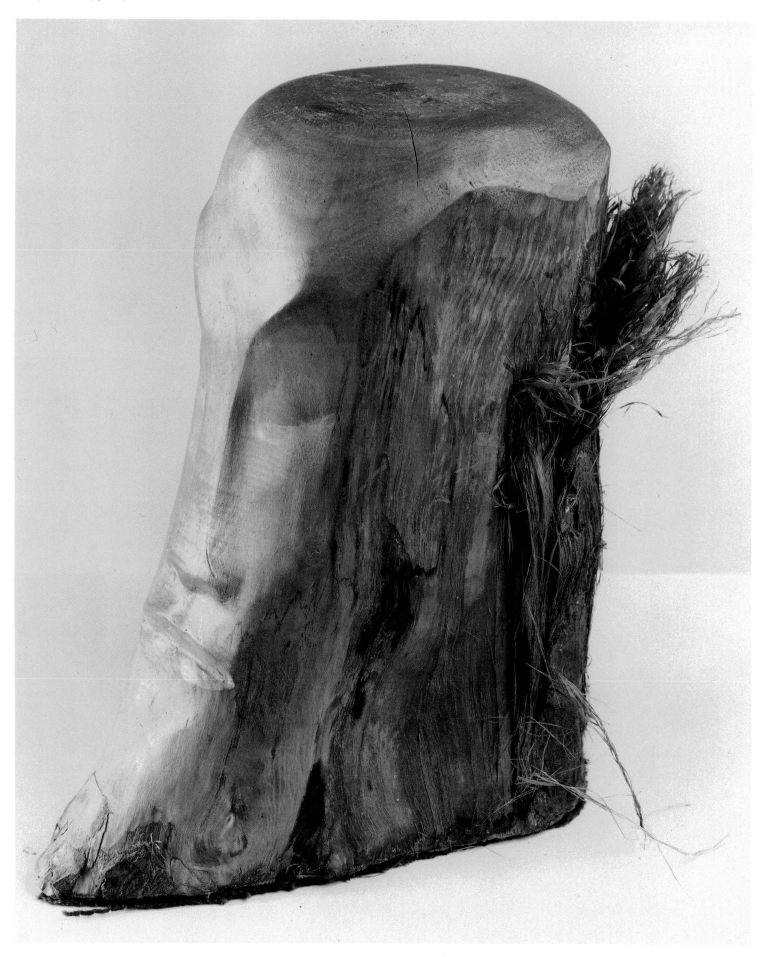

William Frater
The artist's wife 1915 Oil

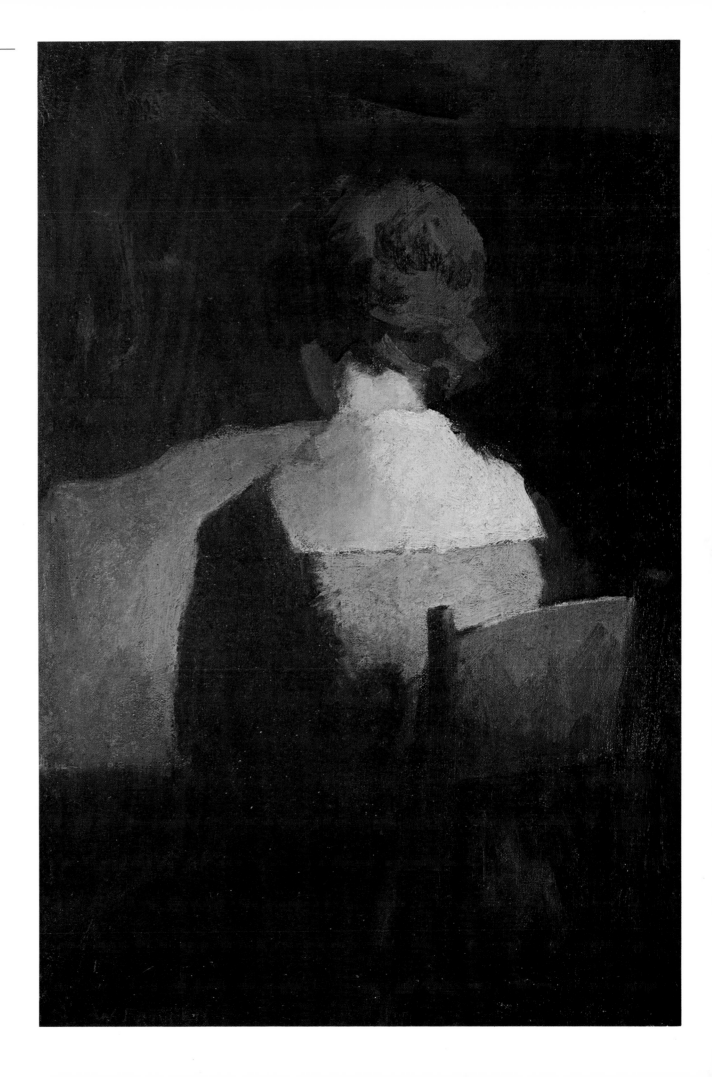

Thea Proctor
Portrait of a woman (1920s) Pencil and watercolour

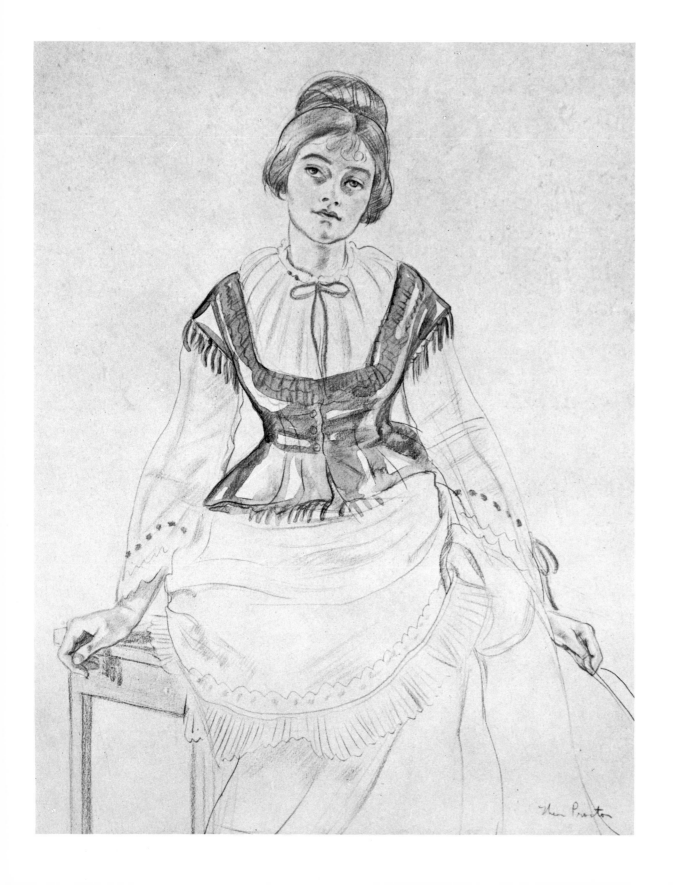

Thea Proctor
The sun room (1940s) Watercolour

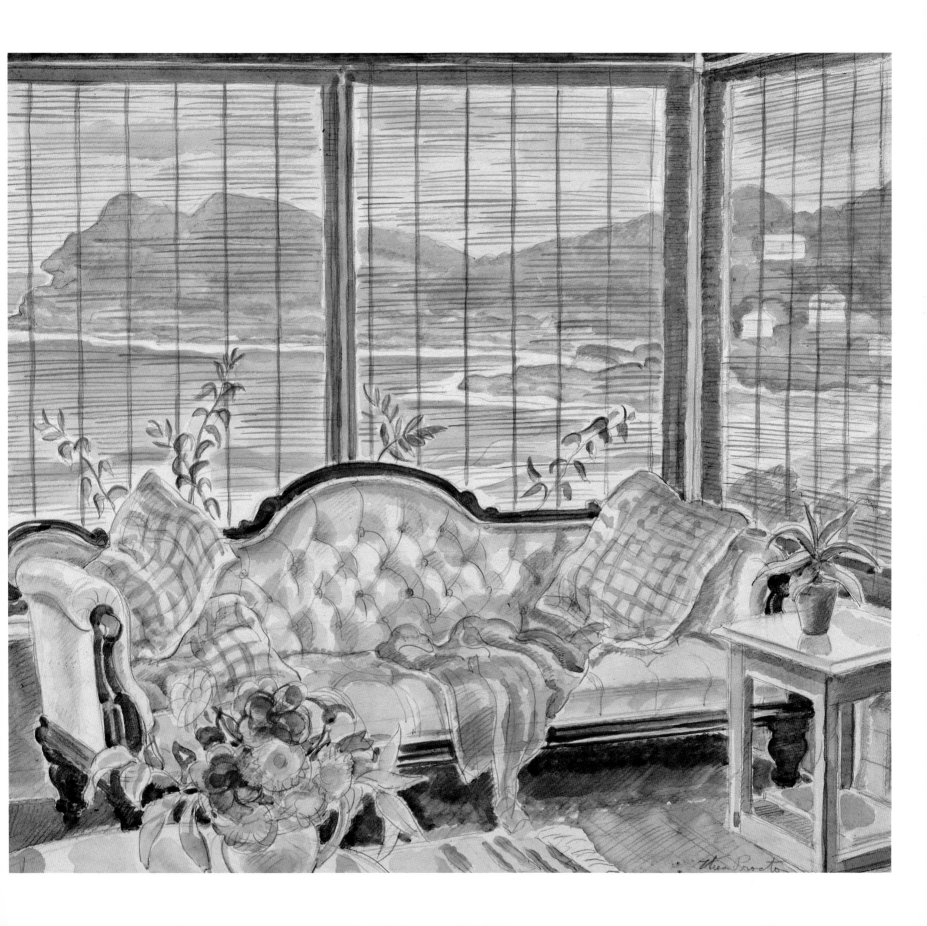

Thea Proctor
Women with fans (c. 1930) Woodcut

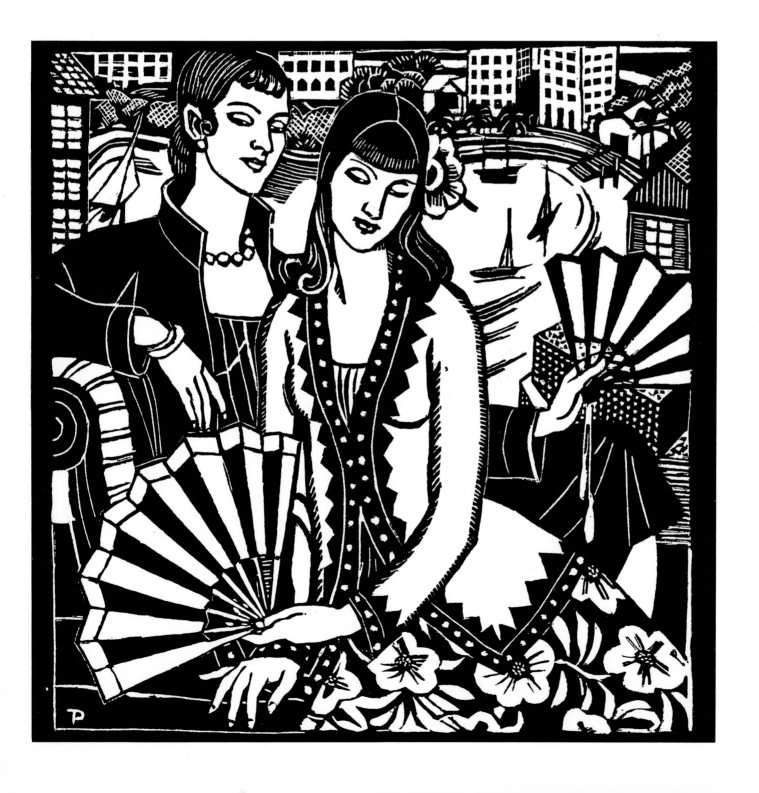

Edith Trethowan
Sunny waters near Fremantle
(*c*. 1928) Wood-engraving

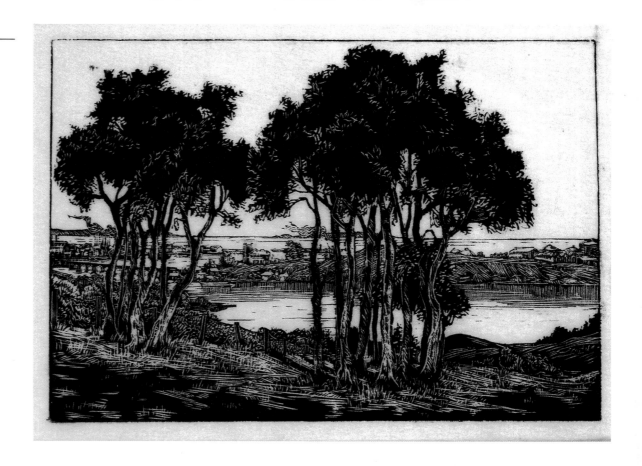

Dorrit Black
Hillside houses (early 1930s) Linocut

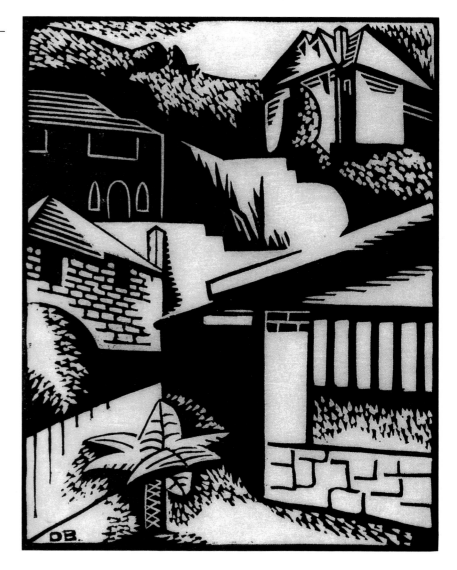

Eveline Syme
The bay 1933 Linocut

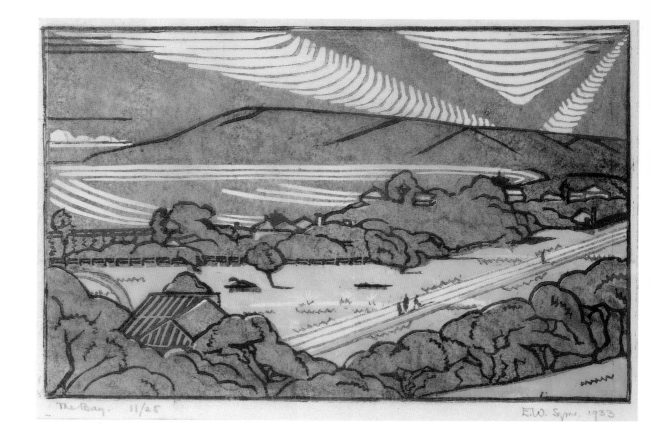

Ethel Spowers
The Works, Yallourn 1933 Linocut

Bessie Davidson
The embankment (*c.* 1940) Oil

Sybil Craig
Design, Banksias (1945) Linocut

Sybil Craig

Margaret Preston
Fuchsias (1928) Woodcut, hand-coloured

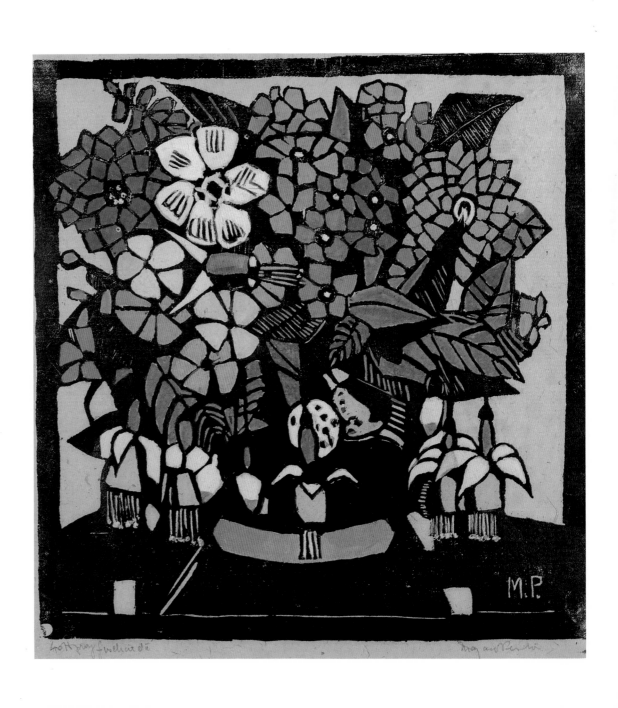

Margaret Preston
Flannel flowers 1938 Oil

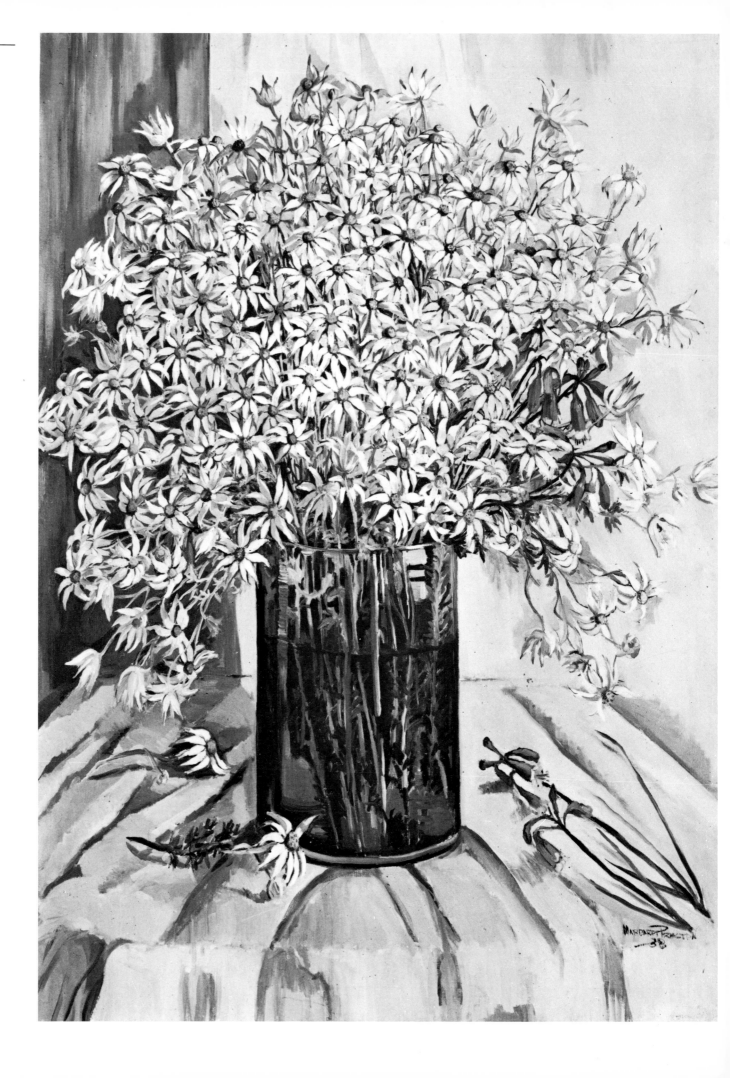

169

Margaret Preston
Middle Harbour (1946) Monotype

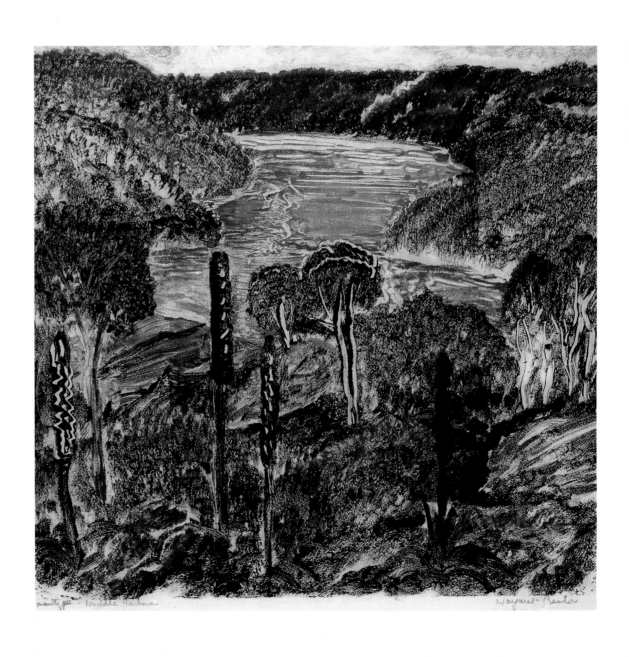

Merric Boyd
Koala bowl 1931 Earthenware

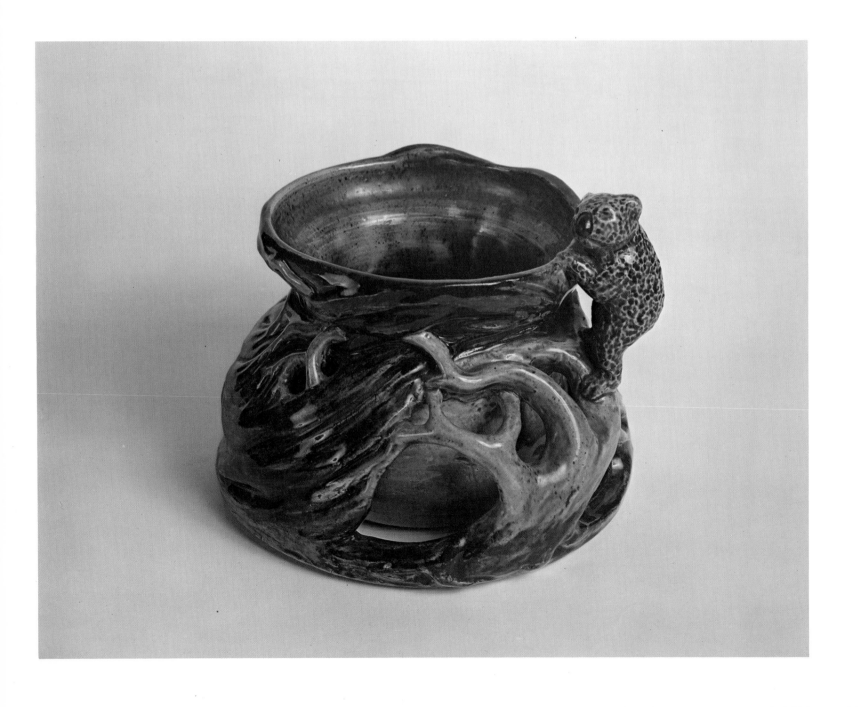

171

H. R. Hughan
Platter (1940s) Stoneware

172

H. R. Hughan
Lidded jar (1940s) Stoneware

Hilda Rix Nicholas
Autumn bounty (c. 1930) Oil

174
Roland Wakelin
Landscape 1920 Oil

Roland Wakelin
On Ball's Head 1919 Oil

Roy de Maistre
Syncromy, Berry's Bay 1919 Oil

Roy de Maistre
Abstract 1936 Oil

Roy de Maistre
Reclining figure 1933 Oil

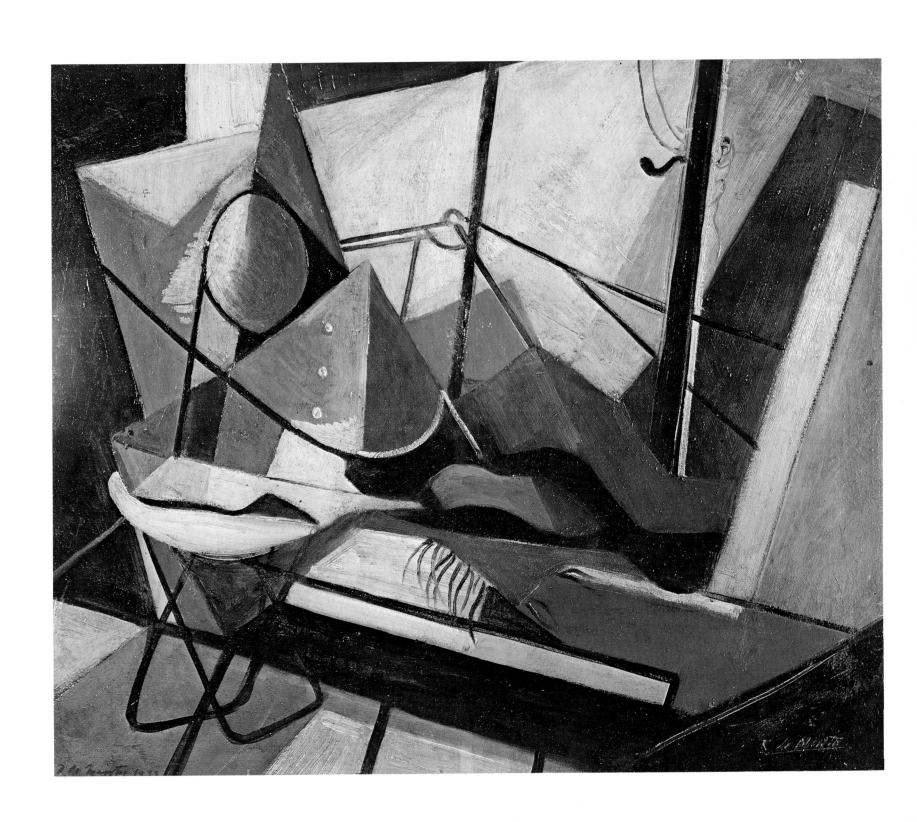

Grace Crowley
Study for portrait (1935) Pencil

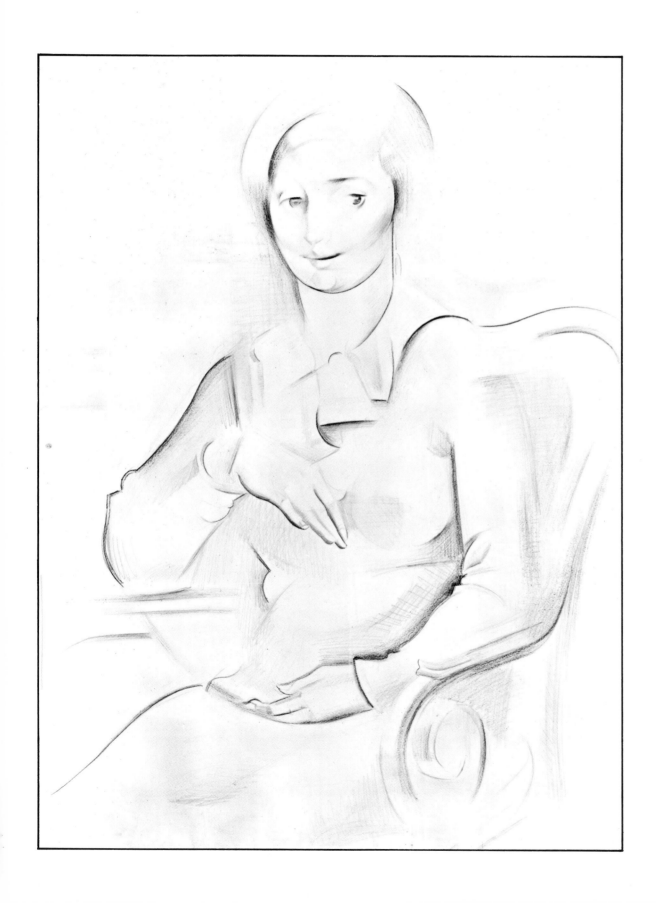

Rah Fizelle
Seated figure (c. 1938) Conté crayon

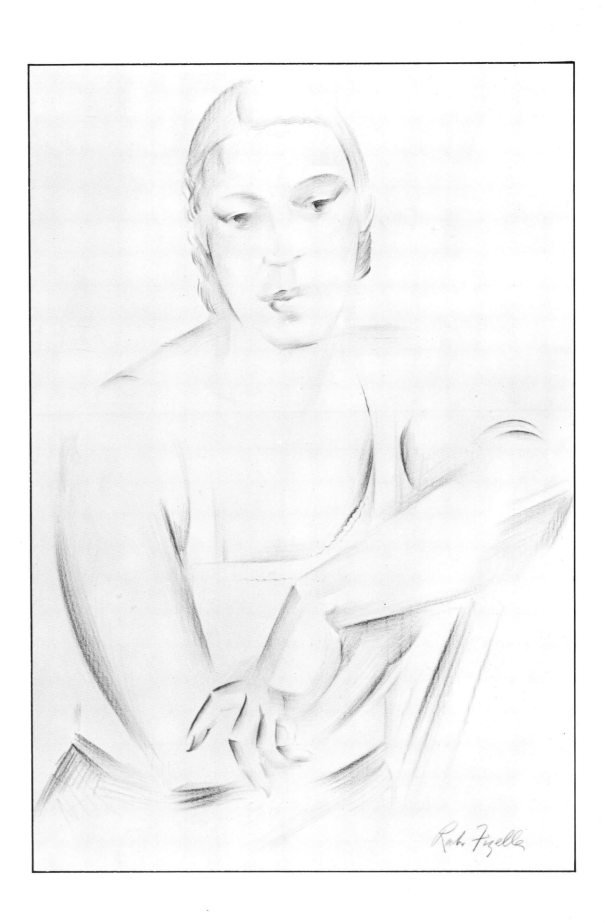

William Dobell
Dead landlord (*c.* 1936) Gouache

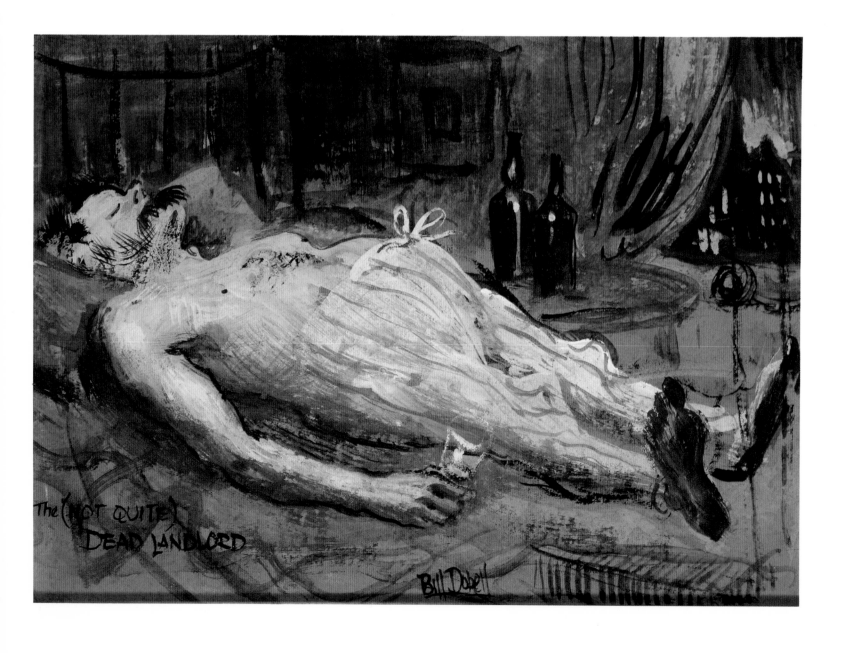

William Dobell
Study for 'The Cypriot' (*c.* 1938) Oil

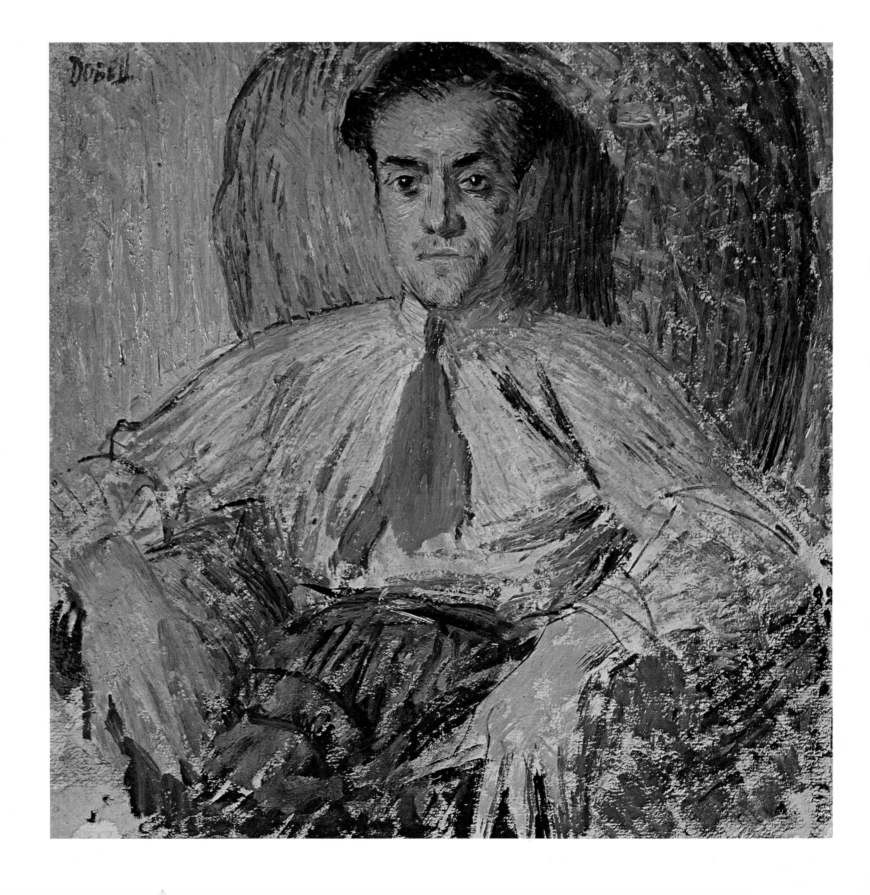

William Dobell
Self-portrait (*c.* 1965) Oil

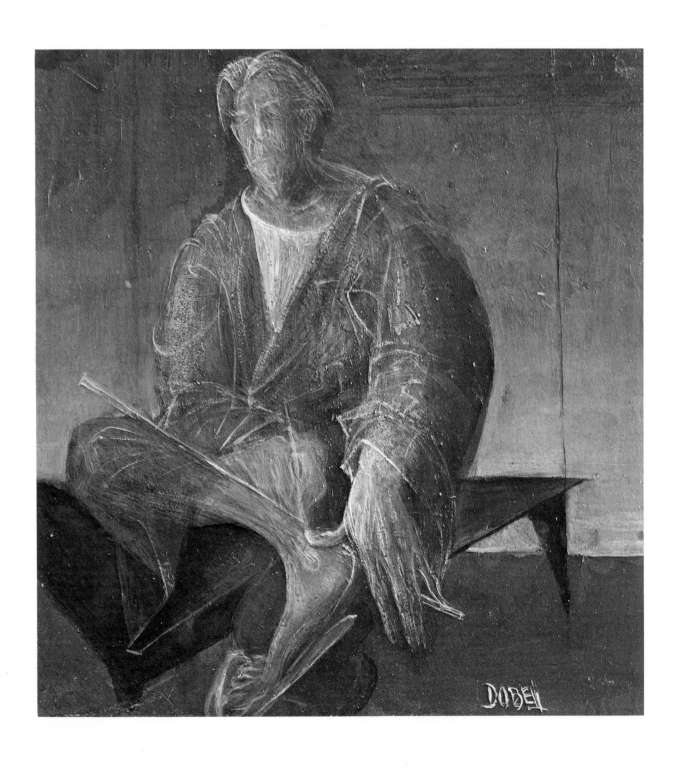

Eric Wilson
Wantabadgery landscape 1946 Oil

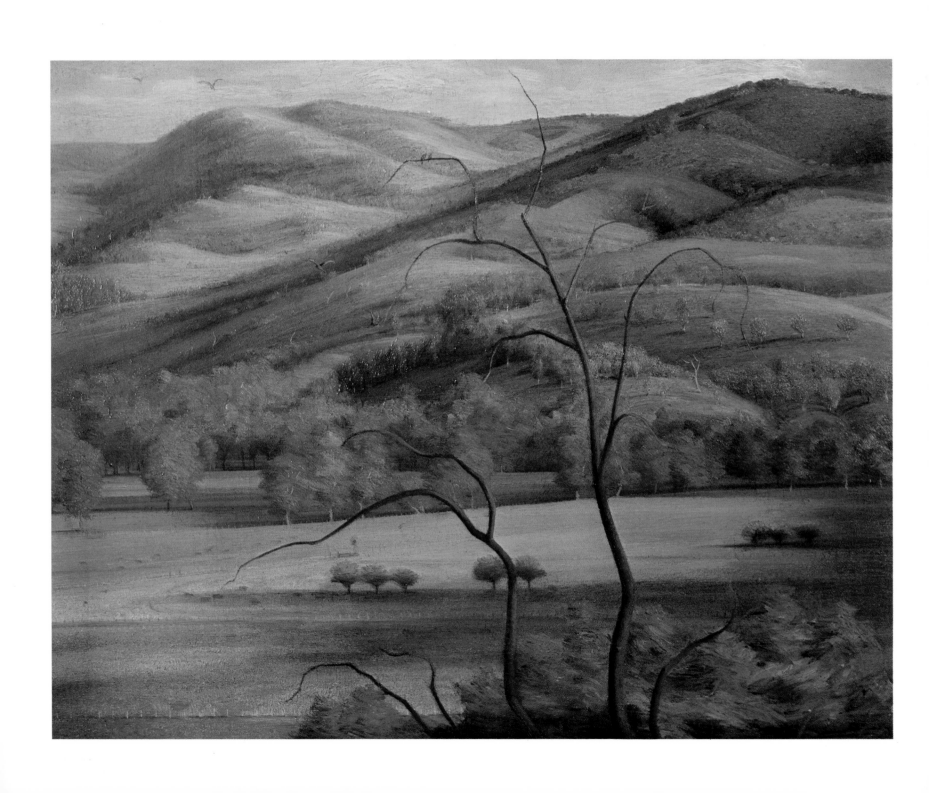

Lloyd Rees
Fig tree 1934 Pencil

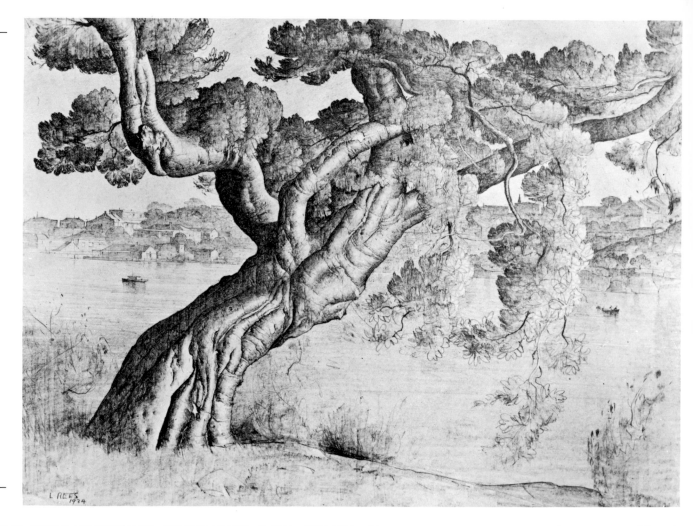

186

Lloyd Rees
Waverton 1932 Pencil

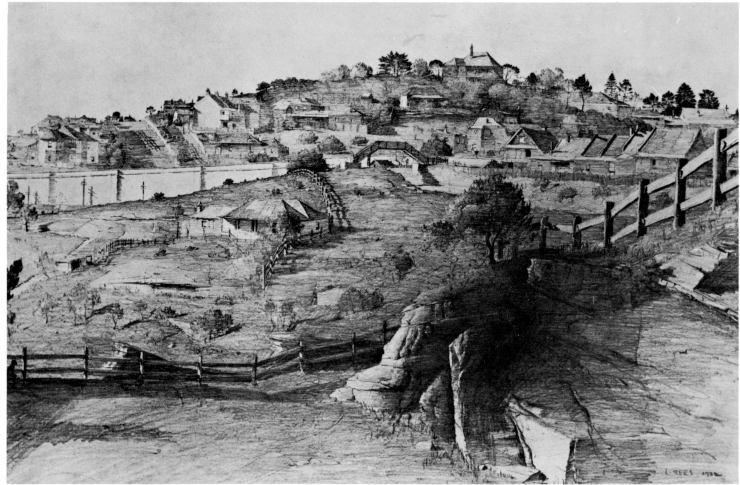

Lloyd Rees
The harbour (1920s) Oil

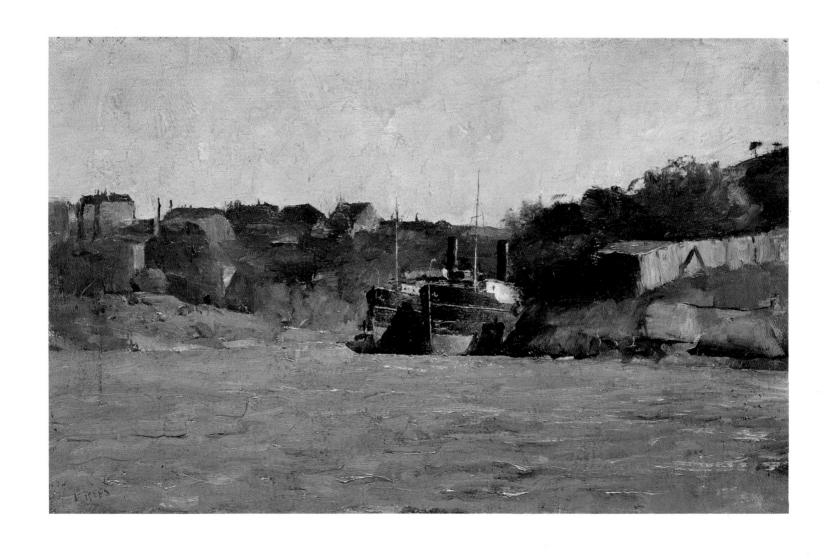

Lloyd Rees
South Head, Sydney 1954 Oil

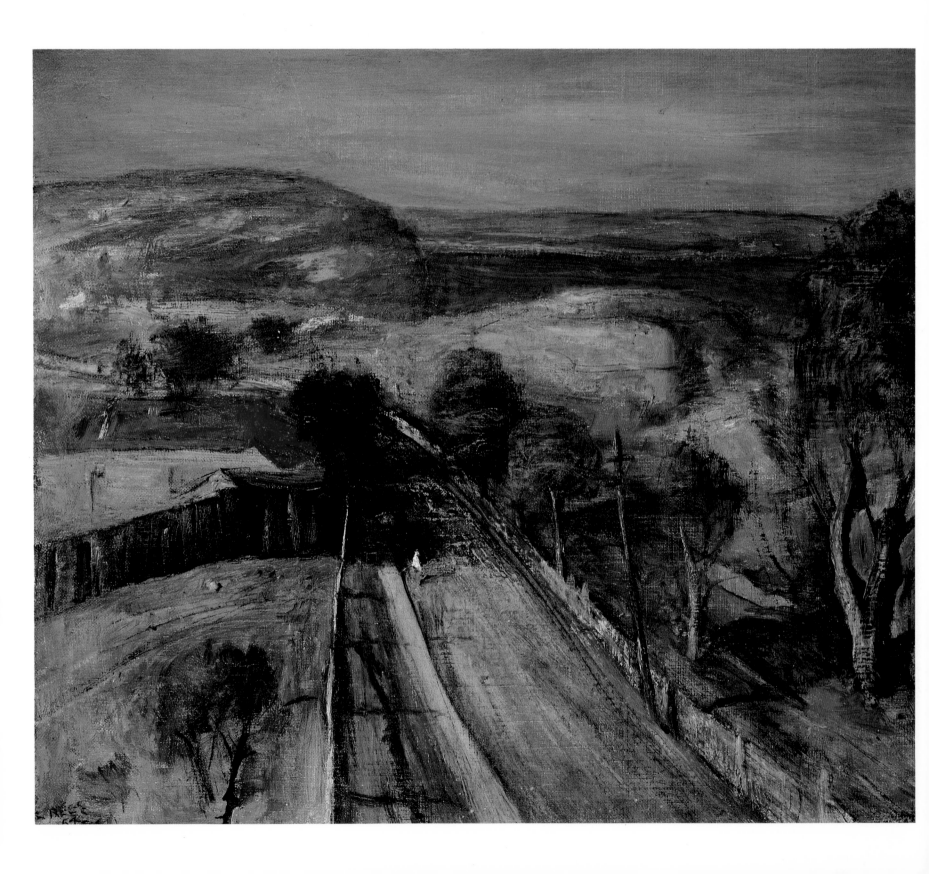

189

Lloyd Rees
Dusk on the Derwent 1985 Oil

Arnold Shore
Flower study 1932 Oil

George Bell
Greek head 1959 Oil

Russell Drysdale
Industrial landscape 1937 Gouache

Russell Drysdale
Hangar, Rose Bay　(1940s)　Ink and gouache

Russell Drysdale
Man with ram (1941) Charcoal

Russell Drysdale
Sketch for 'The rabbiters' (1947) Ink and body colour

Russell Drysdale
Sketches for 'Tree form' (1945) Ink and body colour

Russell Drysdale
Tree form (1945) Oil

Russell Drysdale
Studies for 'The gatekeeper's wife' (*c.* 1947) Pencil

Russell Drysdale
Diver, Broome (1959) Oil

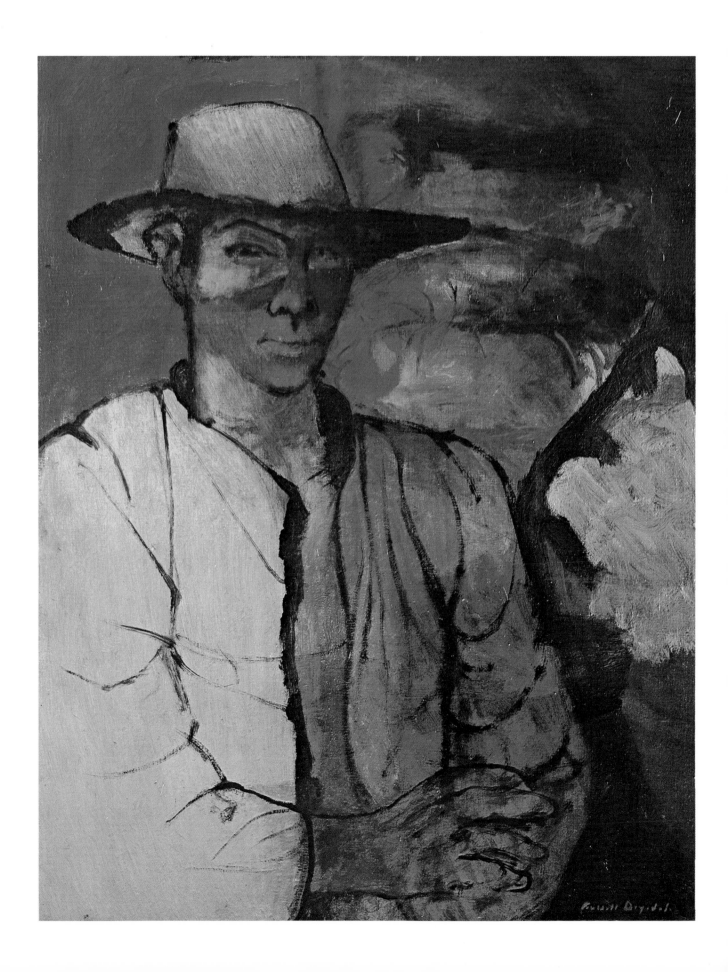

Peter Purves Smith
Vase with flowers (*c*. 1940) Oil

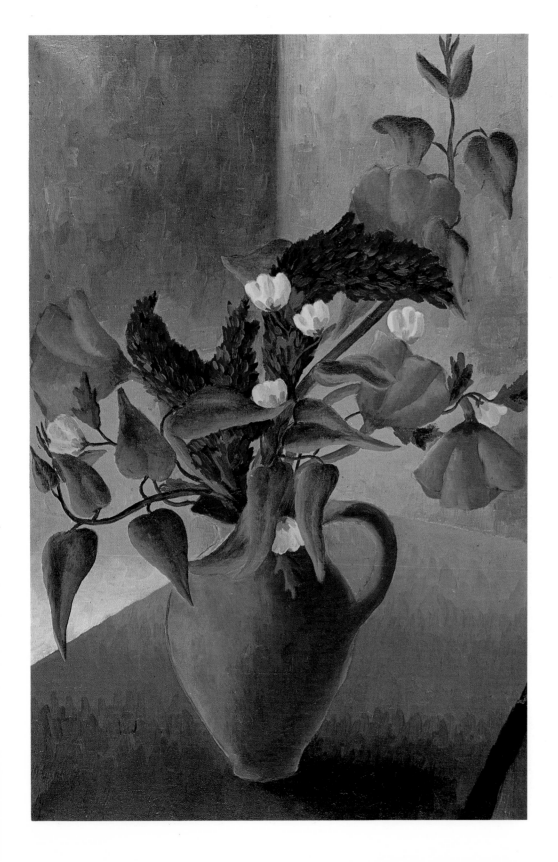

Peter Purves Smith
The pond, Paris (*c.* 1938) Oil

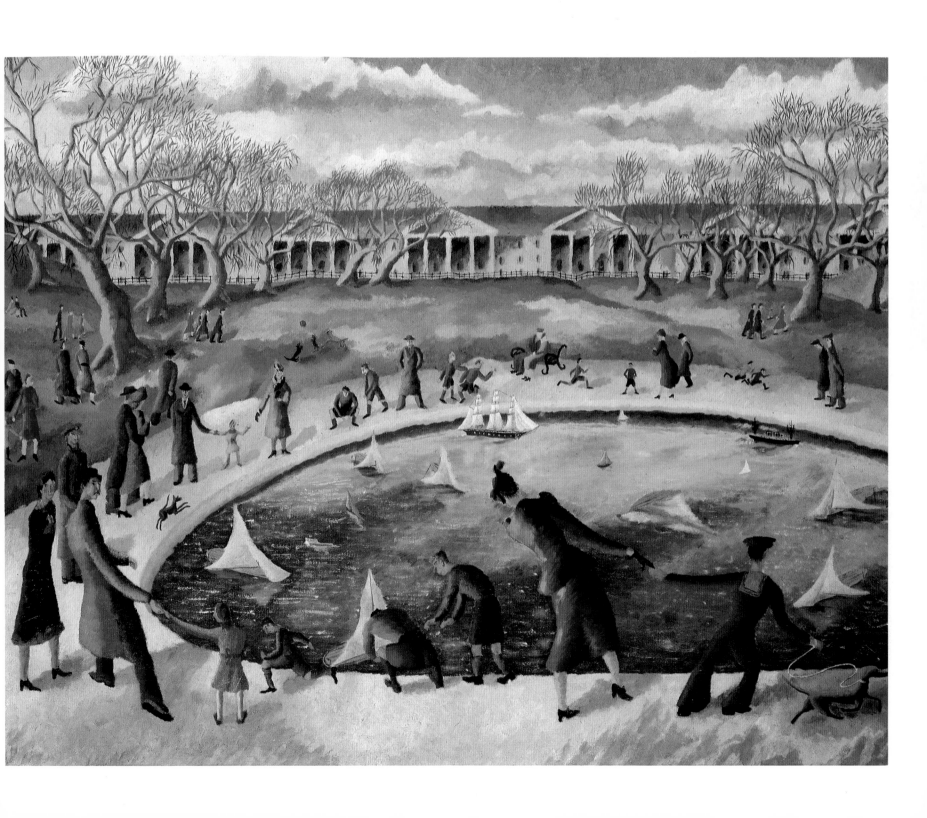

202

Peter Purves Smith
Double head 1947 Oil

Peter Purves Smith
Woman eating 1948 Gouache and pen and ink

Ludwig Hirschfeld Mack
Figure 1940 Watercolour

Kenneth Macqueen
Clouds over landscape 1926 Watercolour

Clive Stephen
Winged horse (1930s) Marble

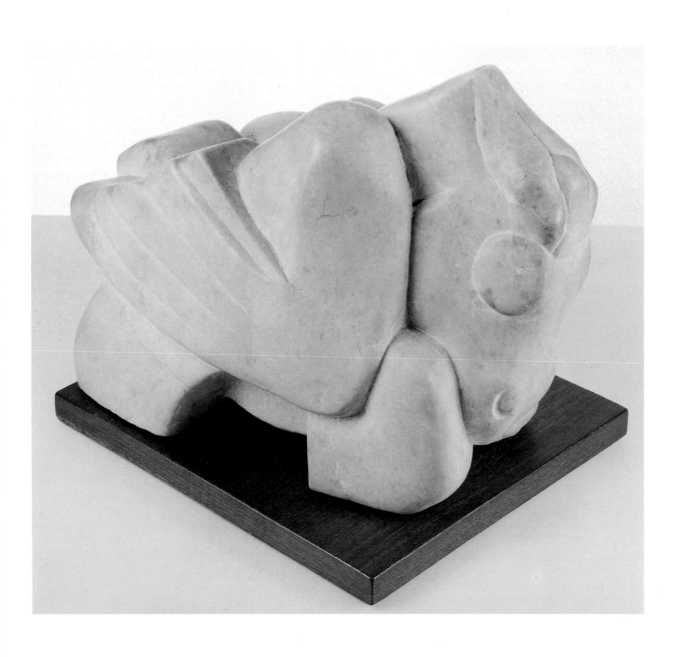

Sali Herman
Still life 1931 Oil

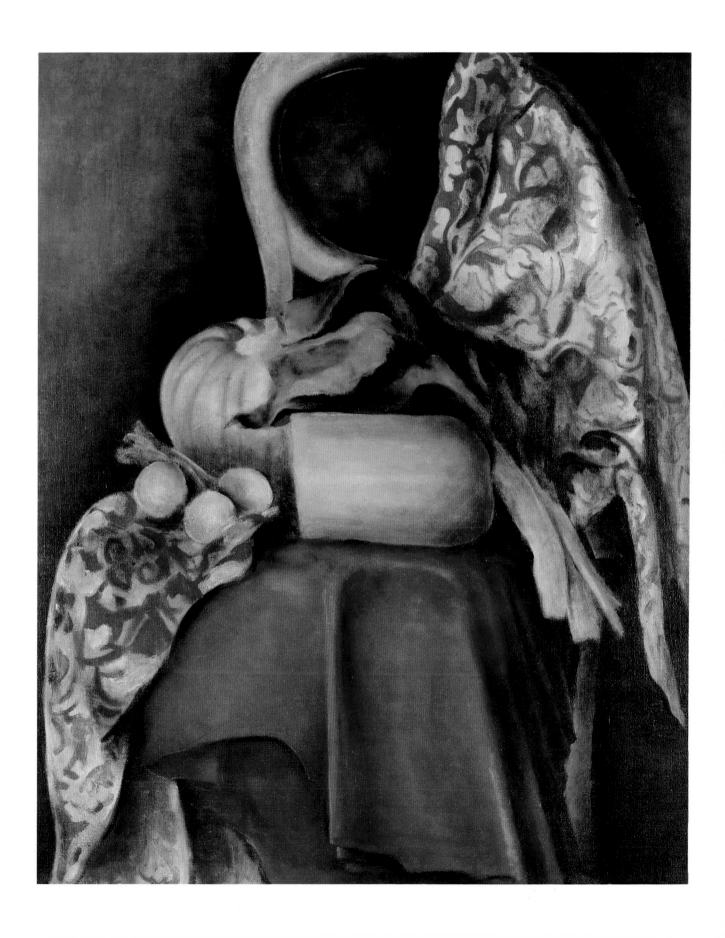

William Dargie
Draped mask and still life 1935 Oil

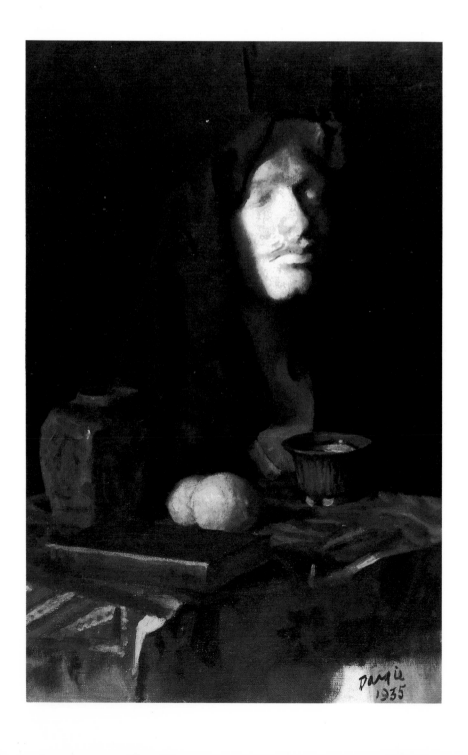

Constance Stokes
Three sisters (*c.* 1945) Oil

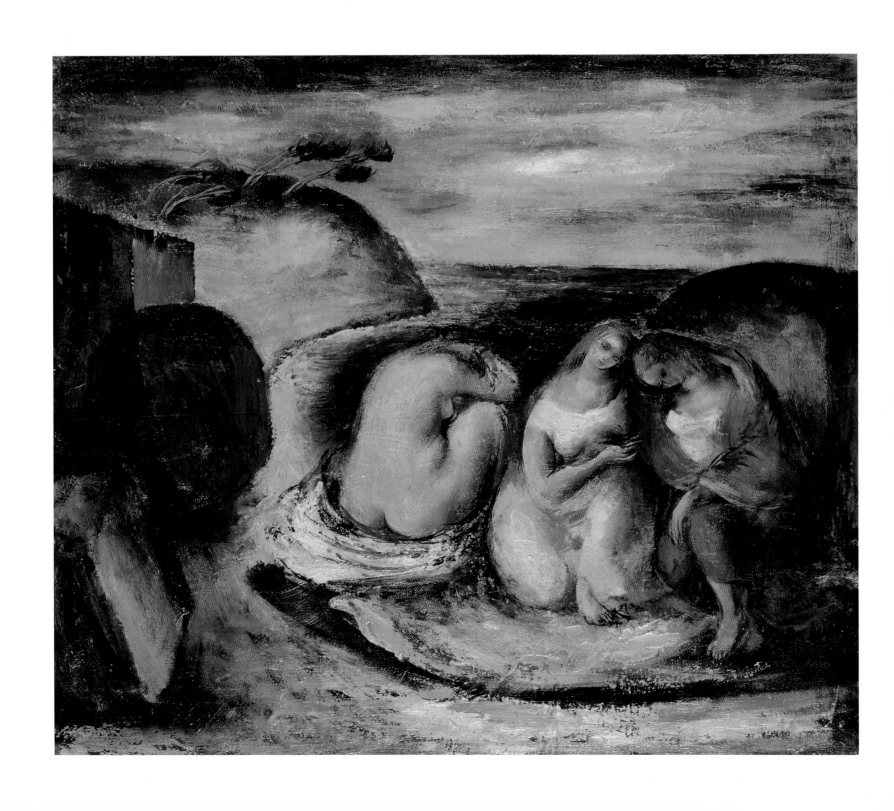

Grace Cossington Smith
Kuringai Avenue 1943 Oil

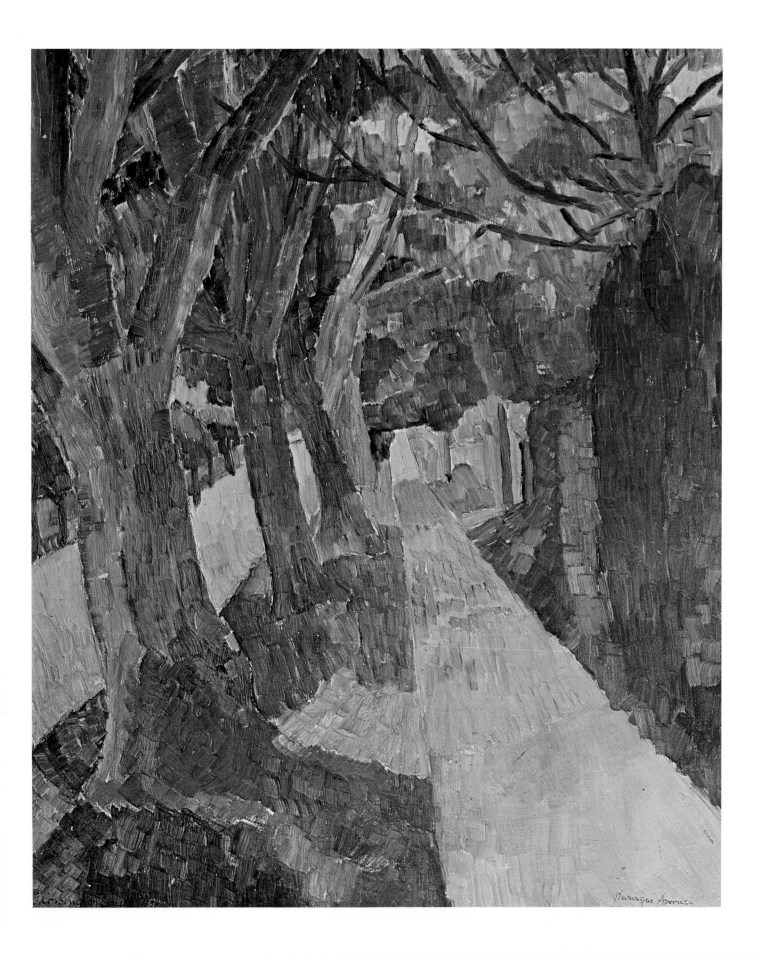

Grace Cossington Smith
Fruit in the window 1957 Oil

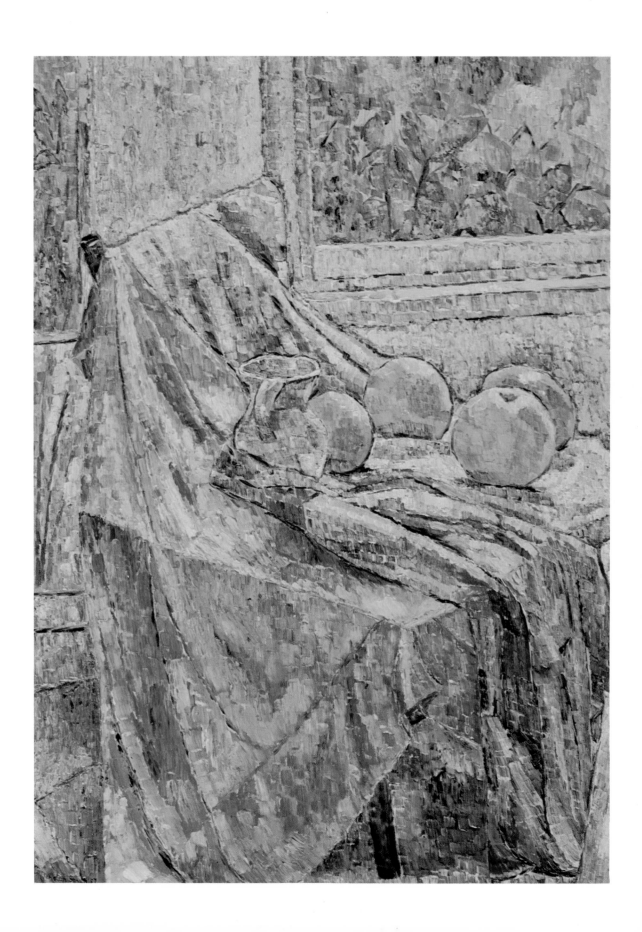

Ewald Namatjira
The Centre (1950s) Watercolour

Otto Pareroultja
Gums (1950s) Watercolour

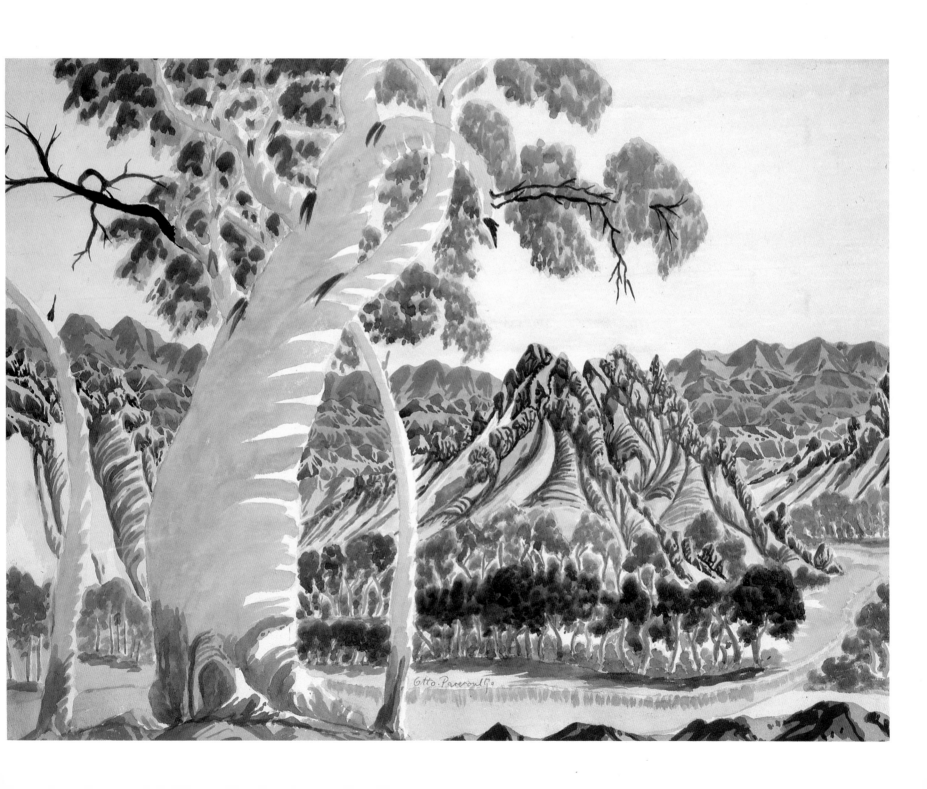

Henri Bastin
Flower study 1962 Gouache

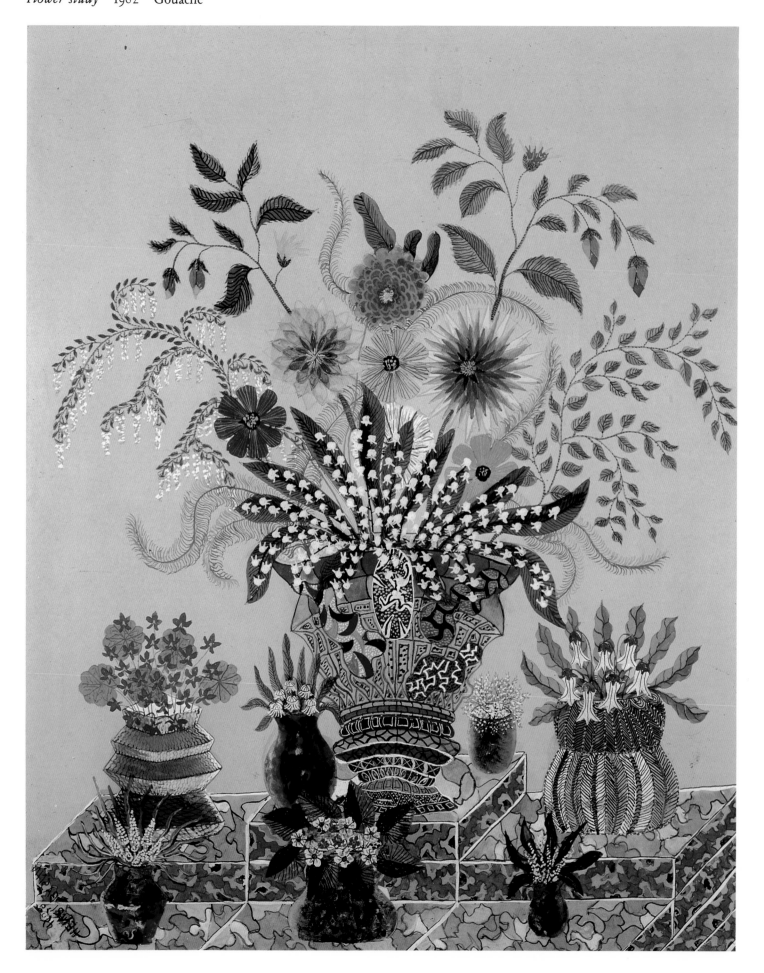

Henri Bastin
Flower study 1962 Gouache

Sam Byrne
Rabbit plague 1891 (*c.* 1960) Oil

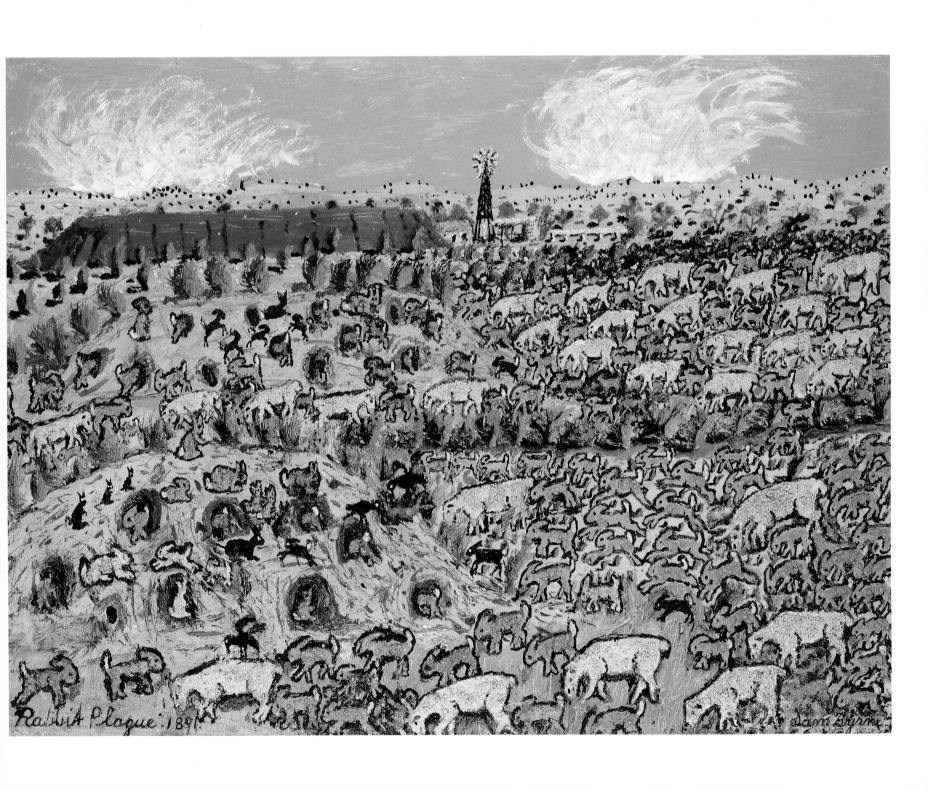

Ian Fairweather
Two Philippine children (1933) Oil

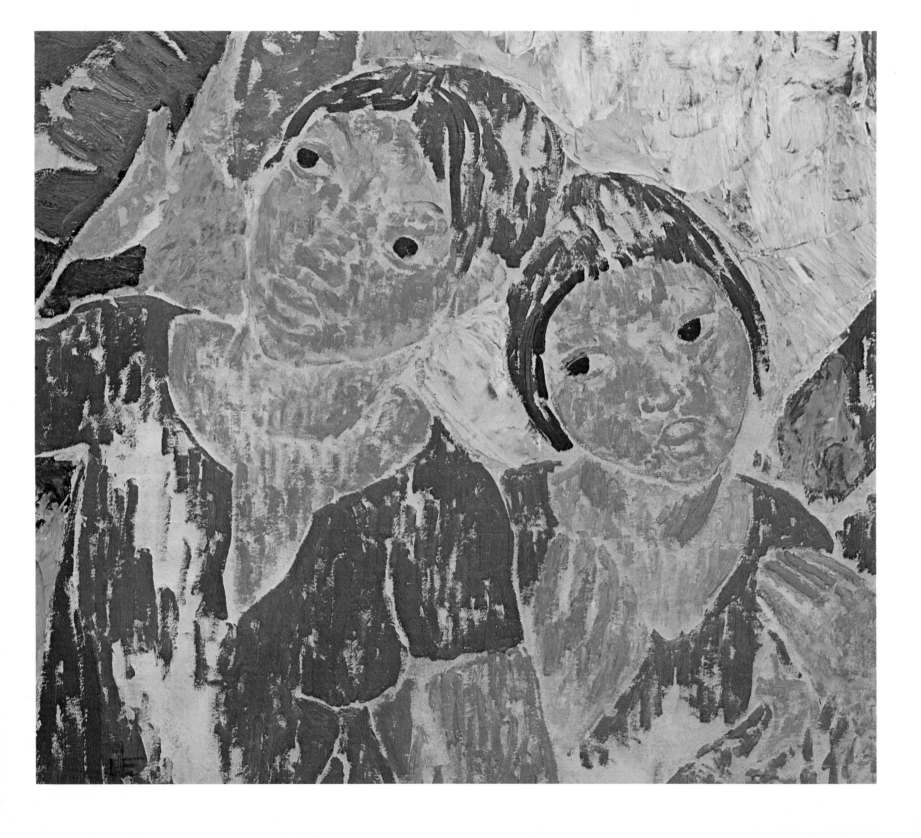

Ian Fairweather
Two Philippine children (1933) Oil

Ian Fairweather
Musicians (1954) Gouache

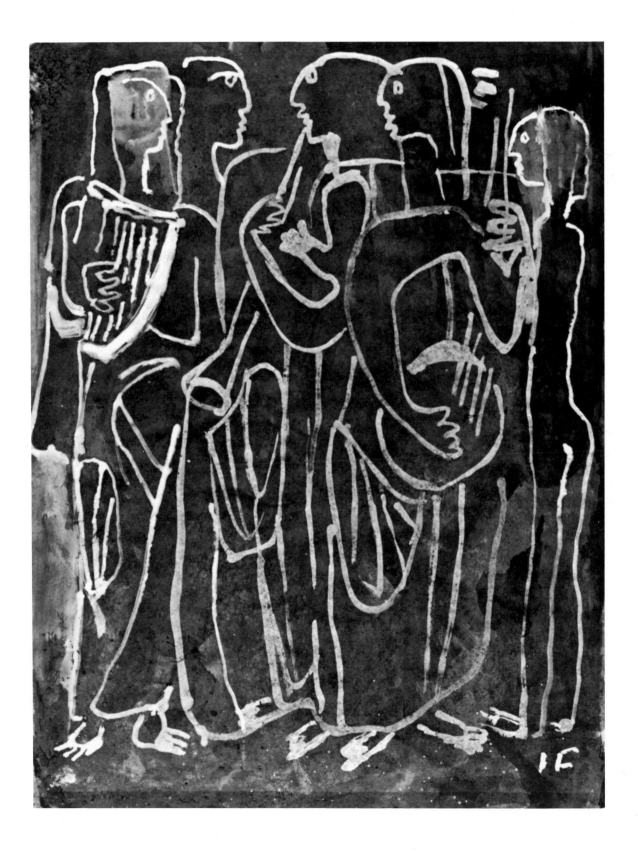

Adrian Lawlor
Traipsing vase (*c.* 1930) Oil

Lina Bryans
The dancing gum 1960 oil

Eric Thake
Oceania 1945 Linocut

"Oceania" Eric Thake 1945

Jean Bellette
Acheron (*c.* 1944) Oil

Horace Brodzky
The tidings 1958 Oil

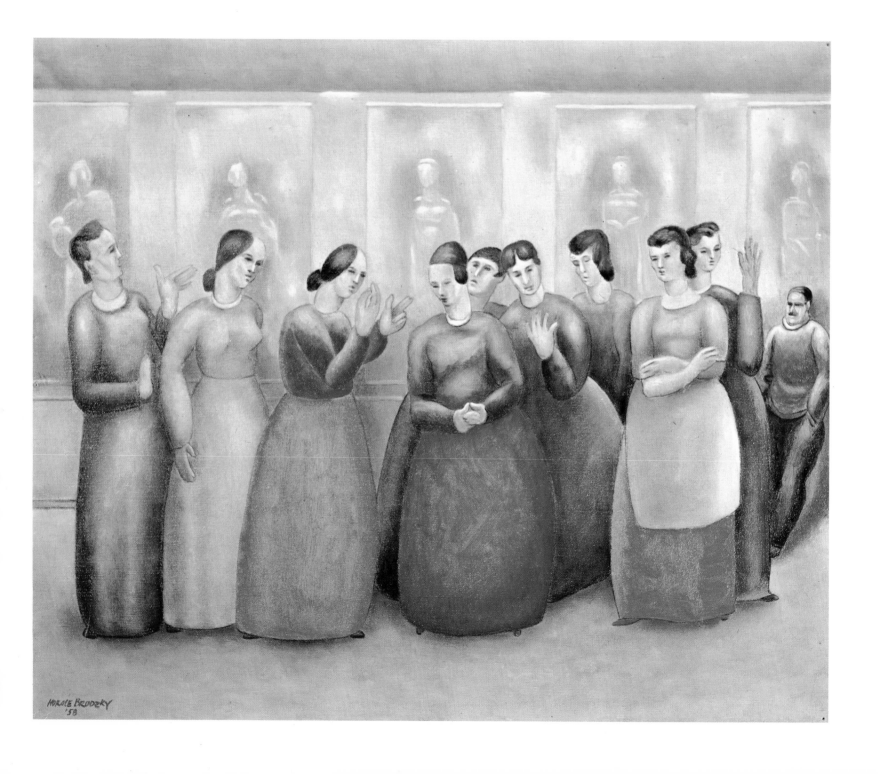

Edwin Tanner
Hats and shoe 1955 Oil

Adrian Feint
House and flame tree 1941 Oil

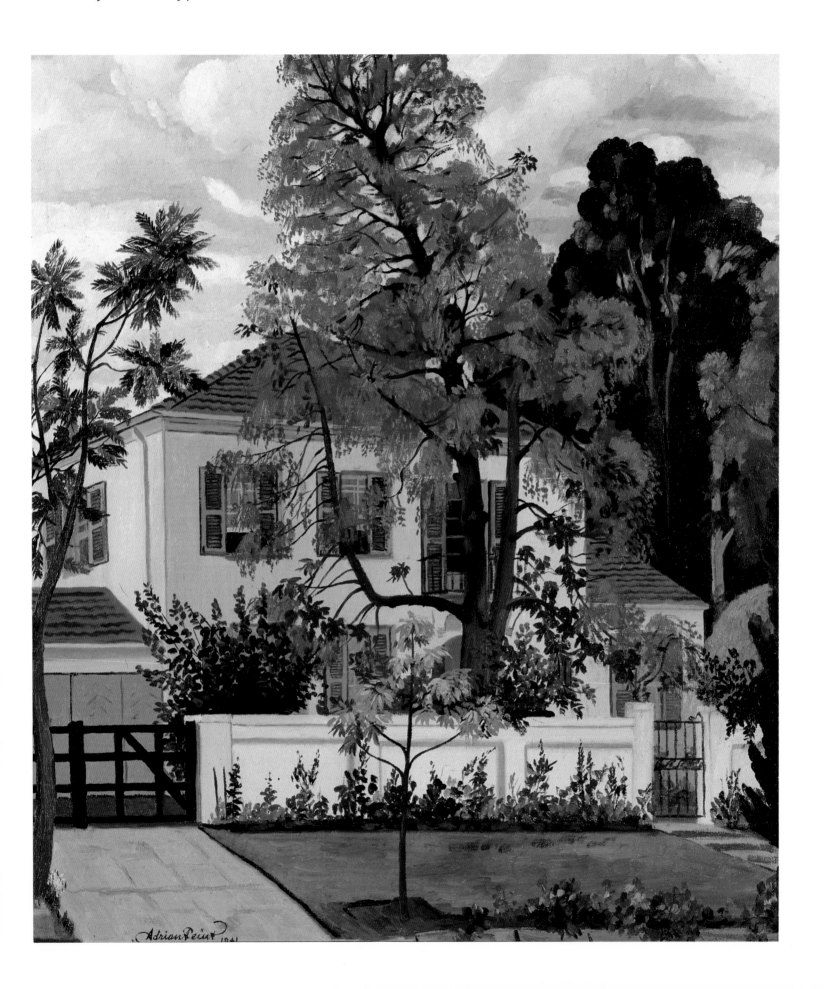

Godfrey Miller
House in moonlight (*c.* 1940) Oil

Godfrey Miller
Design (1940s) Oil

Godfrey Miller
Trees and forest series (1940s) Oil

Godfrey Miller
Still life with jug (1949–54) Oil

Godfrey Miller
Still life with jug (1949–54) Oil

227

Godfrey Miller
Trees in quarry (1961–63) Oil

John Passmore
Children and pony (1930s) Oil

John Passmore
Shag on scratch (c. 1959) Oil

John Passmore
Millers Point (c. 1953) Oil

John Passmore
Boys fossicking for mussels (*c.* 1955) Oil

Ralph Balson
Painting 1954 Oil

Ralph Balson
Painting 1959 Enamel

Weaver Hawkins
Abstract 1962 Oil

237

Frank Hinder
Abstract 1952 Oil

Danila Vassilieff
The buffet 1934 Oil

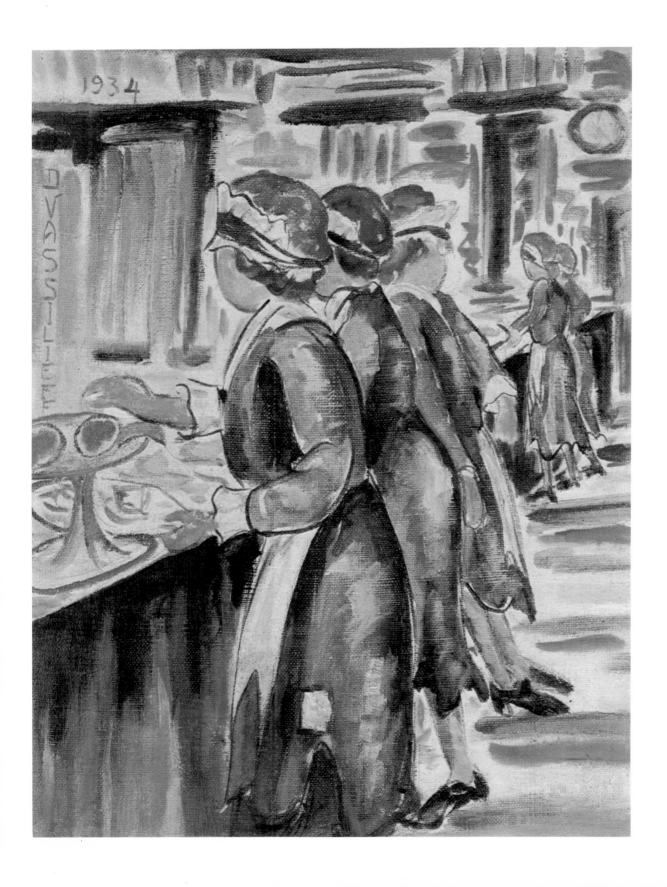

Danila Vassilieff
Fitzroy street scene　(c. 1938)　Oil

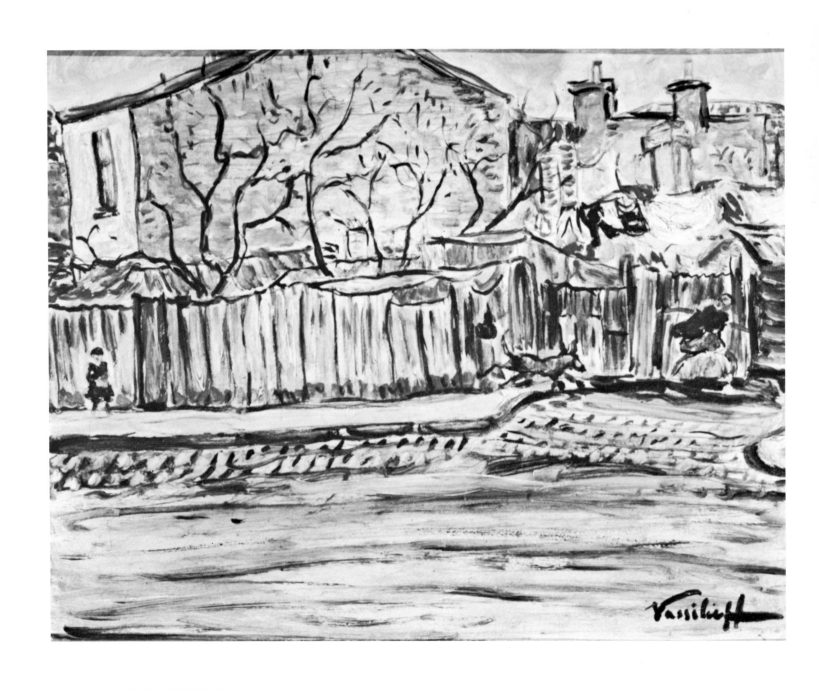

Danila Vassilieff
Predator and prey (early 1950s) Marble

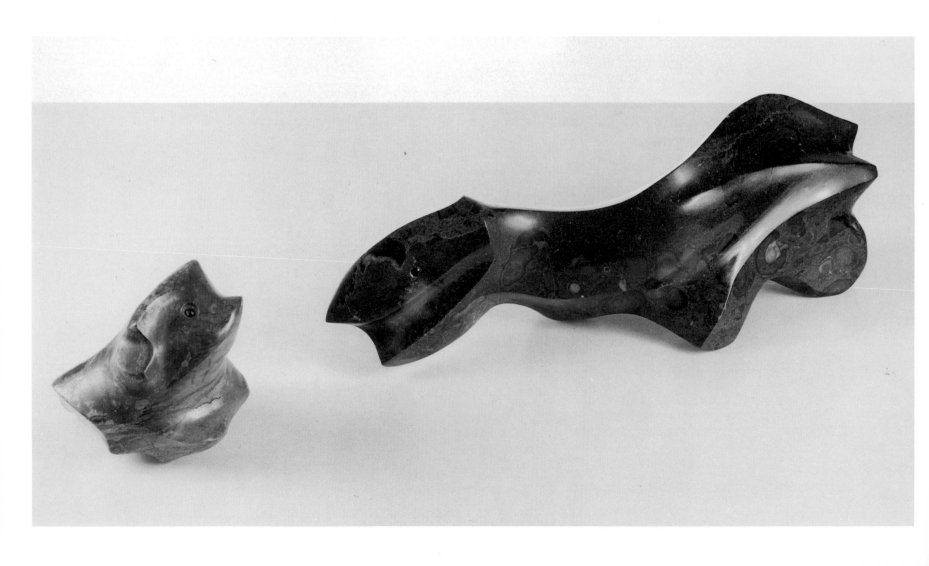

Danila Vassilieff
Nude (early 1950s) Marble

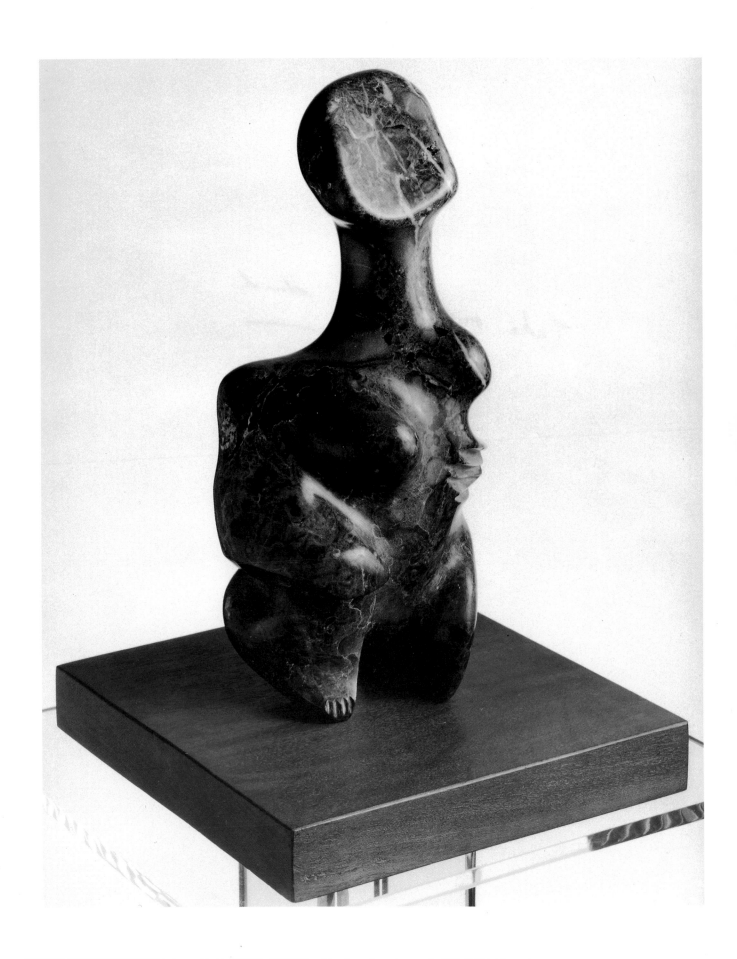

Danila Vassilieff
Family: Murray River carnival 1956 Oil

Danila Vassilieff
Sir Bernard Heinze conducting (1951–52) Walnut

John Perceval
Boy with kite, Fitzroy 1943 Oil

John Perceval
Boy with kite, Fitzroy 1943 Oil

John Perceval
Potato field 1948 Oil

John Perceval
Floating dock and tugboats 1956 Oil

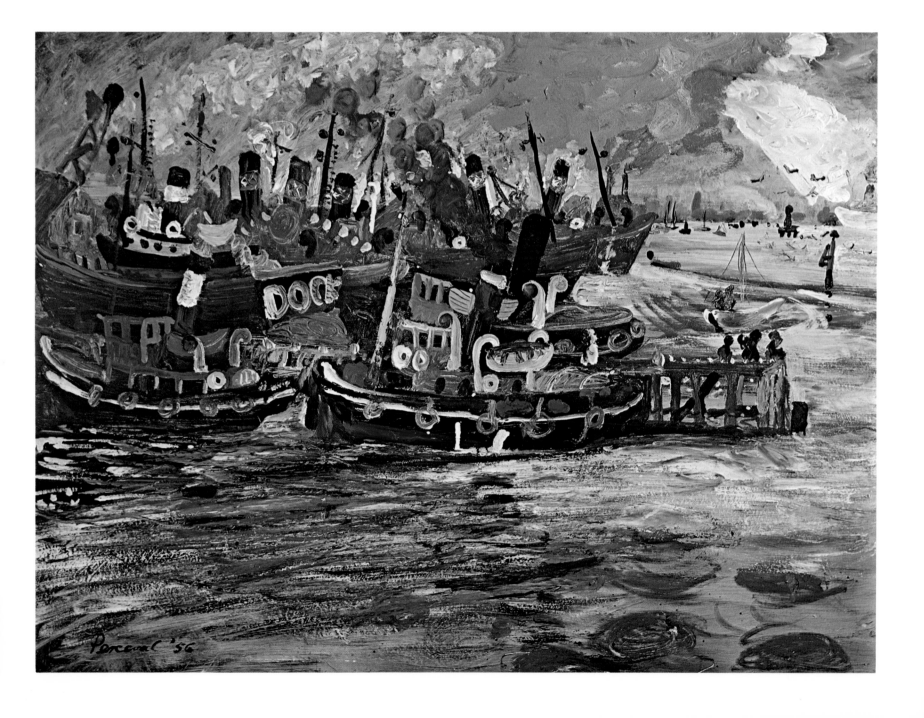

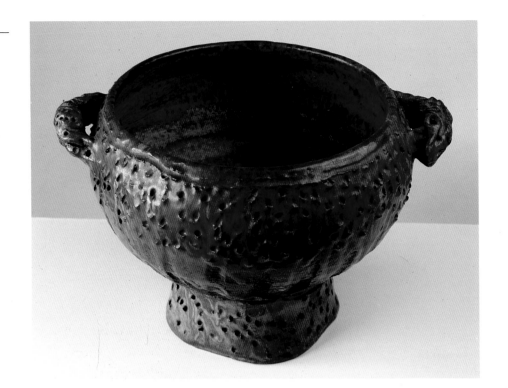

247
John Perceval
Bowl 1957 Earthenware

248
John Perceval
Two angels 1961 Earthenware

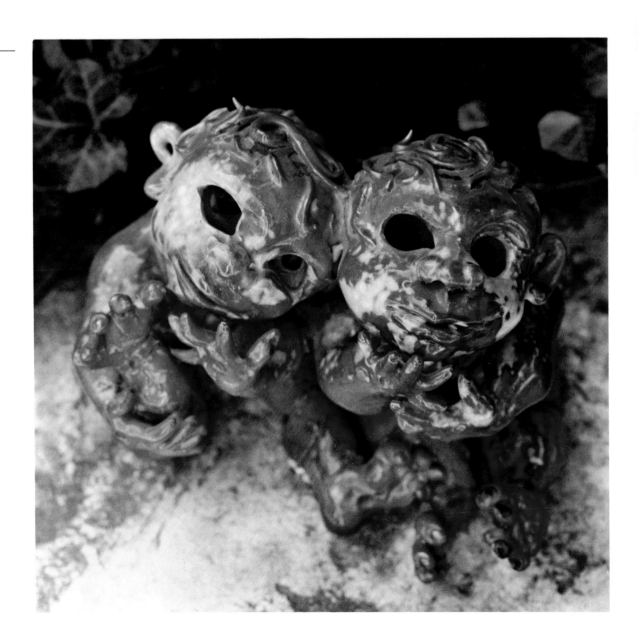

Albert Tucker
Image of Modern Evil 1945 Pen and coloured inks

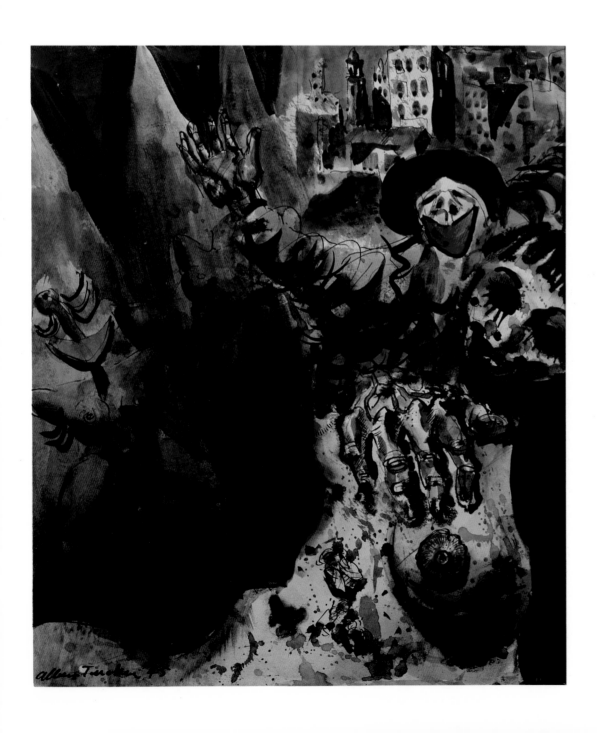

Albert Tucker
Image of Modern Evil (1945) Oil

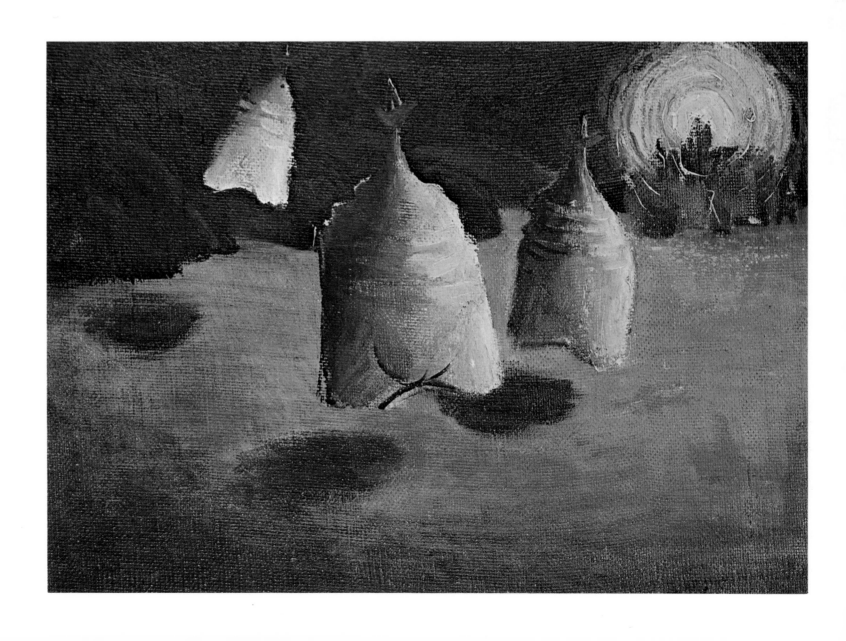

Albert Tucker
Image of Modern Evil (c. 1970) Bronze

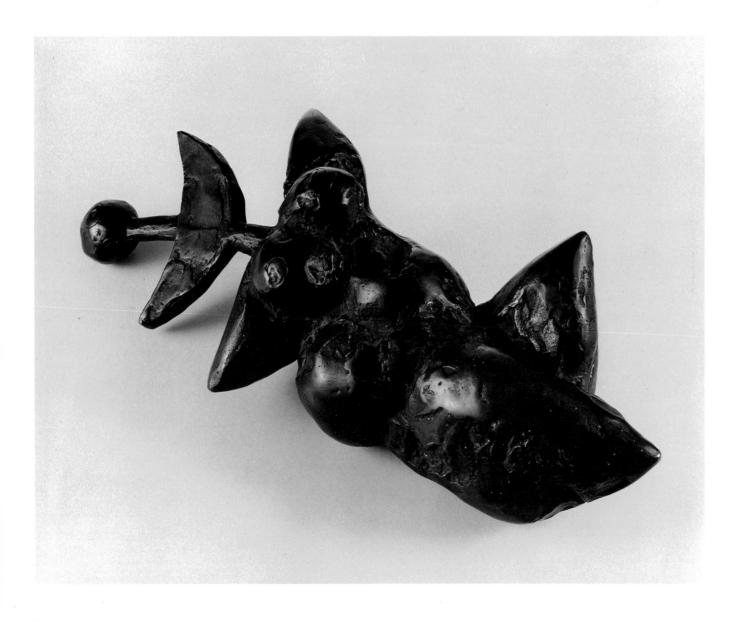

Albert Tucker
Explorer and parrot 1960 Oil

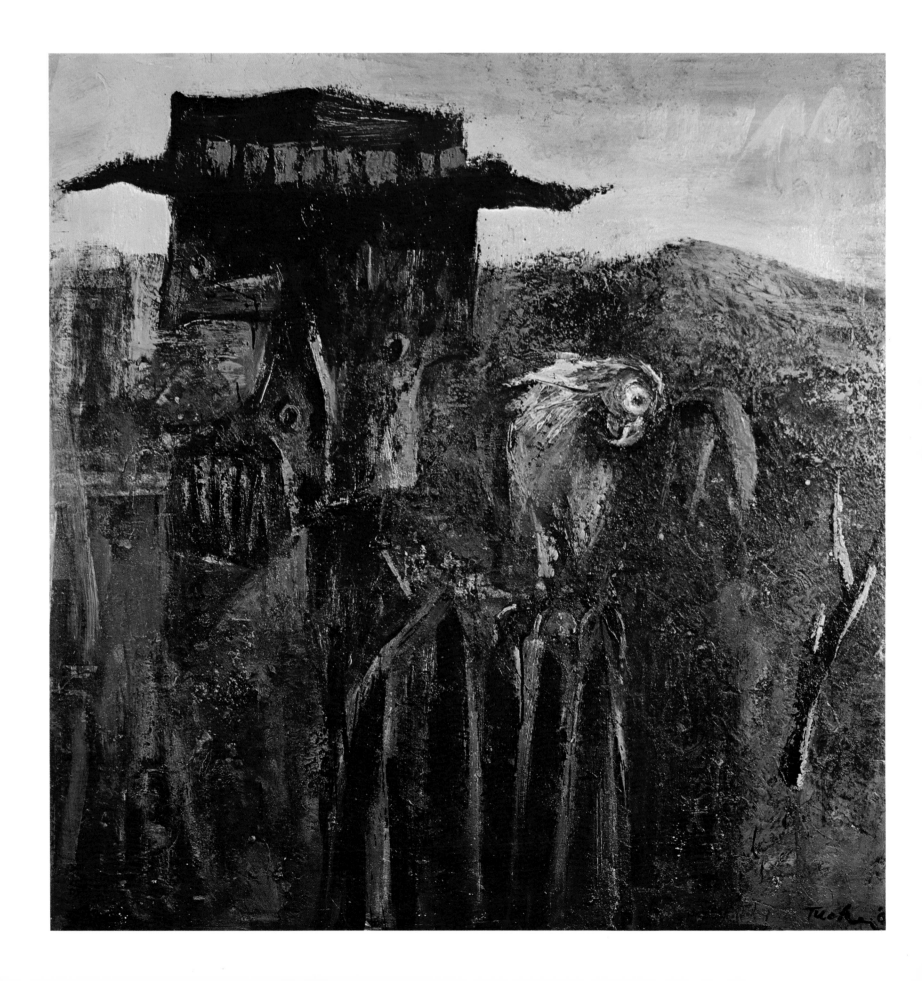

Sidney Nolan
Abstract drawing (1940) Monotype

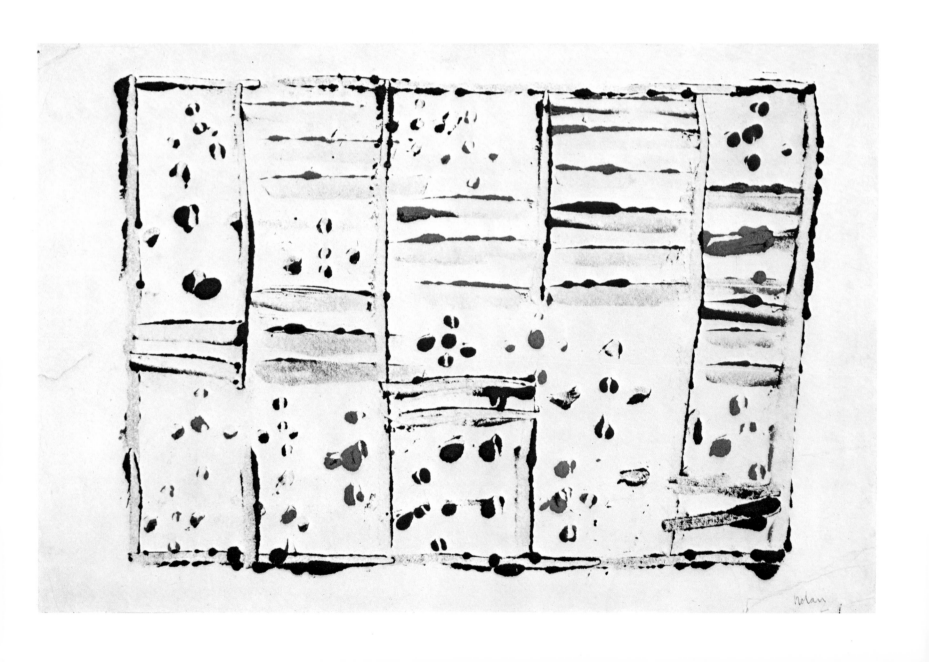

Sidney Nolan
Bell, St Kilda (c. 1942) Oil

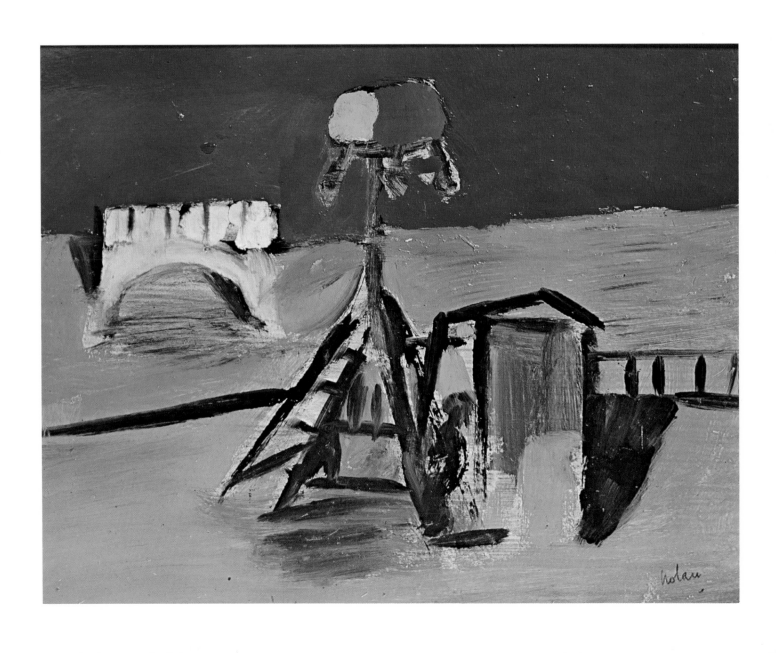

Sidney Nolan
Unnamed ridge, Central Australia (1949) Ripolin enamel

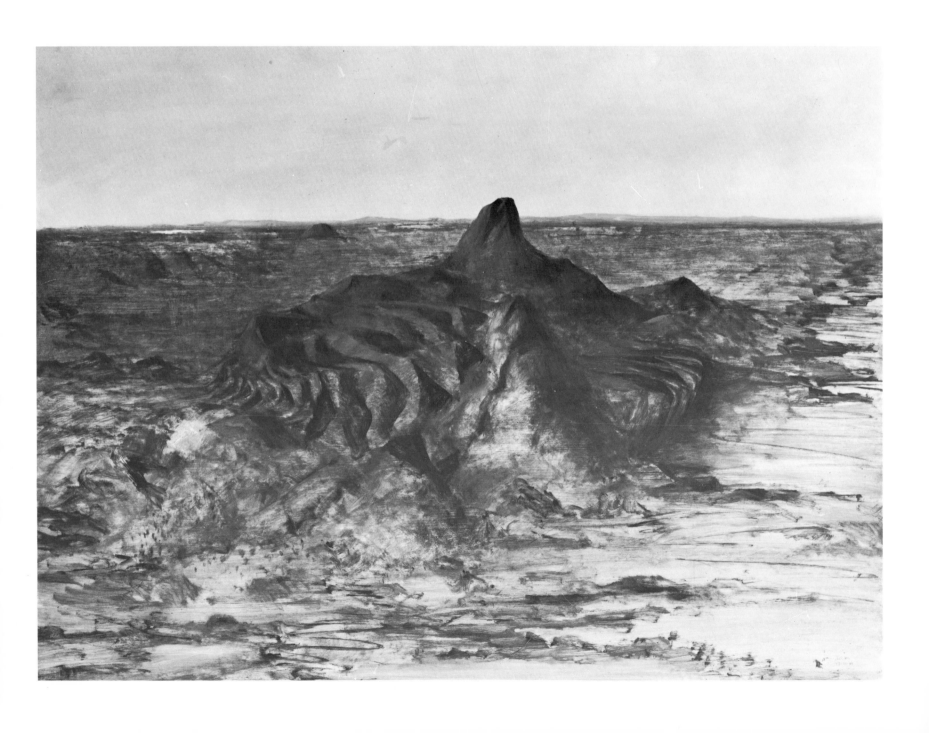

Sidney Nolan
Unnamed ridge, Central Australia (1949) Ripolin enamel

Sidney Nolan
Carcass (*c.* 1950) Ripolin enamel

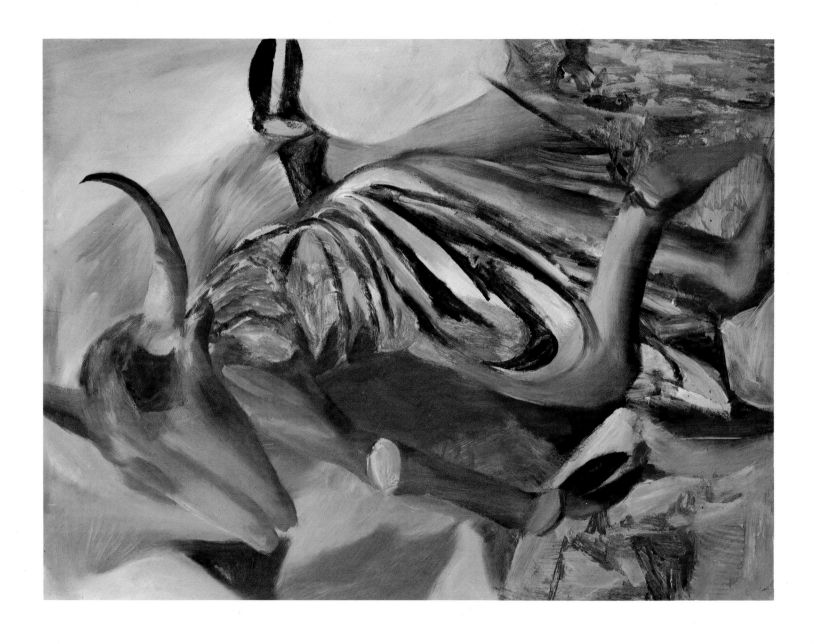

Sidney Nolan
Crucifix 1955 Oil

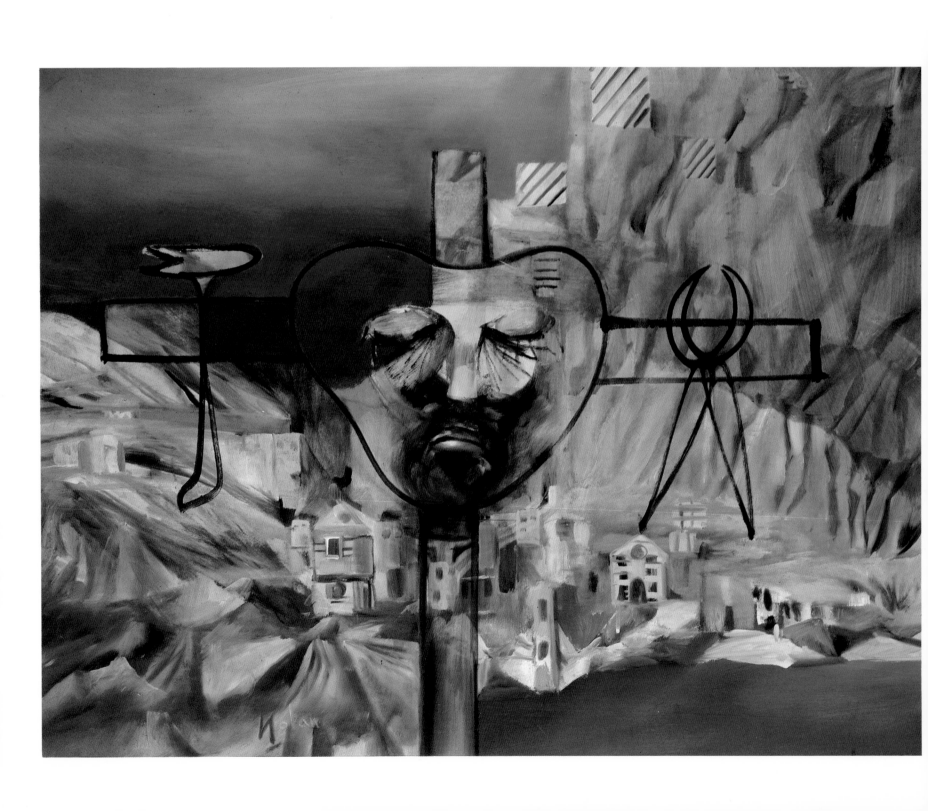

Arthur Boyd
Christ bearing the Cross (*c.* 1946) Oil

Arthur Boyd
Family group (*c.* 1946) Oil

Arthur Boyd
Family group (*c.* 1946) Oil

Arthur Boyd
Wheatfield, Berwick (1948) Oil

Arthur Boyd
Europa and the Bull platter (c. 1948) Earthenware

Arthur Boyd
Bride and groom by a creek (c. 1960) Oil

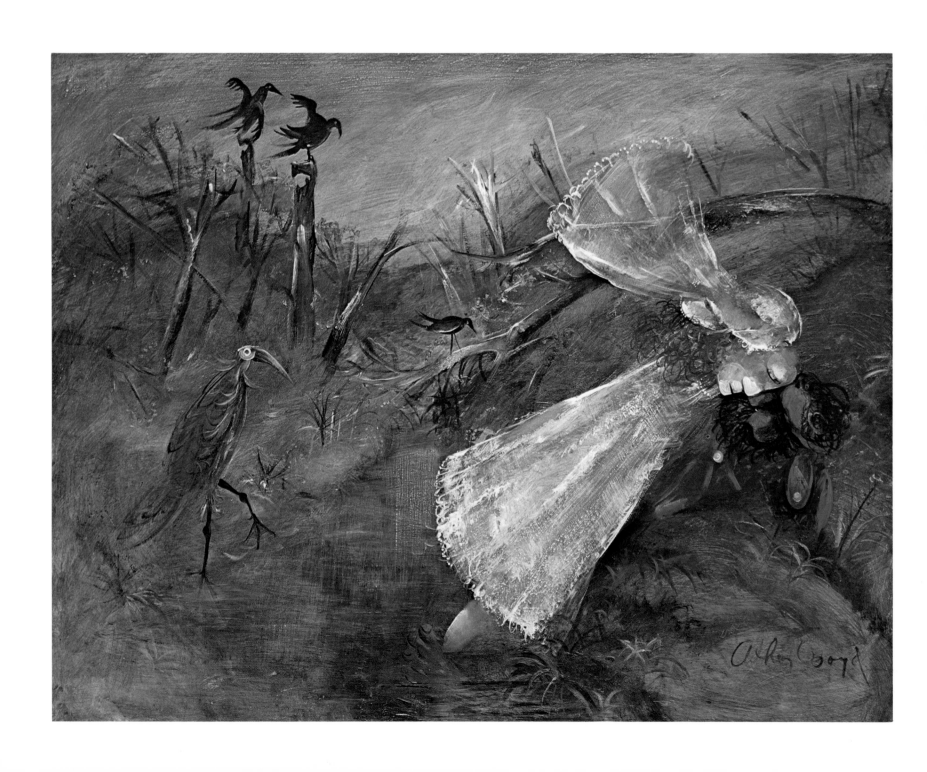

Arthur Boyd
Lysistrata (1970) Pen and ink

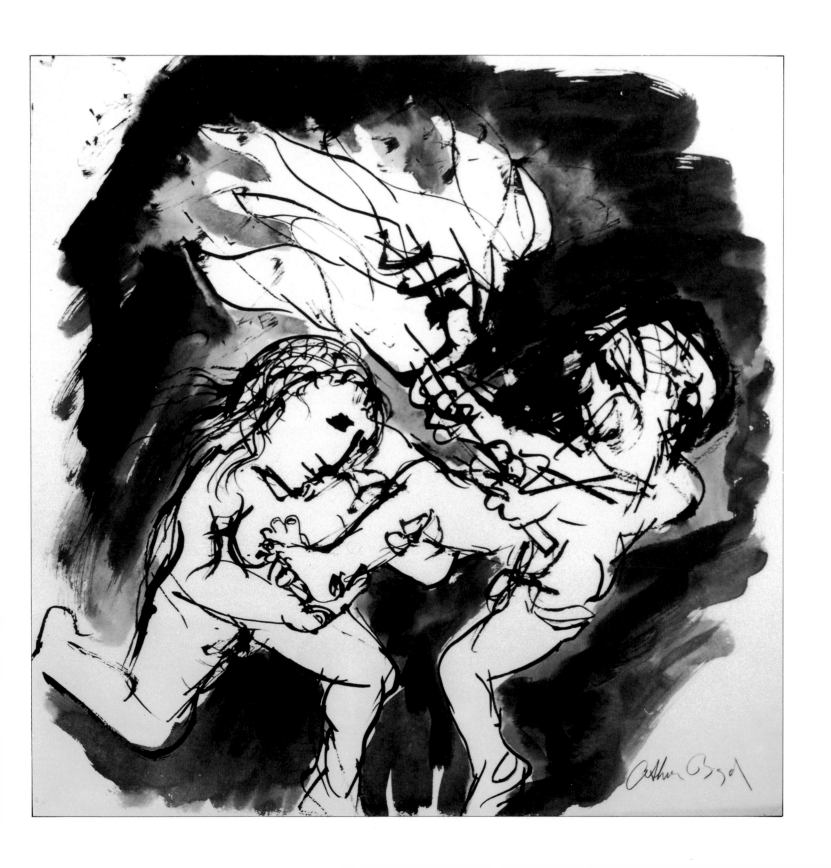

Arthur Boyd
Birth of Narcissus (1976) Oil

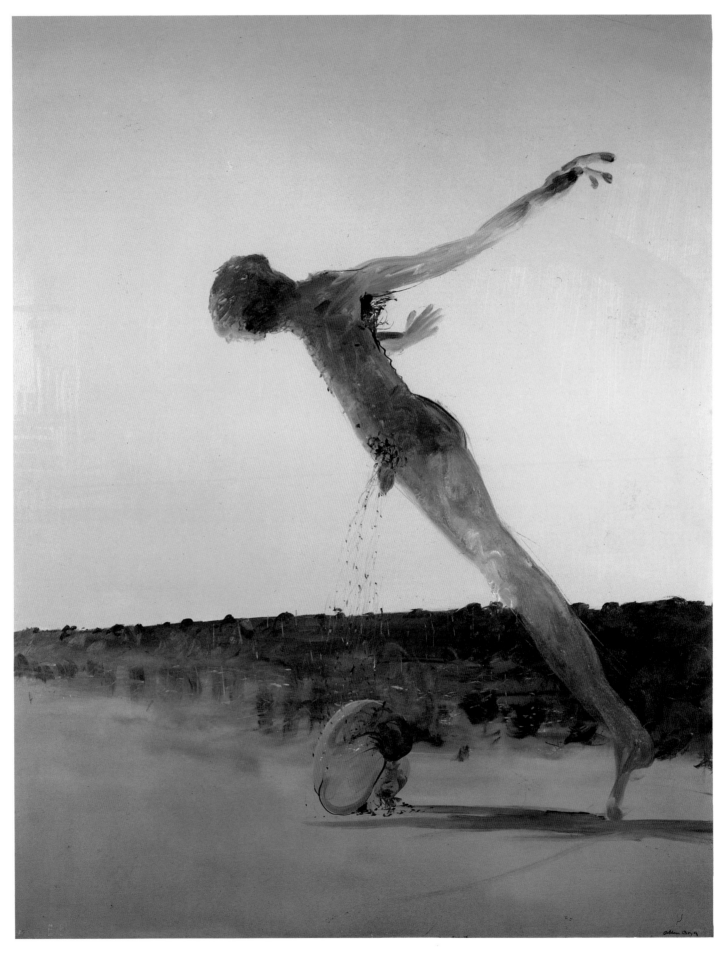

Arthur Boyd
Stoat (1970) Oil

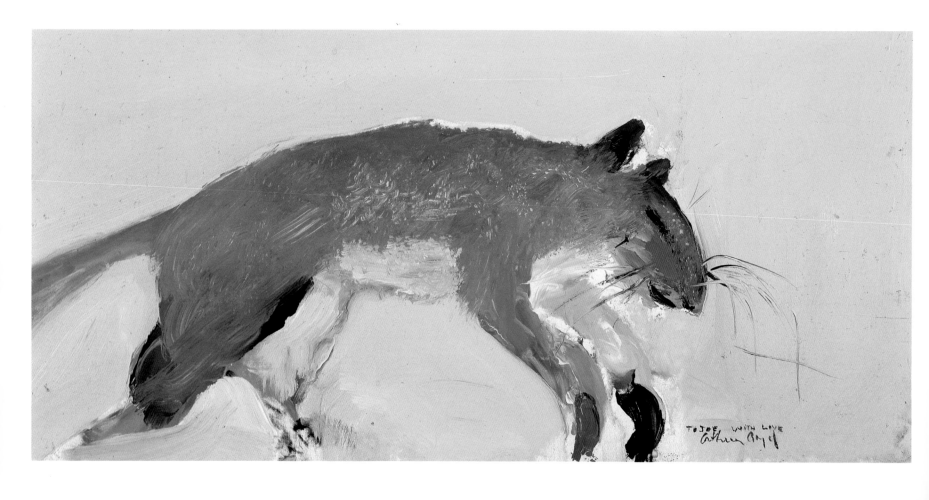

Arthur Boyd
Clay and rockface at Bundanon (1981) Oil

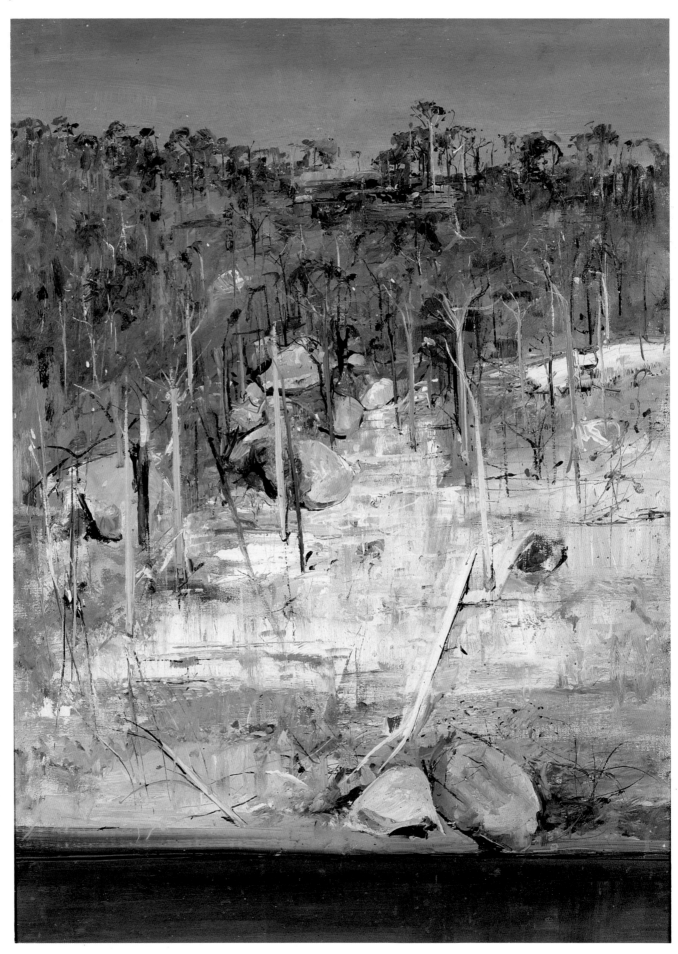

Joy Hester
Lovers (*c.* 1945) Watercolour

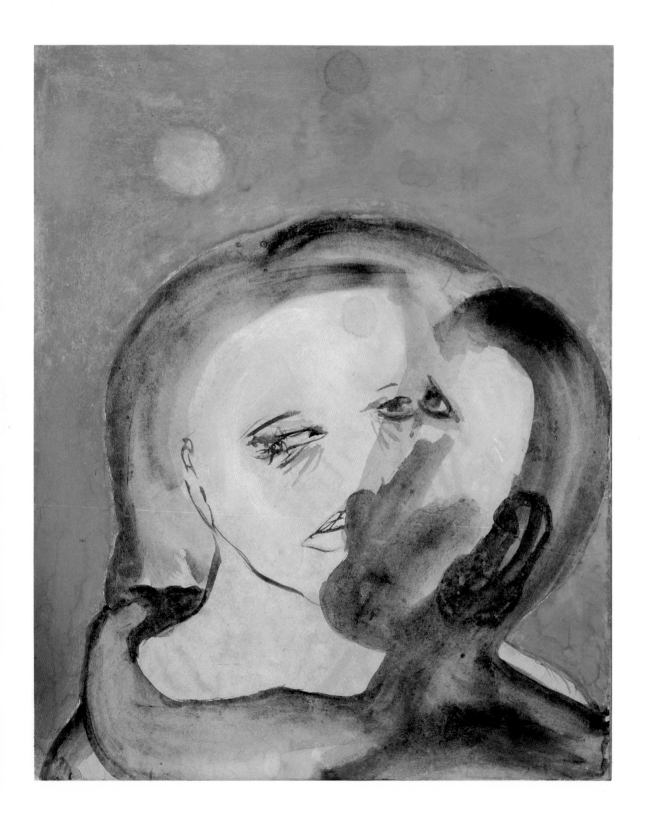

Joy Hester
Lovers (*c.* 1945) Watercolour

James Wigley
Salvation Army meeting 1937 Watercolour

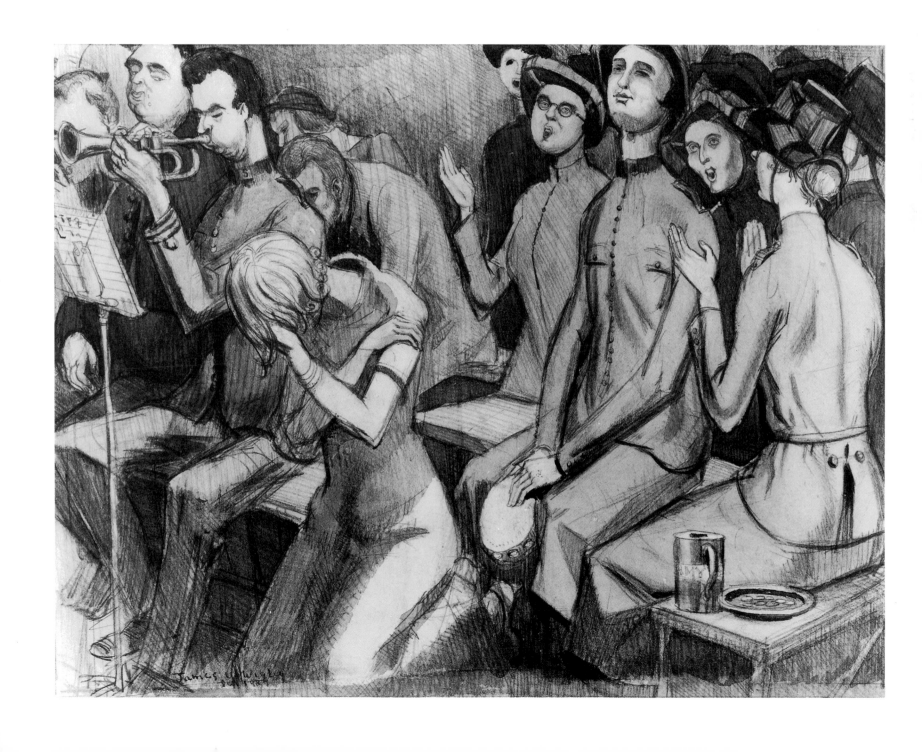

Yosl Bergner
House backs, Parkville (*c*. 1938) Oil

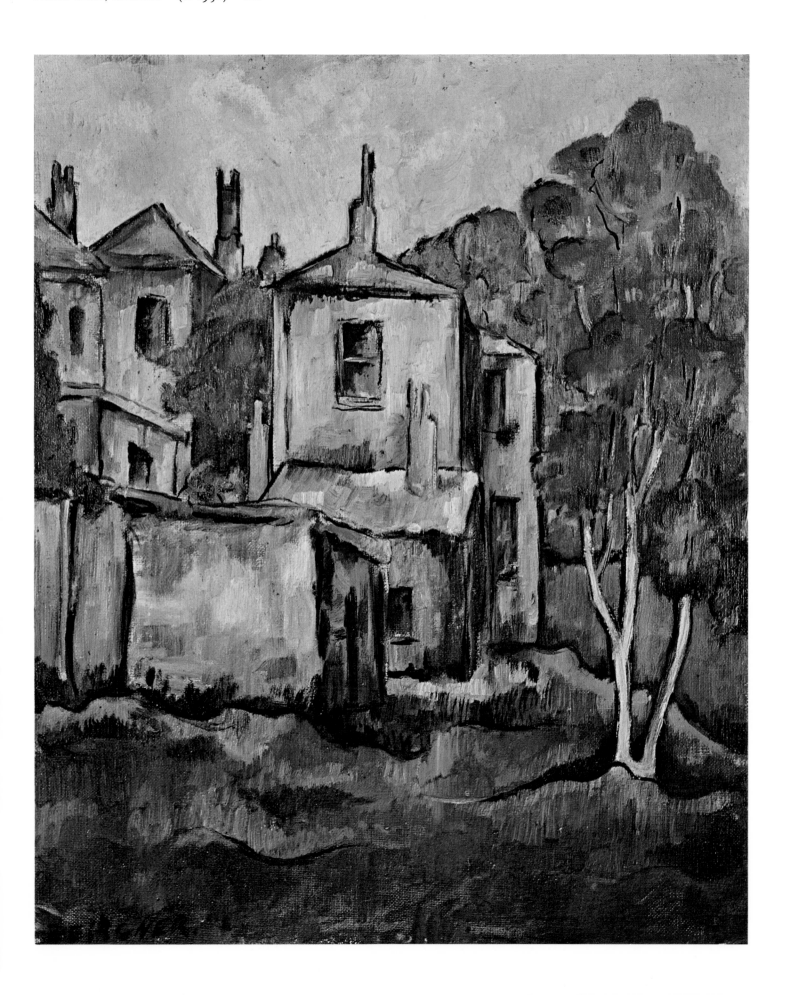

Yosl Bergner
In Fitzroy (*c.* 1940) Oil

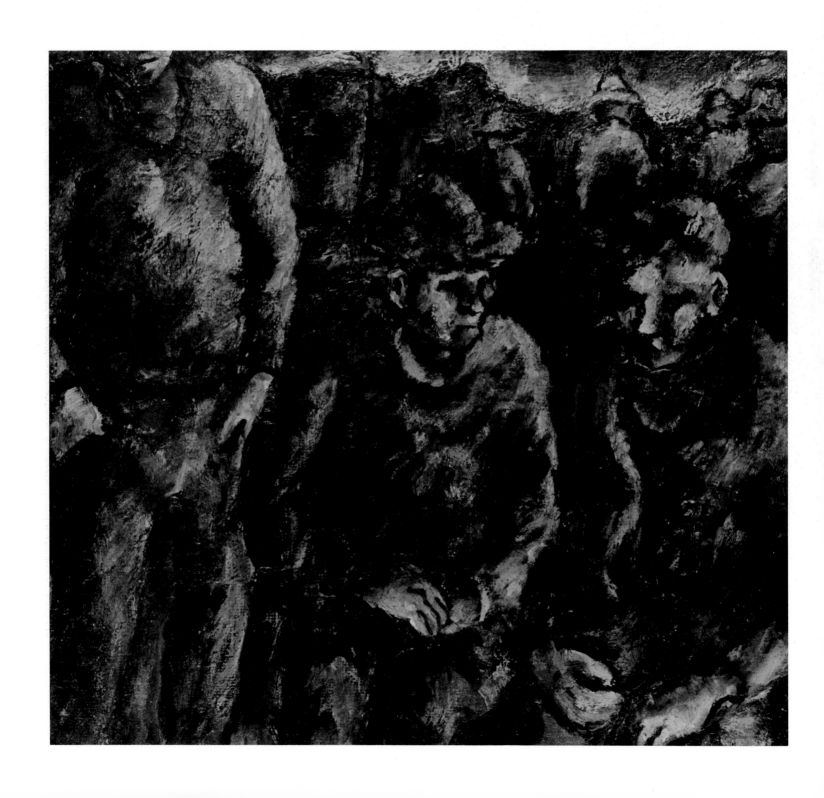

Vic O'Connor
Refugees (c. 1942) Oil

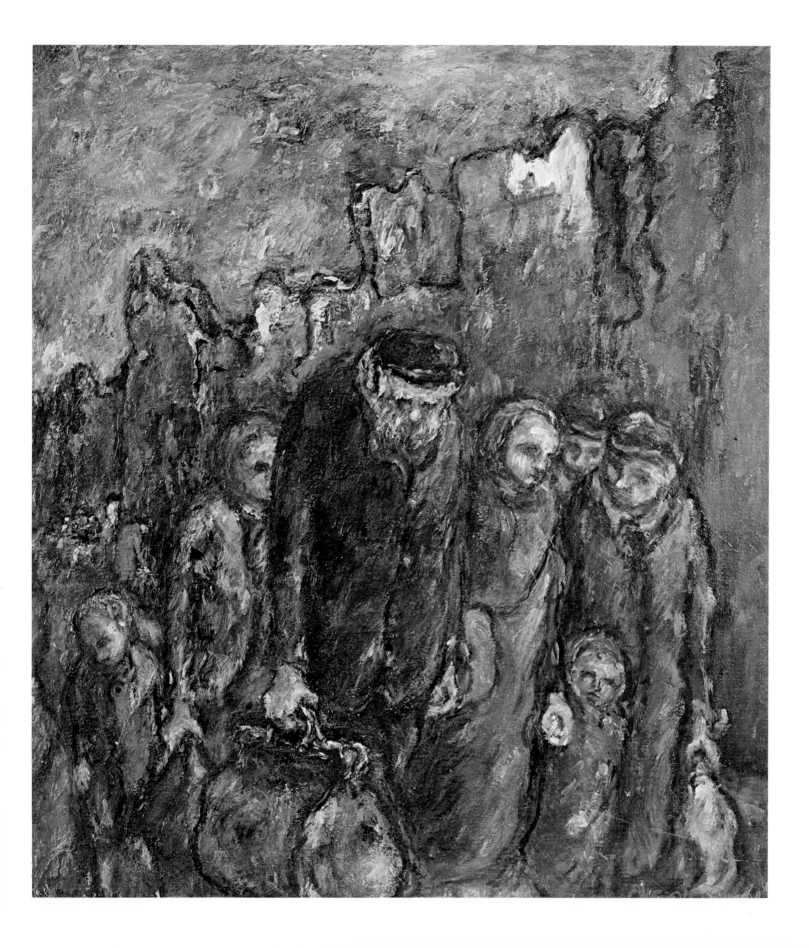

Vic O'Connor
Refugees (c. 1942) Oil

Noel Counihan
The lady with the fox fur coat 1942 Oil

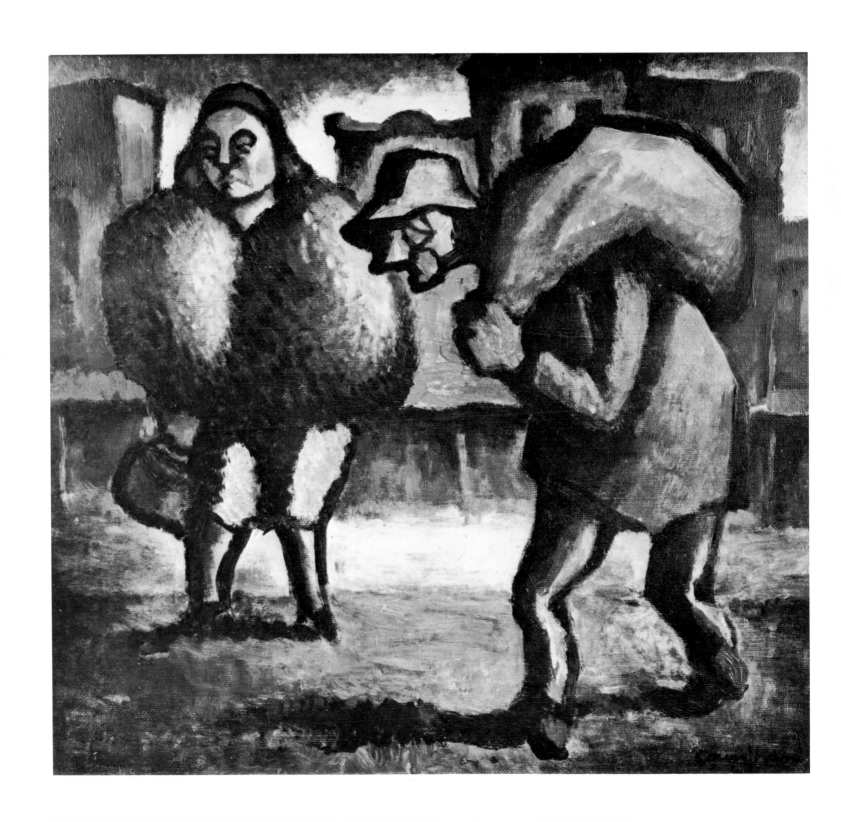

Robert Klippel
Metal sculpture (1965) Steel

Robert Klippel
R.K. 255 1970 Steel

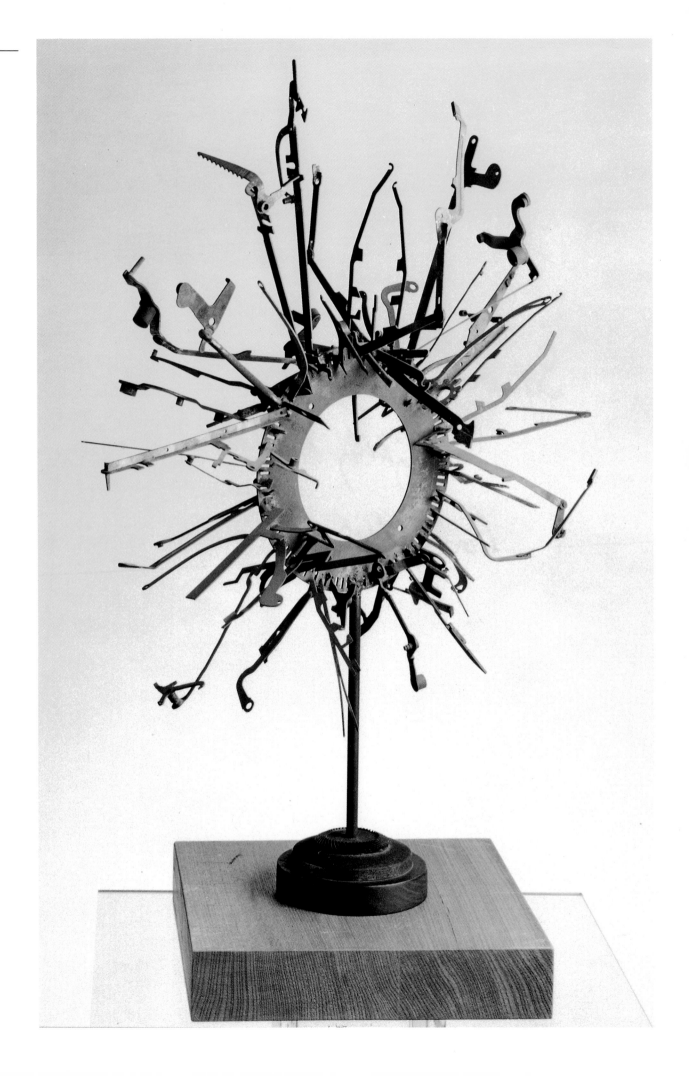

Robert Klippel
Landscape 1970 Watercolour

Robert Klippel
R.K. 451 1982 Bronze

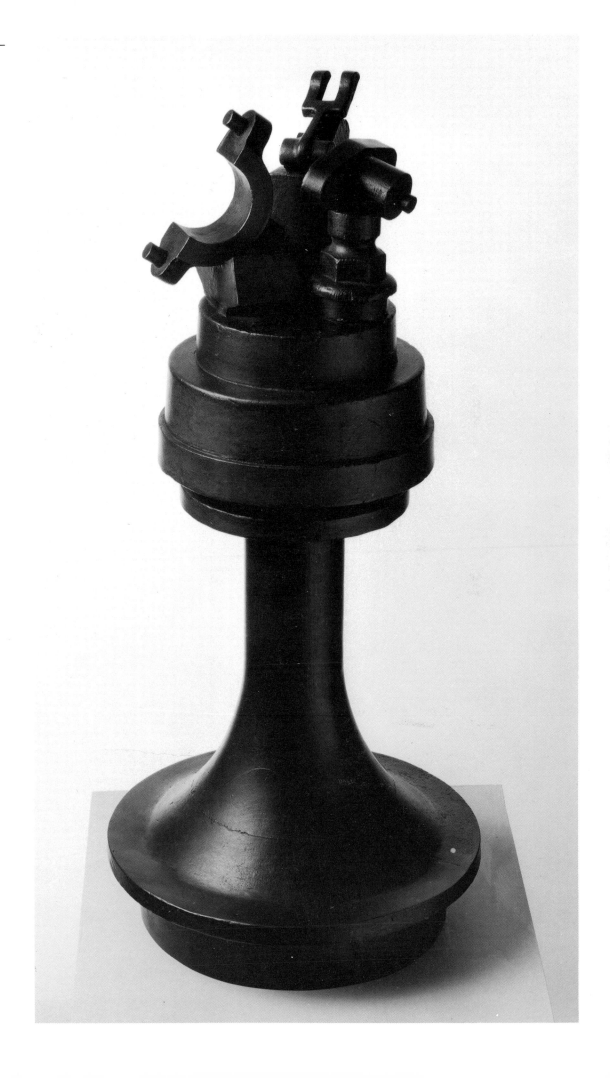

Jon Molvig
Head of madman 1957 Charcoal

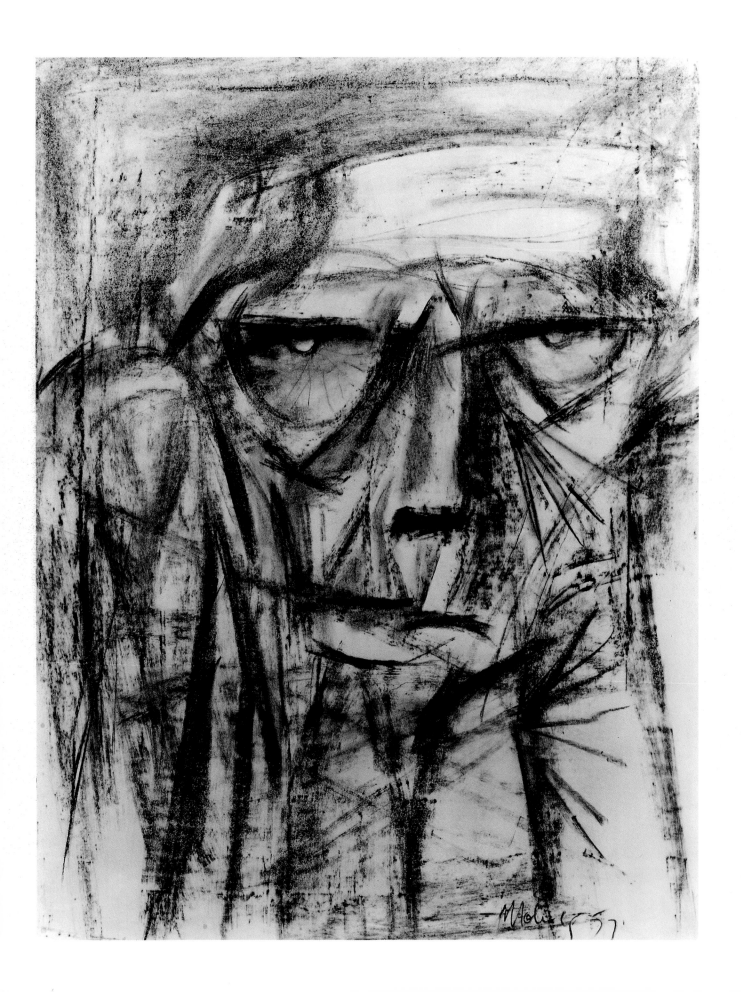

Clifton Pugh
Bush 1957 Oil

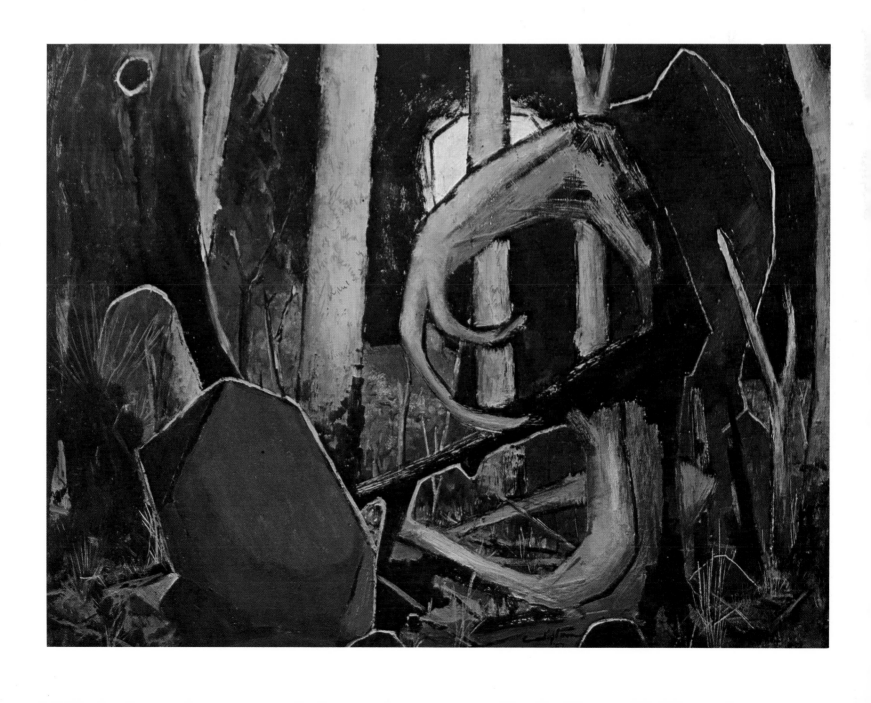

Desiderius Orban
Abstract (1950s) Pastel

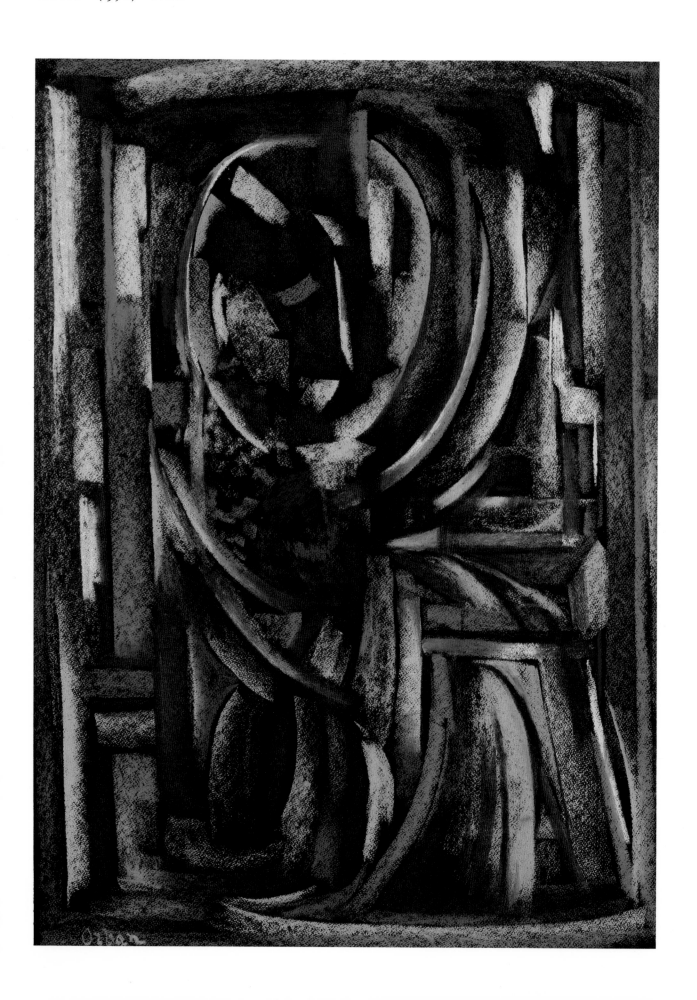

Sam Atyeo
Little Lonsdale Street (*c.* 1950) Watercolour

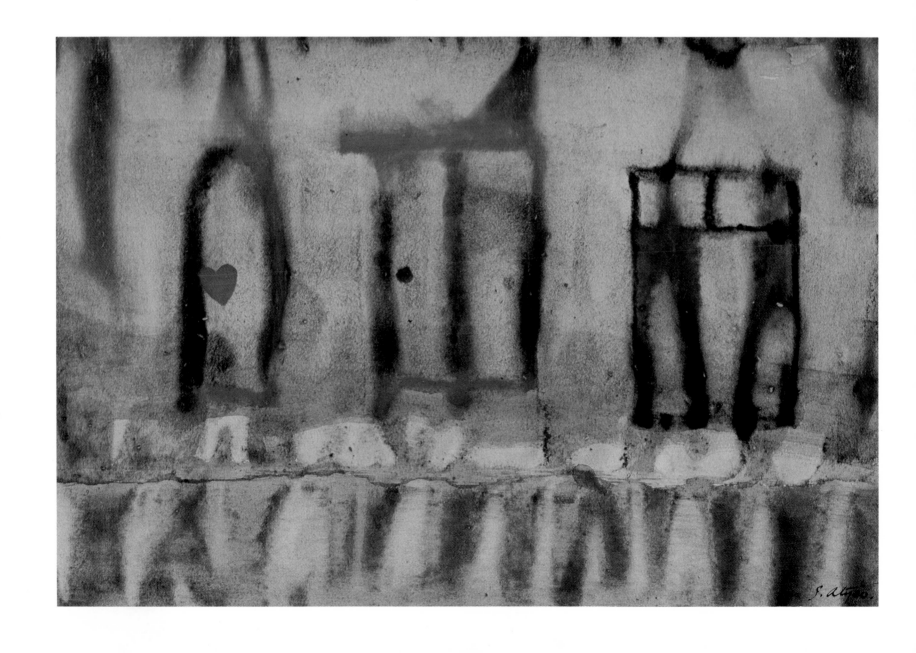

Teisutis Zikaras
Head (1960) Wood

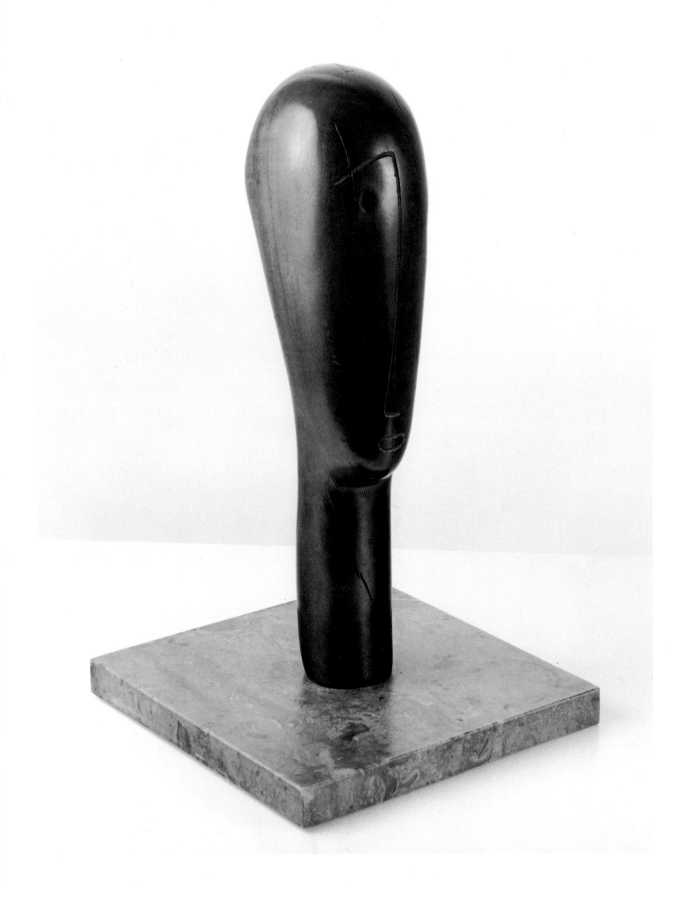

Sam Fullbrook
Plane with yellow wings (1963) Oil

Justin O'Brien
Head of a girl (c. 1950) Oil

Donald Friend
The Clarence from Yulgilbar (1963) Oil

Ivor Francis
Nostalgic landscape 1944 Oil

James Gleeson
The Siamese Moon 1951 Oil

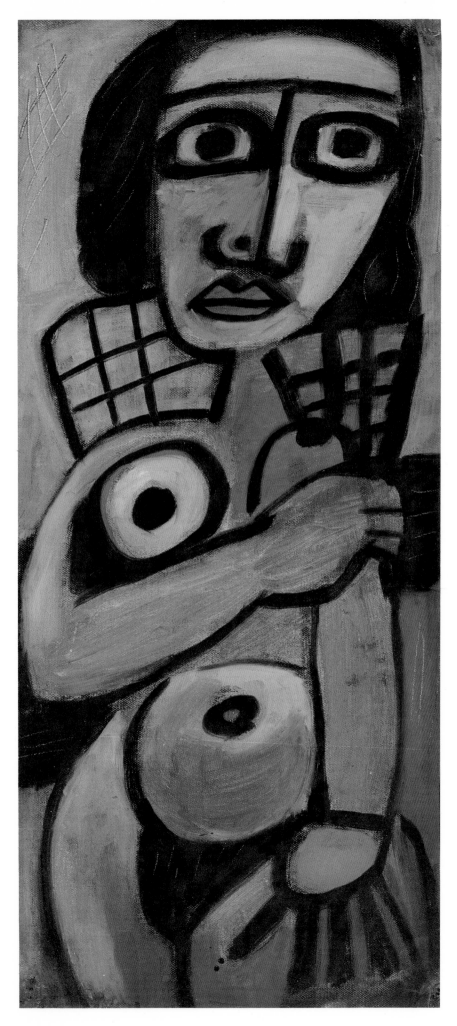

Tony Tuckson
Female nude (1952) Oil

Tony Tuckson
Untitled (c. 1955) Gouache

Roger Kemp
Sequence 1973 Etching

Roger Kemp
Abstract (1960) Oil

George Baldessin
The enclosure (1964) Bronze

George Baldessin
Personage with striped dress 1968 Etching

Fred Williams
Cricketer 1955 Oil

Fred Williams
Beach scene 1954 Gouache

Fred Williams Decorated by **Williams**, potted by **Tom Sanders**
Water urn 1967 Earthenware

296

Fred Williams
Upwey landscape (1965) Gouache

297

Fred Williams
Werribee Gorge 1978 Gouache

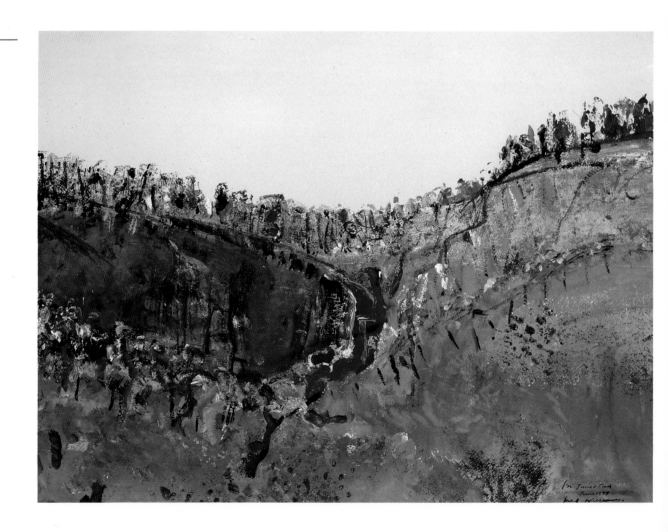

Fred Williams
Mill's Beach, Mornington (1970s) Gouache

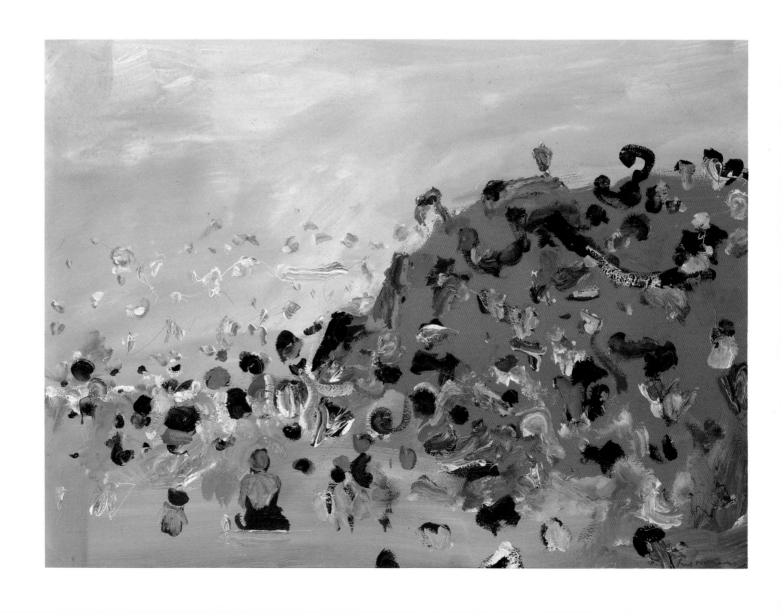

Fred Williams
Woman (1955) Etching

Fred Williams
Saplings (1962) Etching

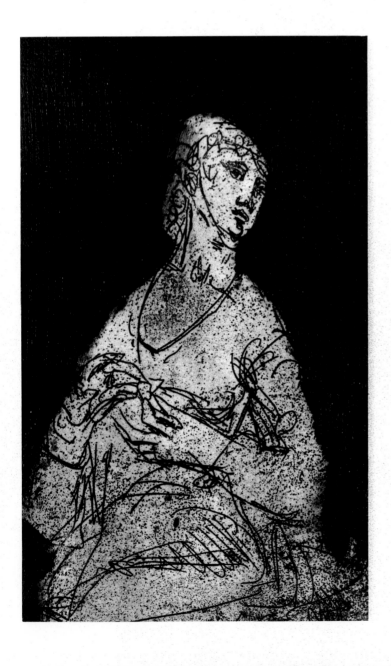

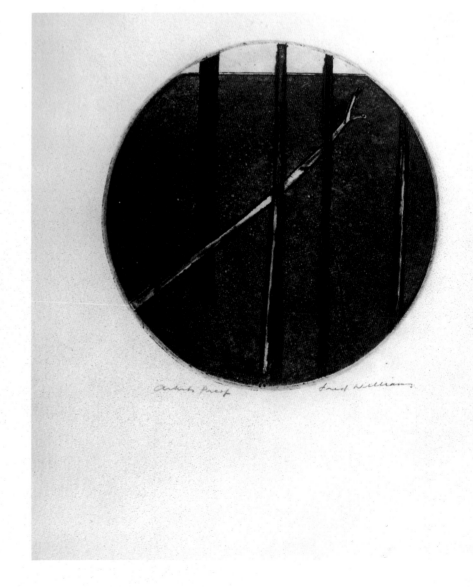

Fred Williams
Young girl III (1966) Etching

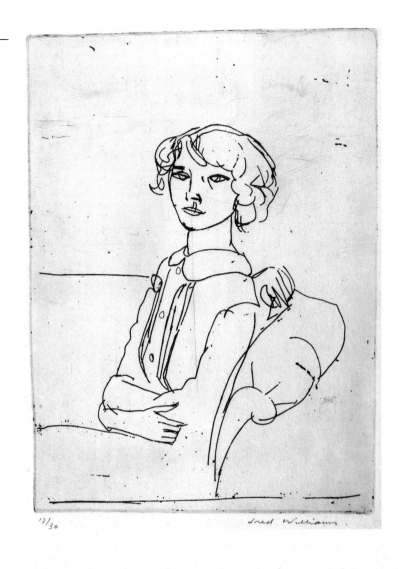

Fred Williams
The actor 1956 Etching

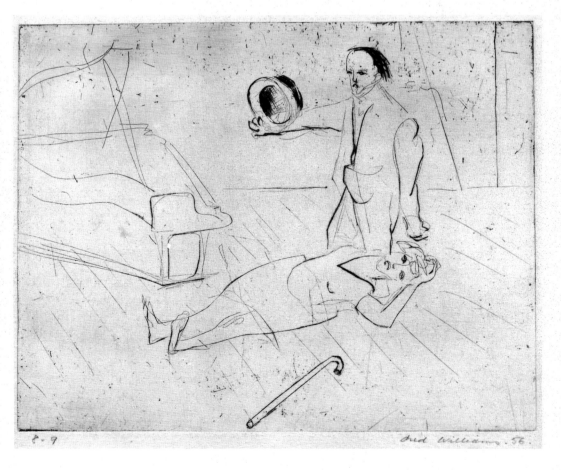

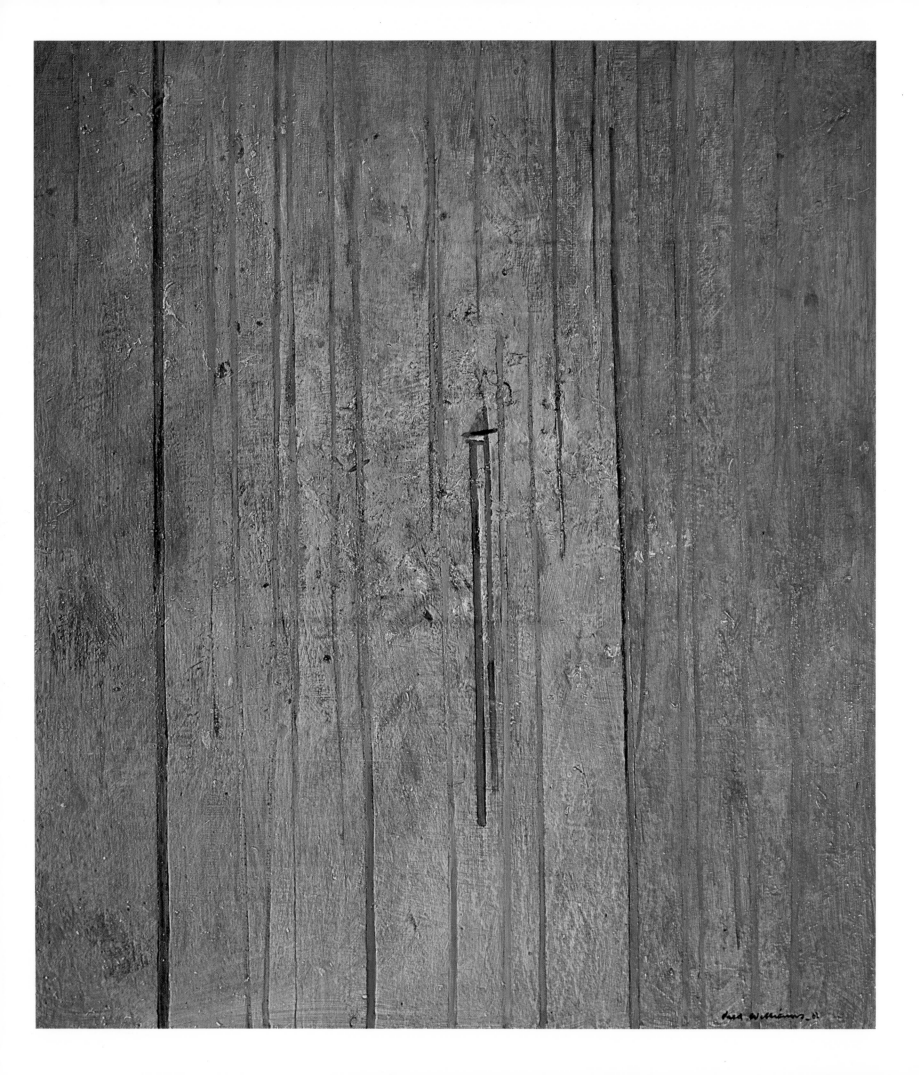

303
Fred Williams
Echuca landscape 1962 Oil

304
Fred Williams
Hillside (1966) Oil

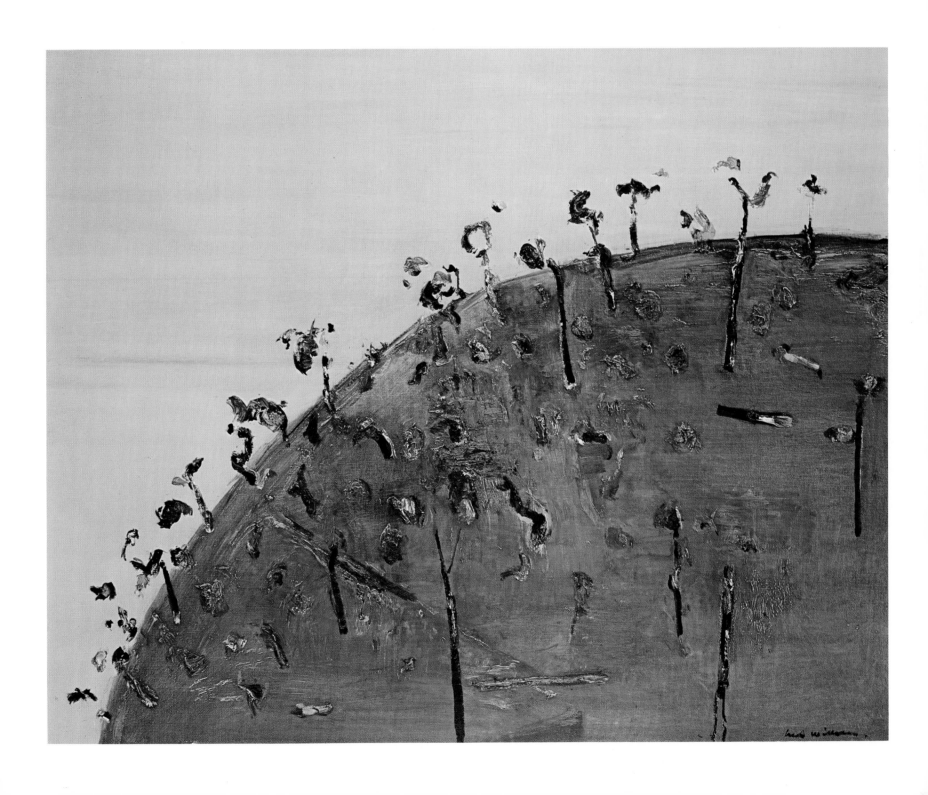

Leonard French
Death and Transfiguration (1957) Enamel

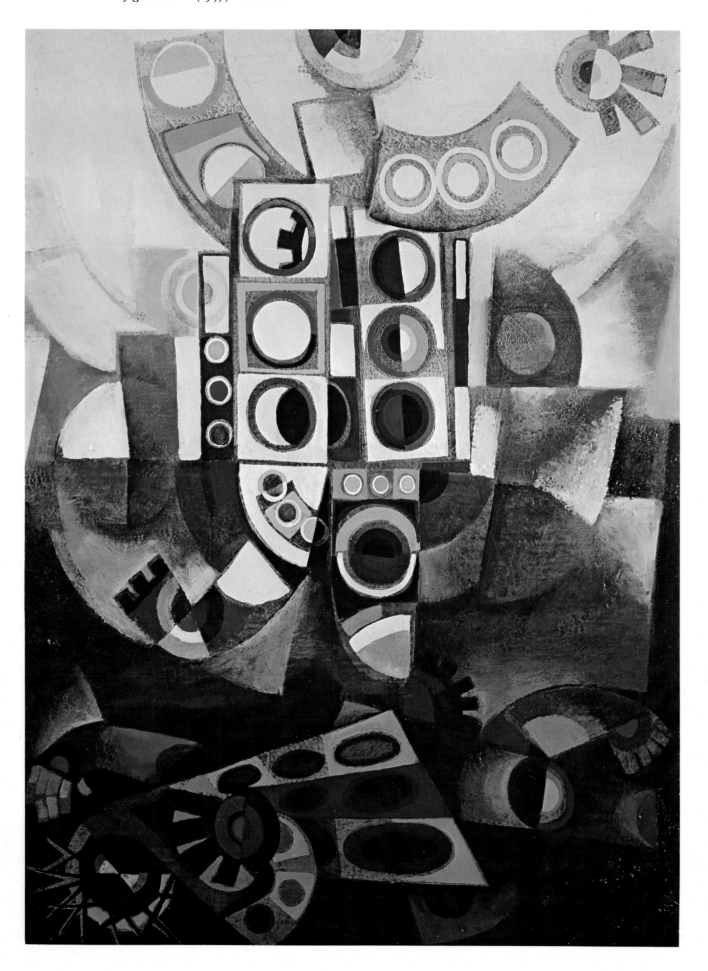

George Johnson
Pilgrim (1963) Oil

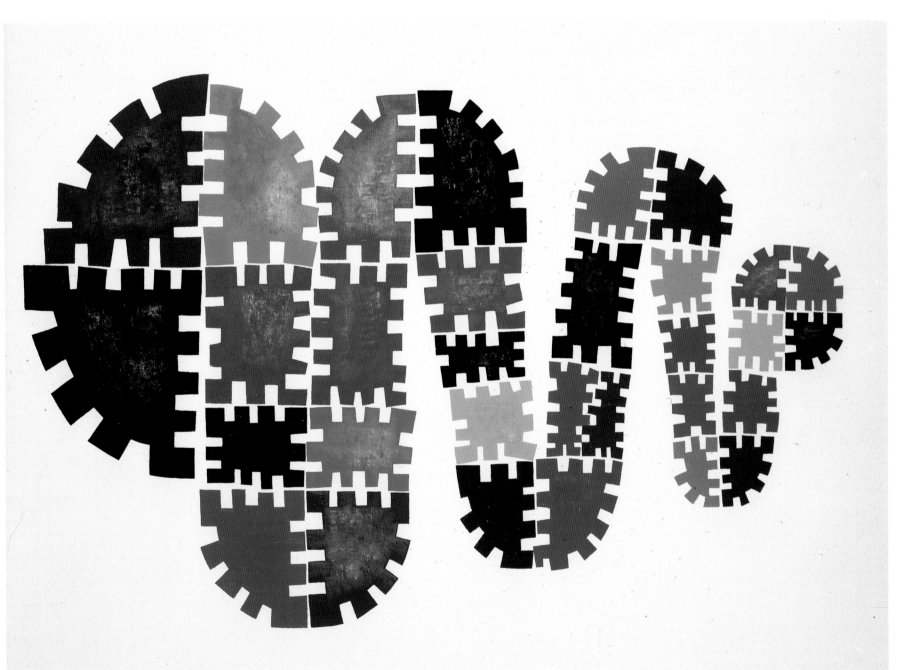

Clifford Last
Cruciform 1965 Wood

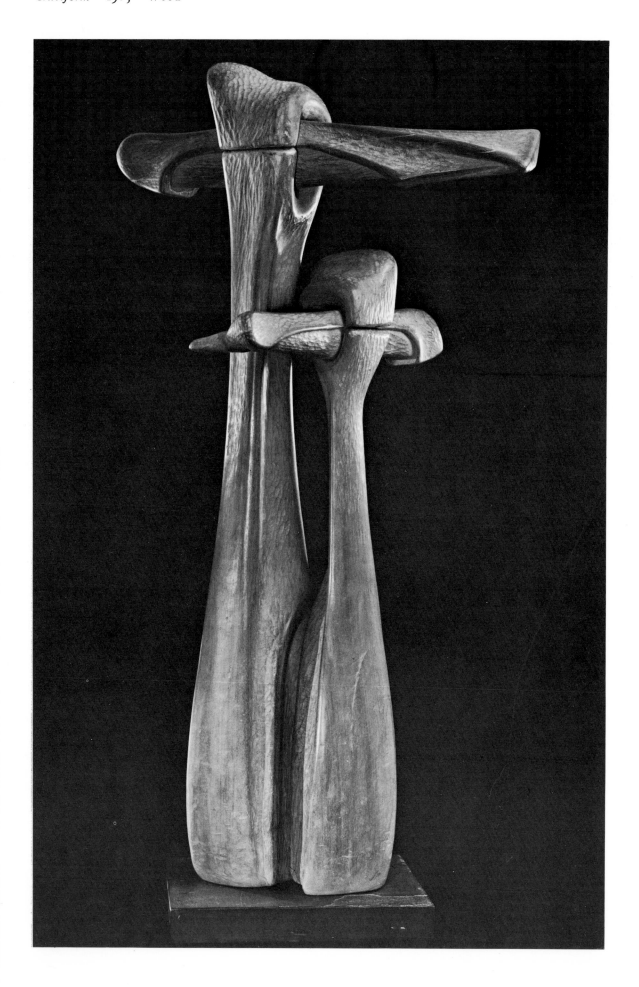

Clifford Last
The custodians 1967 Bronze

John Brack
The block 1954 Oil

John Brack 54

John Brack
Two jockeys 1956 Drypoint

311
John Brack
Two typistes 1955 Oil

John Brack
Nude with dressing gown
1967 Oil

313

John Brack
Nude on a small chair 1975 Pastel

John Brack
Confrontation 1978 Pen and ink and watercolour

Charles Blackman
Rooftop (1953) Charcoal

Charles Blackman
Lovers 1960 Oil

Charles Blackman
Rooftop (1953) Charcoal

Mike Brown
One, two, three four five . . . (c. 1965) Enamel and collage

Keith Looby
The family (1960s) Oil

William Rose
Abstract 1966 Watercolour and ink

Norma Redpath
Horse, bird and sun 1963 Bronze

Elwyn Lynn
Second half (1961) Mixed media

Elwyn Lynn
Second half (1961) Mixed media

Jeffrey Smart
On the roof (1967) Oil

Stanislaus Ostoja-Kotkowski
The planet 1965 Paper collage

Alun Leach-Jones
Noumenon Forecast VI (1969) Acrylic

Sydney Ball
Canto no. 28 1966 Acrylic

Peter Upward
September Tablet 1961 Oil

Guy Stuart
Baffles 1971 Crayon

John Olsen
Granada 1959 Oil

John Olsen
Man absorbed in landscape 1966 Oil

John Olsen
Vase 1971 Earthenware

Brett Whiteley
Painting (*c.* 1961) Oil and canvas collage

Brett Whiteley
Baboon (c. 1966) Fibreglass

Brett Whiteley
Still life with cornflowers 1976 Oil

Ivan Durrant
Clark Gable nightflight 1974 Acrylic

Dale Hickey
Group of cups (1972) Oil

Asher Bilu
Graphite I (1969) Synthetic resin
Gifted to the Australian National Gallery

Asher Bilu
Graphite I (1969) Synthetic resin
Gifted to the Australian National Gallery

Donald Laycock
Metamorphis 1970 Oil
Gifted to the Australian National Gallery

Robert Jacks
Silently emptied 1966 Oil

Clement Meadmore
Bent 1966 Steel

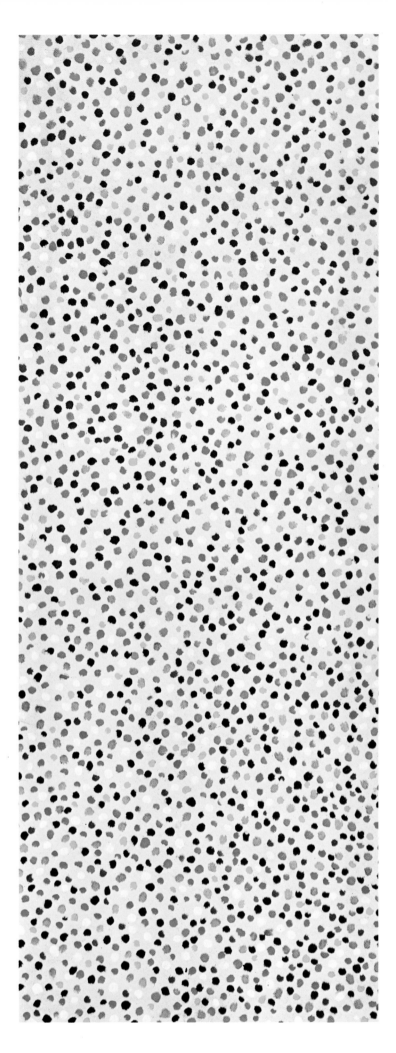

John Peart
Painting (1968) Oil

John Firth-Smith
Sydney Harbour 1966 Oil

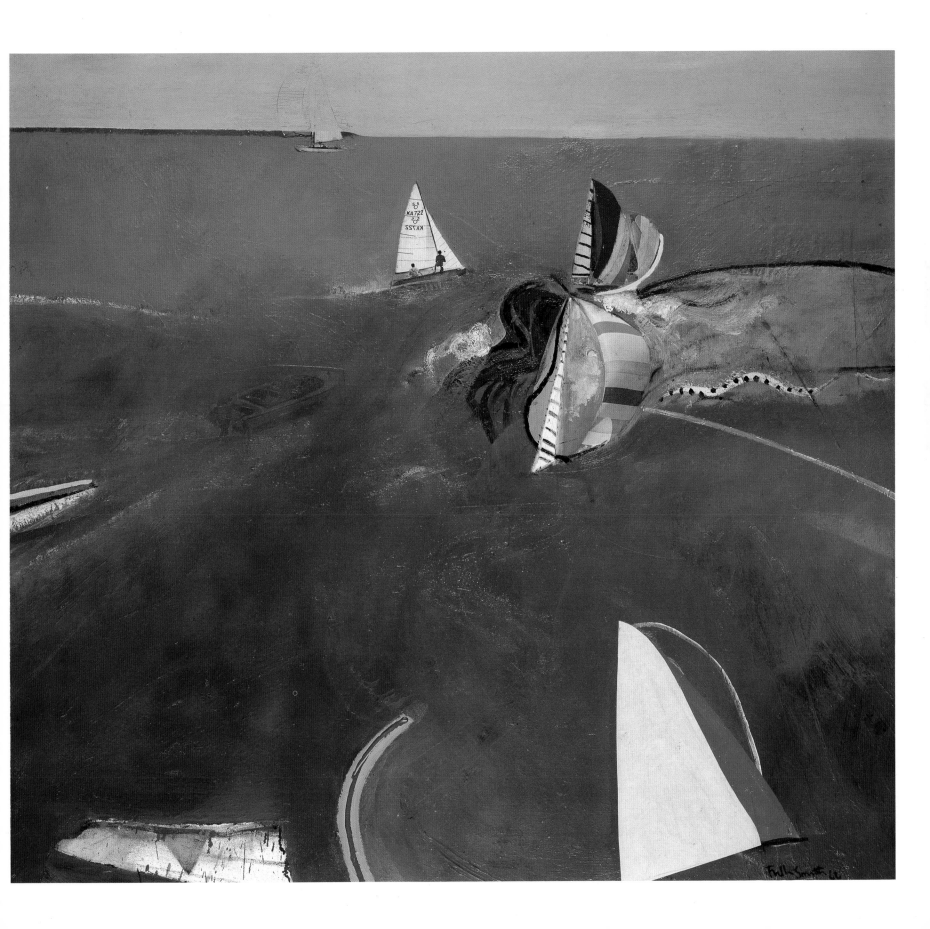

Peter Booth
Red, yellow, black abstract 1966–67 Oil

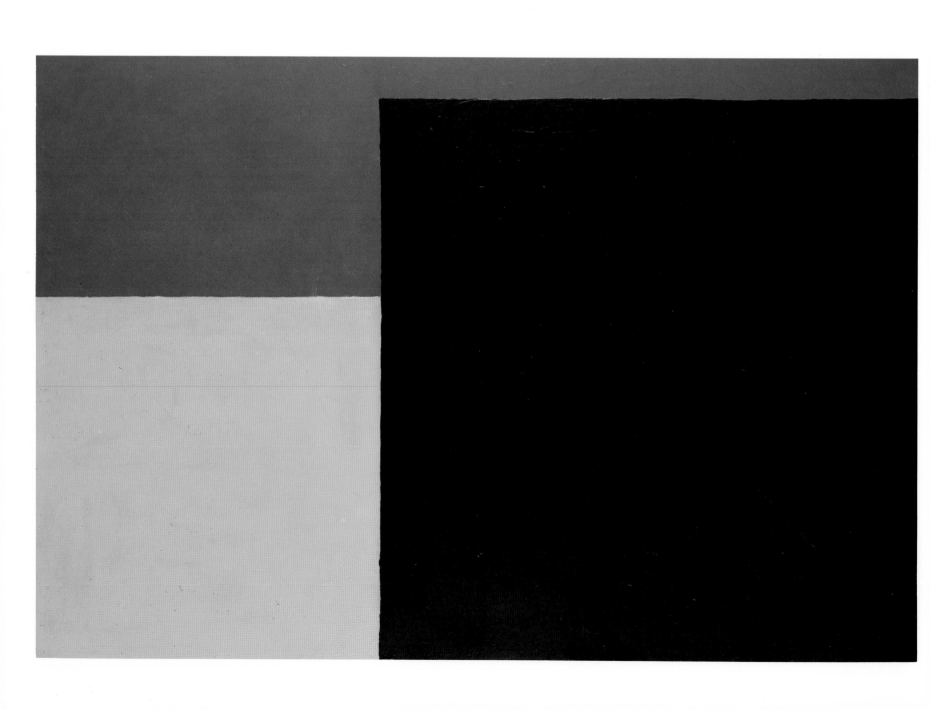

Peter Booth
Red, yellow, black abstract 1966–67 Oil

Peter Booth
Drawing 1979 Brush and ink

344
Gunter Christmann
Rhastu-dh-dhill 1970
Acrylic

David Aspden
'Brazil' series (1972) Oil

Ron Robertson-Swann
Vault (1978–79) Steel

Ron Robertson-Swann
Figure and ground at the dance (1983) Acrylic

Louis Kahan
Australian Imagination XVII (1973) Offset print

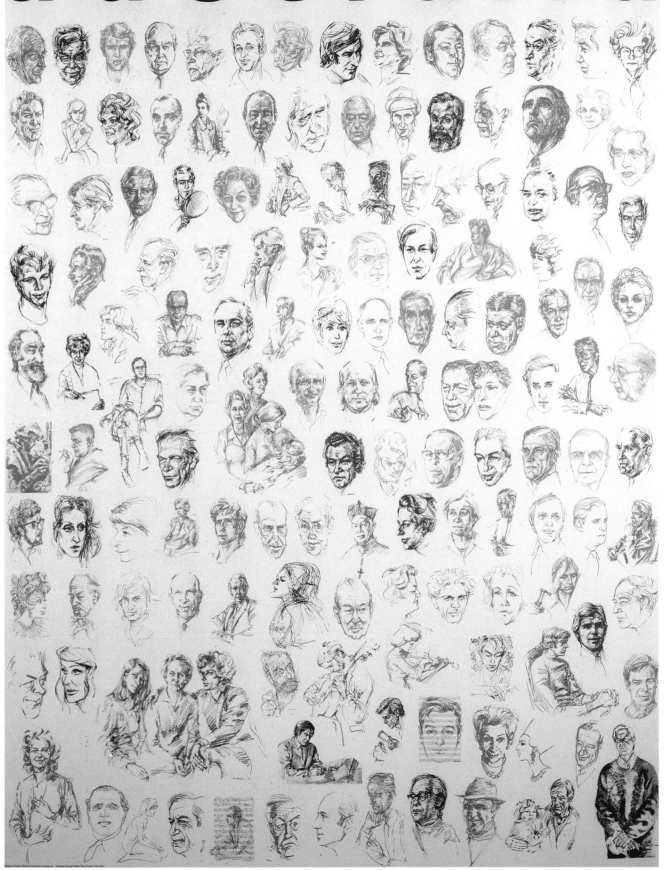

australia

Inge King
Black sun (1975) Steel

Michael Taylor
Rainbow Hill 1975 Acrylic

Taylor '75

William Delafield Cook
Three cabbages (1977) Charcoal and conté crayon

William Delafield Cook
Three cabbages (1977) Charcoal and conté crayon

Ken Whisson
Houses and grass: Australian landscape 1984 Oil

Mike Parr
The arm of the Cyclops (1982) Charcoal

Colin Lanceley
Forest oracle 1977 Watercolour

355

Michael Shannon
Interior with green sofa 1979
Mixed media

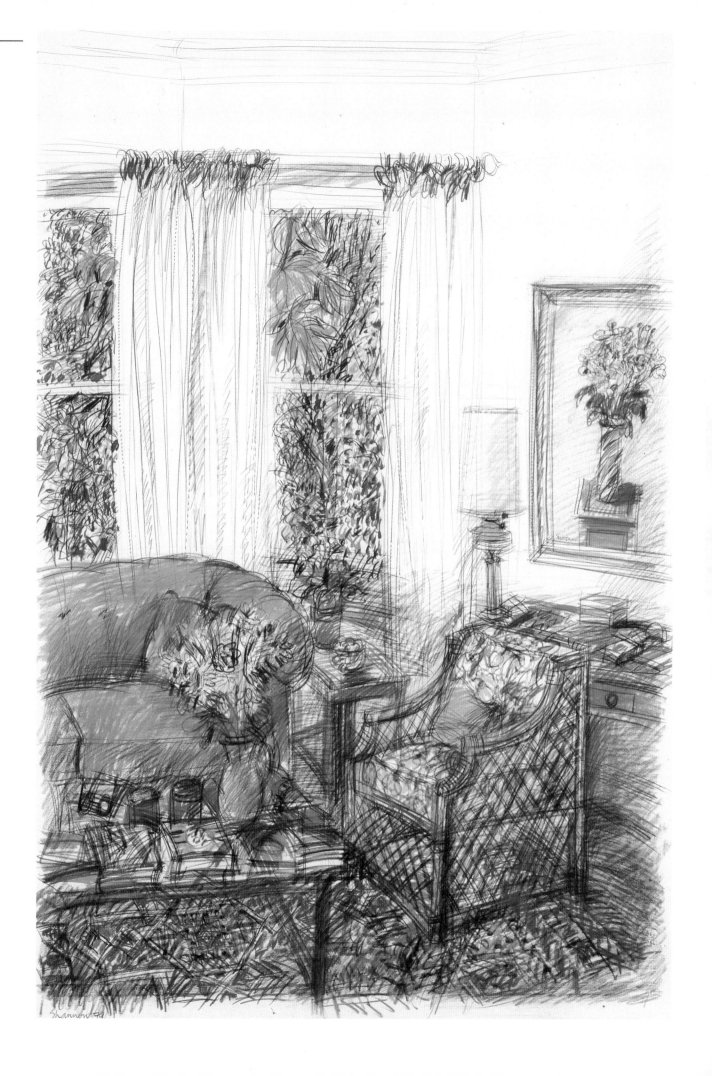

David Wilson
Dry pool (1979) Steel

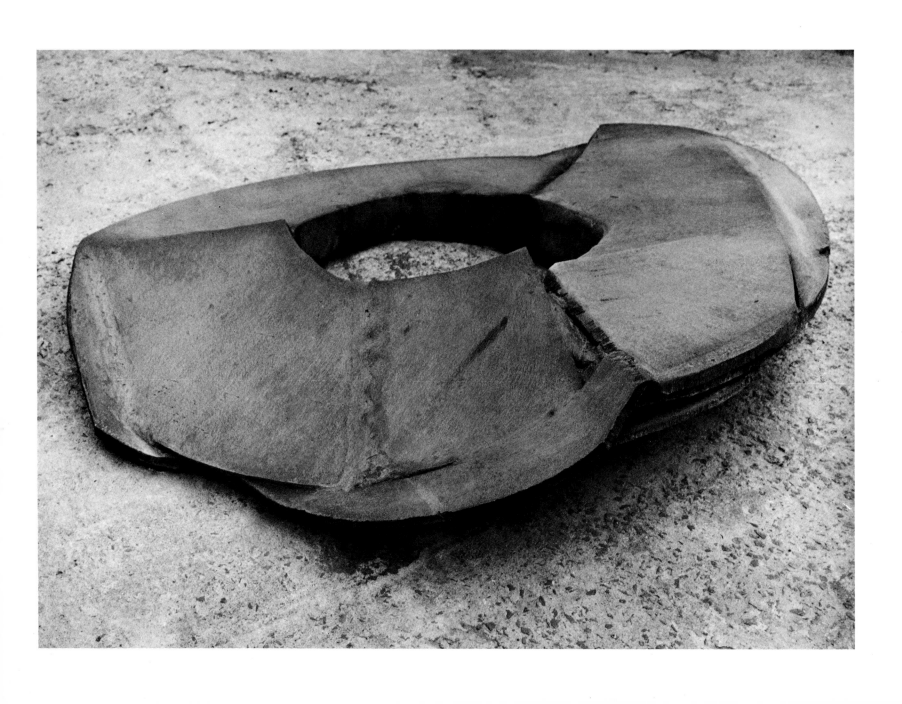

Paul Partos
Untitled (Yellow) 1979 Oil

Richard Larter
Untitled 1979–80 Oil

Bea Maddock
Four-finger exercise for two hands 1981 Four-colour relief etching

Gareth Sansom
Temptation (1978) Mixed media

Robert Rooney
Born to die (1985) Acrylic

Howard Taylor
Landscape unfolding 1984 Oil

Howard Taylor
Landscape unfolding 1984 Oil

Rosalie Gascoigne
Pink on blue (1982–83) Wood

Jan Senbergs
Hill town 1984 Pastel

365

Davida Allen
Where's Sara? (1985) Oil

Imants Tillers
Anything goes: War of the world (1982) Charcoal

Imants Tillers
Anything goes: War of the world (1982) Charcoal

Hossein Valamanesh
Target practice (1986) Wood, rope diptych

Ken Unsworth
Open cut (1980) Steel

Dick Watkins
Barbed wire (1986) Acrylic

Peter Tyndall
A person looks at a work of art . . . (1984) Acrylic

Trevor Nickolls
Third eye (1986) Acrylic

Tim Johnson
Notes on Thailand 1987 Oil

Tim Johnson
Notes on Thailand 1987 Oil

Nicholas Nedelcopoulos
The Great Australian Dream　1987　Etching

Robert MacPherson
Untitled 1977 Enamel

Allan Mitelman
Untitled 1986 Oil and pencil

Stephen Killick
Presto 1987 Wood

Geoffrey Bartlett
Cockatoo in flight (1977) Steel

378

Noel McKenna
Williamsburg, Brooklyn
1986 Watercolour

379

Joe Furlonger
Three figures on beach 1986 Watercolour

Vicki Varvaressos
Three women 1987 Acrylic

Tom Risley
Garden seat 1988 Wood and nylon

382

Patrick Henigan
Down for the count 1988 Charcoal

383

Ian Westacott
Factory light and bridge against the wall (1988) Etching

Lorraine Jenyns
A tiger's tale (1987) Earthenware

Stephen Benwell
Vase 1988 Earthenware

Nerissa Lea
Origin of a species (1988) Charcoal

Rosslynd Piggott
Italy 1988 Oil

Dini Campbell
Tingari men and women, Nyilanya (1987) Acrylic

Clifford Possum
Parrot dreaming at Intangkangu (1987) Acrylic

Paddy Japaltjarri Stewart
Marlu Jukurrpa (Kangaroo Dreaming) 1987 Acrylic

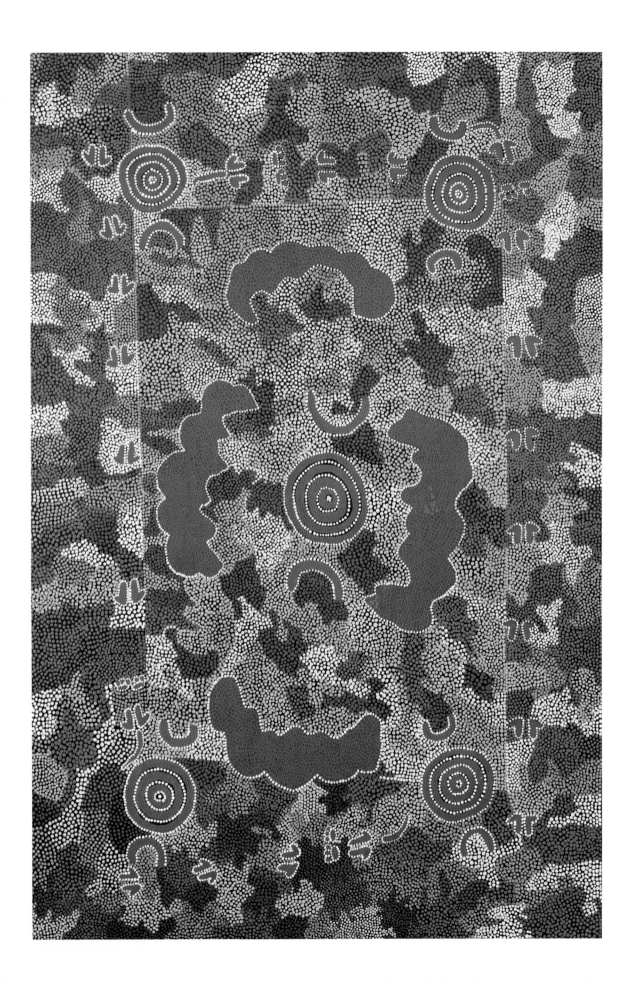

PORTRAITS OF JOSEPH BROWN

WORKS BY JOSEPH BROWN

PORTRAITS OF JOSEPH BROWN WORKS BY JOSEPH BROWN

THERE ARE OTHER portraits of Joseph Brown in the Joseph Brown Collection besides those illustrated in this section and in Louis Kahan's *Australian Imagination XVII*, Plate 348 in the main body of the book. (Joseph Brown begins the fifth of twelve rows of famous Australians of 1973 in that poster by Kahan.)

All the portraits are by friends and most have been informal gifts of small sketches to a fellow artist and fellow art lover. However, the earliest and the latest of the ten shown here, the George Luke of 1940 and the Wes Walters of 1983, are large, formal set-pieces; they are symbols as well as likenesses and tokens of affection.

Trooper Joseph Brown of the 13th Light Horse is a striking symbol of extreme change. The young man from Poland has become an Australian of a traditional 'national type', a 1940 successor to George W. Lambert's 1920 painting *A Sergeant of Light Horse in Palestine*.

Dr Joseph Brown, 1983, a more traditional symbolic image of honour for community service, brings that story full circle. The honorary doctorate of letters conferred on Joseph Brown, OBE, by Monash University was conferred, like the Royal honour of Officer in the Order of the British Empire, for distinguished service to Australian culture. The young Polish immigrant had become one of the most significant interpreters of Australia to Australians. In particular it was his collection of two hundred years of Australian art, presented since 1973 in the various editions of this book, which had performed that service for the people of Australia.

There are personal details to enjoy. The forty-ninth birthday pencil-sketch by William Dobell is one of the last portraits before the Brown beard was grown. Dorothy Braund's watercolour series captures the special conviviality of a dinner party with the Russell Drysdales. Sir William Dargie, who had been on the formative committees for the Australian National Gallery, puts his appreciation of Joseph Brown's support of the National Gallery (and the National Library) into a small oil painting. A beloved dog called Bow occurs twice in this selection.

Arthur Boyd's suite of four portraits, the first with the new beard, further emphasize and enjoy the variability of human identity by showing four different expressions and attitudes. These are portraits not only about Arthur Boyd's love of Joseph Brown but also about appreciation of social and personal changes, self-discoveries and creativities.

FOR A FEW MONTHS in Melbourne in 1934 Joseph Brown was an art student at what was then called the Working Men's College (now the Royal Melbourne Institute of Technology). His favourite teacher there was Napier Waller, one of whose watercolours is in this book. In the 1980s Joseph Brown's favourite work in his collection is Ralph Balson's colour-abstraction *Painting*, 1954.

Joseph Brown never gave up his art practice even though it had to become an occasional and spare-time activity. The straightforward academic portraits of his father, Jacob Brown, 1935, and of his wife,

Estelle, 1946, are followed by modernist abstraction in both paintings and sculpture. Not illustrated here are abstract surrealist works of the 1940s and 1950s which were influenced by contemporary British artists John Tunnard and Henry Moore.

His later work, following the clues of his preference for Ralph Balson's colour painting and his interest in sculptural space, explores light and surface. A 1967 self-portrait as a beachcomber indulges in North Queensland tropical atmosphere; *The cave*, a wood-carving, encourages the flow of light through controlled spaces and across surfaces whose materials are tender and tactile.

The work of Joseph Brown, Sunday painter (and sculptor), like the portraits of Joseph Brown, tells us that he is a man to trust and depend upon. The art and the man are solid, stable, secure, and (therefore) generous. Those qualities attract love and affection not only from his artist friends but also from those who might know him only from his collection and this book.

Daniel Thomas
1989

George Luke
Trooper Joseph Brown 1940 Oil

Arthur Boyd
Four portraits of Joseph Brown (1969) Oil

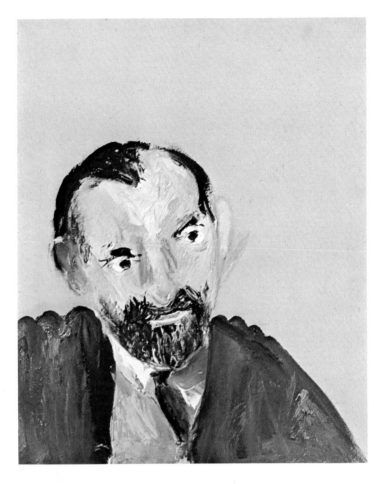

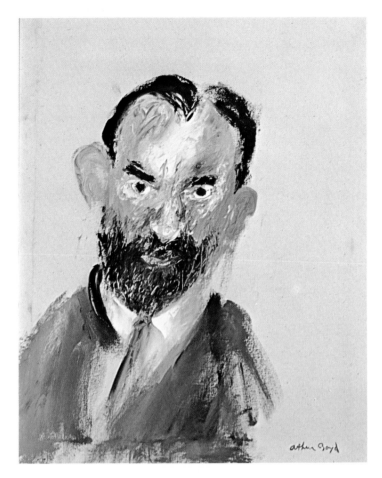

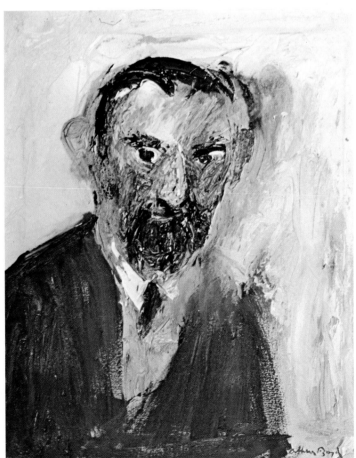

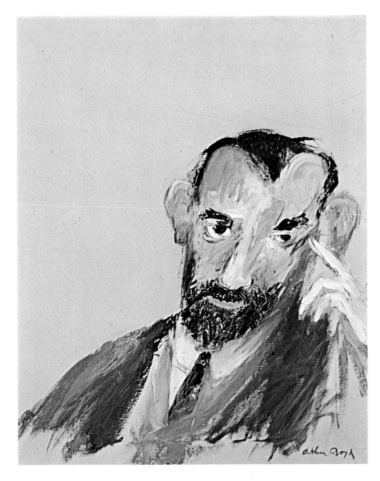

Clifton Pugh
Joseph Brown 1971–72 Oil

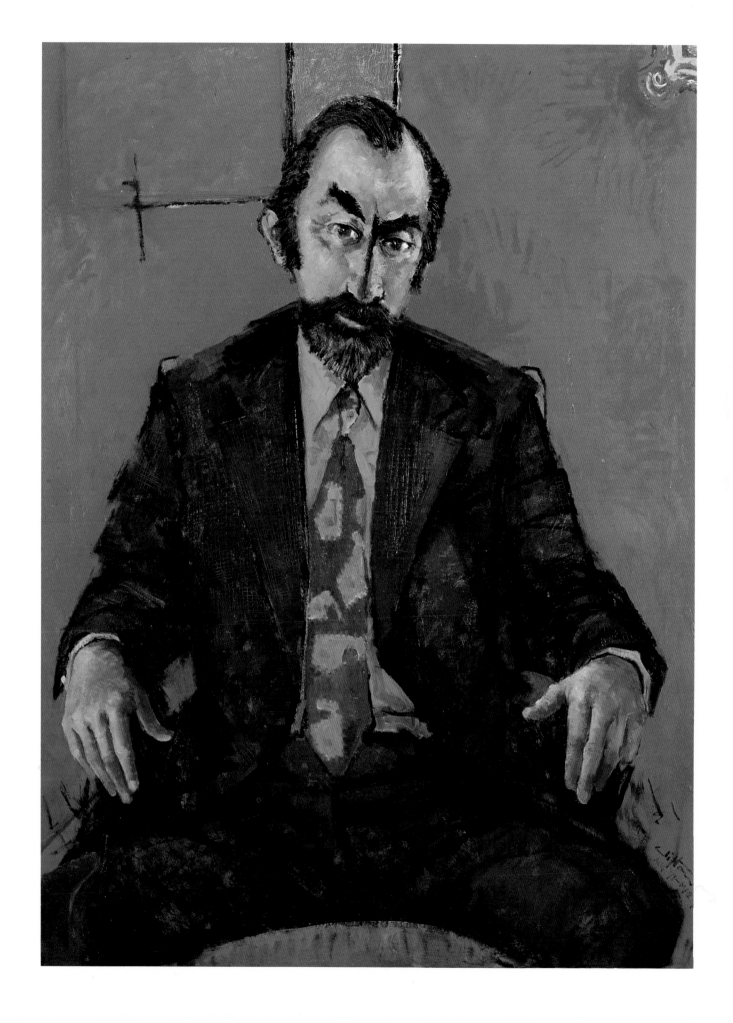

William Dargie
Joseph Brown and Bow (1975) Oil

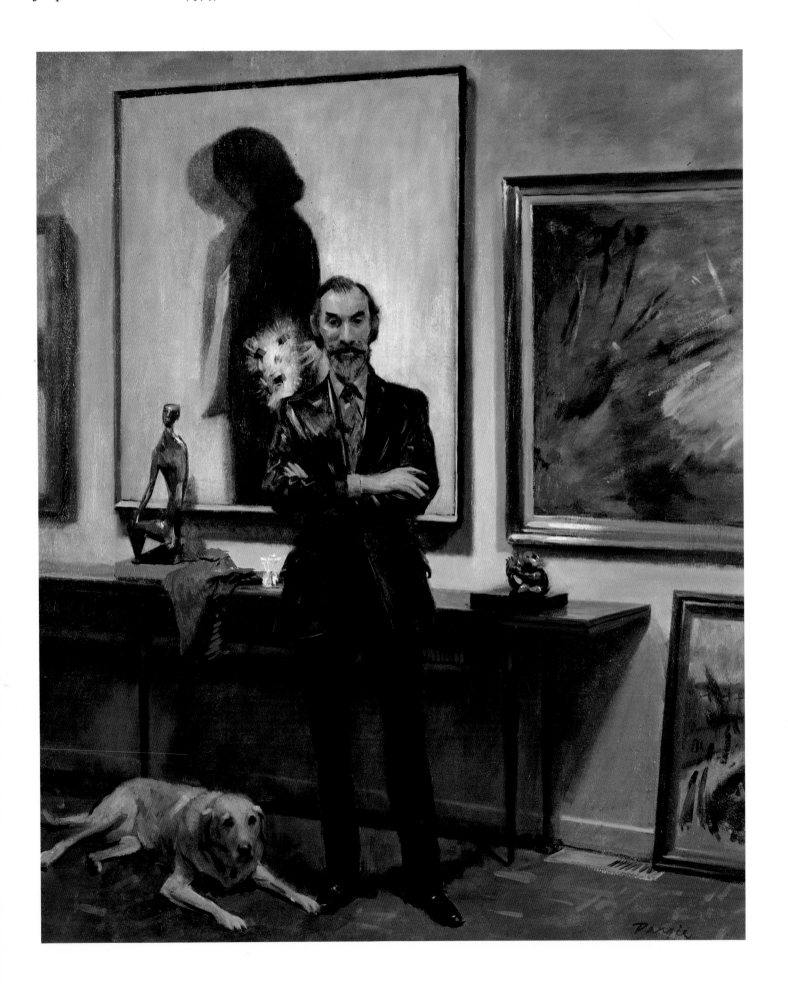

Brian Dunlop
Joseph Brown and Bow (1982) Watercolour

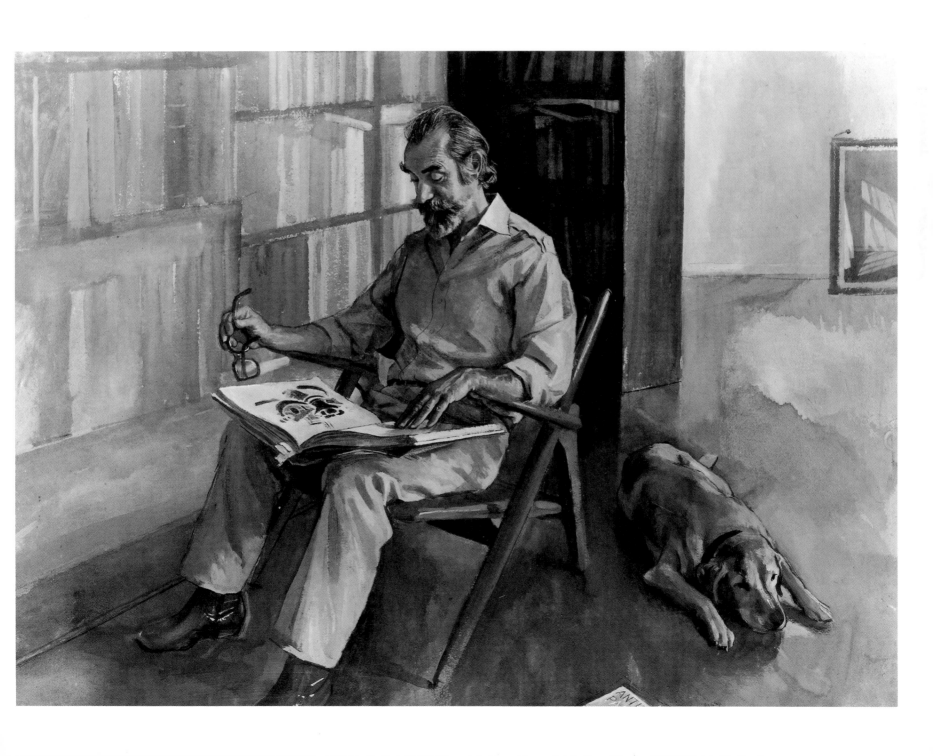

Brian Dunlop
Joseph Brown and Bow (1982) Watercolour

William Dobell
Joseph Brown 1967 Pencil

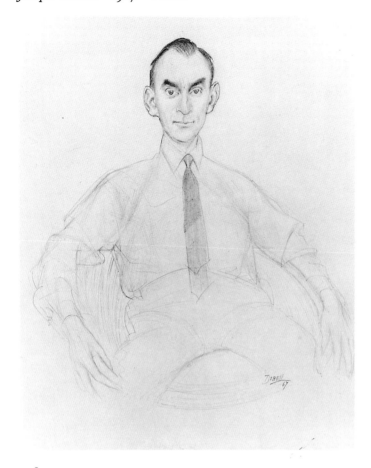

Rick Amor
Joseph Brown 1974 Oil

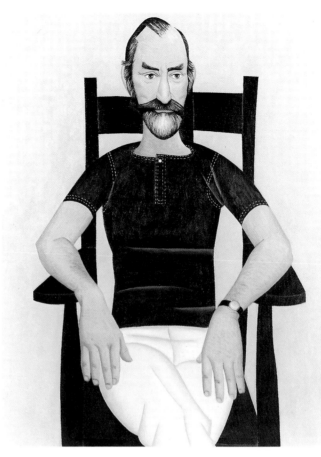

Dorothy Braund
Joseph Brown with friends 1981 Watercolour (detail)

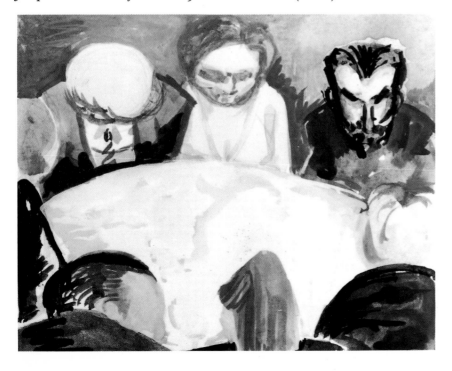

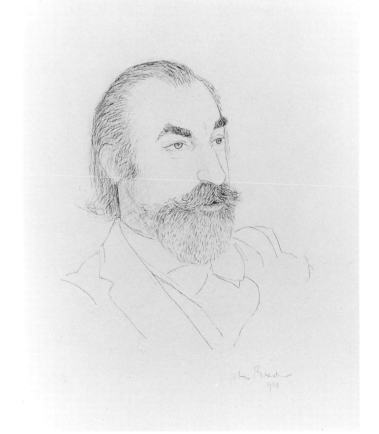

John Brack
Joseph Brown 1980 Pencil

Wes Walters
Dr Joseph Brown 1983 Oil

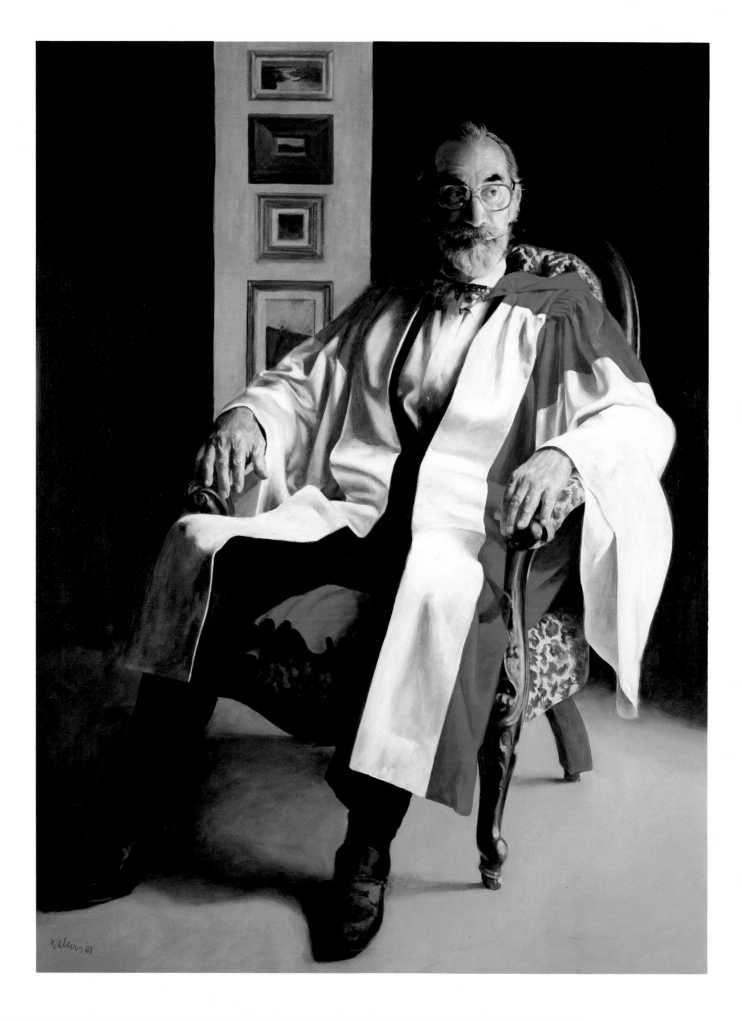

Joseph Brown
Jacob Brown (1935) Oil

Joseph Brown
Estelle (1946) Oil

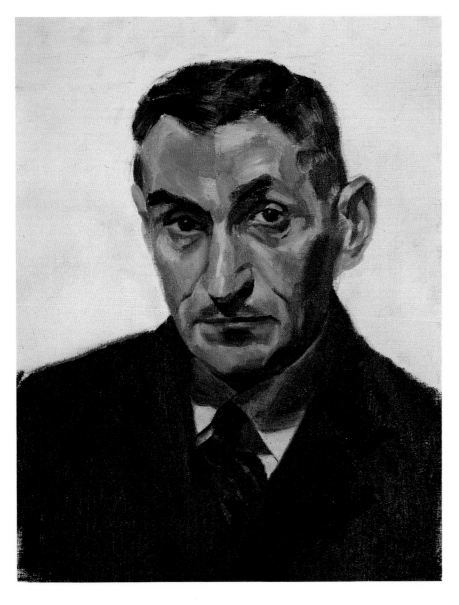

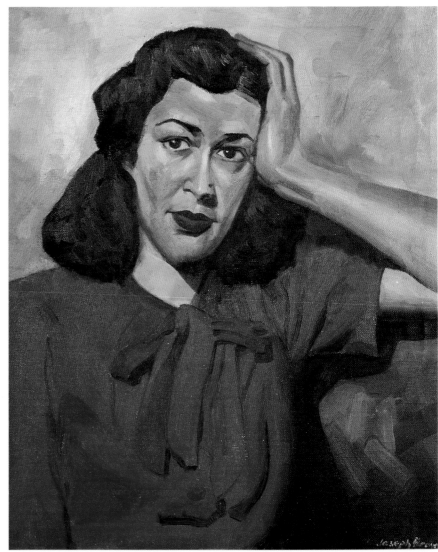

Joseph Brown
Jacob Brown (1935) Oil

Joseph Brown
Estelle (1946) Oil

Joseph Brown
Torso (1950) Bronze

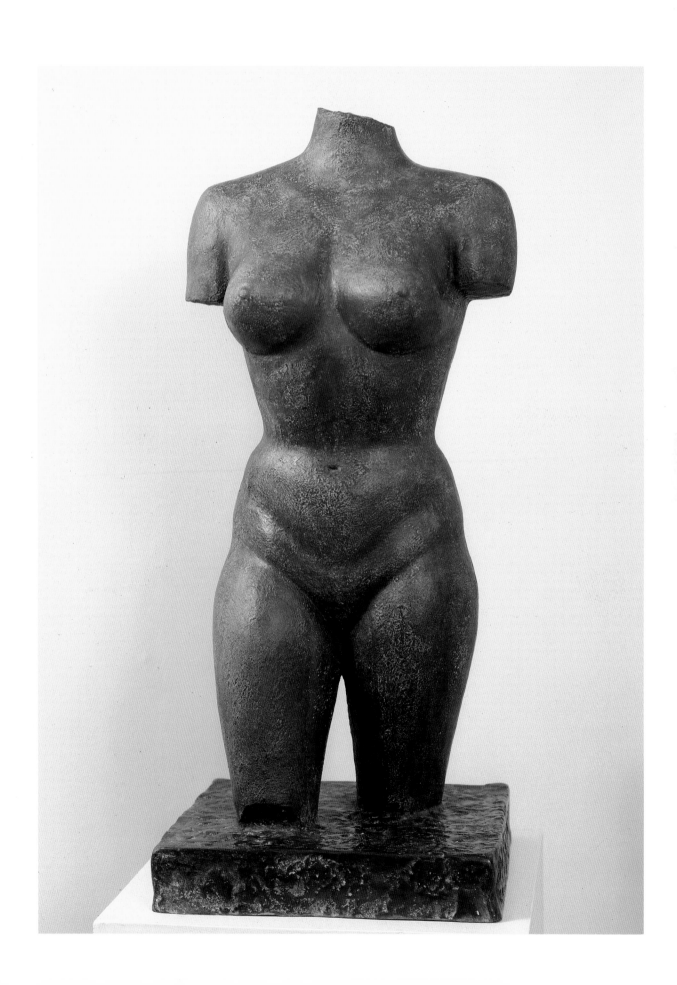

Joseph Brown
Self-portrait 1968 Oil

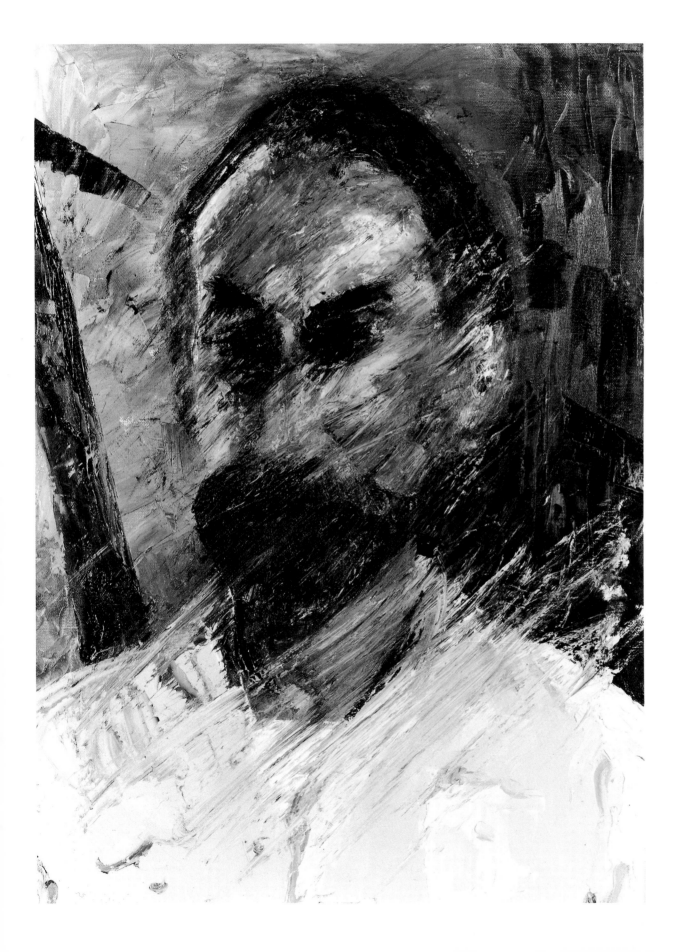

Joseph Brown
Continuity of line (1956) Bronze

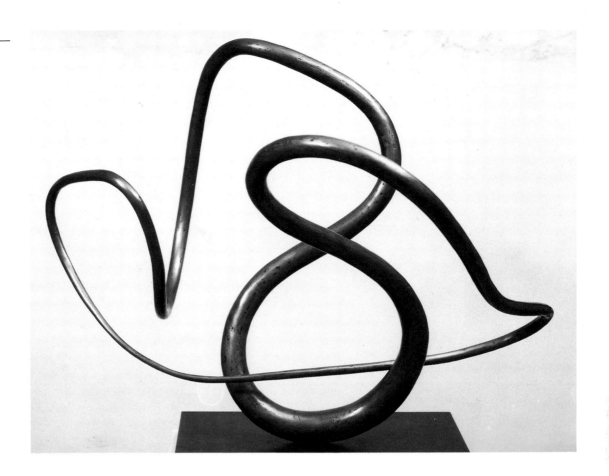

Joseph Brown
The cave (1987) Wood

407

Joseph Brown
Abstract 1986 Oil

Joseph Brown
Abstract 1986 Oil

CATALOGUE AND
INDEX OF ARTISTS

CATALOGUE

Titles provided by someone other than the artist are given in parentheses.
Dates in parentheses are those that have been established by research rather than given in inscriptions.

Australian Aboriginal artist, Arnhem Land
1 (*Fish*) (1940s)
 Ochres on bark 48 × 77 cm

After F.P. Nodder (working 1771–*c.* 1800)
2 *The Banksia*
 The Banksia gibbosa 1789
 Engraving, hand-coloured 22.5 × 17.5 cm
 Captioned *I. Debrett London. Published as the Act directs Dec 29, 1789*

William Hodges (1744–97)
3 (*Wooded river landscape with a waterfall*)
 (*c.* 1776)
 Oil on canvas 63.5 × 76.2 cm
 Unsigned
 From Spink, London

After Robert Cleveley (1747–1809)
4 *View in Port Jackson* 1789
 Engraving, hand-coloured 22 × 37 cm
 Captioned *View in Port Jackson/ Published July 13, 1789 by J. Stockdale*
 R. Cleveley/ T. Bratteny sculp

After John Eyre (1771 — after 1812)
5 *Port Jackson Harbour, in New South Wales, with a distant view of the Blue Mountains* 1812
 Engraving, hand-coloured 22 × 37 cm
 Captioned *Port Jackson Harbour, in New South Wales with a Distant View of the Blue Mountains/ Taken from South Head/ Dedicated to his Excellency Lachlan Macquarie Esq, Governor of New South Wales/ Published Nov 30th 1812 by A. West Sydney/ Engraved W. Preston/ Drawn by J. Eyre/ No 2*

William Westall (1781–1850)
6 *The wreck of The Porpoise* (1803)
 Pencil 16 × 25.5 cm
 Inscribed *Boats crew picking up stragglers after the wreck of The Porpoise on a coral reef off the N.E. Coast of Australia*

7 *The Island of Timor* 1808
 Watercolour 20.3 × 31.7 cm
 Signed *W. Westall 1808*
 Sotheby, London, 28 January 1971, Lot 103
 Westall, on board Flinders's *Investigator* whose survey of the Australian coast had just been abandoned, was at Coupang, Timor, in March–April 1803. Back in London a view of Timor was engraved for the *Naval Chronicle* in 1806, and another in 1808, but this watercolour was probably painted for Westall's exhibition, in a Brook Street gallery, April 1808, of views of places he had visited. In 1808 he also showed ten foreign watercolours in the Associated Artists' exhibition

Walter Preston (working 1812–19)
8 *View of Hunter's River, Newcastle, New South Wales* (1819)
 Engraving 14 × 22 cm
 Captioned *View of Hunter's River. Newcastle. New South Wales./ London publ. Sept. 1, 1820 at R. Ackermann's 101 Strand/ Engraved by W. Preston from a drawing by Capt Wallis 46th Regt*
 One of twelve views illustrating Captain James Wallis's *An Historical Account of the Colony of New South Wales*, for sale in Sydney, January 1819, re-dated for publication in London

Joseph Lycett (1775–1828)
9 *Distant view of Hobart Town, Van Diemen's Land, from Blufhead* 1825
 Aquatint, hand-coloured 17.5 × 27 cm
 Captioned *Distant View of Hobart Town,/ Van Dieman's [sic] Land, from Blufhead/ London, Published 1825 by J. Souter 73, St Pauls Church Yard/ Lycett del* et Execute*

J. W. Lewin (1770–1819)
10 *The tree creeper* (*c.* 1813)
 Engraving, hand-coloured 30 × 24 cm
 Captioned *P/no XXV/ J.W. Lewin N.S.W.*

Richard Browne (1776–1824)
11 *Killigrant* (1820)
 Watercolour 29.2 × 21 cm
 Inscribed *Killigrant*

John Glover (1767–1849)
12 (*View of London from Greenwich*) (*c.* 1815)
 Oil on canvas 74.3 × 109.2 cm
 Unsigned
 From Agnew, London, 1969
 A similar Greenwich view is in the Art Gallery of South Australia. In 1815 Glover exhibited *Greenwich Hospital, London in the Distance* with the Old Watercolour Society; in 1816 *Greenwich Hospital. Walker's Quarterly,* April 1924 states: 'One of Glover's best oils is a view of Greenwich belonging to Colonel M. H. Grant'

13 (*A mountain torrent*) (*c.* 1837)
 Oil on canvas laid on board 73.7 × 111.8 cm
 Unsigned
 From a Melbourne auction, *c.* 1962, as *One-Tree Bridge, Tasmania.* There is no other evidence for the identification of the subject, which is not obviously Tasmanian. The style is of Glover's Tasmanian period and the subject could be the Lake District, England

Benjamin Duterrau (1767–1851)
14 *The Conciliation* 1835
 Etching 23 × 29 cm
 Captioned *Designed, etched & published by Bn. Duterrau July 15th 1835 Hobart Town Van Diemen's Land*

John Skinner Prout (1806–76)
15 *Fern Tree Gully, Mount Wellington* 1844
 Watercolour 23 × 31 cm

Unsigned
Inscribed *Fern Tree Gully, Table Mountain/ Hobarton V.D.L./ Feb'y 1844*
'Table Mountain, Hobarton, V.D.L.' [Van Diemen's Land] is now Mount Wellington, Hobart, Tasmania. A lithograph by Prout in his album *Tasmania Illustrated*, Hobart 1844, shows approximately this composition, and is captioned *'Fern Tree Gully, Mount Wellington'*. In London *c.* 1851 the composition was developed into a large watercolour (now in the Art Gallery of New South Wales) in which the seated artist is replaced with a group of Aborigines

Conrad Martens (1801–78)
16 *Coastal scene near Exmouth* (1829)
Watercolour 45.5 × 68.5 cm
Unsigned

17 *Rio Santa Cruz* (after 1833)
Watercolour 17.8 × 25.4 cm
Unsigned
A condor preying on the remains of a guanaco A larger version of this composition, 27.9 × 41.9 cm is in the National Gallery of Victoria and another 18.4 × 26.6 cm is in the Dixson Library, Sydney. Martens, on board FitzRoy's *Beagle* was in Patagonia in 1833–4. Charles Darwin bought a version of this composition when the *Beagle* reached Sydney in 1836

18 (*Australian landscape with cattle and stockman at a creek*) 1839
Oil on board 47 × 66 cm
Signed *C. Martens 1839*
Conrad Martens exhibition, Clune Galleries, 1967. Martens's account book lists a picture *Ford of the Wollondilly*, sold on 25 June 1839 for twelve guineas to 'H. McArthur', that is to Hannibal Macarthur, who had land on the Wollondilly. No other picture listed under 1839 seems to be identifiable with this

19 (*Aboriginal camp site*) (*c.* 1840)
Watercolour 30 × 26 cm
Signed *Conrad Martens*

20 *View of Sydney from St Leonards* 1842
Lithograph, hand-coloured 27.3 × 50.7 cm
Signed *C. Martens 1842*
Captioned *Sydney from the North Shore 1842/ Drawn on stone by T. S. Boys/ View of Sydney from St. Leonards/ C. Graf Lith to Her Majesty*

George E. Peacock (working 1837 — after 1856)
21 *View of the Heads of Port Jackson, New South Wales, from above Vaucluse Bay* (1840s)
Oil on canvas 25.4 × 34.3 cm
Label on stretcher, in the artist's hand, with title and signature *G. E. Peacock 18(4?)6*

George French Angas (1822–86)
22 *The City and Harbour of Sydney* 1852
Lithograph, hand-coloured 29.5 × 55 cm
Attached verso, caption cut from original sheet, *The City and Harbour of Sydney from near Vaucluse/ Published by J. Hogarth 1852*
Lithographed by T. S. Boys

W. B. Gould (1801–53)
23 (*Sailing ships off a rocky coast*) 1840
Oil on canvas, laid on board, 64.1 × 80 cm
Signed *W. B. Gould Painter/ 1840 VDL*
The initials VDL stand for Van Diemen's Land, the early name for Tasmania

24 (*Flowers and fruit*) 1842
Oil on canvas 50.8 × 61 cm
Signed *W. Gould/ Painter/ 1842*
From Christies, Sydney, 6 October 1971, Lot 292
Exhibited Clune Galleries, Sydney, W. B. Gould exhibition 1968

William Dexter (1818–60)
25 (*Wheatfield with bird's nest*) (1850s)
Oil on canvas, diameter 47 cm
Signed *W. Dexter*
Although an English subject this was probably painted in Australia after Dexter's arrival in 1852

Unknown artist
26 (*Landscape with kangaroos in foreground*) (*c.* 1850)
Oil on board 24 × 34 cm
Inscribed on verso *Yoolooga . . . Remarkable Rock*

Unknown Tasmanian artist
27 *George and Rosalie Waterhouse, children of Susan Waterhouse* (1840s)
Pair of watercolour miniatures, each 19 × 14 cm
Identification of the sitters was provided by the Melbourne dealer from whom these

miniatures were bought together with one of their father or grandfather. The artist was said to be Thomas Bock, active in Tasmania in the 1840s, but none of his securely attributed work used this stippled technique. They are at present in frames with the printed label of *R. L. Hood, Liverpool Street, Hobart*

Unknown Tasmanian artist
28 *Emily Jones* (*c.* 1860)
Pastel 27.5 × 23 cm
Unsigned

George Rowe (1797–1864)
29 *Panorama of Melbourne from Flagstaff Hill* (1859)
Lithograph 21.5 × 140 cm
Unsigned

J. A. Houston (1812–84)
30 *Dr E. Nasmyth Houston* (1840s)
Watercolour 36.8 × 24.1 cm
Unsigned
Exhibited Joseph Brown Gallery, Autumn 1971, with a companion drawing of Dr Houston's mother. Dr Houston practised medicine in Melbourne, where he died in 1861. The artist, who worked in Edinburgh from 1840 to 1858, was Dr Houston's brother

Henry Gritten (1818–73)
31 (*Melbourne from the Botanical Gardens*) 1865
Oil on canvas, laid on board, 30.5 × 45.7 cm
Signed *Hy Gritten 1865*

S. T. Gill (1818–80)
32 (*The Flinders Range*) (*c.* 1865/70)
Watercolour 41.9 × 55.9 cm
Signed *S.T.G.*
A subject from South Australia which Gill left in 1852; painted in Melbourne *c.* 1865–70 probably from sketches made in 1846; possibly from the inland journey of exploration led by Horrocks in 1846

33 *Tin dish washing* (*c.* 1865)
Watercolour 24 × 18.5 cm
Signed *S.T.G.*
Inscribed *Tin Dish Washing*

34 *A Bendigo mill 1852* (c. 1865)
Watercolour 20.7 × 26.5 cm
Signed *S.T.G.*
Inscribed *A Bendigo Mill 1852*
Goldfields subjects in the style of nos. 33 and 34 were probably executed in Melbourne after Gill's return in 1864 from Sydney, from sketches made in 1852

35 *Baby* 1867
Watercolour 24.1 × 35.6 cm
Signed *S.T.G./ Baby (Xmas?)/67*
Gill lived in Melbourne in 1867

Owen Stanley (1811–50)
36 *Leaving Sydney Harbour for Bass Strait* 1848
Watercolour 17.5 × 25.7 cm
Signed *Owen Stanley*
Inscribed *Leaving Sydney Harbour for Bass Straits Feb'y 2 1848*

Frederick Garling (1806–73)
37 (*Schooner in full sail, leaving Sydney Harbour*) (1860s)
Watercolour 33 × 50.8 cm
Unsigned

Thomas Woolner (1825–92)
38 *Sir Charles Nicholson* 1854
Bronze medallion, diameter 21 cm
Signed *T Woolner Sc. 1854*

Richard Noble (recorded 1828–65)
39 *Master Benedetto John Bernasconi* 1860
Oil on canvas 92.1 × 71.1 cm
Signed *Rich^d. Noble Sydney N.S.W. 1860.* On back of canvas *Benedetto John Bernasconi. Born 17 August 1854 in London. This likeness painted by Rich^d. Noble June 1860 in Sydney N.S.W.*
From auction, Christies, Sydney, October 1971

Thomas Robertson (working 1853 — died 1873)
40 *View of Hobson's Bay* (c. 1857)
Oil on canvas 104.1 × 182.8 cm
Unsigned
The subject's identification is made, tentatively, by the owner. Other works on the Melbourne art market have been signed *Thos*

Robertson ONZ and have carried dates in the 1860s; Captain Robertson first exhibited in 1853

Henry Burn (1807?–84)
41 (*Studley Park Bridge over the Yarra*) (c. 1860)
Oil on board 29.2 × 40.6 cm
Unsigned
From Christies, Melbourne 1972

42 (*Harvest scene*) 1876
Oil on canvas 61 × 91.5 cm
Signed *H. Burn 1876*

Haughton Forrest (1826–1925)
43 (*Shipwreck off a steep coast*) 1877
Oil on canvas 45.7 × 76.2 cm
Signed *H. Forrest* (the initials in monogram) *1877*
Forrest's marine subjects, even when painted after his arrival in Tasmania in 1877, seldom have an identifiable coast. Those inscribed by the artist are usually subjects from Britain or France

Unknown artist
44 (*Gold finders*) (c. 1860)
Oil on canvas 73.7 × 137.2 cm
Unsigned
From auction, Gray's, Sydney, 1965, as by an unknown artist. If this is an Australian subject of the 1850s or 1860s, the style of the painting is not close enough to William Strutt's or Thomas Clark's to attribute it securely to either of them. J. M. Crossland is another possibility but he died in 1858

William Strutt (1826–1915)
45 *Study for man* 1883
Oil on board 37 × 28 cm
Signed *William Strutt*
Inscribed *Study for Man/ Dec 1883*

46 *Lady Blunt's Arab mare, Sherifa* 1884
Pencil and crayon 35.5 × 61 cm
Signed *William Strutt F.Z.S.*
Inscribed *Lady Blunt's celebrated Arab mare Sherifa in action/ Sept 27th 1884*

47 (*Dogs with flowers and game*) (1850s)
Oil on canvas 50.8 × 43.2 cm
Signed *William Strutt*
From auction, Page–Cooper collection, Joels, Melbourne, 1967

Thomas Clark (1814–83)
48 (*The Wannon Falls*) (1865?)
Oil on canvas 76.2 × 121.9 cm
Signed *Thos Clark 18(..)*, the last two numerals indistinct, perhaps 1865

Robert Dowling (1827–86)
49 (*An afternoon siesta*) 1859
Oil on canvas 50.8 × 35.6 cm
Signed *R. Dowling* (the initials in monogram)/ *from/ Tasmania/1859*
From the Ewan Phillips Gallery, London
The title is given on a label on the frame, probably placed there by the Ewan Phillips Gallery. Painted in London, for Dowling left Tasmania in 1857

50 *John Ware* (c. 1860)
Oil on canvas 92 × 71 cm
Unsigned

51 *Miss Annie Ware* 1882
Oil on canvas 91.4 × 71.1 cm
Signed *R. Dowling 1882*. Painted on back of canvas *Miss Annie Ware/ Painted by R. Dowling* (the initials RD in monogram) *27 Colebrooke Road West Brompton/ London/ 1882*
Miss Ware, daughter of John Ware of Yalla-y-Poora, an Australian station homestead. The portrait descended to John Ware's granddaughter Mrs Callard and was bought in May 1968 from the auction of her widower's house, Melbourne. At the same time the Yalla-y-Poora landscape by von Guérard was bought

Eugene von Guérard (1811–1901)
52 *Yalla-y-Poora* 1864
Oil on canvas 69.9 × 121.9 cm
Signed *Eugen von Guérard 1864*
Commissioned by John Ware, owner of Yalla-y-Poora, in the Western District of Victoria, thence by descent to M. E. Callard, and purchased at Callard auction, Melbourne, May 1968
A pencil sketch in the Mitchell Library, Sydney, is dated *14 May 1864* and inscribed *General view of Station Yalla-y-Poora from South to North (Fiery Creek 17 miles north of Streatham)*

53 *Spring in the valley of the Mitta Mitta with the Bogong Ranges in the distance* 1863
Oil on canvas 43.2 × 66 cm
Signed *Eug. v. Guérard/ Melb : fec :/ 1863*
Bought by John Ware for his homestead

Yalla-y-Poora, thence by descent to M. E. Callard
A view from Patton's station
A larger version, 68.3 × 106.7 cm, dated 1866, has been in the National Gallery of Victoria since 1866

54 *Ferntree Gully in the Dandenong Ranges* 1857
Oil on canvas 90.2 × 135.2 cm
Signed *Joh : Eug : von Guérard fecit/ Melb : 1857*
Exhibited Victorian Society of Fine Arts, Melbourne 1857, no. 144, £210. Collection Frederick Dalgety, founder of the pastoral company Dalgety & Co; at his country house Lockerly Hall, Hampshire, where it remained in family possession until 1970. Bought at auction, Christies, Melbourne, March 1970, Lot 93, as *Sherbrooke Forest* which title was painted on the frame. A drawing of the subject, in pen and ink, from a series of Australian views commissioned by Sir Henry Barkly, Governor of Victoria, is dated *1859*, and titled *Dobson's Gully, Dandenong Ranges*. A lithograph, plate 13 in *Eugène von Guérard's Australian Landscapes*, has the title *Ferntree Gully, Dandenong Ranges, Victoria*.
Gifted to Australian National Gallery

Nicholas Chevalier (1828–1902)
55 *Mount Arapiles and the Mitre Rock* 1863
Oil on canvas 77.5 × 120.6 cm
Signed *N. Chevalier 1863*
Painted for Alexander Wilson, squatter, whose station, Vectis, in the Wimmera district included Mount Arapiles. In *N. Chevalier's Album of Chromo Lithographs*, Melbourne 1865 as *Mount Arapiles — Sunset*.
Gifted to Australian National Gallery

Louis Buvelot (1814–88)
56 (*Farm sheds, below the You Yangs*) 1874
Pencil, white gouache 55.9 × 86.4 cm
Signed *Ls Buvelot 1874*

57 (*Bush track, Dromana*) 1875
Oil on canvas 55.9 × 85.1 cm
Signed *L Buvelot 1875*
From Barry Humphries 1967, with this title. It could well be Dromana, a district often painted by Buvelot

58 *Childers Cove* 1875
Oil on canvas 76.2 × 111.8 cm
Signed *L. Buvelot 1875*

From the Camperdown Golf Club, Western District, Victoria. I. Whitehead's framer's label on back

59 (*Pastoral*) 1881
Oil on canvas 45.7 × 68.6 cm
Signed *Louis Buvelot 1881*
From auction, Joels, Melbourne 1970, with this title. Most of Buvelot's landscape subjects are from near Melbourne

Chester Earles (1821–c. 1905)
60 (*Interior with figures*) 1872
Oil on canvas 60.6 × 70.4 cm
Signed *C. Earles/ 1872*
The subject is unidentified. The man appears to be looking at a ring on the second finger of the woman's hand. The costume, hairstyles, and furniture belong to a period thirty years earlier than the painting, and appear to be English not Australian

Emma Minnie Boyd (1856–1936)
61 (*Interior with figures, The Grange*) 1875
Watercolour 23.5 × 35.6 cm
Signed *EMa'B (the initials in monogram)/ 27/3/75*
The living room at The Grange, Harkaway, a Boyd family country house near Melbourne. In the 1940s when the novelist Martin Boyd lived there, his nephew Arthur Boyd painted biblical murals on the dining room walls.
The initials EMa'B stand for the artist's maiden name Emma Minnie a'Beckett; she later married Arthur Merric Boyd (1862–1940)

J. H. Carse (1818/19–1900)
62 *The Weatherboard Falls, Blue Mountains* 1876
Oil on canvas 60.9 × 106.7 cm
Signed *J. H. Carse/ Sydney 1876*
Titled on label on back of original frame. Other versions of this composition exist

W. C. Piguenit (1836–1915)
63 *A winter's evening, Lane Cove* (1888)
Oil on canvas 76.2 × 127 cm
Signed *W.C.Piguenit*
Exhibited Art Society of New South Wales, Sydney, 1888. Illustrated in line in the exhibition catalogue
Piguenit lived at Hunters Hill, Sydney, his house facing up the Lane Cove River

G. F. Folingsby (1830–91)
64 *Autumn* (c. 1882)
Oil on canvas 96.5 × 61 cm
Signed *G.F.Folingsby*
A companion picture *Spring*, of a woman picking blossom, is illustrated in Alan McCulloch, *Encyclopedia of Australian Art*, 1984, pl. 37; in *Autumn* the woman is picking blackberries

John Ford Paterson (1851–1912)
65 *Sunset, Werribee River* 1886
Oil on canvas 61 × 81.4 cm
Signed *John Ford Paterson 1886*
Title from auction catalogue, Joel's, Melbourne

Girolamo Nerli (1860–1926)
66 (*Botanical Gardens, Sydney*) 1886
Oil on canvas, laid on board 58.4 × 31.7 cm
Signed *G.P.Nerli.Sydney 1886*

67 (*Coast scene with pier*) (1890s)
Oil on board 23.5 × 34 cm
Signed *G. P. Nerli*
Probably a New Zealand subject

Julian Ashton (1851–1942)
68 (*Study of a woman's head*) (1890s)
Oil on canvas 61 × 40.6 cm
Not inscribed
Labelled on back by Artarmon Galleries, Sydney, with artist's name, and as sent to Sydney in 1966 from Mrs G. W. Lambert's collection, London
Datable to the 1890s

69 (*A tranquil afternoon*) (c. 1890)
Oil on board 26.5 × 27 cm
Unsigned

Arthur Loureiro (1860–1932)
70 *An autumn morning* 1893
Oil on canvas, laid on board 71.1 × 101.6 cm
Signed *Arthur Loureiro/ 1893*
Exhibited at Victorian Artists' Society, Melbourne, April 1893

Walter Withers (1854–1914)
71 *Farmer's girl* 1892
Oil on canvas 39.4 × 27.9 cm

60

Signed *Walter Withers.92*
In 1892 Withers was living at Heidelberg near Melbourne

Tom Roberts (1856–1931)

72 *Louis Buvelot* (1886)
Etching 23 × 23.5 cm
Unsigned

73 (*Moorish doorway, Granada*) 1883
Oil on canvas 48.3 × 33 cm
Signed *Tom Roberts—/ Granada Oct/83*

74 *Marie Wechsler* (1895)
Pastel 44.4 × 36.8 cm
Signed *Tom Roberts*, dated indistinctly, probably *1895*
From the collection of Mrs Elizabeth Finley. The subject was a pianist friend of Roberts. Most of Roberts's pastels belong to the late 1890s

75 *Captain Broomfield* 1898
Oil on canvas 69.2 × 59 cm
Signed *Tom Roberts 98*

76 *The artist's wife* (1905/1980s)
Bronze 38 × 31 cm
On verso, foundry stamp *V.F. Melbourne*

77 (*Australian landscape*) (*c.* 1925)
Oil on board 30.5 × 40.6 cm
Signed *Tom Roberts*
Roberts revisited Australia from London in 1920, returned permanently in 1923. This painting might belong to the earlier 1920s

Frederick McCubbin (1855–1917)

78 *Mary Jane Moriarty* (1889?)
Oil on canvas, laid on plywood, 54 × 38.7 cm
Signed *F.McCubbin* (89?), the numerals almost illegible, perhaps 85, 89, or 95
The sitter was sister of McCubbin's wife, and died in 1933 aged 85. David Thomas confirms a date around 1890, for the painting belongs stylistically to 1886–94. (*Art and Australia*, vol. 7, no. 1, June 1980)

79 *Autumn Memories* 1899
Oil on canvas 121.9 × 182.9 cm
Signed *F.McCubbin/ 1899*
One of McCubbin's more important canvases from the period when he lived at Brighton, Melbourne

80 *Nude study* (*c.* 1910)
Oil on canvas board 30.5 × 40.6 cm

Signed *F.McCubbin.* MS label on back by artist's daughter, Kathleen Mangan, '*Nude Study*'/ *by Fred McCubbin/ painted about 1910*

81 (*The coming of spring*) (*c.* 1908)
Oil on canvas 35.5 × 50.8 cm
Signed *F. McCubbin*

82 (*Landscape sketch, Macedon*) (1915)
Oil on canvas board 25.4 × 35.6 cm
Signed *F. McCubbin.* Inscribed on back . . . *by my father the late Frederick McCubbin/ Kathleen Mangan 12/1/69/ Subject— Mt Macedon 1915*

Jane Sutherland (1855–1928)

83 (*The creek*) (*c.* 1895)
Pastel 47.5 × 34 cm
Signed *J.Sutherland*

Clara Southern (1861–1940)

84 (*Landscape with cottage*) (*c.* 1900)
Oil on canvas 35.5 × 22.5 cm
Signed *C Southern*

Louis Abrahams (1852–1903)

85 (*Lion's head*) 1880
Oil on board 12 × 12 cm
Signed with monogram *LA/ 1880*
Inscribed verso *Louis Abrahams/ ex Tom Robert's studio/purchased from the wife of his grandson, Noel Roberts. J.B.*

Charles Conder (1868–1909)

86 *Miss Raynor* (*c.* 1890)
Oil on cedar panel 18.4 × 24.4 cm
Unsigned
If Australian, this undocumented picture would be no later than 1890, when Conder left Melbourne for Europe. Fragmentary pen and ink label on the back: *A sketch by Charles Conder/ Sitter Miss Raynor/ Painted near /Art . . .*

87 *The meeting* (*c.* 1895)
Watercolour on silk, oval 25.5 × 35.5 cm
Signed *C. Conder*

88 (*Figure composition*) (*c.* 1905)
Oil on canvas 61 × 83.8 cm
Signed *Conder*
Stylistically datable to Conder's late period in London

Arthur Streeton (1867–1943)

89 (*In the artist's studio*) 1891
Oil on a tambourine skin 25.5 cm diameter
Incised signature *A Streeton 1891*

90 (*Figures on a hillside, twilight*) (*c.* 1889)
Oil on board 41.3 × 26 cm
Unsigned
Certified on the back by R. H. Croll as found in Tom Roberts's studio at Kallista after his death and unhesitatingly attributed to Roberts's brush. However other works from Roberts's studio, e.g. by Nerli, have been wrongly attributed by Croll to Roberts. It was titled *The Parting* when bought from Artarmon Galleries, Sydney. A drawing by Streeton for this composition has been found by Mary Eagle in a sketchbook

91 (*The Spirit of the Drought*) (*c.* 1895)
Oil on wood panel 34 × 32 cm
Not inscribed
Previously attributed to Conder
Gifted to the Australian National Gallery

92 (*Bathers*) (*c.* 1896)
Oil on cedar panel 59 × 16.5 cm
Not inscribed

93 (*Standing female figure*) 1895
Oil on cedar panel 58.1 × 39 cm
Signed *A. Streeton/ 1895*
The figure is probably a mythological temptress, perhaps Circe. From auction, Christies, Sydney, October 1971, Lot 327

94 (*Sydney Harbour*) 1895
Oil on board 59.7 × 16.5 cm
Signed *Arthur Streeton/ 95*
Probably painted near Sirius Cove, where Streeton lived in a tented camp

95 *A bush idyll* 1896
Oil on cedar panel 53.3 × 30.5 cm
Signed *Arthur Streeton/ 1896*
Originally bought by Professor G. W. L. Marshall Hall

96 *The Centre of the Empire* (*c.* 1903)
Oil on canvas 122 × 122 cm
Signed *Arthur Streeton*
Gifted to National Gallery of Victoria

John Longstaff (1862–1941)

97 (*Farmhouse*) (*c.* 1889)
Oil on canvas on wood panel 12 × 25 cm
Signed *J.Longstaff*
Label on verso *Sketch upon French/ farms by*

Sir John/ Longstaff — given to us/ by his trustees after his death/ Daryl Lindsay

98 (*Twilight landscape*) (1896?)
Oil on canvas board 30.2 × 50.5 cm
Signed *J. Longstaff*
There is perhaps a date *96* or *06* beside the signature. However the subject appears Australian, and the style more typical of Melbourne painting in the 1880s than later. Longstaff left Melbourne for Paris and London in 1888, returned from 1896 to 1901, and finally returned in 1919. Sketching boards of the kind found here were uncommon in the 1880s. Longstaff was still painting sombre Australian landscapes in the 1920s

Bertram Mackennal (1856–1931)
99 (*Portrait head of a woman*) (c. 1888)
Terracotta height 36.8 cm
Signed *Mackennal*
Probably executed in Melbourne, 1886–92

100 *Circe* (1902/1904, from 1892 statue)
Bronze, height 57 cm
Signed *B. Mackennal*
Inscribed *KIP/ KH*
Label on base inscribed *Fondeur E. Gruet jeune Paris.* One of about eight statuettes made 1902–04, the full-size statue of 1892, also cast by Gruet jeune, in *c.* 1902, was bought for the National Gallery of Victoria in 1910

101 (*Goddess*) (1890s)
Bronze plaque 33.6 × 27.3 cm
Signed *Bertram Mackennal*
From the collection of Mrs Elizabeth Finley. Probably executed in London in the 1890s. The costume and helmet indicate that the subject is a goddess

Tudor St George Tucker (1862–1906)
102 *Springtime* 1890
Oil on canvas 31.5 × 52.5 cm
Signed *T. St. G. Tucker/ Etaples/ Nov 1890*

E. Phillips Fox (1865–1915)
103 (*Nude study*) 1884
Charcoal 48.2 × 35.6 cm
Signed *E.P.Fox/ 84*
In 1884 Fox was a student at the National Gallery School, Melbourne, under G. F. Folingsby and O. R. Campbell

104 *Studio, Charterisville* (c. 1895)
Oil on cedar panel 19.7 × 30.5 cm
Inscribed on reverse *Studio, Charterisville*

105 (*The bathers*) 1912
Oil on canvas, laid on plywood, 152.4 × 114.3 cm
Signed *E.Phillips Fox.* Titled on a label on the back, which also states *Painted in France in 1912*
The present owner was told by Lucy Beck that the model for the principal figure was her aunt, a woman who married Penleigh Boyd

106 (*Mother and child*) 1908
Oil on canvas 99.1 × 73.7 cm
Signed *E.Phillips Fox/ 1908*
The artist's sister-in-law Mrs David Fox and her younger daughter, painted in Melbourne while the artist was on a visit from Paris. It is a study for the full-length canvas *Motherhood*, exhibited Royal Academy 1908 and Paris Salon 1910, now in the Art Gallery of New South Wales

Ethel Carrick (1872–1952)
107 (*Figures on jetty*) (c. 1910)
Oil on panel 26.6 × 34 cm
Unsigned

Rupert Bunny (1864–1947)
108 *Mermaids dancing* 1896
Oil on canvas 51 × 78.5 cm
Unsigned
Inscribed on verso *Tritons of Rupert Bunny/ painted in 1896*
Canvas stamp on verso *Paul Foinet*
Exhibited Royal Society of British Artists, winter 1896 as *Mermaids dancing*

109 (*Haymaking, Finistère*) (1900)
Oil on canvas 48 × 69 cm
Signed with initials *R.C.W.B.*
Canvas stamp on verso *P. Foinet Fils Lefebvre*
In David Thomas's monograph on Bunny it appears as no. 0506, *Farmhouse in Brittany*

110 (*Nattering*) (c. 1908)
Oil on canvas 60 × 73 cm
Signed *Rupert C W Bunny*
Canvas stamp on verso *Paul Foinet Fils*
Dated to *c.* 1908 by David Thomas, in whose monograph on Bunny it appears as no. 0507. In 1908 Bunny was living in Paris

Aby Altson (1864–c. 1950)
111 (*Nymphs in grotto*) 1896
Oil on canvas 61.5 × 38.5 cm
Signed *Abbey Altson 1896*
The artist also, and perhaps more commonly, used the signature *Aby Altson*

A. H. Fullwood (1863–1930)
112 (*Girl with galah*) (1890s)
Gouache 45 × 31 cm
Signed with initials *A.H.F.*

Mortimer Menpes (1855–1938)
113 (*Peasant woman*) (c. 1890)
Oil on cedar panel 11 × 8 cm
Signed *Mortimer Menpes*

Charles Douglas Richardson (1853–1932)
114 *A Seaside Vision* (c. 1900)
Plaster 24 × 13 × 11 cm
Signed at base *C Douglas Richardson*
Inscribed at base *A Seaside Vision*

David Davies (1863–1939)
115 (*Street scene, Dieppe*) (c. 1910)
Watercolour 30.5 × 37 cm
Signed *D. Davies*

116 (*Head of a man*) (c. 1895)
Oil on canvas laid on board 44.4 × 35.7 cm
Signed *Davies*
Davies left Melbourne for England in 1897 then moved to France in 1908. This painting has been thought a French peasant, but its style agrees with Davies's Australian period

John Russell (1858–1930)
117 *Doña Peppa Mattiocco* 1886
Conte crayon 44 × 41 cm
Signed *John Russell/ Parigi 1886*
Inscribed *Doña Peppa/ Mattiocco — Di*
This is a portrait of the mother of Russell's fiancée Anne Marie (Marianna) Mattiocco, whom he married in 1888

118 (*Elge, Italy*) 1889
Oil on canvas 60 × 96.5 cm
Signed *John Russell/ Elche 1889*
Gifted to the National Gallery of Victoria

119 (*Almond tree in blossom*) (1887?)
Oil and gold ground on canvas on panel 45.7 × 53.3 cm

62

Not inscribed
Russell visited Sicily in 1887 and painted orchards in blossom. This could be from the series

120 (*Fishing boats, Goulphar*) 1900
Oil on canvas 55.2 × 64.8 cm
Signed *John Russell Belle-Ile 1900*

121 (*Rhododendrons and head of a woman*)
(*c.* 1900)
Oil on canvas 40 × 64.8 cm
Signed *J.R.*
Assigned to *c.* 1900 in the Russell exhibition catalogue, Wildenstein, London, 1965

122 (*Rough sea*) 1900
Oil on canvas 62.9 × 62.9 cm
Signed *John Russell/ B.I. '00*
The initials B.I. stand for Belle-Ile, the island off the Atlantic coast of Brittany where Russell spent each summer from 1886

123 *Portofino* (*c.* 1915)
Watercolour 49 × 61.5 cm
Unsigned

124 *Muscovy bungalow from below* (1920s)
Watercolour 24.5 × 30.5 cm
Signed with initials *JR Syd*
Inscribed on verso '*Muscovy' Bungalow/ Fr Below/ JR*
The artist's waterfront home at Watson's Bay, Sydney, 1923–30

Sydney Long (1871–1955)
125 *The Spirit of the Plains* (1918)
Aquatint and drypoint, black ink 18 × 35 cm
Signed *Sydney Long 42/50*
Made in London; based on the artist's 1897 painting made in Sydney

126 (*Farm landscape*) 1905
Oil on canvas 88.9 × 55.9 cm
Signed *Sid Long/ 1905*
In 1905 Long was living in Sydney. His landscape subjects were often found among the Hawkesbury River farms

Bernard Hall (1859–1935)
127 *The artist's wife* (1890s)
Oil on canvas board 30 × 21 cm
Unsigned

128 *The Quest* (*c.* 1905)
Oil on canvas 61 × 40.5 cm
Signed *B. Hall*

129 (*Staircase to Public Library*) (1930s)
Oil on canvas 69 × 51 cm
Signed *B. Hall*

130 (*Nude reading at studio fire*) (1920s)
Oil on canvas 50.8 × 68.6 cm
Signed *B. Hall*
From the Malvern Gallery, Melbourne, 1971
A similar subject is dated 1905

George W. Lambert (1873–1930)
131 *Self-portrait* (*c.* 1900)
Oil on canvas 45.7 × 38.1 cm
Unsigned
There is an unfinished sketch of a promenading couple on the back of the canvas. On back of frame *Self portrait and sketch/ Geo Lambert*

132 (*Landscape*) 1900
Oil on canvas, laid on board, 86.4 × 90.2 cm
Signed *G.W. Lambert/ Sydney. Sept. 1900*
From the store rooms of James R. Lawson, auctioneers, Sydney, in the 1960s. Said to be a major fragment of one of the pictures for which Lambert was awarded the Society of Artists' Travelling Scholarship in Sydney in 1900; after damage by fire one-third of the painting on the right hand side was lost

Miles Evergood (Myer Blashki) (1871–1939)
133 (*Head of an old man*) (*c.* 1897)
Oil on board 22.4 × 18.1 cm
Signed *MB* (monogram)
Datable to *c.* 1897, the time when Evergood left Melbourne for the United States. Born Myer Blashki, the artist changed his name to Miles Evergood in America.
Pen and ink label on the back
Myer Blashki/ 'The Mansion'/ Bayswater Road/ Darlinghurst

Hugh Ramsay (1877–1906)
134 (*Seated nude*) 1896
Oil on canvas 73 × 59.5 cm
Signed *H. Ramsay '96*

135 (*Seated figure*) (1903/1904)
Oil on canvas 59.5 × 49.5 cm
Signed *HR* in monogram
The sitter is the artist's fiancée Lischen Muller

136 *Self-portrait* (1904)
Oil on canvas, laid on board, 45.7 × 38.1 cm

Unsigned
Painted at Barnawatha, Victoria, where he grew a beard in October 1904 (Patricia Fullerton 1988)

Max Meldrum (1875–1955)
137 (*Flowerpiece*) 1943
Oil on board 46 × 38 cm
Signed *Meldrum '43*

138 (*Studio interior*) (1930s)
Oil on canvas, laid on board, 45.7 × 38.1 cm
Signed *Meldrum*
From the collection of C. A. S. Shepherd, Sydney

J. J. Hilder (1881–1916)
139 (*Bridge*) (*c.* 1910)
Watercolour 17.1 × 17.1 cm
Signed *J.J.Hilder*
Hilder's subjects mostly come from Epping, near Sydney, or from Dora Creek

Elioth Gruner (1882–1939)
140 (*Misty landscape*) (*c.* 1920)
Oil on canvas, mounted on hardboard, 39.4 × 48.9 cm
Unsigned
Subjects of this kind were found by Gruner on the Hawkesbury River, near Windsor, around 1920

Hans Heysen (1877–1968)
141 (*Gum trees*) 1918
Watercolour 38.1 × 31.7 cm
Signed *Hans Heysen 1918*
In 1918 Heysen lived at Hahndorf, near Adelaide

Penleigh Boyd (1890–1923)
142 (*Wattle on the Yarra*) (*c.* 1920)
Oil on canvas 89.5 × 135.9 cm
Signed *Penleigh Boyd*
Penleigh Boyd's wattle-blossom subjects were mostly found at Warrandyte, near Melbourne, and painted around 1920

Rayner Hoff (1894–1937)
143 *Faun and nymph* (1924)
Bronze 26.7 × 28.6 cm

63

Signed *G.Rayner Hoff*
Another cast, in the Art Gallery of New South
Wales, is dated 1924, and numbered 4

Blamire Young (1862–1935)
144 *Moonlight revels* (c. 1924)
Watercolour 37.5 × 48.2 cm
Signed *Blamire Young*

Web Gilbert (1869–1925)
145 *Dorothy* (1913)
Bronze height 34.3 cm
Signed *Web Gilbert*

Norman Lindsay (1879–1969)
146 (*Bedroom scene*) (c. 1909)
Etching 15.2 × 12.7 cm
Etched signature *NL*
The style indicates an early work, perhaps
about 1909

147 *The Garden of Happiness* (1920s)
Pen and ink 29.5 × 26 cm
Signed *N.L.*
Inscribed *To my friend John Mauquin/ 2
The Garden of Happiness*

Cumbrae Stewart (1883–1960)
148 (*Weeping girl*) 1924
Pastel 24 × 19.5 cm
Signed *Cumbrae Stewart/ '24*

Clarice Beckett (1887–1935)
149 *Sherbrooke Forest* (c. 1925)
Oil on board 35 × 36 cm
Signed *C.Beckett*
Sticker on verso *Cat.No. 11 'Sherbrooke
Forest'*

M. Napier Waller (1893–1972)
150 *The dance* 1926
Watercolour 45 × 58.5 cm
Signed *M. Napier Waller 26*

Harold Herbert (1892–1945)
151 *Morning sunlight* 1931
Watercolour 34.5 × 47 cm
Signed *Harold Herbert 1931*
Label on verso *Harold Herbert, Morning
Sunlight, Menhennitt Collection*

Robert Campbell (1902–72)
152 *A corner of Berry's Bay, Sydney Har-
bour* 1939
Oil on board 12 × 17 cm
Signed *R.R.Campbell*
Inscribed on backing sheet *A Corner of
Berry's Bay, Sydney Harbour 1939/ All Good
Wishes from/ the Campbells/ 1953*

Florence Rodway (1881–1971)
153 (*Little girl holding orange*) 1934
Pastel 96.5 × 43.5 cm
Signed *F Rodway 1934*

Mary Cockburn Mercer (1882–1963)
154 *Lesbians* (c. 1940)
Watercolour 22 × 26.5 cm
Signed *M.C.Mercer*
Inscribed on backing sheet
Lesbians/ M Cockburn-Mercer

Kathleen O'Connor (1886–1968)
155 (*White flowers and jug*) (c. 1920)
Oil on canvas on board 64.7 × 54 cm
Signed *K. O'Connor*

Ola Cohn (1892–1964)
156 *Confucius* (1920s)
Wood and bark 27 × 18 × 13 cm
Not inscribed

William Frater (1890–1974)
157 *The artist's wife* 1915
Oil on canvas on plywood 45.7 × 32.4 cm
Unsigned
MS label on back in the artist's
hand *Painted in 1915 in Melbourne. The
artist's wife*

Thea Proctor (1879–1966)
158 (*Portrait of a woman*) (1920s)
Pencil and watercolour 34.3 × 27.3 cm
Signed *Thea Proctor*

159 (*The sun room*) (1940s)
Watercolour 34 × 39 cm
Signed *Thea Proctor*

160 *Women with fans* (c. 1930)
Woodcut 21.8 × 22 cm
Signed *P on block*

Signed *Thea Proctor*
Inscribed *Women with Fans*
A watercolour on silk version of this work,
titled *The Bay*, is in the Art Gallery of New
South Wales

Edith Trethowan (1901–39)
161 *Sunny waters near Fremantle* (c. 1928)
Wood-engraving 10 × 15 cm
Unsigned

Dorrit Black (1891–1951)
162 *Hillside houses* (early 1930s)
Linocut 20 × 16.5 cm
Signed *D.B. 1/1*

Eveline Syme (1888–1961)
163 *The bay* 1933
Linocut 17 × 26 cm
Signed *E.W.Syme 1933*
Inscribed *The Bay 11/25*

Ethel Spowers (1890–1947)
164 *The Works, Yallourn* 1933
Linocut 16 × 35 cm
Signed *E.L.Spowers 1933*
Inscribed *The Works, Yallourn 3/50*

Bessie Davidson (1879–1965)
165 *The embankment* (c. 1940)
Oil on board 41 × 52 cm
Signed *Bessie Davidson*

Sybil Craig (born 1901)
166 *Design, Banksias* (1945)
Linocut 19 × 24 cm
Signed *Sybil Craig*
Jim Alexander Gallery, 18 April 1982.
Noted in catalogue *First design in a series*

Margaret Preston (1875–1963)
167 *Fuchsias* (1928)
Woodcut, hand-coloured 28 × 27 cm
Signed on block *M.P.*
Signed *Margaret Preston*
Inscribed *40th Proof Fuchsia etc*

168 *Flannel flowers* 1938
Oil on canvas 121.9 × 91.4 cm
Signed *Margaret Preston 1938*

169 *Middle Harbour* (1946)
Monotype 36 × 37 cm
Signed in image *M.P.*
Signed *Margaret Preston*
Inscribed *Monotype/ Middle Harbour*
From the Mervyn Horton Collection

Merric Boyd (1888–1959)
170 *Koala bowl* 1931
Earthenware, blue glaze 19 × 25.4 cm
Signed *Merric Boyd/ 1931*

H. R. Hughan (1893–1986)
171 *Platter* (1940s)
Stoneware 8.5 × 50.5 × 50.5 cm
Signed on base with monogram *HRH*
Exhibition: *Hughan Retrospective*, National
Gallery of Victoria, 1969, no. 397

172 *Lidded jar* (1940s)
Stoneware 27 × 23 × 23 cm
Signed on base with monogram *HRH*

Hilda Rix Nicholas (1884–1961)
173 *Autumn bounty* (c. 1930)
Oil on canvas 93 × 72 cm
Unsigned

Roland Wakelin (1887–1971)
174 *(Landscape)* 1920
Oil on board laid on hardboard
30.5 × 36.8 cm
Signed *R. Wakelin 1920*
The landscape subject is unidentified, but it
could be near Terrigal where Wakelin some-
times holidayed around 1920

175 *On Ball's Head* 1919
Oil on board 22.9 × 28.5 cm
Signed *R. S. Wakelin 1919*

Roy de Maistre (1894–1968)
176 *(Syncromy, Berry's Bay)* 1919
Oil on plywood 25.4 × 34.9 cm
Signed *R de Mestre 1919*
Included in de Maistre's and Wakelin's
Colour in Art exhibition, Gayfield Shaw's
Gallery, Sydney 1919, perhaps no. 3,
Syncromy in Yellow Green Minor, 15 guineas.
A 1919 painting by Wakelin of the same sub-
ject is illustrated in *Art and Australia*, March
1967

177 *Abstract* 1936
Oil on canvas 56 × 76.5 cm
Signed *R de Maistre 1936*

178 *Reclining figure* 1933
Oil on cardboard 50.8 × 61 cm
Signed *R de Maistre 1933*
Painted in London. Roi de Mestre changed his
name to Roy de Maistre after he left Sydney
for Europe in 1930

Grace Crowley (1890–1979)
179 *Study for portrait* (1935)
Pencil 76 × 58 cm

Rah Fizelle (1891–1964)
180 *Seated figure* (c. 1938)
Conté crayon 72 × 50 cm
Signed *Rah Fizelle*

William Dobell (1899–1970)
181 *Dead landlord* (c. 1936)
Gouache 14.6 × 20.3 cm
Signed *Bill Dobell/ The (not quite)/dead
landlord*
A study for the painting 27.9 × 35.6 cm done
in London in 1936

182 *Study for 'The Cypriot'* (c. 1938)
Oil on board 25.4 × 25.4 cm
Signed *Dobell*
Study for the canvas, 121.9 × 121.9 cm,
1940, now in the Queensland Art Gallery.
This study would date from Dobell's London
period

183 *Self-portrait* (c. 1965)
Oil on hardboard 17.8 × 17.8 cm
Signed *Dobell*
Painted at Wangi Wangi, near Newcastle,
N.S.W.

Eric Wilson (1911–46)
184 *(Wantabadgery landscape)* 1946
Oil on canvas 58.4 × 74.9 cm
Signed *Eric Wilson 46*
From the collection of Sir Keith Murdoch,
Melbourne, who had a property at Wanta-
badgery, near Wagga

Lloyd Rees (1895–1988)
185 *Fig tree* 1934

Pencil drawing 20.3 × 26.7 cm
Signed *L.Rees/ 1934*
One of several drawings based on fig trees at
McMahons Point, Sydney

186 *Waverton* 1932
Pencil 22.9 × 34.3 cm
Signed *L.Rees 1932*
Three other versions of this view were
exhibited in Rees's retrospective, Art Gallery
of New South Wales 1969. Waverton is a sub-
urb of Sydney

187 *(The harbour)* (1920s)
Oil on board 21 × 33 cm
Signed *L.Rees*
Inscribed on verso *Lloyd Rees — The
Anchorage 192-? From Lady Langker*

188 *South Head, Sydney* 1954
Oil on board 39.5 × 46 cm
Signed *L.Rees '54*

189 *Dusk on the Derwent* 1985
Oil on canvas board 61 × 91 cm
Signed *L.Rees '85*
Inscribed on verso *Dusk on the Derwent
(Tas)/ . . . The artist painted this picture
specially for me in 1984 . . . JB*

Arnold Shore (1897–1963)
190 *(Flower study)* 1932
Oil on board 68 × 55 cm
Signed *Shore 32*

George Bell (1878–1966)
191 *Greek head* 1959
Oil on canvas 41 × 36 cm
Signed *George Bell 59*

Russell Drysdale (1912–81)
192 *Industrial landscape* 1937
Gouache 43.2 × 43.8 cm
Signed *Drysdale 37*

193 *Hangar, Rose Bay* (1940s)
Ink and gouache 18 × 23.5 cm
Signed *Russell Drysdale*

194 *Man with ram* (1941)
Charcoal 29.8 × 22.5 cm
Signed *Russell Drysdale*

195 *Sketch for 'The rabbiters'* (1947)
Ink and and body colour 14 × 26.5 cm
Signed *Russell Drysdale*

196 *Sketches for 'Tree form'* (1945)
Ink and body colour 25 × 22 cm
Signed *Russell Drysdale*

197 *Tree form* (1945)
Oil on canvas 61 × 76.2 cm
Signed *Russell Drysdale*

198 *Studies for 'The Gatekeeper's Wife'*
(c. 1947)
Pencil 38.1 × 25.4 cm
Signed in ink *Russell Drysdale/ Studies for
The Gatekeeper's Wife*

199 *Diver, Broome* (1959)
Oil on canvas 76.2 × 61 cm
Signed *Russell Drysdale*

Peter Purves Smith (1912–49)
200 *Vase with flowers* (c. 1940)
Oil on canvas 61 × 40.5 cm
Not inscribed

201 *The pond, Paris* (c. 1938)
Oil on canvas 71.1 × 91.4 cm
Unsigned. From the collection of Lady
Drysdale. Reproduced with this title in *Aus-
tralian Present Day Art*, 1943. The artist was
in Paris 1938–9

202 *Double head* 1947
Oil on canvas 81.3 × 61 cm
Signed *Purves Smith 1947*

203 *Woman eating* 1948
Gouache and pen and ink 45.7 × 61 cm
Signed *Purves Smith 1948*

Ludwig Hirschfeld Mack (1893–1964)
204 (*Figure*) 1940
Watercolour 24.1 × 16.5 cm
Signed *L. H. Mack 40*

Kenneth Macqueen (1897–1960)
205 (*Clouds over landscape*) 1926
Watercolour 39 × 45 cm
Signed *Kenneth Macqueen 1926*

Clive Stephen (1889–1957)
206 (*Winged horse*) (1930s)
Marble 26 × 37 × 26 cm
Not inscribed

Sali Herman (born 1898)
207 (*Still life*) 1931

Oil on canvas 69.5 × 57 cm
Signed *S.Herman/ '31*

William Dargie (born 1912)
208 *Draped mask and still life* 1935
Oil on canvas board 61 × 41 cm
Signed *Dargie/ 1935*
Label on verso *Draped Mask and Still Life by
W.A.Dargie*

Constance Stokes (born 1906)
209 *Three sisters* (c. 1945)
Oil on canvas 51 × 61 cm
Signed *Constance Stokes*
Inscribed on verso *Three Sisters*

Grace Cossington Smith (1892–1984)
210 *Kuringai Avenue* 1943
Oil on hardboard 48.9 × 41.9 cm
Signed *G.Cossington Smith.43/ Kuringai
Avenue*
The subject is outside the artist's house,
Turramurra, Sydney

211 *Fruit in the window* 1957
Oil on board 78.5 × 58 cm
Signed *G. Cossington Smith 57*

Ewald Namatjira (born 1930)
212 (*The Centre*) (1950s)
Watercolour 35 × 52 cm
Signed *Ewald Namatjira*

Otto Pareroultja (1914–73)
213 (*Gums*) (1950s)
Watercolour 54 × 73 cm
Signed *Otto Pareroultja*

Henri Bastin (1896–1979)
214 (*Flower study*) 1962
Gouache 63 × 50 cm
Signed *Henri Bastin 1962*

Sam Byrne (1883–1978)
215 *Rabbit plague 1891* (c. 1960)
Oil on board 57 × 76 cm
Signed *Sam Byrne*
Inscribed *Rabbit Plague 1891*

Ian Fairweather (1891–1974)
216 *Two Philippine children* (1933)
Oil on plywood 43.2 × 49.5 cm
Signed *IF*

217 (*Musicians*) (1954)
Gouache 44.4 × 34.9 cm
Signed *IF*

Adrian Lawlor (1889–1969)
218 *Traipsing vase* (c. 1930)
Oil on canvas 53 × 39 cm
Signed *Adrian*
Label on verso *Traipsing Vase*
Inscribed on verso *To Lina with everything
I've got. Adrian with love*

Lina Bryans (born 1909)
219 *The dancing gum* 1960
Oil on board 60 × 49 cm
Signed *Lina 60*

Eric Thake (1904–82)
220 *Oceania* 1945
Linocut 45.2 × 28.6 cm
Signed *Eric Thake 1945*
Inscribed *Oceania*

Jean Bellette (born 1919)
221 *Acheron* (c. 1944)
Oil on paper on hardboard 31.7 × 41.3 cm
Signed *J.B.*

Horace Brodzky (1885–1968)
222 *The tidings* 1958
Oil on canvas 50.8 × 61 cm
Signed *Horace Brodzky/ 58*. Titled on can-
vas turnover
In 1958 Brodzky lived in London

Edwin Tanner (1920–80)
223 (*Hats and shoe*) 1955
Oil on canvas 66 × 102 cm
Signed *Edwin Tanner '55*

Adrian Feint (1894–1971)
224 (*House and flame tree*) 1941
Oil on canvas 45.5 × 41 cm
Signed *Adrian Feint 1941*

Godfrey Miller (1893–1964)

225 *House in moonlight* (c. 1940)
Oil on board 27 × 23 cm
Unsigned
Inscribed on verso *JH 354*
Pasted on verso: Letter of Authentication by Darlinghurst Galleries, Sydney, giving title, signed by Lewis Miller, John Henshaw and John Kaplan, 1972. Authentication No. 15977 JH 354

226 *Design* (1940s)
Oil on canvas on board 34 × 24 cm
Unsigned
Pasted on verso: Letter of Authentication by Artarmon Galleries, Sydney. Cat No.8, Sept 1981. Signed by J.G. Henshaw

227 *Trees and forest series* (1940s)
Oil on canvas on board 29 × 38 cm
Unsigned
Inscribed *JH 235*
Pasted on verso: Letter of Authentication by Darlinghurst Galleries, Sydney. Signed by Lewis Miller, John Henshaw and John Kaplan

228 *Still life with jug* (1949–54)
Oil on canvas 61 × 96.5 cm
Unsigned. Labelled on back *JH 469*

229 *Trees in quarry* (1961–3)
Oil on canvas 76.6 × 91.4 cm
Signed *Godfrey Miller*. Labelled on back *29 JH*

John Passmore (1904–85)

230 (*Children and pony*) (1930s)
Oil on canvas 99 × 122 cm
Unsigned
Gift from the artist's widow

231 *Shag on scratch* (c. 1959)
Oil on board 76.2 × 91.4 cm
Signed *JP*

232 *Millers Point* (c. 1953)
Oil on hardboard 55.9 × 67.3 cm
Signed *JP*

233 *Boys fossicking for mussels* (c. 1955)
Oil on hardboard 55.9 × 66 cm
Signed *JP*

Ralph Balson (1890–1964)

234 *Painting* 1954
Oil on hardboard 69.8 × 91.4 cm
Signed *R.Balson.54*

235 *Painting* 1959
Enamel on hardboard 74.9 × 90.2 cm
Signed *R.Balson/ 59*

Weaver Hawkins (1893–1977)

236 *Abstract* 1962
Oil on board 71 × 61 cm
Signed *Raokin 62*

Frank Hinder (born 1906)

237 (*Abstract*) 1952
Oil on board 17.5 × 23 cm
Signed *F. C. Hinder 52/ F. C. H. 52*

Danila Vassilieff (1897–1958)

238 (*The buffet*) 1934
Oil on canvas on board
35.5 × 27.9 cm
Signed *D. Vassilieff 1934*

239 *Fitzroy street scene* (c. 1938)
Oil on plywood 36.8 × 43.8 cm
Signed *Vassilieff*

240 *Predator and prey* (early 1950s)
Marble *Predator* 12 × 34 × 8 cm
Prey 11 × 11 × 9 cm
Not inscribed

241 *Nude* (early 1950s)
Marble 35 × 14 × 10 cm
Not inscribed

242 *Family: Murray River carnival* 1956
Oil on canvas 49 × 53 cm
Unsigned
Inscribed on verso *From Murray River Carnival Series 1956*

243 *Sir Bernard Heinze conducting* (1951–52)
Walnut 67 × 23 × 18 cm
Unsigned

John Perceval (born 1923)

244 *Boy with kite, Fitzroy* 1943
Oil on board 63 × 71 cm
Signed *Perceval '43*

245 *Potato field* 1948
Oil on canvas on hardboard
58.4 × 81.9 cm
Signed *Perceval '48*

246 *Floating dock and tugboats* 1956
Oil on hardboard 91.4 × 121.9 cm

Signed *Perceval '56*. Titled in chalk on back. A subject from Williamstown, Melbourne

247 *Bowl* 1957
Earthenware 24 × 32 × 32 cm
Signed on base *Perceval 1957*

248 *Two angels* 1961
Earthenware, sang-de-boeuf glaze
Height 17.8 cm
Signed *Perceval '61*

Albert Tucker (born 1914)

249 *Image of Modern Evil* 1945
Pen and coloured inks 29 × 25.5 cm
Signed *Albert Tucker '45*
Noted on verso *Cover design for 'Angry Penguins'*

250 *Image of Modern Evil* (1945)
Oil on hardboard 33 × 47 cm
Signed *Tucker*. Inscribed on back in chalk *Images of Modern Evil*
'The Images of Modern Evil' series was later retitled 'Night Images'

251 *Image of Modern Evil* (c. 1970)
Bronze 33 × 17 × 10 cm
Signed *T 6/6*

252 *Explorer and parrot* 1960
Oil and PVA on hardboard 121.9 × 121.9 cm
Signed *Tucker '60*
Included in the exhibition *Australian Painting Today*, Australia and Europe 1963–65

Sidney Nolan (born 1917)

253 *Abstract drawing* (1940)
Monotype on blotting paper 27.9 × 43.2 cm
Signed *Nolan*
Probably from Nolan's first one-man show, Melbourne 1940

254 *Bell, St Kilda* (c. 1942)
Oil on board 22.7 × 29.2 cm
Signed *Nolan*
Inscribed on back *Bell?/ Graeme and Margot*
Bought from Martin Smith who identified it as a St Kilda subject

255 *Unnamed Ridge, Central Australia* 1949
Ripolin enamel on board 91.4 × 121.9 cm
Signed *Nolan/ 17-11-49*
Exhibited in Wynne Prize competition, Art Gallery of New South Wales, Sydney, January 1950

256 *Carcass* (*c.* 1950)
Ripolin enamel on board 91 × 122 cm
Unsigned

257 *Crucifix* 1955
Oil on board 92 × 122 cm
Signed *Nolan*
Inscribed on verso *Crucifix Southern Italy Nolan 16/7/55*

Arthur Boyd (born 1920)
258 *Christ bearing the Cross* (*c.* 1946)
Oil on canvas 86.4 × 101.6 cm
Signed *Arthur Boyd*
Painted at Murrumbeena, Melbourne

259 *Family group* (*c.* 1946)
Oil on hardboard 104.1 × 121.9 cm
Signed *Arthur Boyd*
Painted at Murrumbeena, Melbourne

260 *Wheatfield, Berwick* (1948)
Oil on hardboard 73.7 × 73.7 cm
Signed *Arthur Boyd*

261 *Europa and the Bull platter* (*c.* 1948)
Earthenware 9 × 38.5 cm
Signed on base *A.M.Boyd*
Inscribed on base *Arthur Boyd made about 1948*

262 *Bride and groom by a creek* (*c.* 1960)
Oil on hardboard 106.7 × 137.2 cm
Signed *Arthur Boyd*
Painted in London

263 *Lysistrata* (1970)
Pen and ink 59.5 × 60.6 cm
Signed *Arthur Boyd*
For the *Lysistrata Suite*, created in 1970. Published by Ganymed Original Editions Ltd (London)

264 *Birth of Narcissus* (1976)
Oil on canvas 155 × 124.5 cm
Signed *Arthur Boyd*
Inscribed on verso *Gift of artist to Joseph Brown 16.10.85*

265 *Stoat* (1970)
Oil on board 26.5 × 54 cm
Signed *Arthur Boyd*
Inscribed *To Joe with love*

266 *Clay and rockface at Bundanon* (1981)
Oil on canvas 86 × 59 cm
Signed *Arthur Boyd*

Joy Hester (1920–60)
267 (*Lovers*) (*c.* 1945)

Watercolour 29.5 × 23 cm
Unsigned

James Wigley (born 1918)
268 (*Salvation Army meeting*) 1937
Watercolour 26 × 35 cm
Signed *James Wigley Dec. 1937*
Label on verso *James Wigley/ 91 Musical Evening . . .*

Yosl Bergner (born 1920)
269 (*House backs, Parkville*) (*c.* 1938)
Oil on canvas 51.4 × 43.2 cm
Signed *Bergner*

270 (*In Fitzroy*) (*c.* 1940)
Oil on board 35.6 × 38.1 cm
Unsigned

Vic O'Connor (born 1918)
271 *Refugees* (*c.* 1942)
Oil on canvas on hardboard
55.9 × 50.8 cm
Signed *V.G.O'Connor*

Noel Counihan (1913–86)
272 *The lady with the fox fur coat* 1942
Oil on board 61 × 68 cm
Signed *Counihan 42*

Robert Klippel (born 1920)
273 *Metal sculpture* (1965)
Steel height 69.2 cm
Not inscribed

274 *R.K. 255* 1970
Steel 55 × 45 × 21 cm
Inscribed on base *RK 255 1970*

275 *Landscape* 1970
Watercolour 26 × 36 cm
Signed *Robert Klippel 70*
Inscribed *To Joe Brown with best wishes*

276 *R.K. 451* 1982
Bronze 60 × 27 × 27 cm
Signed *RK 451.82 1/6*
Foundry stamp *Cire Perdu Meridian Melbourne*

Jon Molvig (1923–70)
277 *Head of madman* 1957
Charcoal 79.5 × 63 cm

Signed *Molvig 57*
Drawing for the painting in the Mertz Collection, University of Texas, Austin

Clifton Pugh (born 1924)
278 *Bush* 1957
Oil on hardboard 68.6 × 91.4 cm
Signed *Clifton/ 57*

Desiderius Orban (1884–1986)
279 *Abstract* (1950s)
Pastel 72 × 53 cm
Signed *Orban*

Sam Atyeo (born 1911)
280 *Little Lonsdale Street* (*c.* 1950)
Watercolour 32.5 × 46 cm
Signed *S. Atyeo*
Inscribed on reverse *S. Atyeo/ Little Lonsdale Street/ early 30's*

Teisutis Zikaras (born 1922)
281 *Head* (1960)
Wood on marble base 37 × 10 × 11 cm
Inscribed on base *To Joseph Brown with best wishes from T.J.Zikaras*

Sam Fullbrook (born 1922)
282 *Plane with yellow wings* (1963)
Oil on canvas on plywood
30.5 × 39.4 cm
Signed *S/F*

Justin O'Brien (born 1917)
283 *Head of a girl* (*c.* 1950)
Oil on board 29.2 × 19 cm
Signed *O'Brien*

Donald Friend (born 1915)
284 *The Clarence from Yulgilbar* (1963)
Oil on canvas 61 × 45.5 cm
Signed in heart motif *D.F.*

Ivor Francis (born 1906)
285 *Nostalgic landscape* 1944
Oil on canvas 52 × 69 cm
Signed *Francis I/ 44*
Inscribed *Op. 41 No.3 1944*

James Gleeson (born 1915)
286 *The Siamese Moon* 1951
 Oil on canvas 56 × 74 cm
 Signed *Gleeson 51*

Tony Tuckson (1921–73)
287 (*Female nude*) (1952)
 Oil on board 56 × 26 cm
 Unsigned

288 (*Untitled*) (c. 1955)
 Gouache 50 × 76.5 cm
 Unsigned

Roger Kemp (1908–87)
289 *Sequence* 1973
 Etching 101 × 50 cm
 Signed *Roger Kemp 73*
 Inscribed *A/P Sequence*

290 (*Abstract*) (1960)
 Oil on board 110.5 × 118.5 cm
 Signed *Roger Kemp*

George Baldessin (1939–78)
291 *The enclosure* (1964)
 Bronze edition 1/1 height 127 cm
 From Mildura Sculpture Triennial 1964
 Original bronzed plaster gifted to NGV.

292 *Personage with striped dress* 1968
 Etching 57 × 50 cm
 Signed *George Baldessin 68*
 Inscribed *Personage with Striped Dress ed.25*

Fred Williams (1927–82)
293 *Cricketer* 1955
 Oil on canvas on hardboard 45.7 × 34.3 cm
 Signed *Fred Williams 55*
 Painted in London

294 *Beach scene* 1954
 Gouache 55 × 76 cm
 Signed *Fred Williams 54*

295 *Water urn* 1967
 Earthenware 30 × 30 × 30 cm
 Decorated by Williams, potted by Tom Sanders
 Signed on base *Tom Sanders and Fred Williams 67*

296 *Upwey landscape* (1965)
 Gouache 49 × 74 cm
 Signed *Fred Williams*

297 *Werribee Gorge* 1978
 Gouache 55 × 74 cm
 Signed *June 1978 Fred Williams*

298 *Mill's Beach, Mornington* (1970s)
 Gouache 54 × 74 cm
 Signed *Fred Williams*

299 *Woman* (1955)
 Etching 14.5 × 9.5 cm
 Unsigned

300 *Saplings* (1962)
 Etching 16.5 × 16.5 cm
 Signed *Fred Williams*
 Inscribed *Artist's Proof*

301 *Young girl III* (1966)
 Etching 23.5 × 17 cm
 Signed *Fred Williams 13/39*
 Inscribed on verso *Portrait of Jawecky Dewarder*

302 *The actor* 1956
 Etching 15 × 20 cm
 Signed *Fred Williams 56*
 Inscribed *ed 8/9*

303 *Echuca landscape* 1962
 Oil on hardboard 138.4 × 121.9 cm
 Signed *Fred Williams '62*

304 *Hillside* (1966)
 Oil on canvas 106.7 × 132.1 cm
 Signed *Fred Williams*

Leonard French (born 1928)
305 *Death and Transfiguration* (1957)
 Enamel on hardboard 120.6 × 90.2 cm
 Signed *French*

George Johnson (born 1926)
306 *Pilgrim* (1963)
 Oil on board 122 × 152 cm
 Inscribed on verso *George Johnson*

Clifford Last (born 1918)
307 *Cruciform* 1965
 Bleached jarrah wood height 137.2 cm
 Signed with six-pointed star */ 65/ C.Last*

308 *The custodians* 1967
 Bronze 191 × 119 × 31 cm
 Signed with initials in monogram
 Inscribed *LXVII and edition III/III*
 Foundry mark *Vittorio & Fernando Melbourne*

John Brack (born 1920)
309 *The block* 1954
 Oil on canvas 60 × 72 cm
 Signed *John Brack 54*

310 *Two jockeys* 1956
 Drypoint 17 × 26 cm
 Signed *John Brack 56*
 Inscribed *Ed 14/25*

311 *Two typistes* 1955
 Oil on canvas 51 × 61 cm
 Signed *John Brack 55*
 A variation on two figures in the painting *Collins Street, 5 p.m.*, 1955

312 *Nude with dressing gown* 1967
 Oil on canvas 115.6 × 81.3 cm
 Signed *John Brack '67*. Titled on canvas turnover

313 *Nude on a small chair* 1975
 Pastel 65 × 86 cm
 Signed *John Brack 1975*

314 *Confrontation* 1978
 Pen and ink and watercolour 71 × 51 cm
 Signed *John Brack 78*

Charles Blackman (born 1928)
315 *Rooftop* (1953)
 Charcoal 54 × 74 cm
 Signed *Blackman*

316 (*Lovers*) 1960
 Oil on hardboard 152.4 × 137.2 cm
 Signed *Blackman 60*

Mike Brown (born 1938)
317 *One, two, three four five . . .* (c. 1965)
 Enamel and collage on board 122 × 91.5 cm
 Unsigned

Keith Looby (born 1940)
318 *The family* (1960s)
 Oil on board 181 × 121 cm
 Signed *Looby*

William Rose (born 1930)
319 *Abstract* 1966
 Watercolour and ink 40 × 69 cm
 Signed *W Rose 66*

Norma Redpath (born 1928)
320 *Horse, bird and sun* 1963

69

Bronze 20.3 × 27.9 × 12.7 cm
Signed *NR 63*

Elwyn Lynn (born 1917)
321 *Second half* (1961)
Mixed media 101.5 × 76 cm
Unsigned

Jeffrey Smart (born 1921)
322 *On the roof* (1967)
Oil on canvas 71.1 × 99 cm
Signed *Jeffrey Smart*

Stanislaus Ostoja-Kotkowski (born 1922)
323 *The planet* 1965
Paper collage on board 121.9 × 121.9 cm
Signed *Ostoja 1965*

Alun Leach-Jones (born 1937)
324 *Noumenon Forecast VI* (1969)
Acrylic on canvas 91.5 × 91.5 cm
Inscribed on verso *Alun Leach-Jones/ Nou-menon Forecast VI*

Sydney Ball (born 1933)
325 *Canto No. 28* 1966
Acrylic on canvas 106.7 × 121.9 cm
Signed on back
Sydney Ball/ March '66

Peter Upward (1932–1983)
326 *September Tablet* 1961
Oil on board 107 × 76 cm
Signed *Upward 61*
Inscribed on verso *September Tablet*

Guy Stuart (born 1942)
327 *Baffles* 1971
Crayon 102.9 × 67.3 cm
Signed *Guy Stuart.1971.'Baffles'*

John Olsen (born 1928)
328 *Granada* 1959
Oil on canvas 99 × 119 cm
Signed *John Olsen 59*
Inscribed *Granada*
Exhibition *Recent Australian Painting*,
Whitchapel Art Gallery, London, 1961

329 *Man absorbed in landscape* 1966
Oil on board 122.5 × 126 cm
Signed *John Olsen 66*
330 *Vase* 1971
Earthenware 69 × 20 cm diameter
Signed on base *John Olsen 71*

Brett Whiteley (born 1939)
331 *Painting* (c. 1961)
Oil and canvas collage on board
121.9 × 121.9 cm
Unsigned
Painted in London

332 *Baboon* (c. 1966)
Fibreglass 48.3 × 44.4 × 67.3 cm
Unsigned

333 *Still life with cornflowers* 1976
Oil on canvas 91.5 × 91.5 cm
Signed *Brett Whiteley*
Inscribed on reverse *Brett Whiteley 1976/ Still Life with Cornflowers*

Ivan Durrant (born 1947)
334 *Clark Gable nightflight* 1974
Acrylic on canvas 122 × 107 cm
Signed *I.Durrant 74*

Dale Hickey (born 1937)
335 *Group of cups* (1972)
Oil on canvas 33 × 33 cm
Unsigned

Asher Bilu (born 1936)
336 *Graphite I* (1969)
Synthetic resin on hardboard
213.7 × 213.7 cm
Unsigned
Gifted to Australian National Gallery

Donald Laycock (born 1931)
337 *Metamorphis* 1970
Oil on canvas 182.9 × 198.1 cm
Signed *D.L. '70*
Exhibited Travelodge Art Prize, Sydney 1970,
as *Metamorphose*
Gifted to Australian National Gallery

Robert Jacks (born 1943)
338 *Silently emptied* 1966

Oil and pencil on canvas 174 × 243 cm
Signed *Jacks 66*
Inscribed on reverse *Silently emptied*

Clement Meadmore (born 1929)
339 *Bent* 1966
Steel height 88.9 cm
Signed *Meadmore 1966 1/2*

John Peart (born 1945)
340 *Painting* (1968)
Oil on canvas 175.2 × 66 cm
Unsigned

John Firth-Smith (born 1943)
341 *Sydney Harbour* 1966
Oil on canvas 108 × 118 cm
Signed *Firth-Smith 66*
Inscribed on verso *Firth-Smith 1966/ 505 and Harbour*

Peter Booth (born 1940)
342 *Red, yellow, black abstract* 1966–67
Oil on canvas 157 × 237 cm
Signed on verso *Peter Booth 1966-7* and
Peter Booth 1970

343 *Drawing* 1979
Brush and ink 65.1 × 103 cm
Inscribed on reverse *Peter Booth/ May 1979*

Gunter Christmann (born 1936)
344 *Rhastu-dh-dhill* 1970
Acrylic on canvas 163 × 223 cm
Signed on verso *G.S.Christmann/ Jan.Feb 70*

David Aspden (born 1935)
345 *'Brazil' series* (1972)
Oil on canvas 177 × 153 cm
Signed on verso *Aspden*

Ron Robertson-Swann (born 1941)
346 *Vault* (1978–79)
Steel 51 × 90 × 66 cm
Not inscribed

347 *Figure and ground at the dance* (1983)
Acrylic on canvas board 23 × 30 cm
Unsigned

Louis Kahan (born 1905)

348 *Australian Imagination XVII* (1973)
Offset print vellum finish 110.5 × 80 cm
Limited edition. Published by *Champion Papers*, a division of Champion International, USA
See appendix to catalogue for the identity of sitters

Inge King (born 1918)

349 *Black sun* (1975)
Steel 62 × 58 × 18 cm
Signed on base *IK 1/1*

Michael Taylor (born 1933)

350 *Rainbow Hill* 1975
Acrylic on canvas 99 × 99 cm
Signed *Taylor 75*
Inscribed on reverse *Rainbow Hill/ June 1975*

William Delafield Cook (born 1936)

351 *Three cabbages* (1977)
Charcoal and conté crayon 66 × 106.7 cm
Signed *W. Delafield Cook*

Ken Whisson (born 1927)

352 *Houses and grass: Australian landscape* 1984
Oil on canvas 90 × 119 cm
Signed on verso on stretcher *15/9/84 Ken Whisson*

Mike Parr (born 1945)

353 *The arm of the Cyclops* (1982)
Charcoal 121 × 235 cm
Unsigned

Colin Lanceley (born 1938)

354 *Forest oracle* 1977
Watercolour 57 × 77 cm
Signed *Lanceley 77*
Inscribed *Forest Oracle*

Michael Shannon (born 1927)

355 *Interior with green sofa* 1979
Mixed media 118 × 79 cm
Signed *Shannon 79*

David Wilson (born 1947)

356 *Dry pool* (1979)
Welded steel, rusted 24 × 122 × 135 cm
Not inscribed

Paul Partos (born 1943)

357 *Untitled (Yellow)* 1979
Oil on canvas 88.5 × 61 cm
Signed on verso *P.Partos 79*

Richard Larter (born 1928)

358 *Untitled* 1979–80
Oil on canvas 185 × 105 cm
Signed on verso *R.Larter 1979-80*

Bea Maddock (born 1934)

359 *Four finger exercise for two hands* 1981
Four-colour relief etching 53 × 47 cm
Signed *Bea Maddock 88* [sic]
Inscribed *1/20 Four Finger Exercise for Two Hands, 1981*

Gareth Sansom (born 1939)

360 *Temptation* (1978)
Mixed media 79 × 100 cm
Unsigned

Robert Rooney (born 1937)

361 *Born to die* (1985)
Acrylic on canvas 122 × 189 cm
Signed on verso *Robert Rooney*

Howard Taylor (born 1918)

362 *Landscape unfolding* 1984
Oil on canvas 92 × 92 cm
Signed on verso *H. Taylor 1984*
Inscribed on verso *. . . Landscape Unfolding*

Rosalie Gascoigne (born 1917)

363 *Pink on blue* (1982–3)
Wood construction 101 × 87 cm
Signed on verso *Rosalie Gascoigne*

Jan Senbergs (born 1939)

364 *Hill town* 1984
Pastel 78 × 117 cm
Signed *J. Senbergs 84*
Inscribed on verso *Hill Town*

Davida Allen (born 1951)

365 *Where's Sara?* (1985)
Oil on canvas 84 × 84 cm
Signed on verso *Davida Allen*

Imants Tillers (born 1950)

366 *Anything goes: War of the world* (1982)
Charcoal on six canvas boards 51 × 115 cm
Signed on verso *Imants Tillers*

Hossein Valamanesh (born 1949)

367 *Target practice* (1986)
Wood, rope diptych
70 × 70 cm each
Not inscribed

Ken Unsworth (born 1931)

368 *Open cut* (1980)
Steel 21 × 25 × 25 cm
Not inscribed

Dick Watkins (born 1937)

369 *Barbed wire* (1986)
Acrylic on canvas 153 × 122 cm
Signed on verso *R.Watkins*

Peter Tyndall (born 1951)

370 *A person looks at a work of art . . .* (1984)
Acrylic on canvas 101 × 121 cm
Inscribed on verso *A Person Looks at a Work of Art/ Someone looks at something/ Peter Tyndall*

Trevor Nickolls (born 1949)

371 *Third eye* (1986)
Acrylic on canvas 91 × 71 cm
Unsigned

Tim Johnson (born 1947)

372 *Notes on Thailand* 1987
Oil on canvas 48 × 76 cm
Signed on verso *Tim Johnson 87*

Nicholas Nedelcopoulos (born 1955)

373 *The Great Australian Dream* 1987
Etching 100 × 50 cm
Signed *Nicholas Nedelcopoulos 1987*
Inscribed *The Great Australian Dream ed 1/20*

Robert MacPherson (born 1937)
374 *Untitled* 1977
Exterior duco enamel on six canvases approximately 30.5 × 30.5 cm each
Signed on verso *MacPherson 77*

Allan Mitelman (born 1946)
375 *Untitled* 1986
Oil and pencil on canvas 30 × 40 cm
Inscribed on verso *Artist: Allan Mitelman/ Title: Untitled 1986*

Stephen Killick (born 1947)
376 *Presto* 1987
Wood 78 × 57 cm
Signed on verso *S.T.Killick*
Inscribed on verso *Stephen Killick/ Presto/ March 87*

Geoffrey Bartlett (born 1952)
377 *Cockatoo in flight* (1977)
Steel 72 × 70 × 40 cm
Not inscribed

Noel McKenna (born 1956)
378 *Williamsburg, Brooklyn* 1986
Watercolour 28 × 38 cm
Signed *N.McKenna 86*

Joe Furlonger (born 1952)
379 *Three figures on beach* 1986
Watercolour 21 × 29 cm
Signed *J.F. 86*

Vicki Varvaressos (born 1949)
380 *Three women* 1987
Acrylic on board 76 × 122 cm
Signed *VV87*
Signed again on verso and inscribed *Three Women*

Tom Risley (born 1947)
381 *Garden seat* 1988
Wood and nylon 133 × 90 × 129 cm
Not inscribed

Patrick Henigan (born 1925)
382 *Down for the count* 1988

Charcoal 57 × 76 cm
Signed *Patrick Henigan 1988*

Ian Westacott (born 1956)
383 *Factory light and bridge against the wall* (1988)
Etching 72 × 89 cm
Signed *Ian Westacott*
Inscribed *A/P and Factory Light and Bridge Against the Wall*

Lorraine Jenyns (born 1945)
384 *A tiger's tale* (1987)
Earthenware 55 × 28 × 16 cm
Not inscribed

Stephen Benwell (born 1953)
385 *Vase* 1988
Earthenware 31 × 30 cm diameter
Signed on base *S.Benwell 88*

Nerissa Lea (born 1959)
386 *Origin of a species* (1988)
Charcoal 100 × 71 cm
Unsigned

Rosslynd Piggott (born 1958)
387 *Italy* 1988
Oil on canvas 76.3 × 91.3 cm
Signed on verso *Rosslynd Piggott 1988*

Dini Campbell (born 1945)
388 *Tingari men and women, Nyilanya* (1987)
Acrylic on canvas 121 × 91 cm
Inscribed on verso *Dini Campbell/ DC 870815*

Clifford Possum (born 1934)
389 *Parrot dreaming at Intangkangu* (1987)
Acrylic on canvas 122 × 107 cm
Inscribed on verso *CP 8706682*

Paddy Japaltjarri Stewart (born 1940)
390 *Marlu Jukurrpa (Kangaroo Dreaming)* 1987
Acrylic on canvas 137 × 91 cm
Inscribed on verso *126/ 87 Paddy Stewart*

PORTRAITS OF JOSEPH BROWN

George Luke (born 1920)
391 *Trooper Joseph Brown* 1940
Oil on canvas 150 × 91 cm
Signed *Luke 40*
Inscribed *Trooper Joseph Brown/ 13th Light Horse/ George Luke 1940*
Gift of the artist

Arthur Boyd (born 1920)
392 *Four portraits of Joseph Brown* (1969)
Oil on canvas, each 76.2 × 63.5 cm
Each signed *Arthur Boyd*
Painted in London, gift of the artist

Clifton Pugh (born 1924)
393 *Joseph Brown* 1971–72
Oil on hardboard 121.9 × 91.4 cm
Signed *Clifton/ Aug'71–Mar'72*

William Dargie (born 1912)
394 *Joseph Brown and Bow* (1975)
Oil on board 57 × 46 cm
Signed *Dargie*
Gift of the artist

Brian Dunlop (born 1938)
395 *Joseph Brown and Bow* (1982)
Watercolour 72 × 99 cm
Signed *Dunlop*

William Dobell (1899–1970)
396 *Joseph Brown* 1967
Pencil 31 × 24 cm
Signed *Dobell 67*
Inscribed *175/ William Dobell/ Sketch of Joseph Brown on his 49th Birthday*
Gift of the artist

Rick Amor (born 1948)
397 *Joseph Brown* 1974
Oil on canvas 117 × 89 cm
Signed *Rick Amor 74*
Inscribed on verso *Portrait of Joseph Brown/ Rick Amor*

Dorothy Braund (born 1926)
398 *Joseph Brown with friends* 1981

Watercolour 36 × 49 cm (detail)
Unsigned
(Friends: Russell Drysdale, Maisie Drysdale,
Rod Andrew, Joan Andrew, Dorothy Braund)
Gift of the artist

John Brack (born 1920)
399 *Joseph Brown* 1980
Pencil 38 × 30 cm
Signed *John Brack 1980*
Gift of the artist

Wes Walters (born 1928)
400 *Dr Joseph Brown* 1983
Oil on canvas 142 × 106 cm
Signed *Walters 83*

WORKS BY JOSEPH BROWN

Joseph Brown (born 1918)
401 *Jacob Brown* (1935)
Oil on board 51 × 41 cm
Signed *Joseph Brown*
Portrait of the artist's father

402 *Estelle* (1946)
Oil on canvas 61 × 51 cm
Signed *Joseph Brown*

403 *Torso* (1950)
Bronze 89 × 38 × 38 cm
Signed on base *Joseph Brown*
First of edition of two, cast in bronze by
Vittorio and Fernando 1969. The second and
final casting made by Meridian Foundry 1987
for Carrick Hill, Adelaide, SA

404 *Self-portrait* 1968
Oil on canvas 61 × 45 cm
Signed on verso *Self portrait painted by me
1968 at Dunk Island. Joseph Brown*

405 *Continuity of line* (1956)
Bronze on marble base 79 × 100 × 73 cm
Not inscribed
Second edition of 2 bronze casts. The first was
commissioned by Geelong Art Gallery,
Victoria and cast by Vittorio and Fernando.
The second casting by Meridian

406 *The cave* (1987)
Wood 79 × 78 × 38 cm
Gifted to Newcastle Region Art Gallery,
NSW.
Bronze cast edition gifted to McClelland State
Regional Gallery Langwarrin, Victoria
Bronze cast of the maquette edition gifted to
Bendigo Art Gallery, Victoria

407 *Abstract* 1986
Oil on board 56 × 76 cm
Signed *Joseph Brown 1986*

INDEX OF ARTISTS

(Numbers in italic type are plate numbers and numbers in bold type are text references.)